Visions of
LONDON

Simon Hadleigh-Sparks

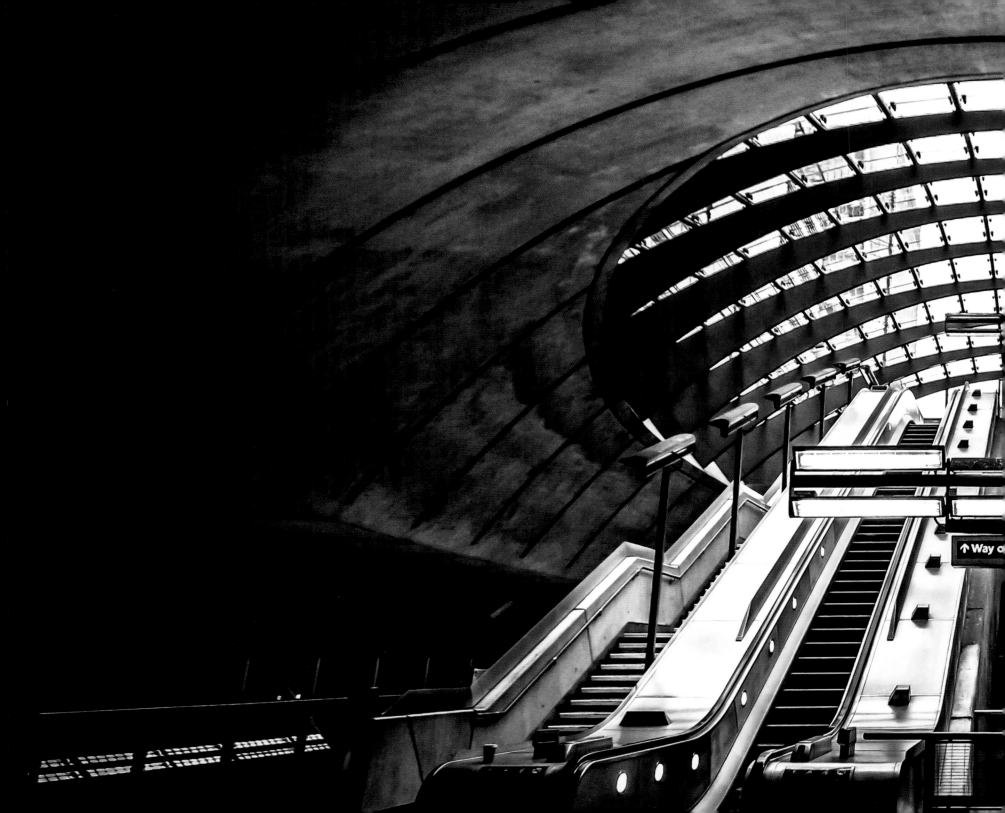

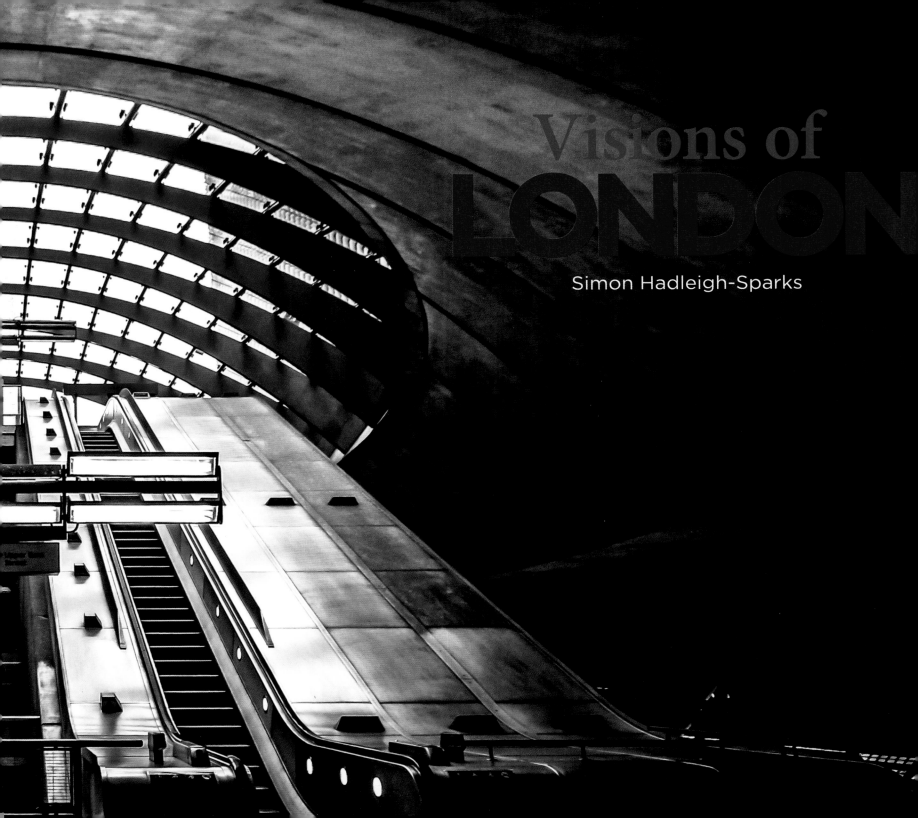

Visions of
LONDON

Simon Hadleigh-Sparks

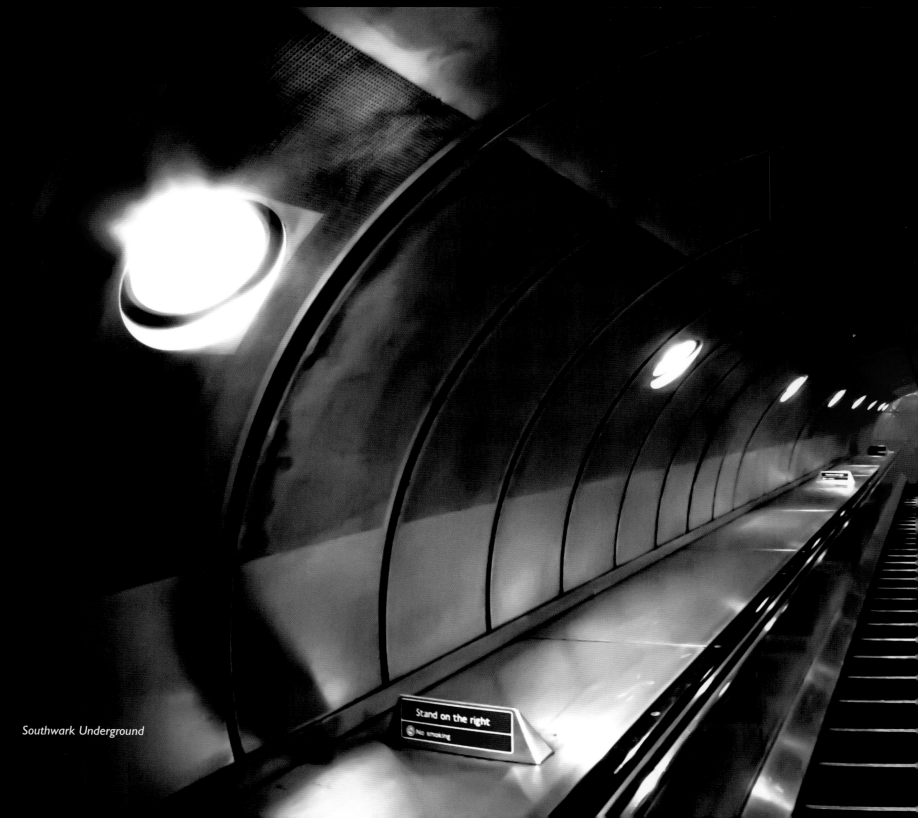

Southwark Underground

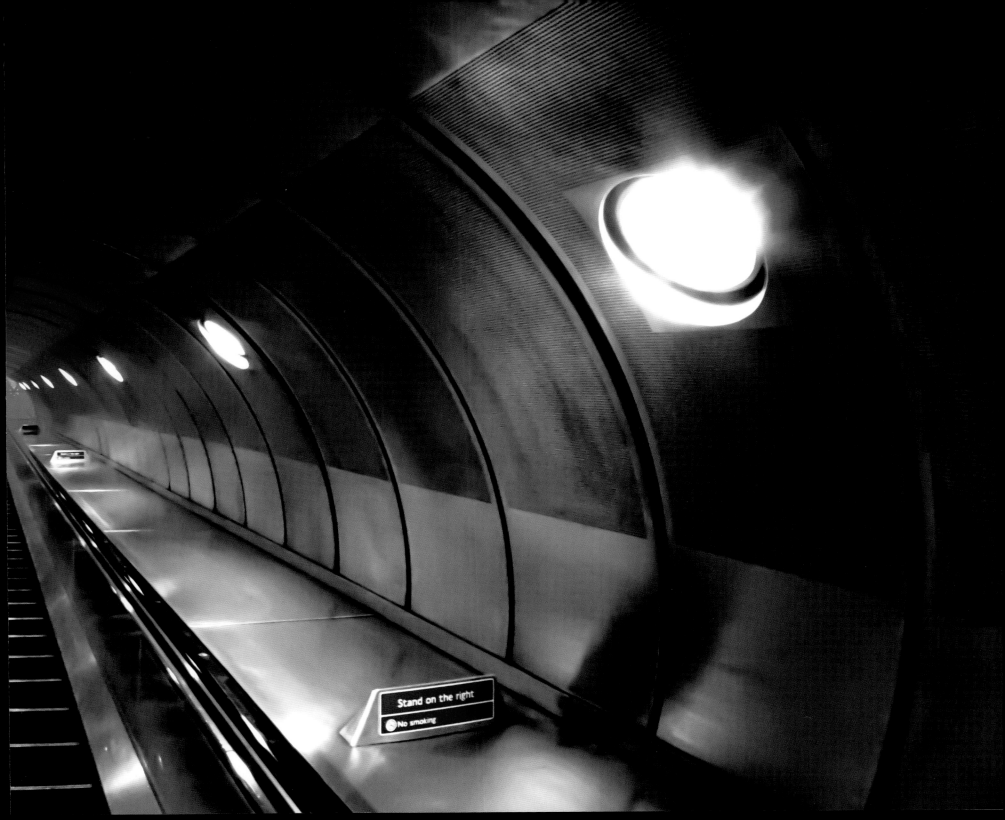

INTRODUCTION

Visions of London is a collection of urban city photography by award-winning photographer Simon Hadleigh-Sparks. The book highlights his passion for abstract-reflected architecture and reflected imagery, a style he has created for himself. He also experiments with extreme contrasts and has been called "a master of light". He has also mastered the art of post-production – blending, temperature, tone curve, and luminance, just to mention just a few.

Simon has been described as 'a digital artist' as a major aspect of his urban photography is his ability to open up a new perspective on the city – its spaces, people and history by abstract photography and innovative digital techniques to reimagine and transform the structures that make up the London Skyline.

Buildings are twisted and contorted, landscapes manipulated, all to create a dynamic new look that will change the way you see one of the greatest cities in the world. Put simply, Simon views the world differently – everything has the potential to be a photographic moment. When out photographing on the street, he often remembers to look up. His eye for clean lines, architectural design and subtle incorporation of human elements give his images a uniqueness that stays true to his fascinating style.

Simon has been the recipient of multiple international awards and recent successes include winner and best in show at the 2014 London Photo Festival, highly commended in the 2014 Urban Photographer of the Year, and 3rd place in the monochrome category of the 2014 International Garden Photographer of the Year Awards. He also had various works exhibited in 2013/2014 in and around London. His photos can currently be seen on a number of websites, blogs and magazine articles.

Simon Hadleigh-Sparks is also a professional gardener in Syon Park, West London, a husband and a father. His photography is a passion; he goes from strength to strength, sharing his photos and maybe inspiring some people along the way. He has a mixture of styles and it is in post-production that Simon produces his most successful photography. This is his second book for New Holland Publishers, following Iconic London (2015).

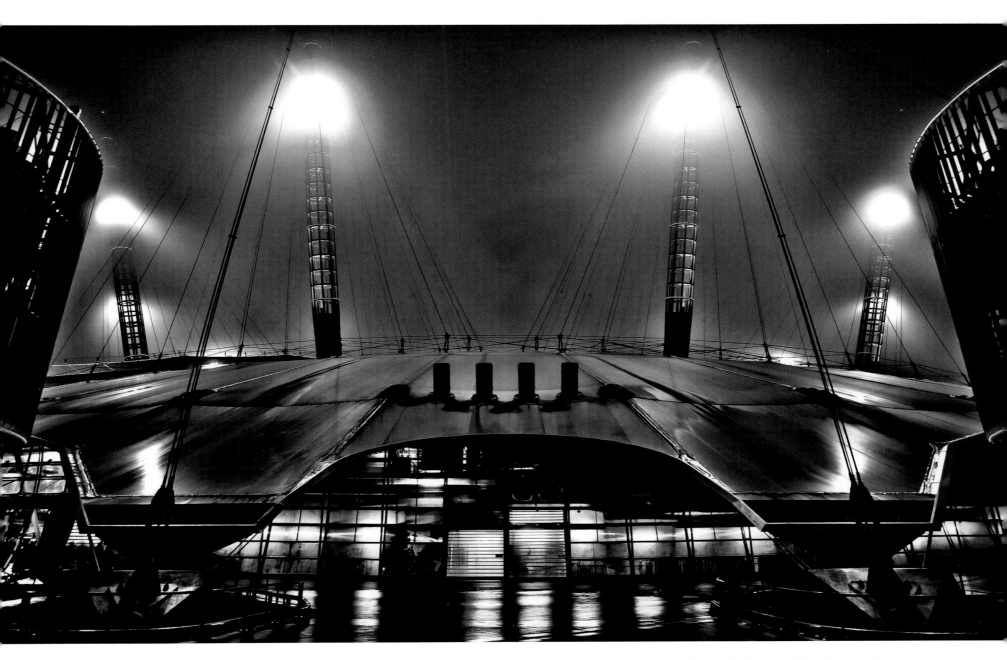

Greenwich O2 Arena (The Millenium Dome)

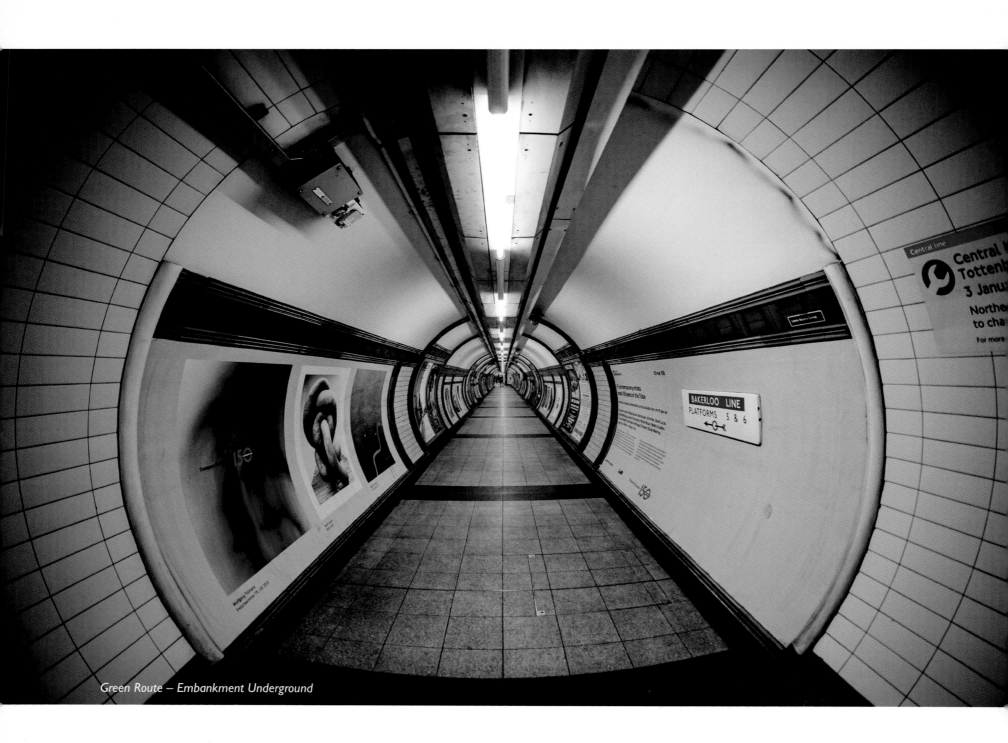

Green Route – Embankment Underground

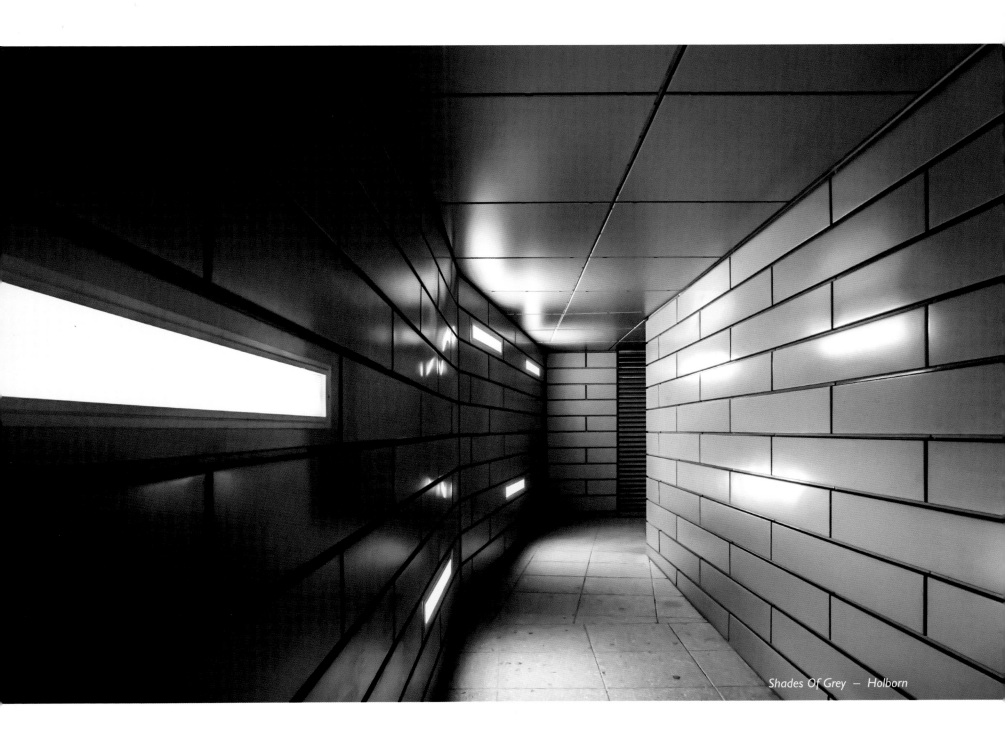

Shades Of Grey — Holborn

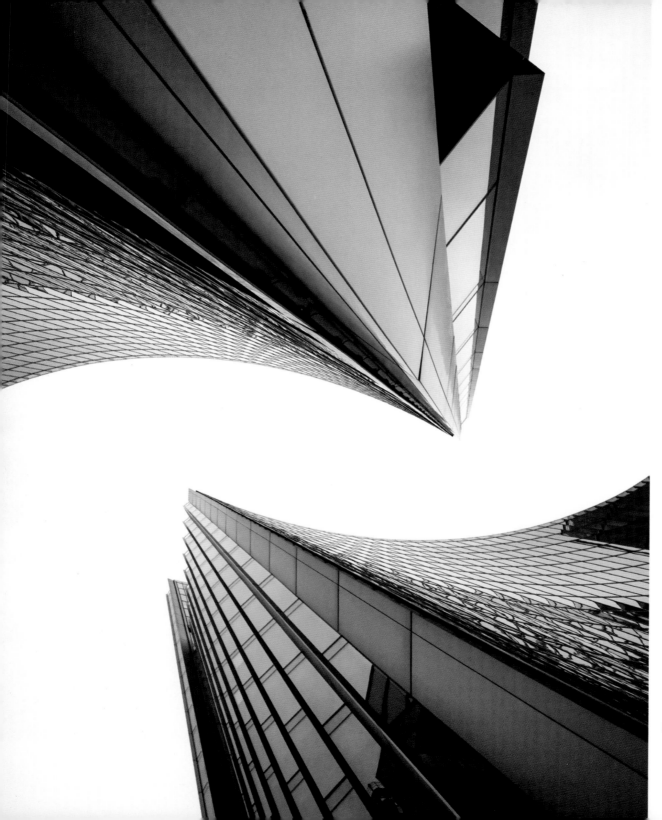

In The Middle — Willis Building

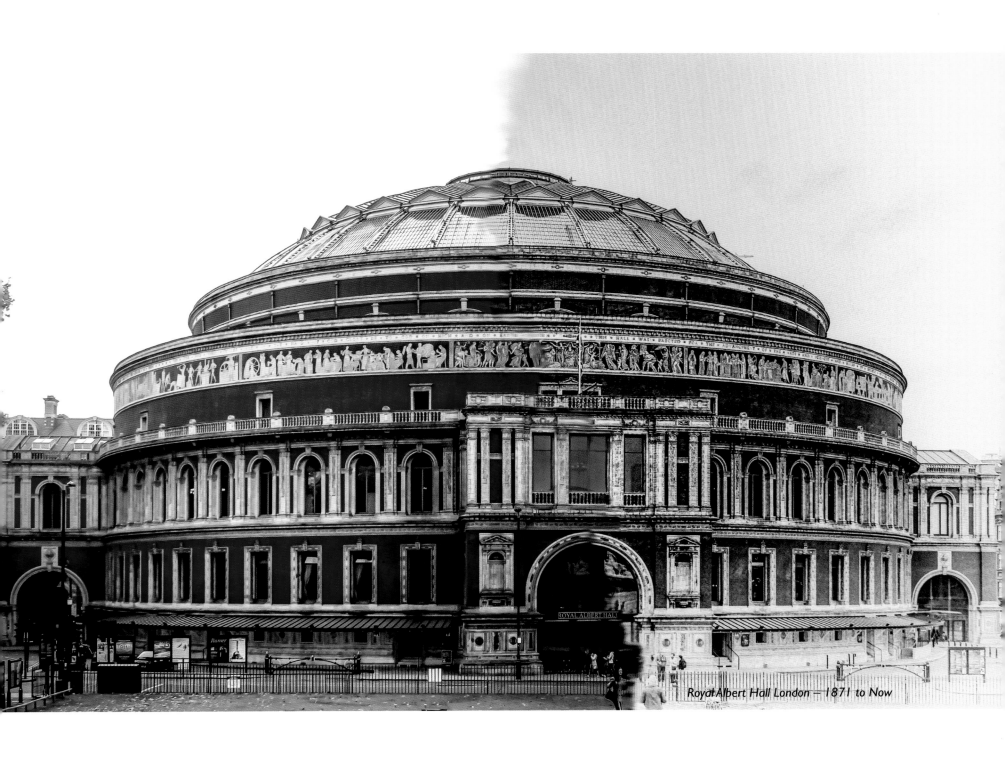

Royal Albert Hall London – 1871 to Now

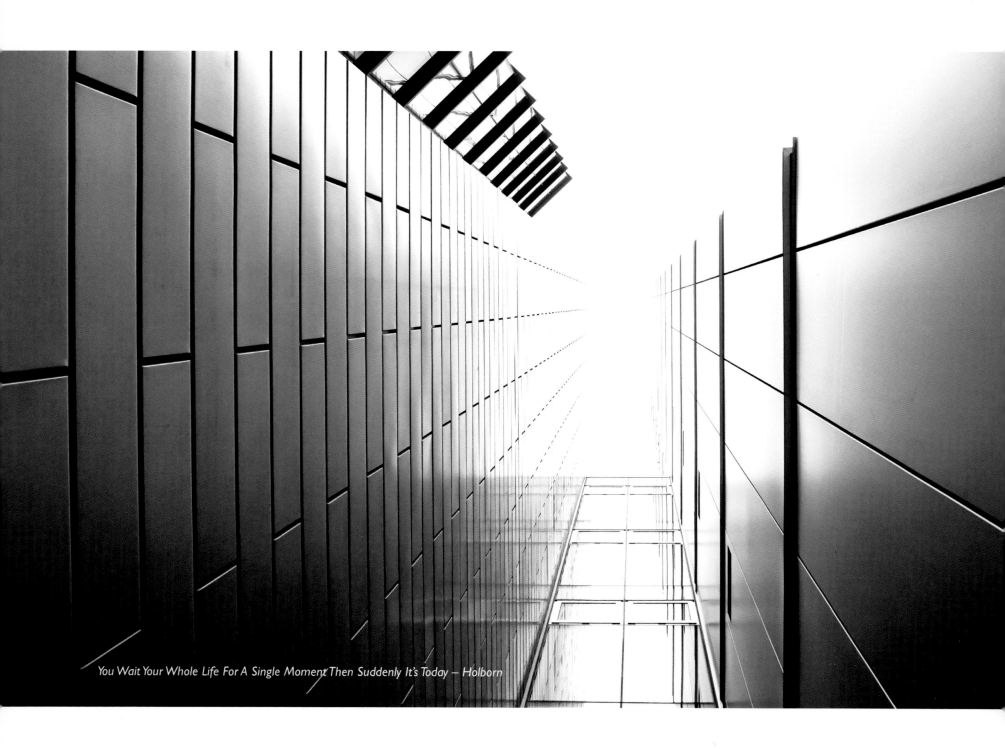

You Wait Your Whole Life For A Single Moment Then Suddenly It's Today — Holborn

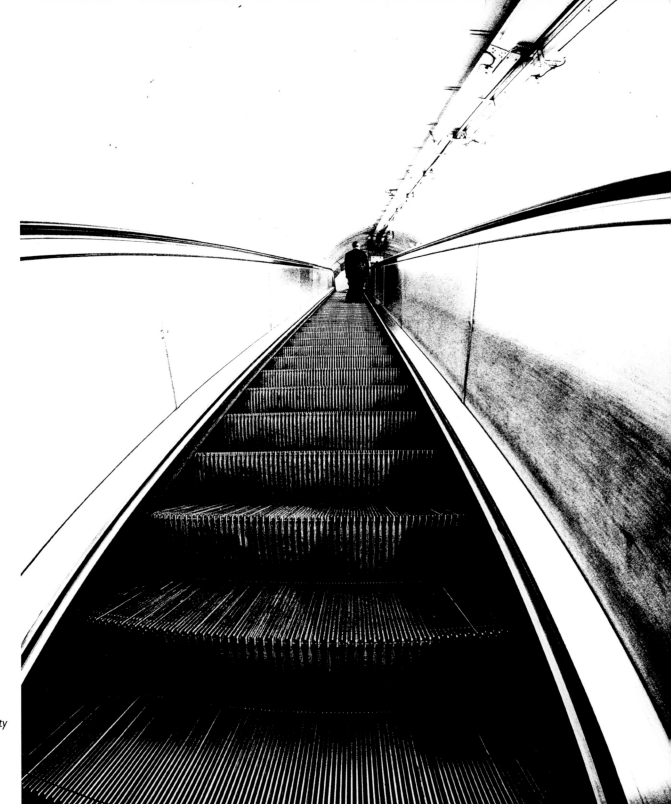

There Are Days Like This In London City

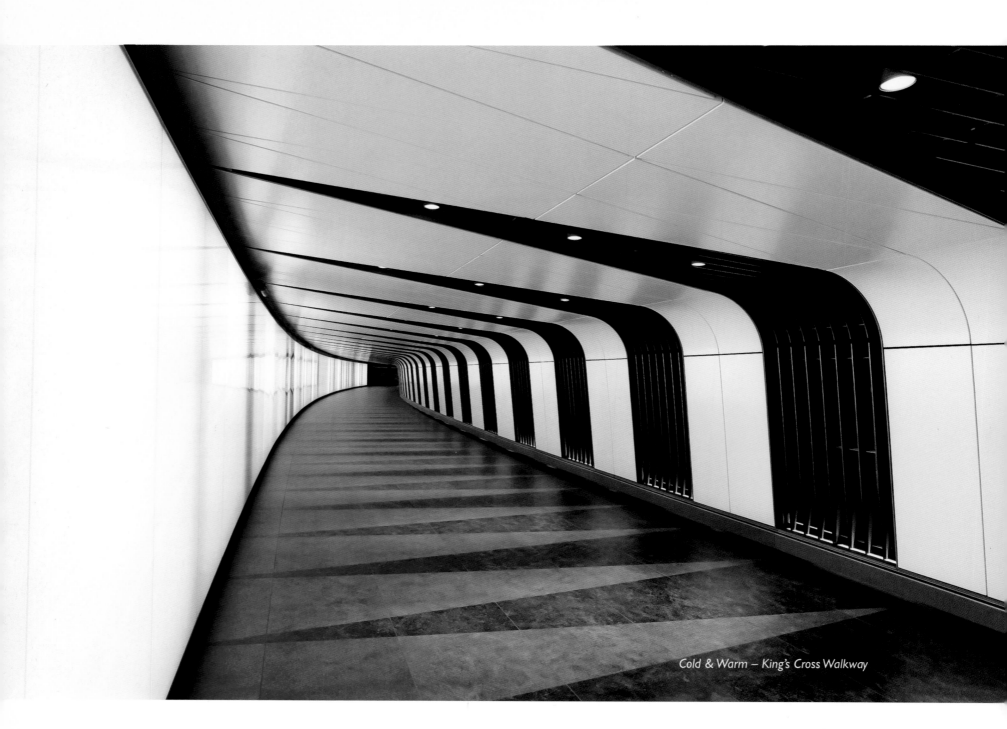

Cold & Warm – King's Cross Walkway

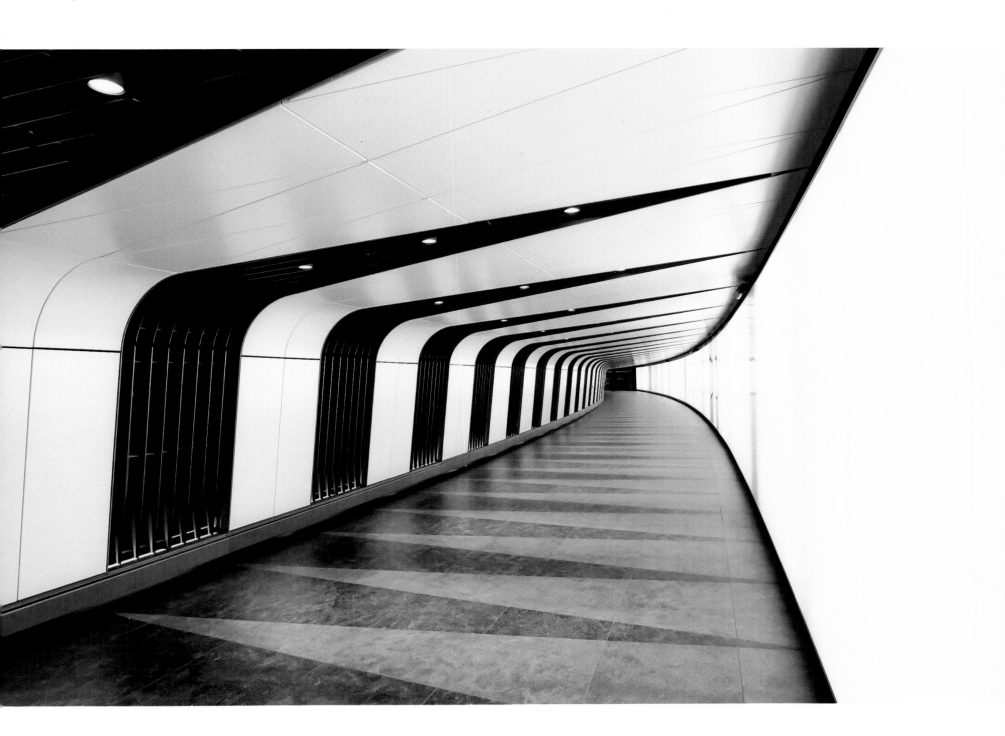

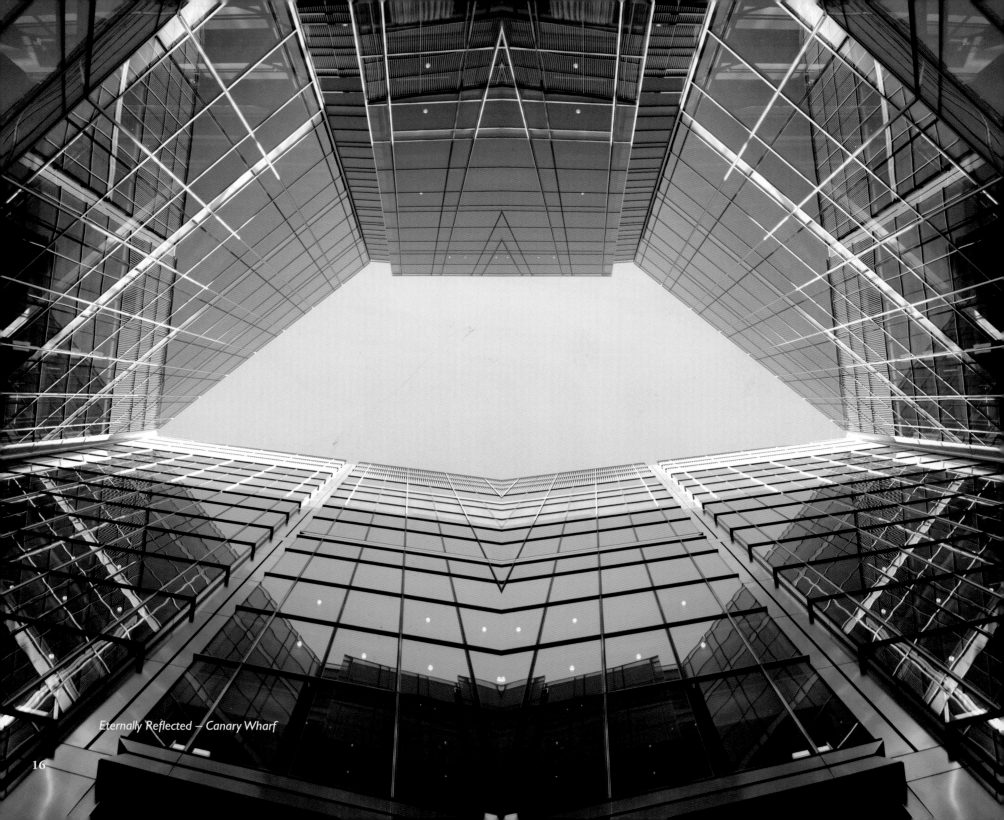

Eternally Reflected – Canary Wharf

16

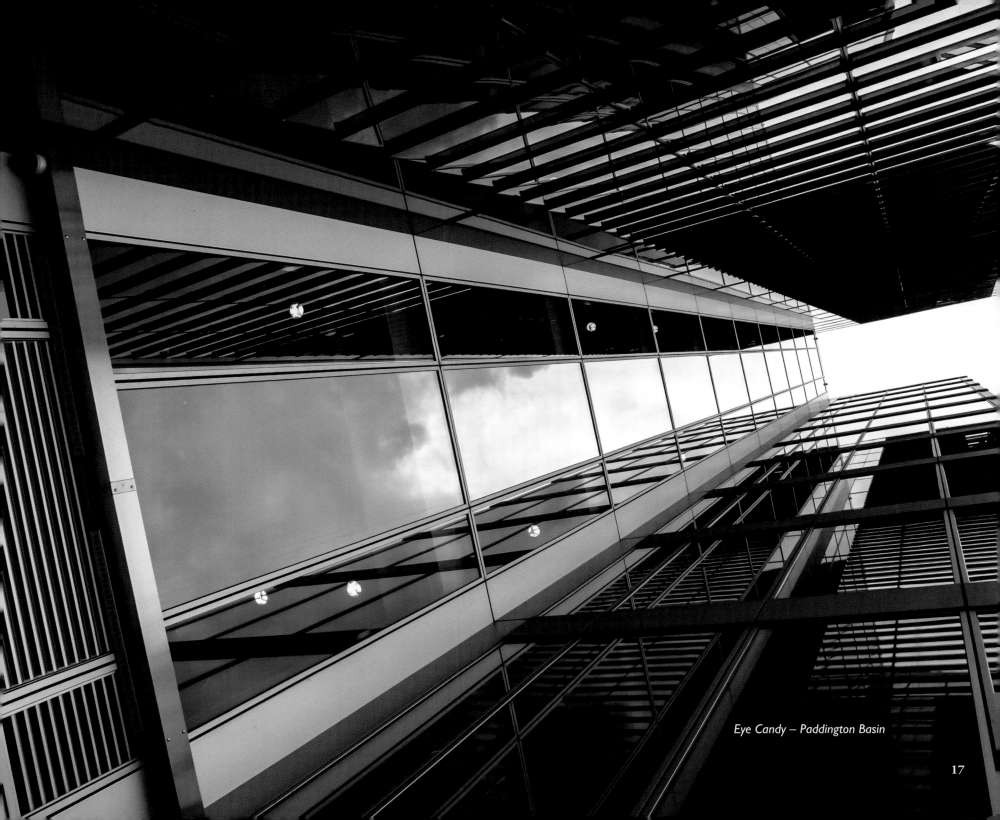

Eye Candy – Paddington Basin

17

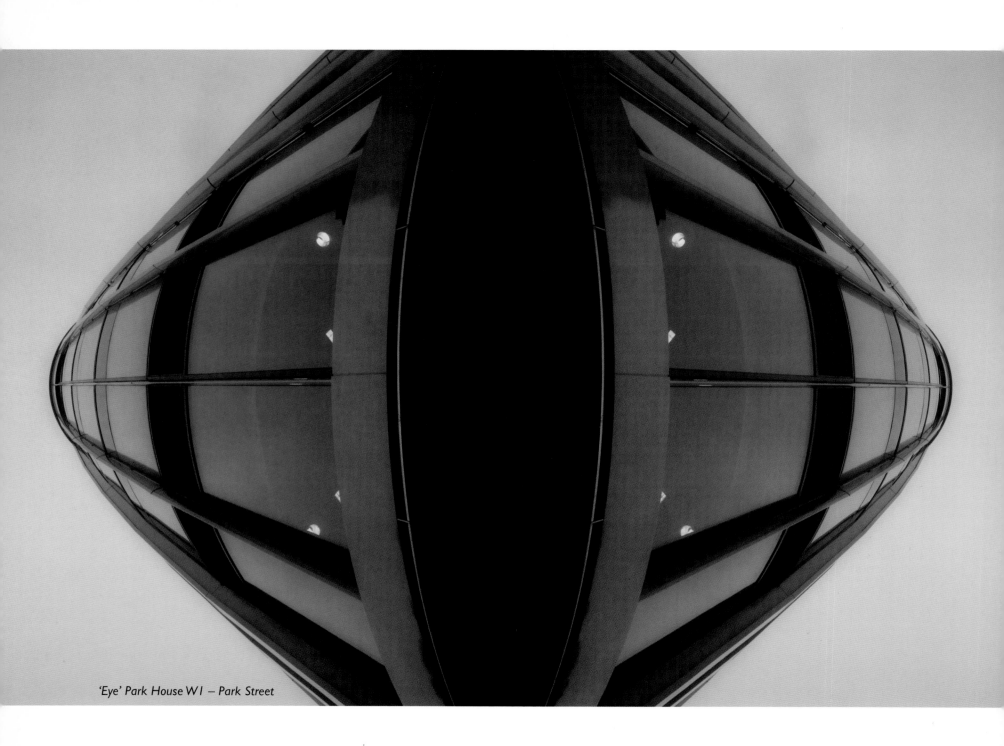

'Eye' Park House W1 – Park Street

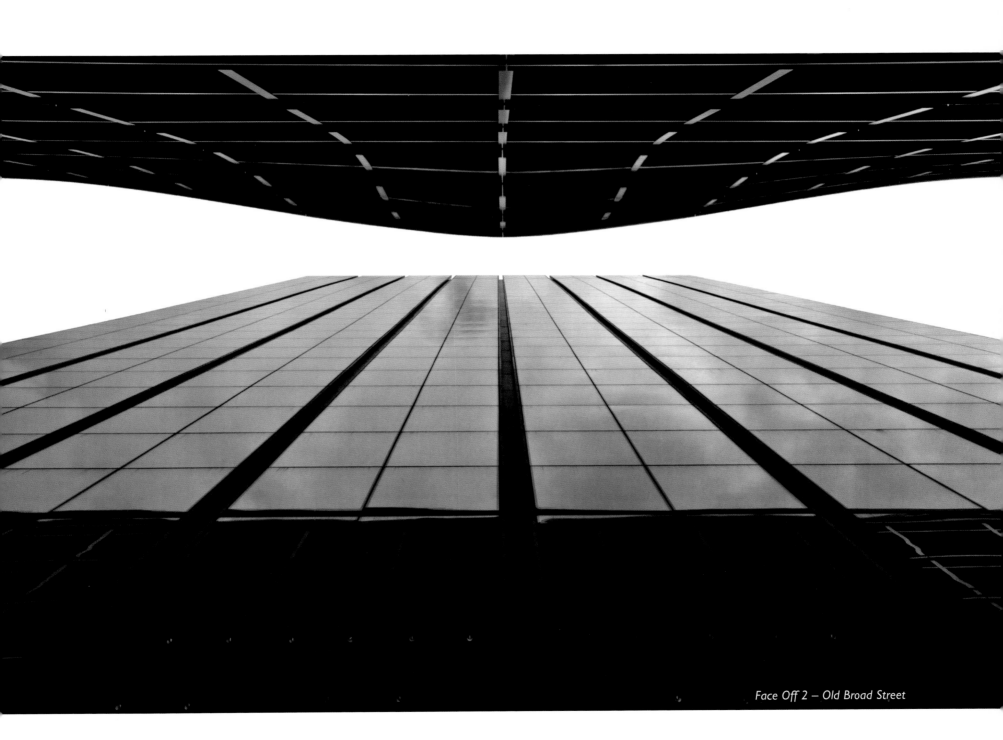

Face Off 2 – Old Broad Street

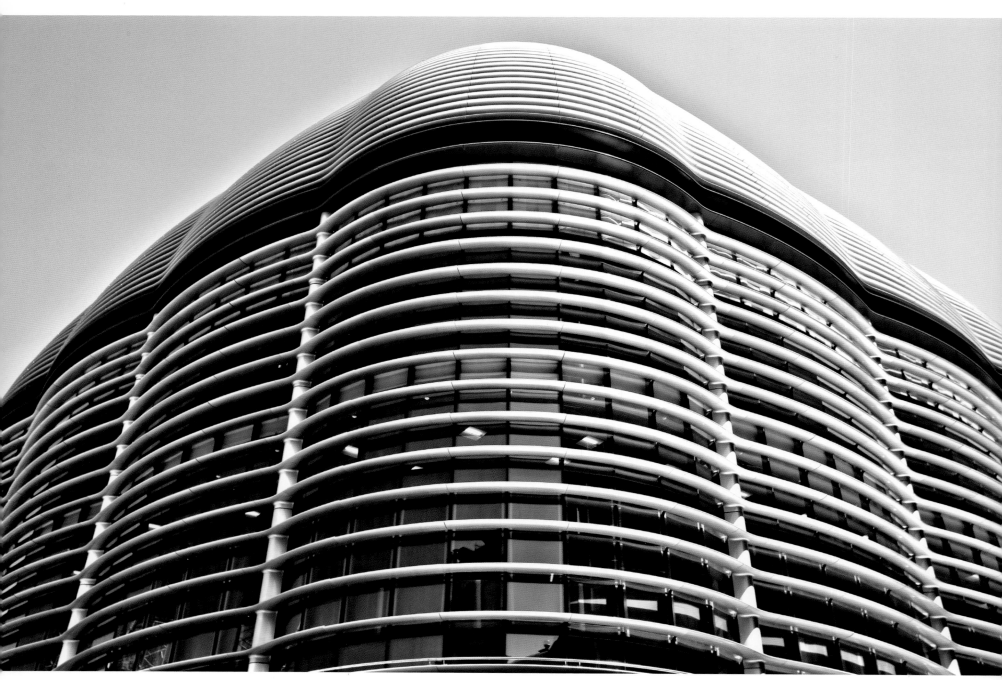

Hive Mind – Office Building Cannon Street

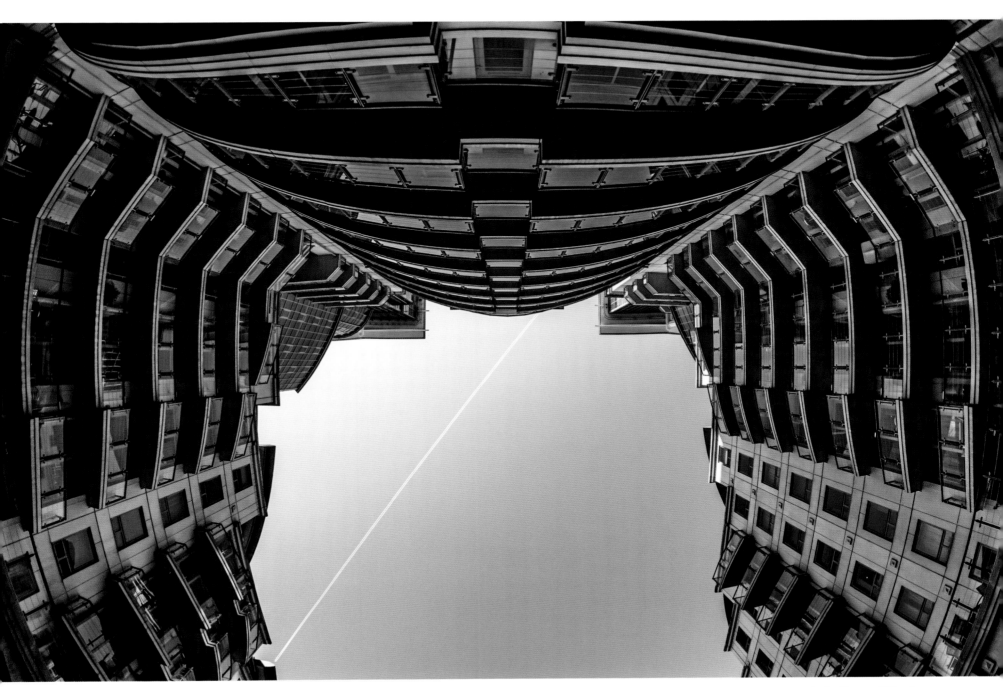

Inside St Georges Wharf

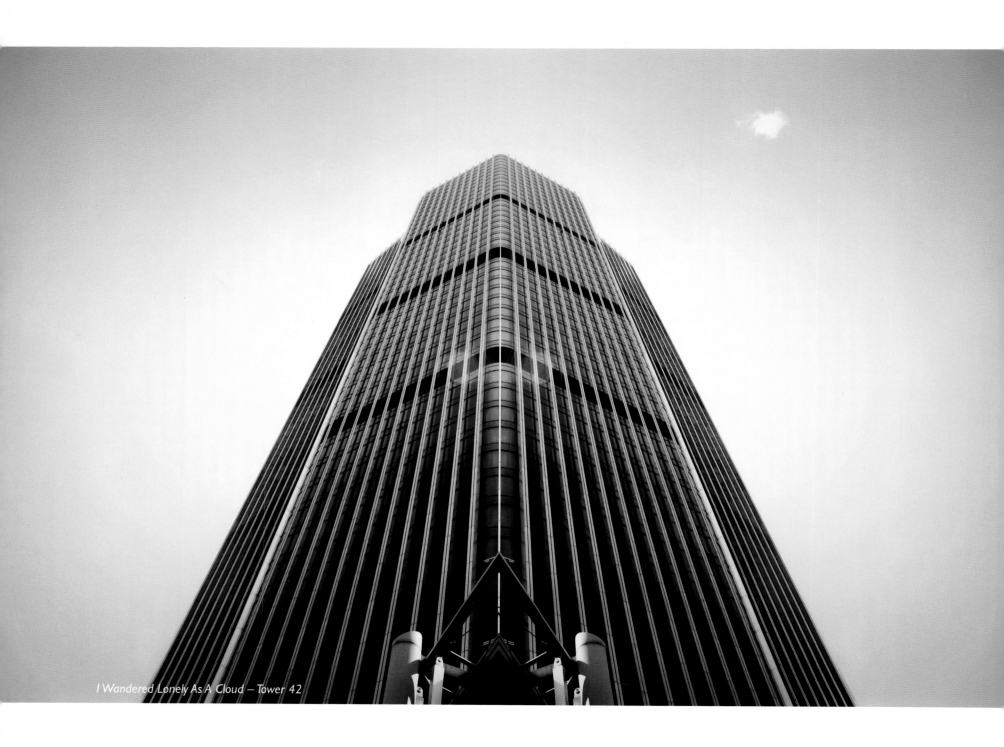

I Wandered Lonely As A Cloud – Tower 42

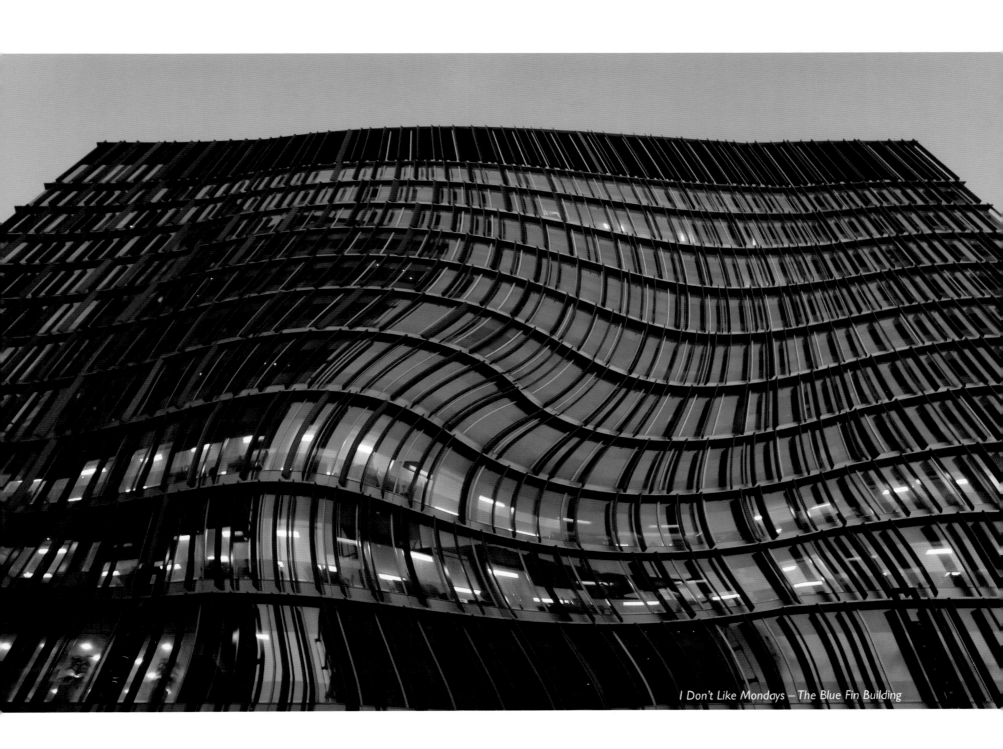

I Don't Like Mondays – The Blue Fin Building

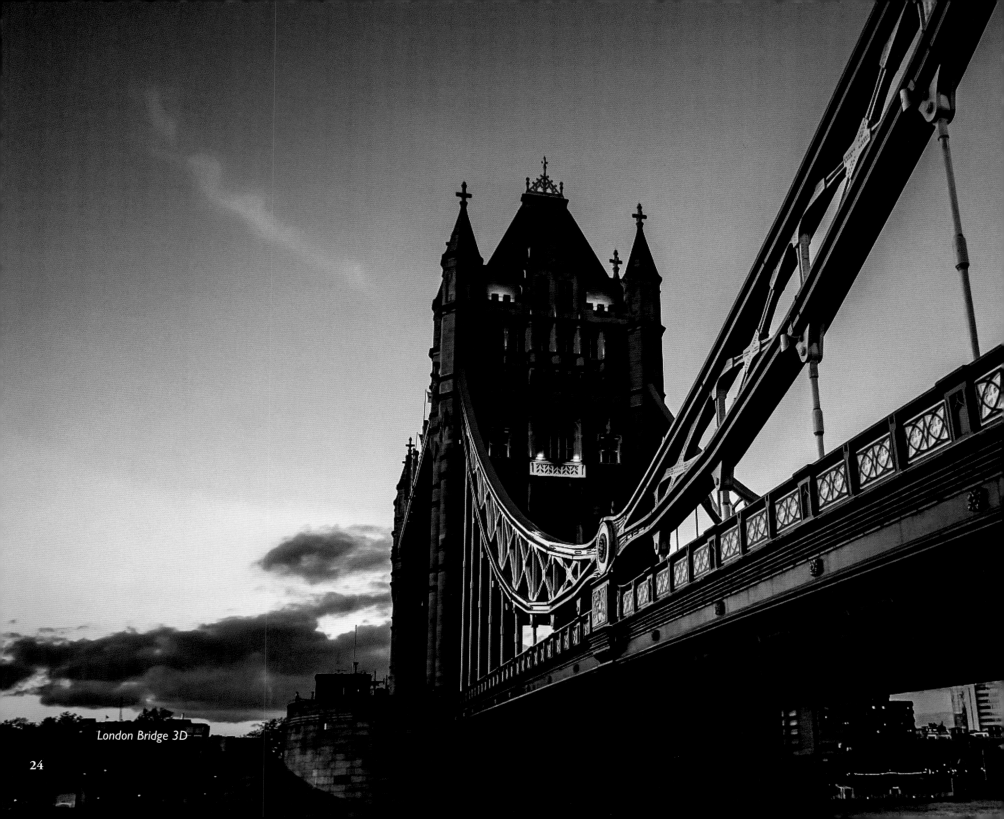

London Bridge 3D

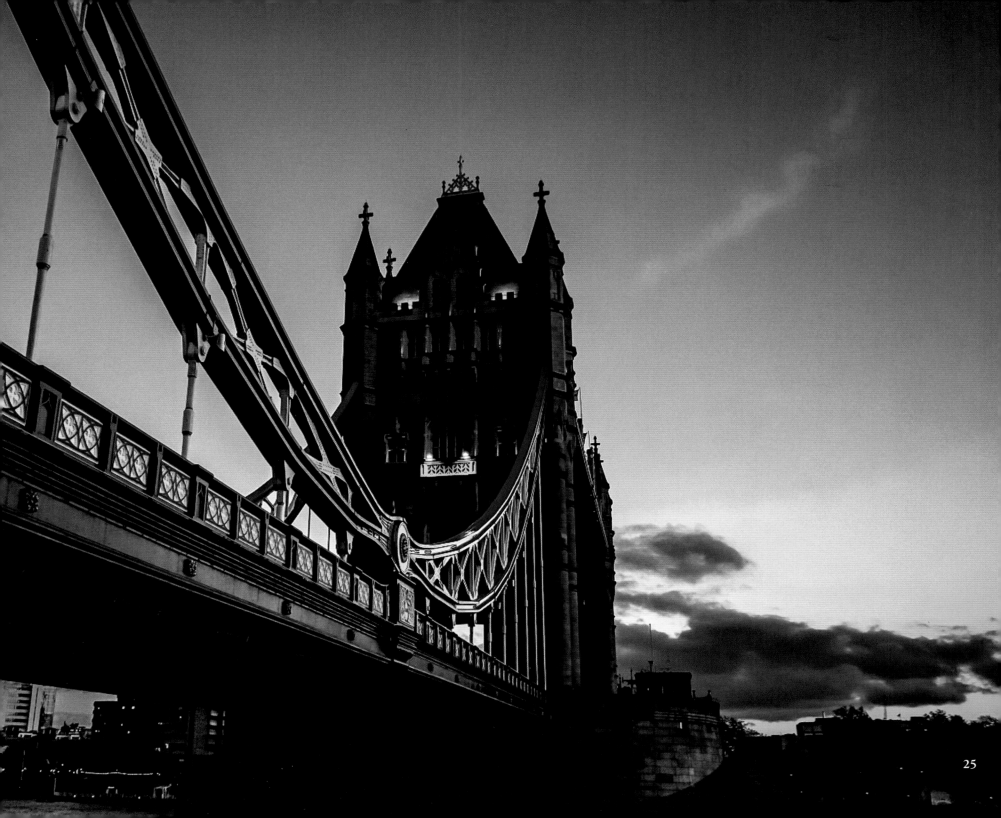

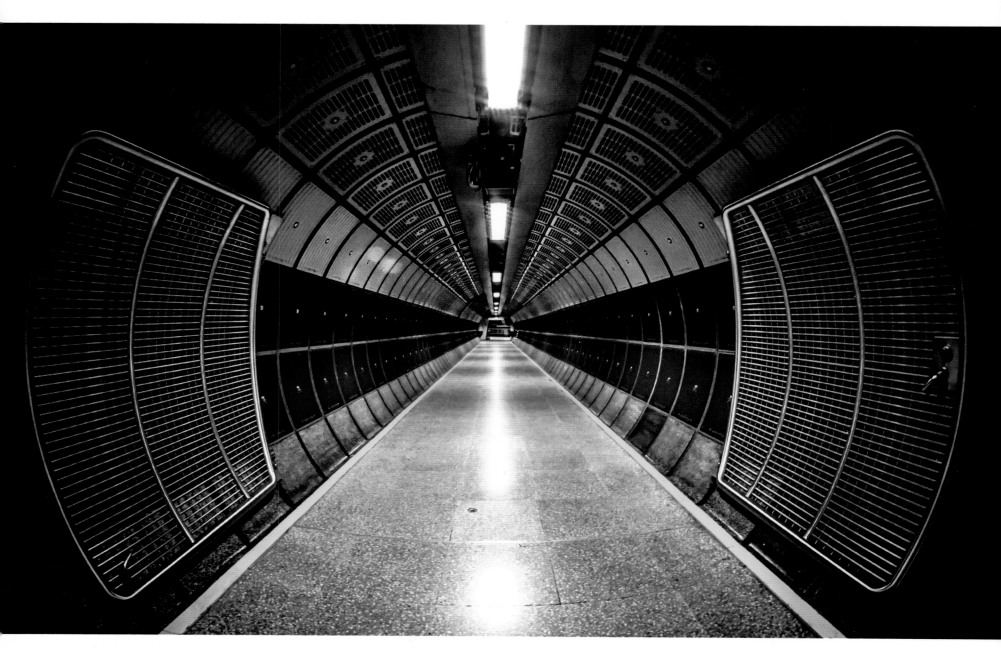

London Bridge Underground

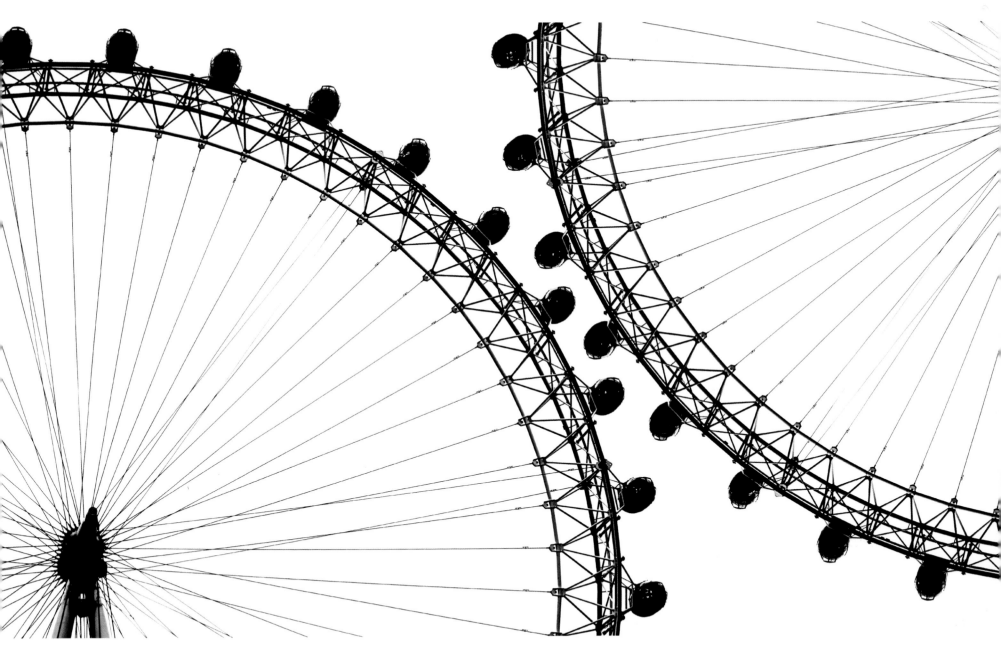

London's Big Wheel – London Eye

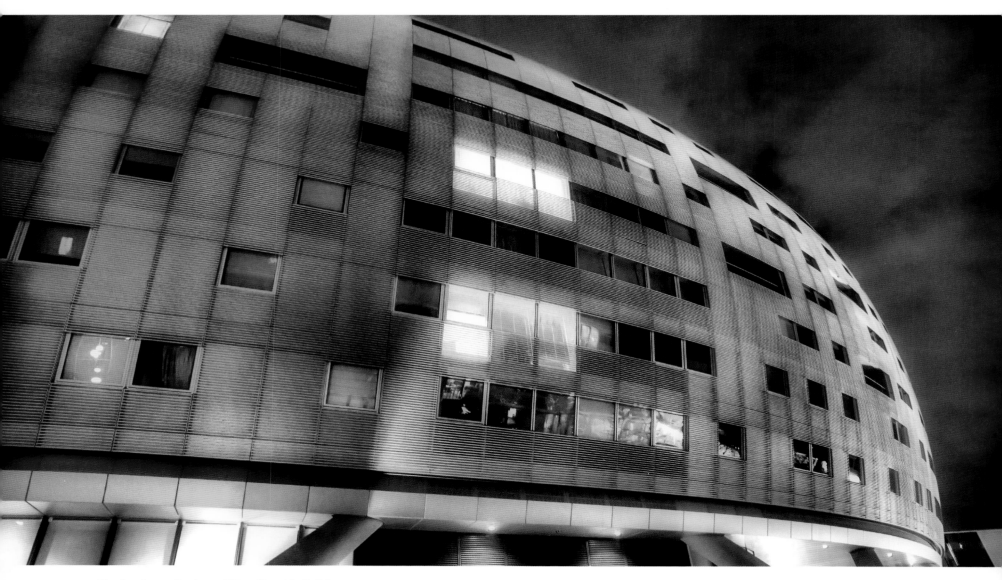

Martian Space Station – Albion Riverside Building

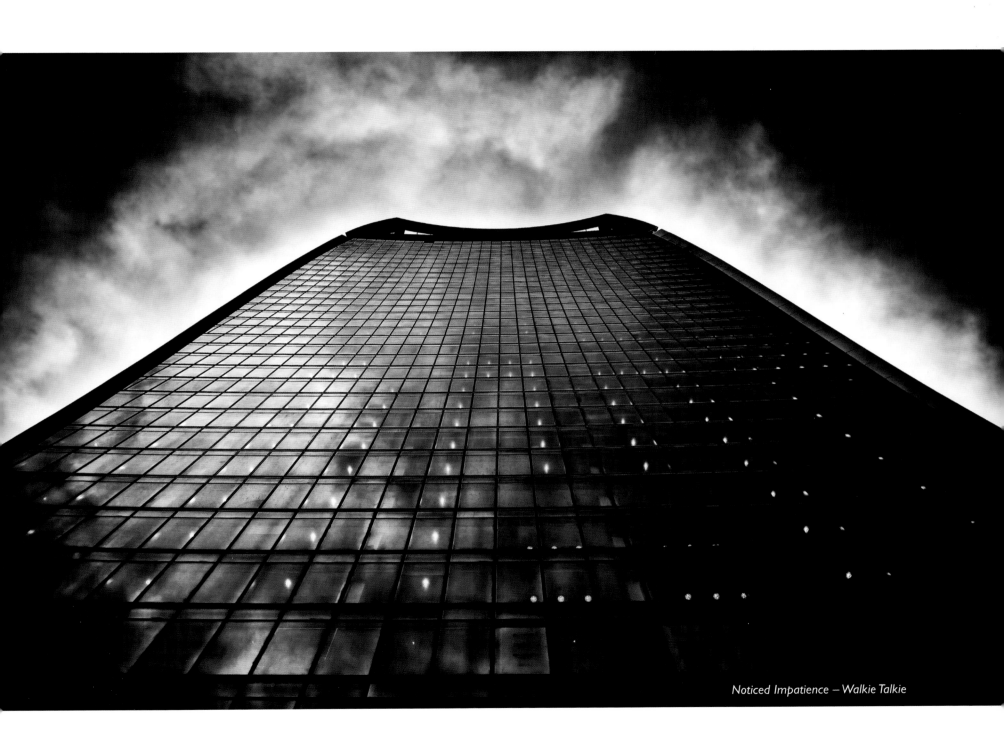

Noticed Impatience – Walkie Talkie

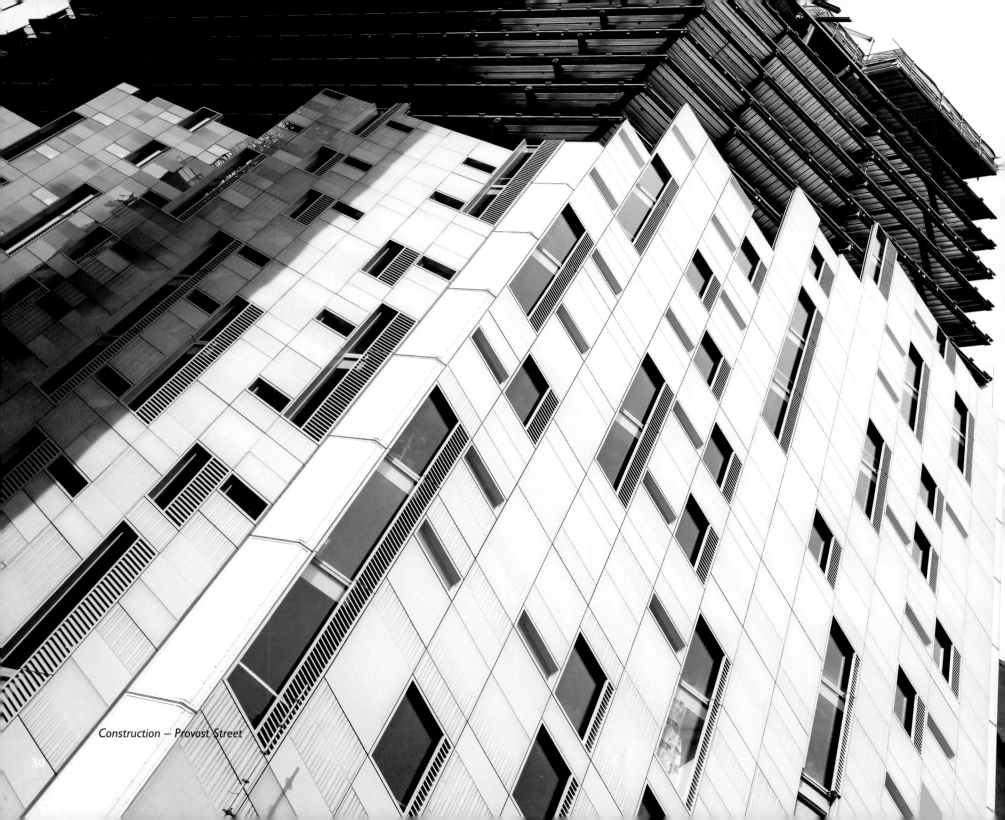

Construction – Provost Street

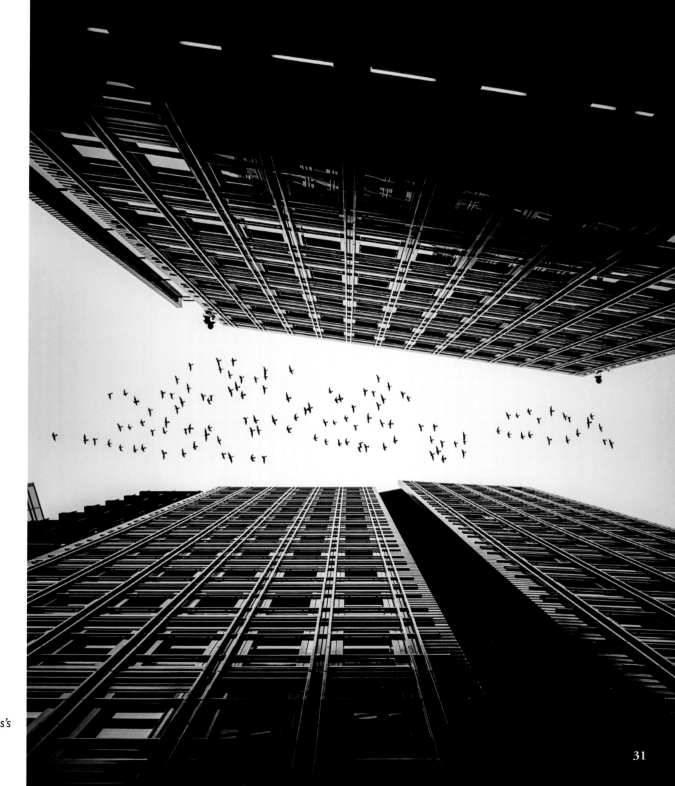

Flying South for Winter – St Giles's

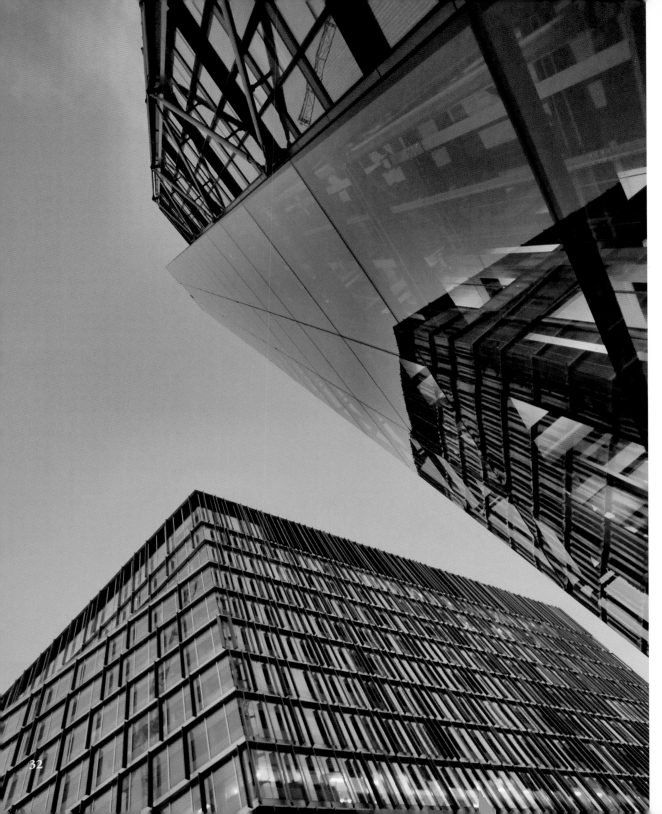

Office Filing – Blackfriars Road

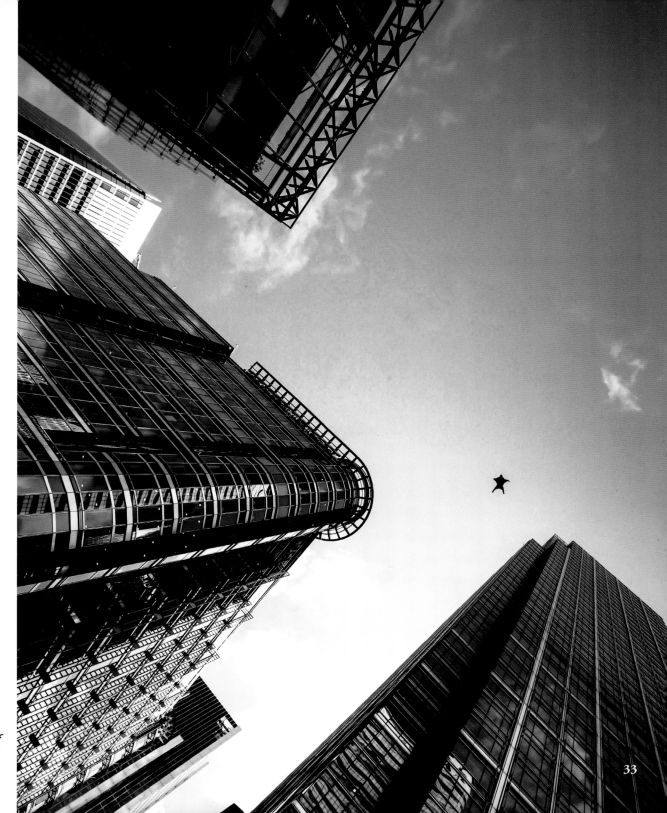

Skyscraper City Base Jumper – Canary Wharf

33

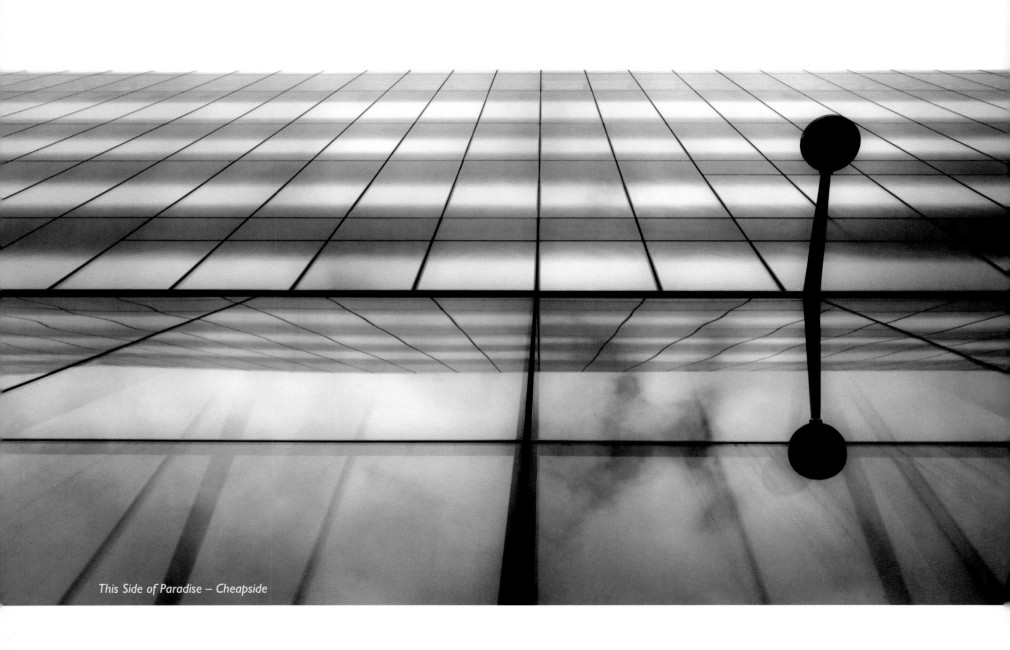

This Side of Paradise – Cheapside

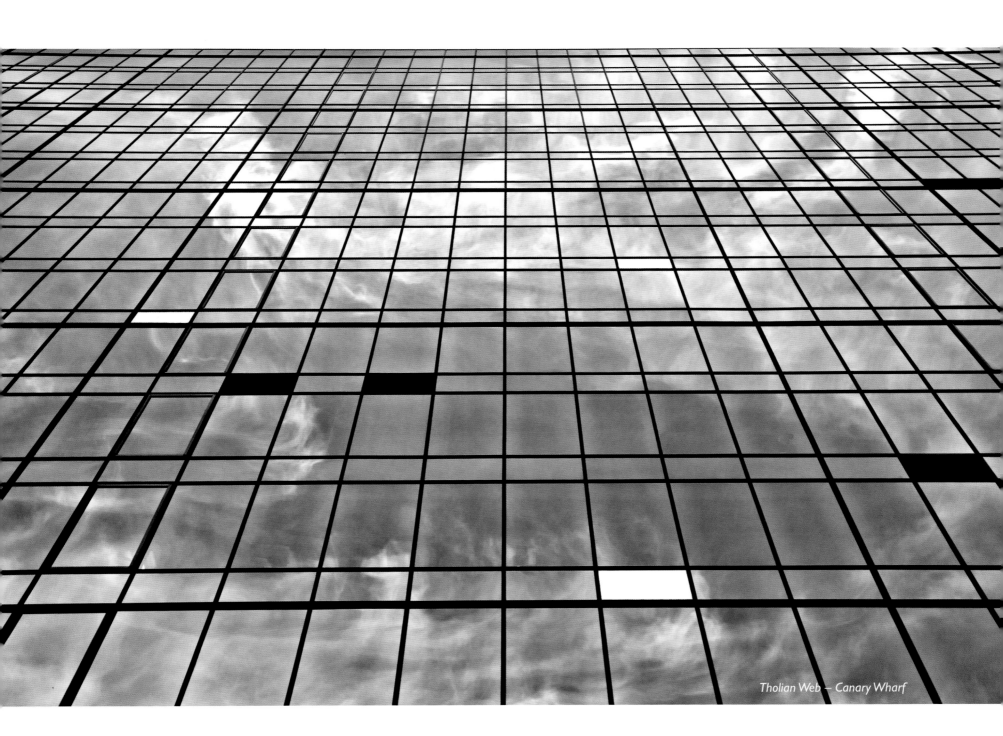

Tholian Web – Canary Wharf

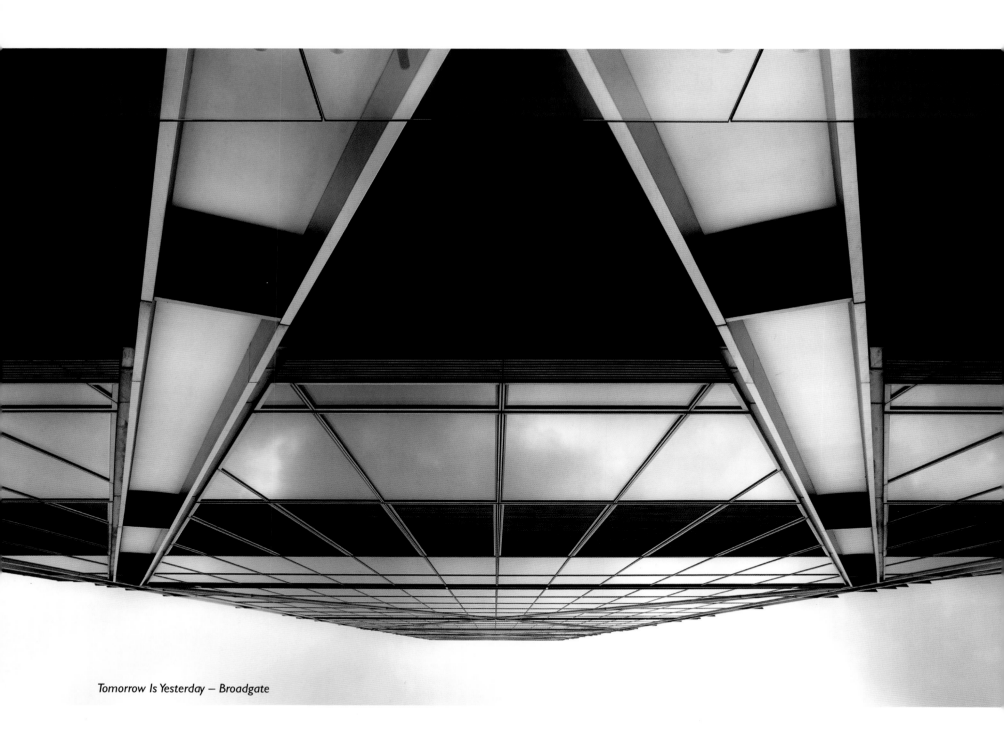

Tomorrow Is Yesterday – Broadgate

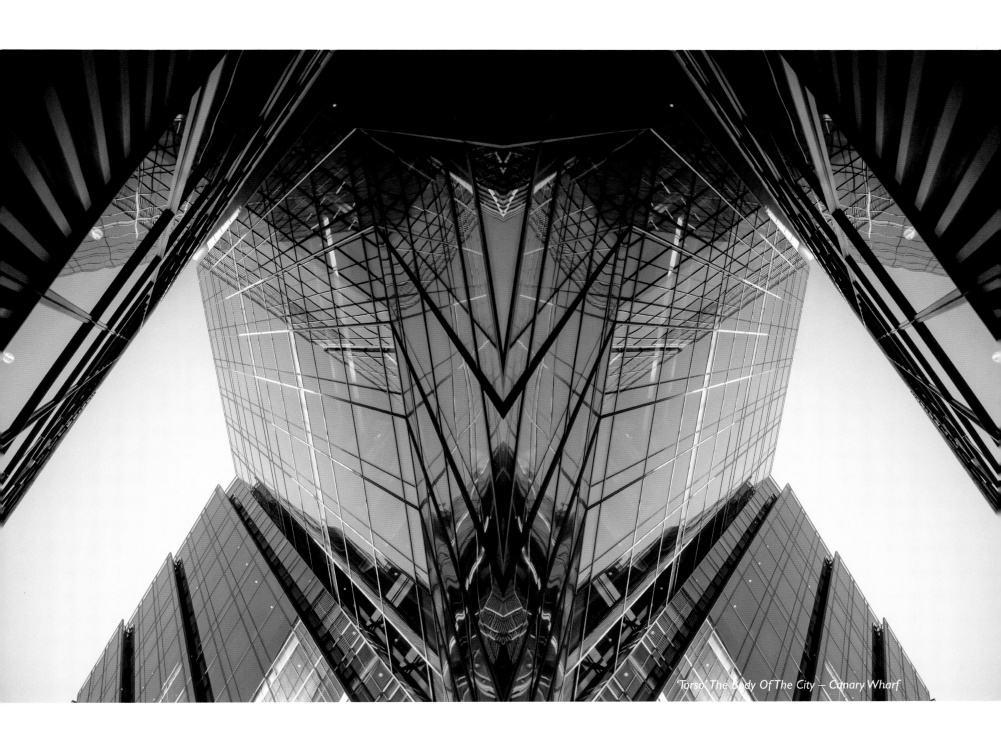

'Torso' The Body Of The City – Canary Wharf

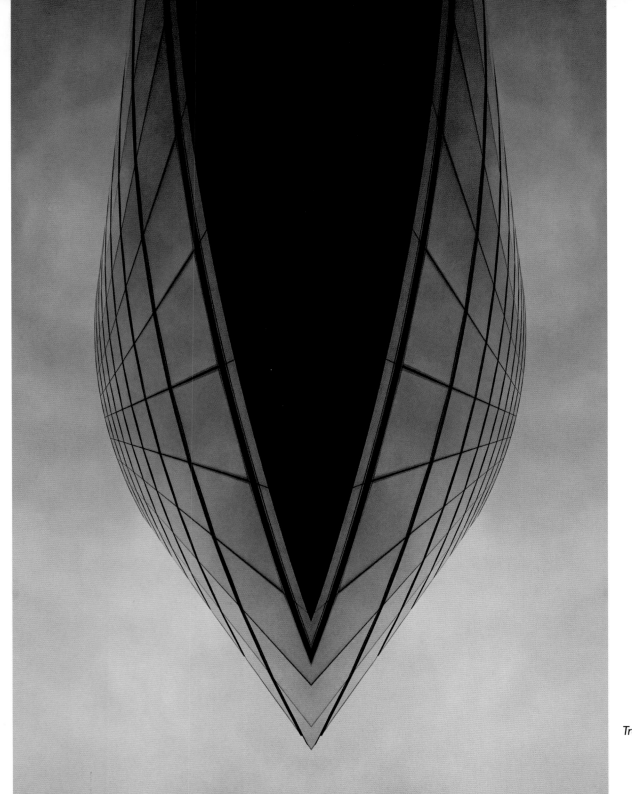

Transformation Desire – The Borough

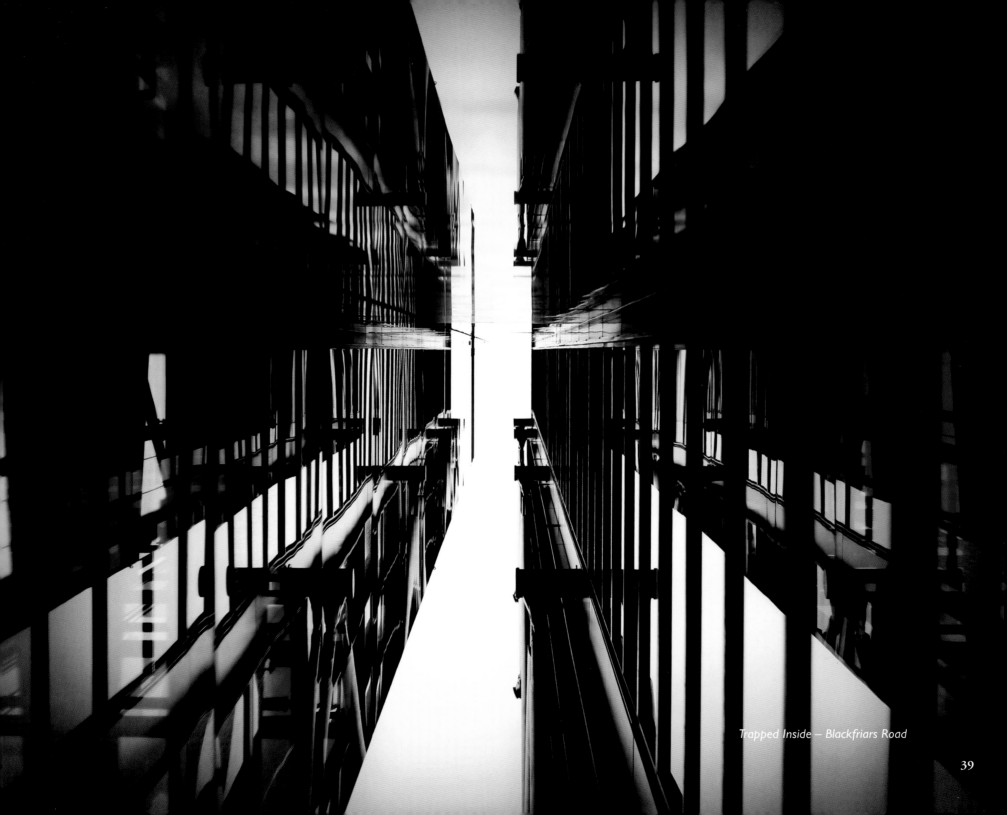

Trapped Inside – Blackfriars Road

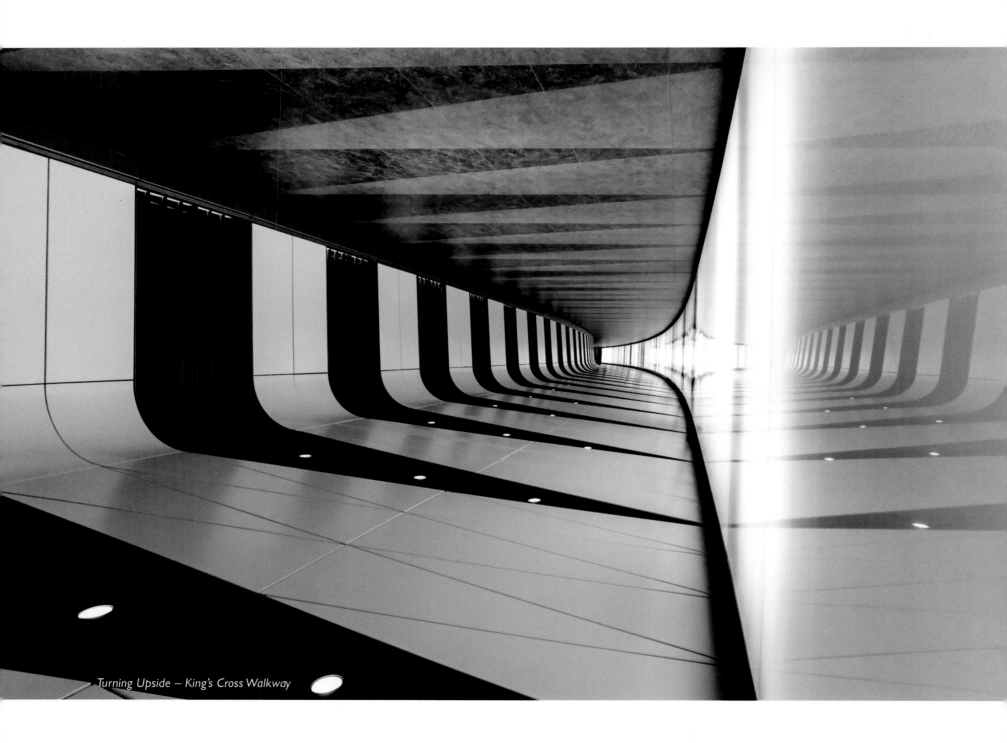

Turning Upside – King's Cross Walkway

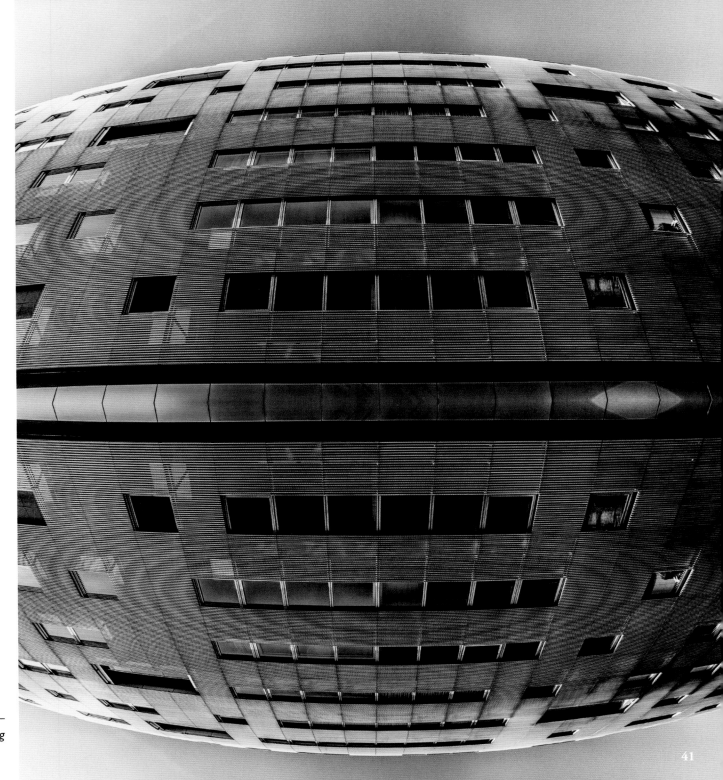

UFO London City Architecture –
Albion Building

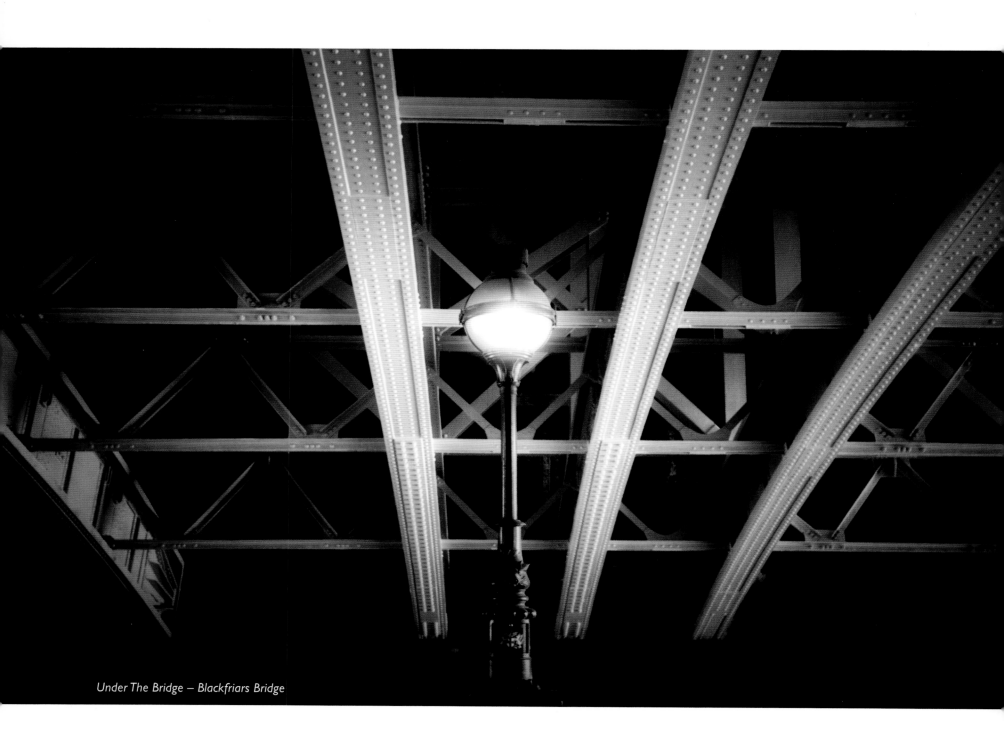

Under The Bridge – Blackfriars Bridge

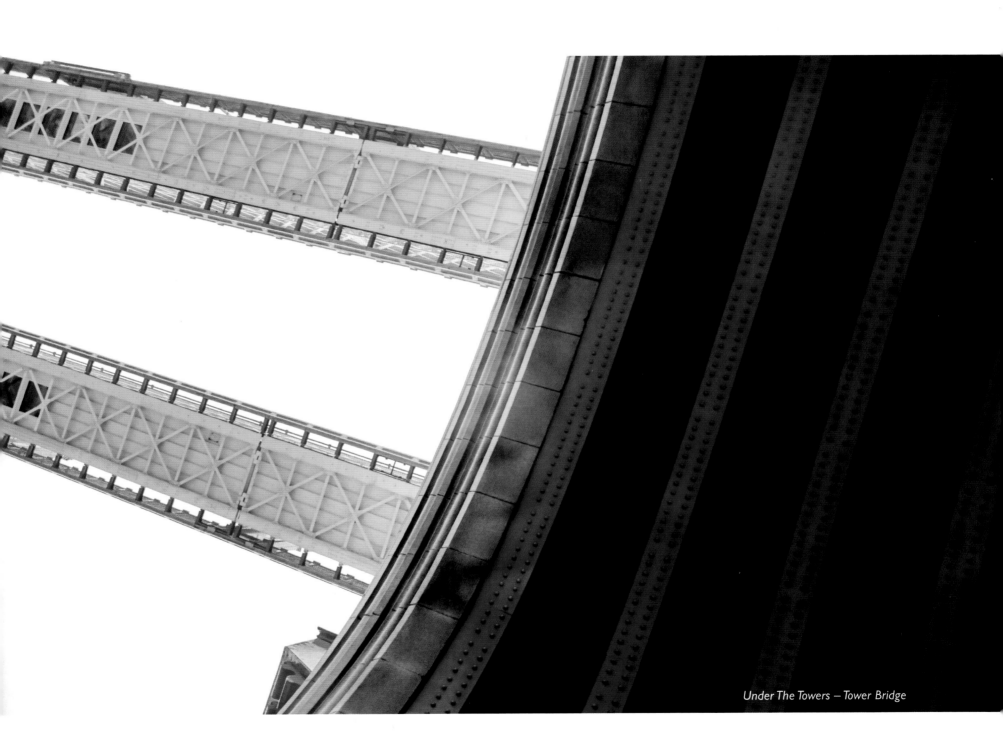

Under The Towers – Tower Bridge

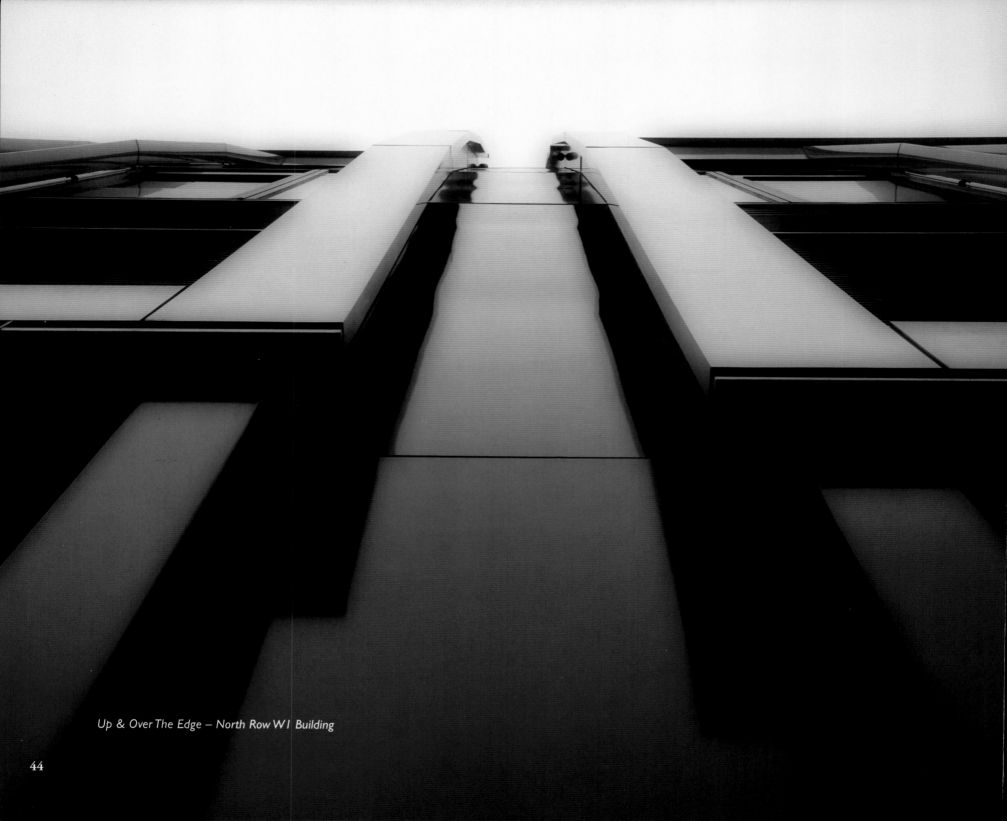

Up & Over The Edge – North Row W1 Building

44

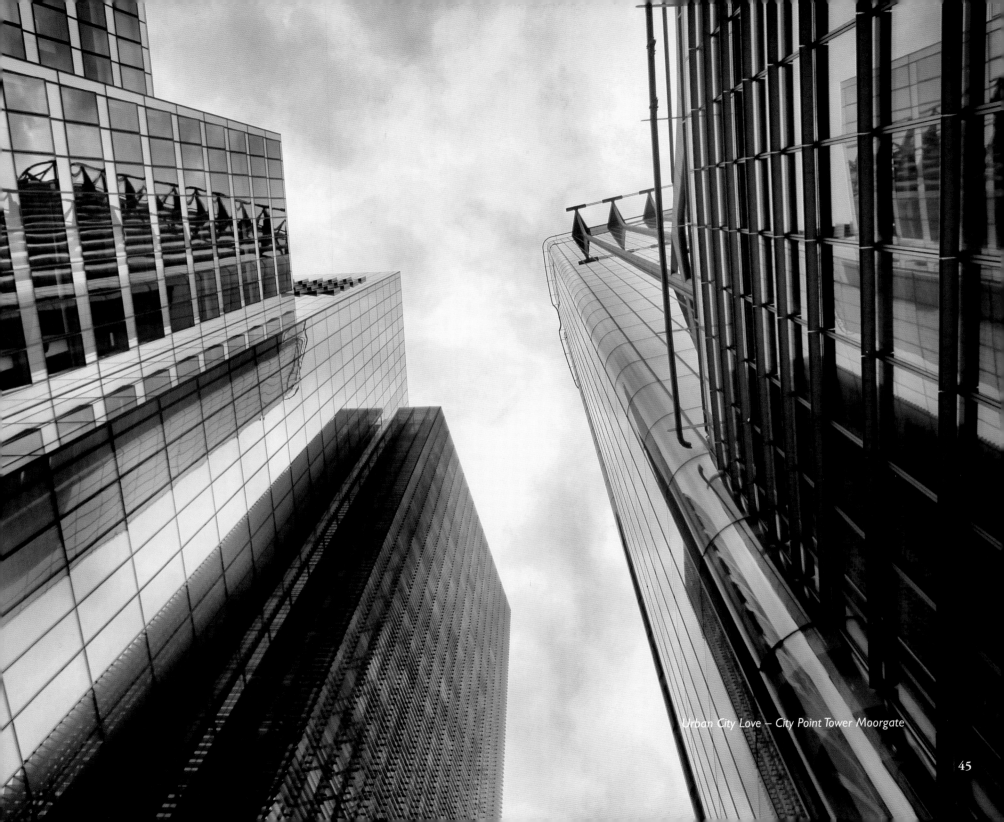

Urban City Love – City Point Tower Moorgate

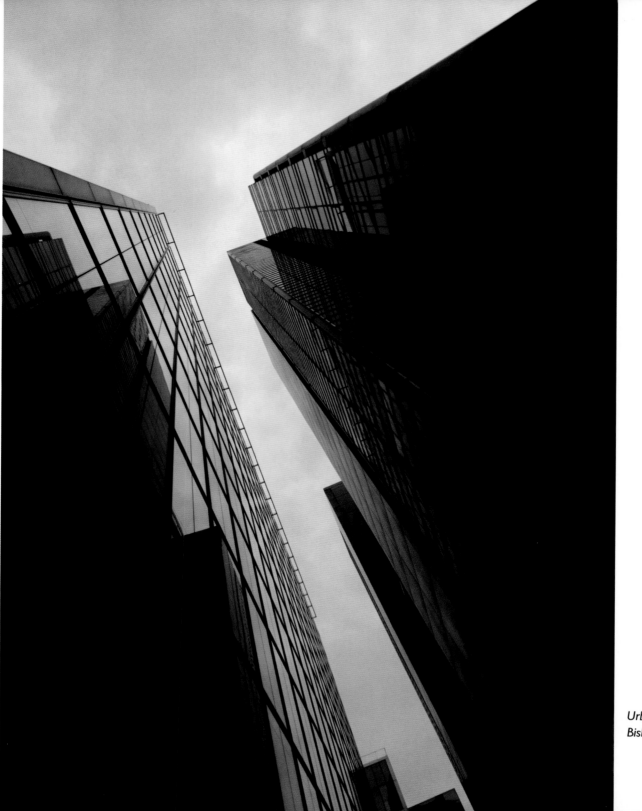

Urban Erotica — Bishopsgate,
Bishops Square

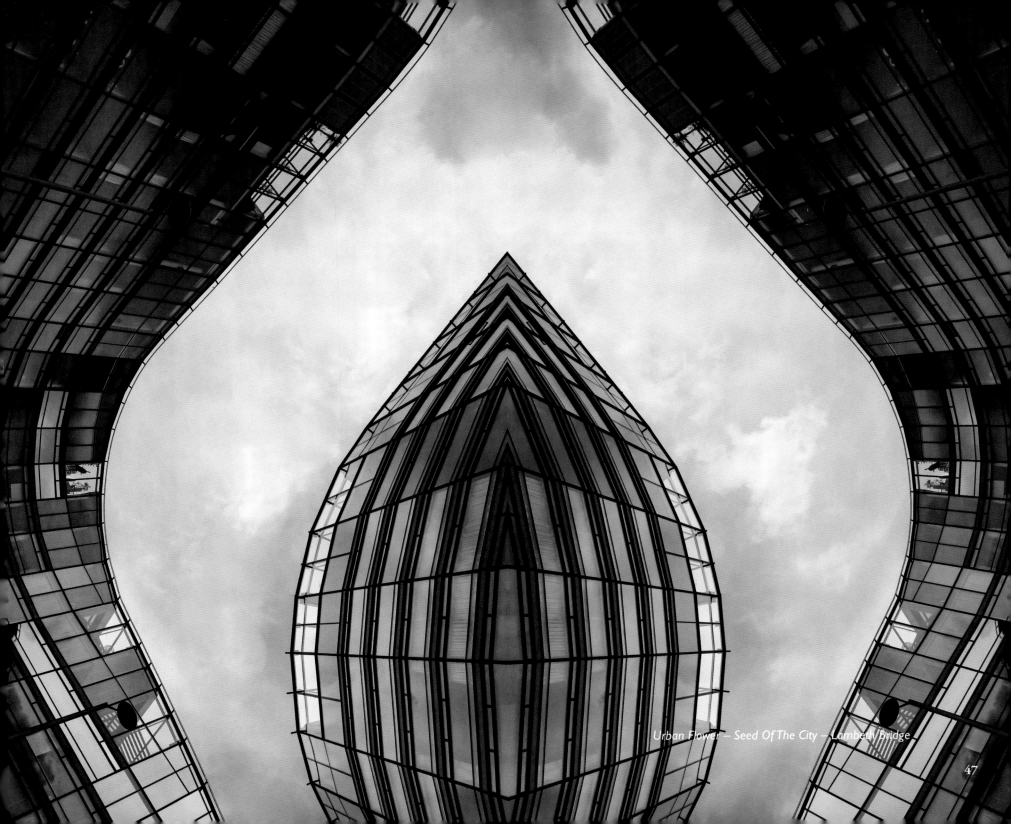

Urban Flower – Seed Of The City – Lambeth Bridge

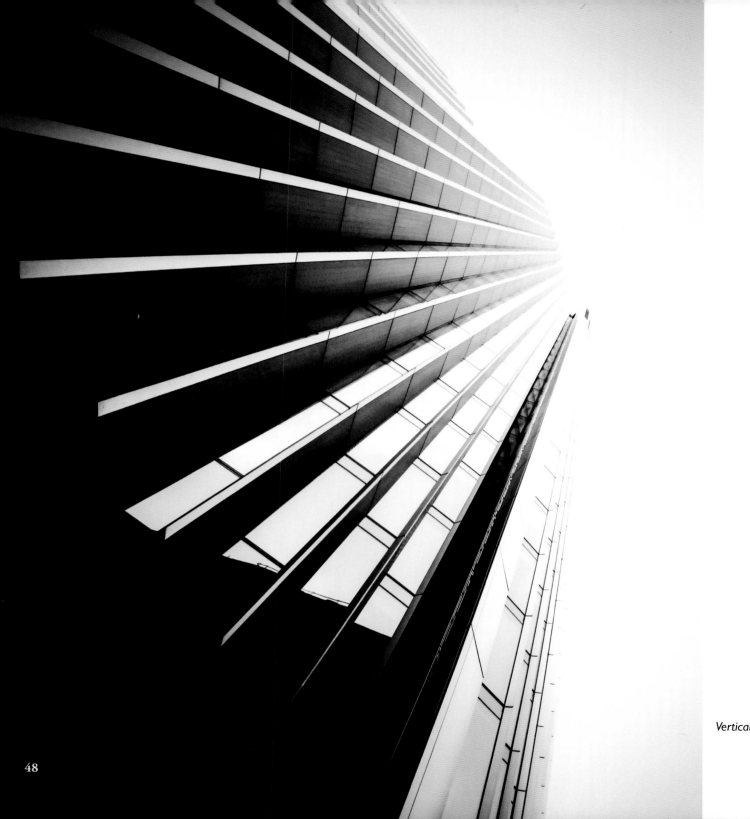

Vertical Skew – Willis Building

48

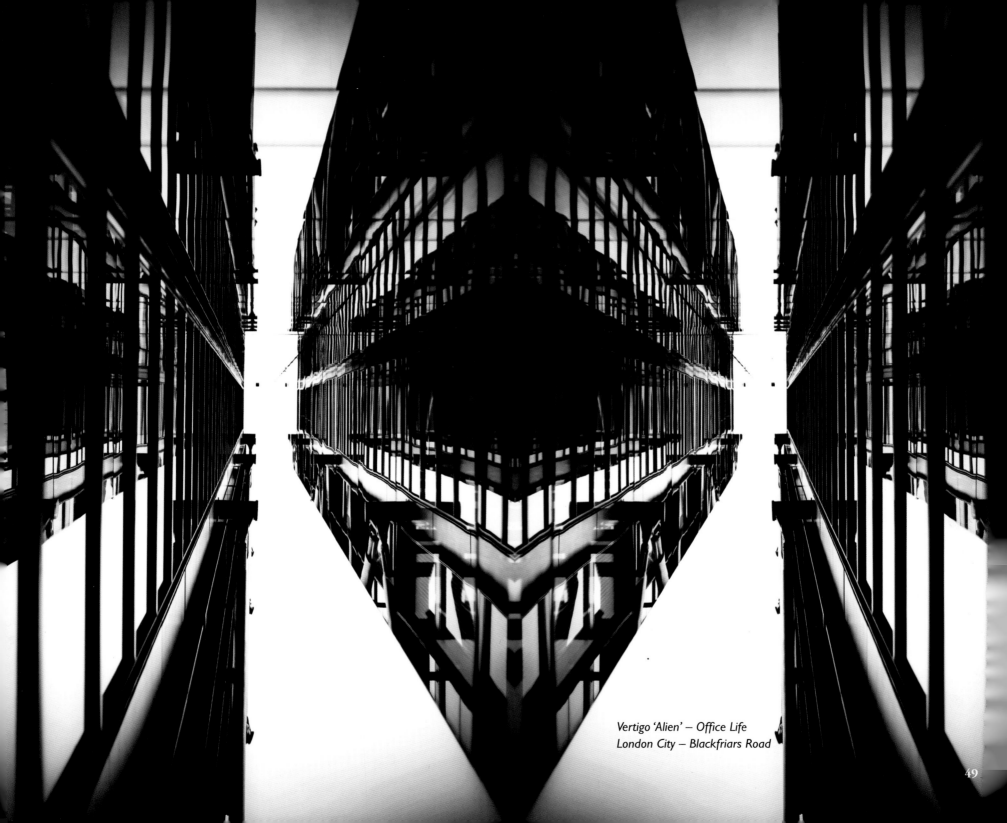

Vertigo 'Alien' – Office Life
London City – Blackfriars Road

49

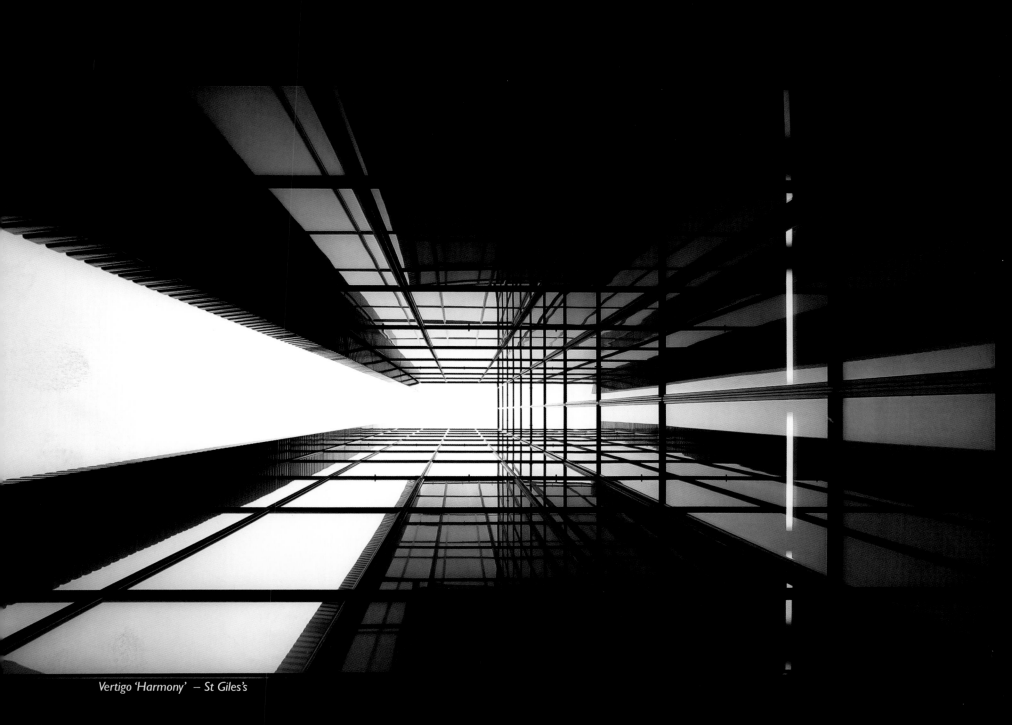

Vertigo 'Harmony' – St Giles's

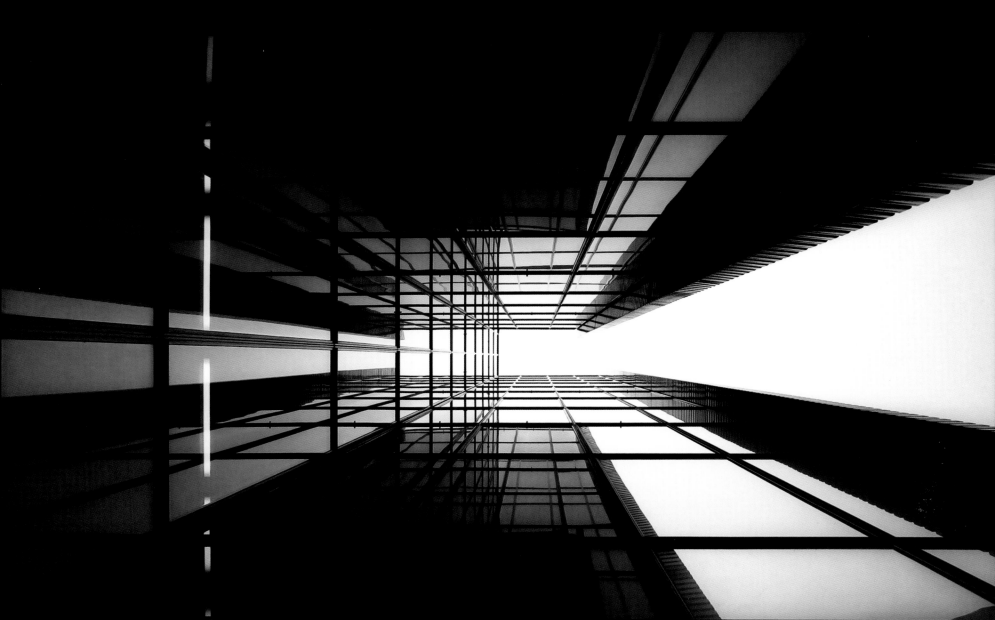

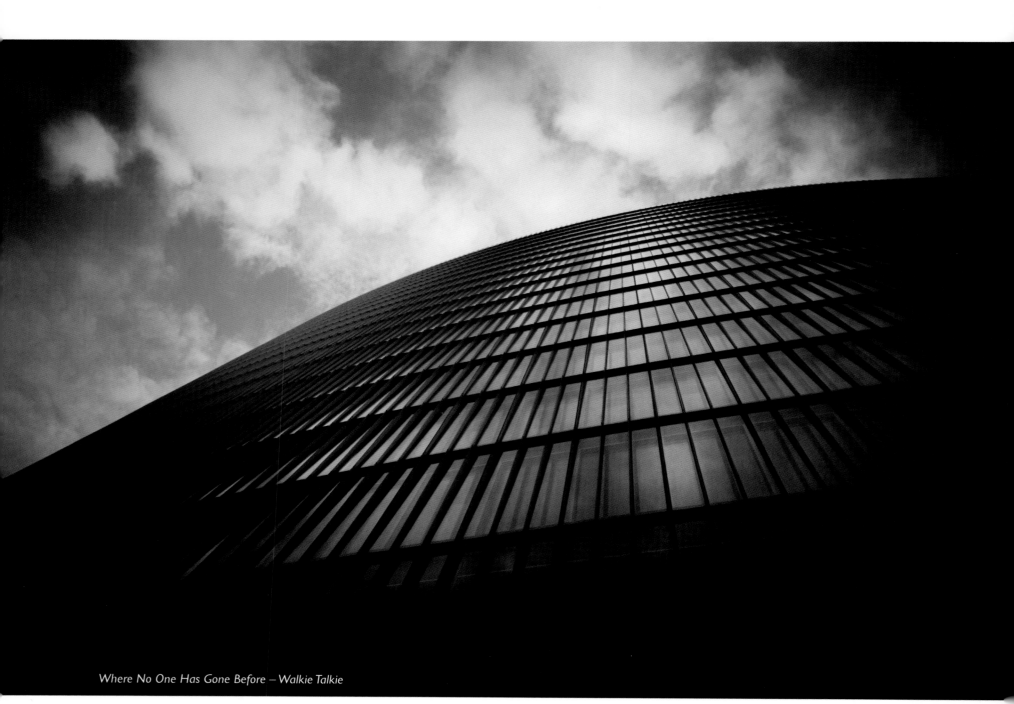

Where No One Has Gone Before – Walkie Talkie

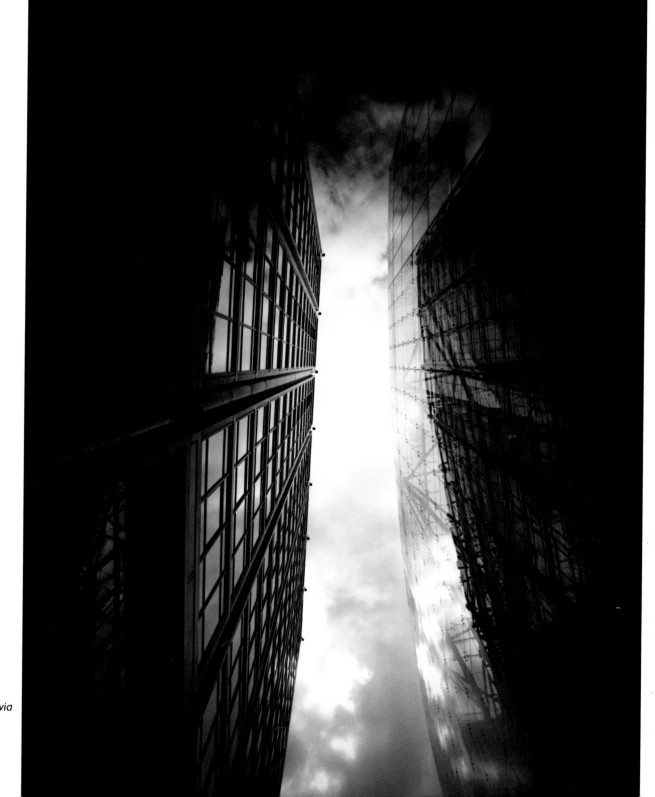

Wink Of An Eye – Fitzrovia

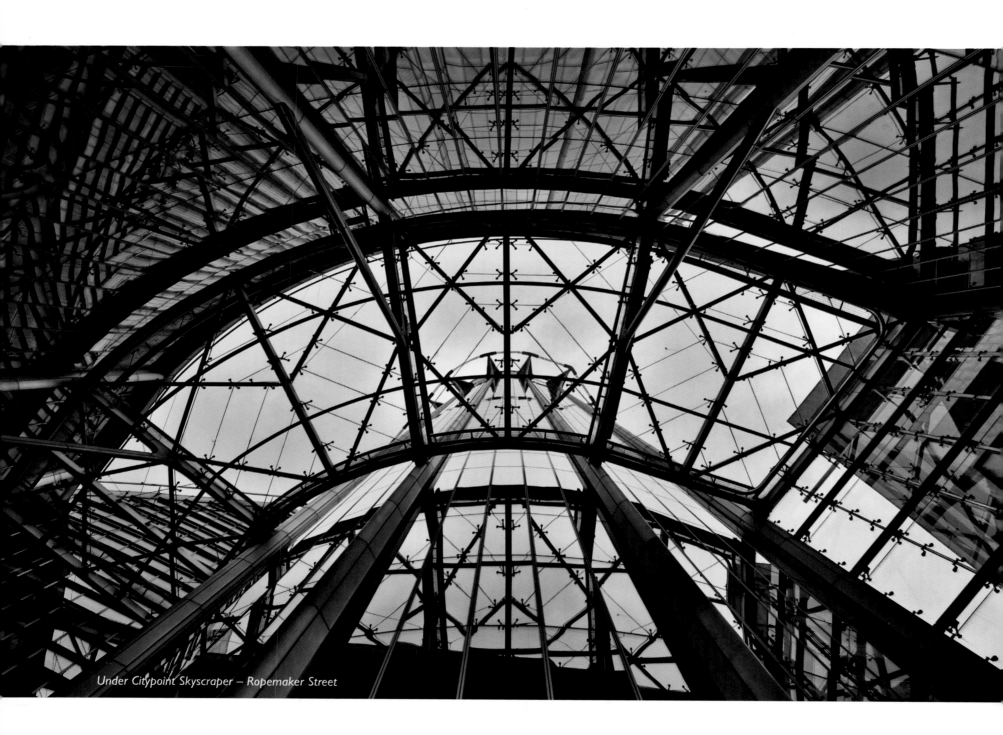

Under Citypoint Skyscraper – Ropemaker Street

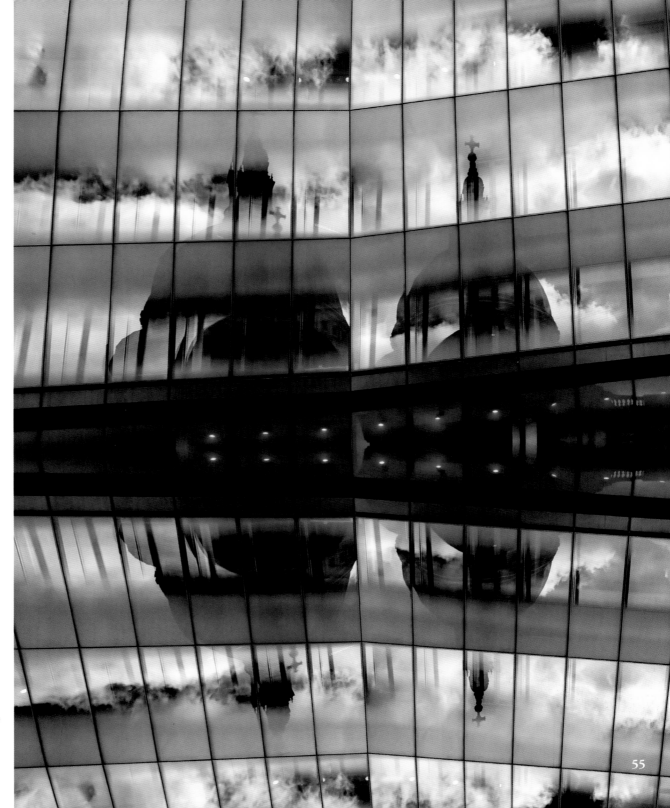

St Paul's Cathedral – Reflection Quadrilogy

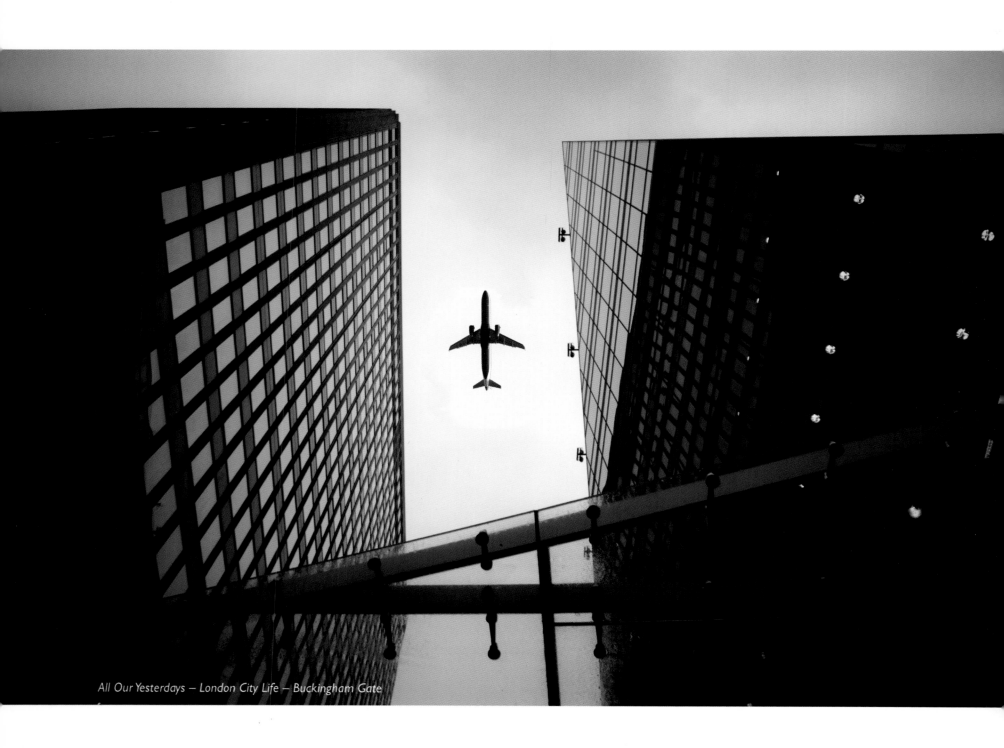

All Our Yesterdays – London City Life – Buckingham Gate

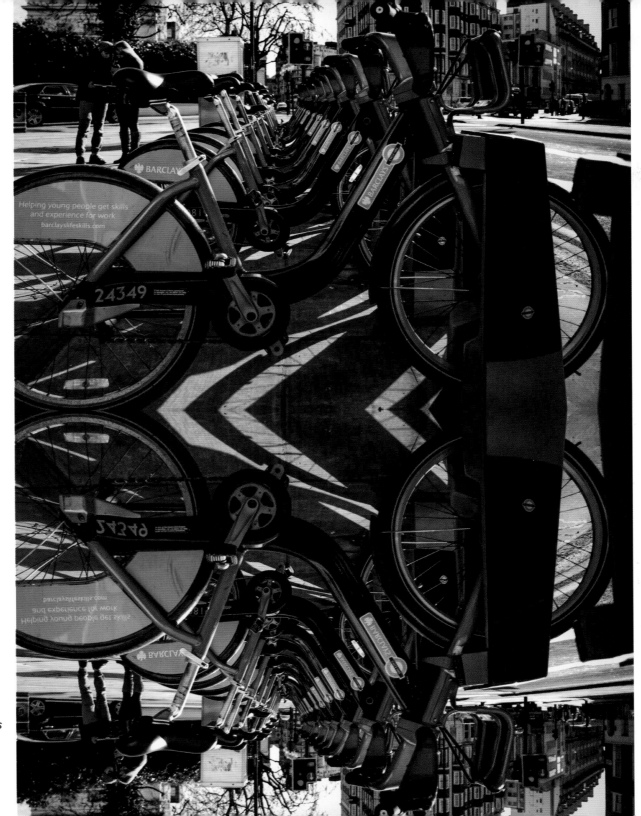

Boris Bikes

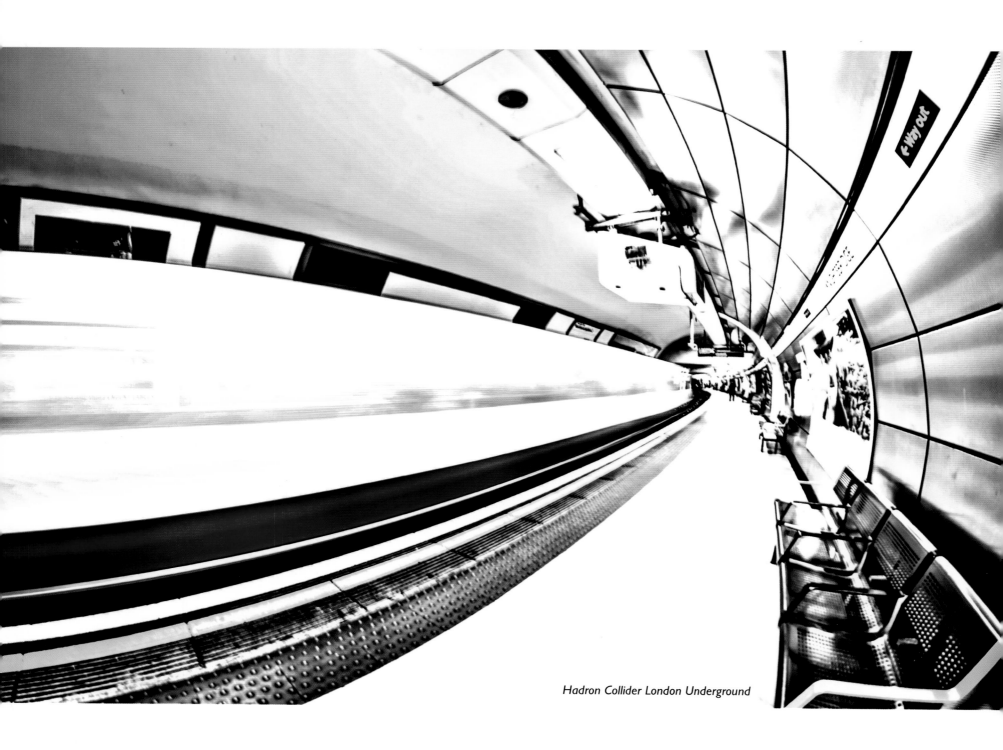

Hadron Collider London Underground

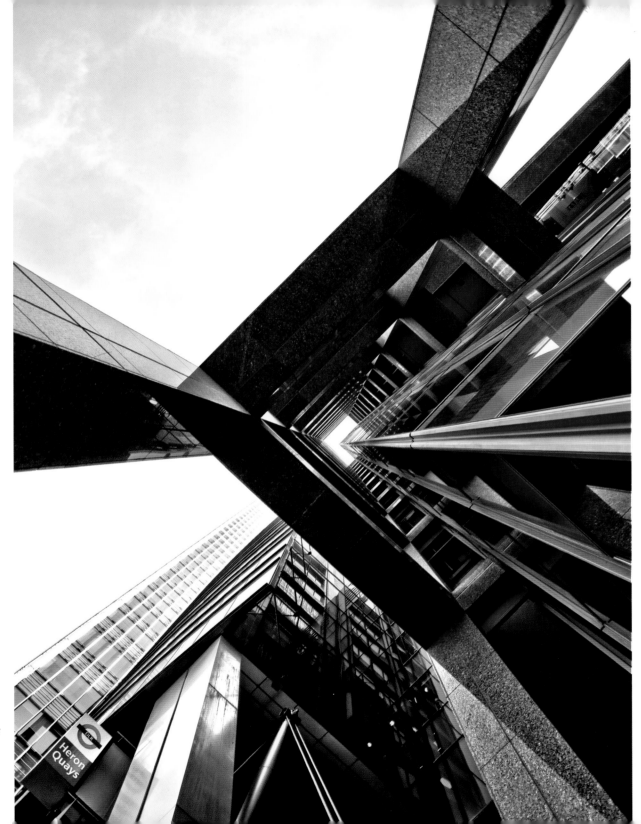

Insane Geometry – Heron Quays

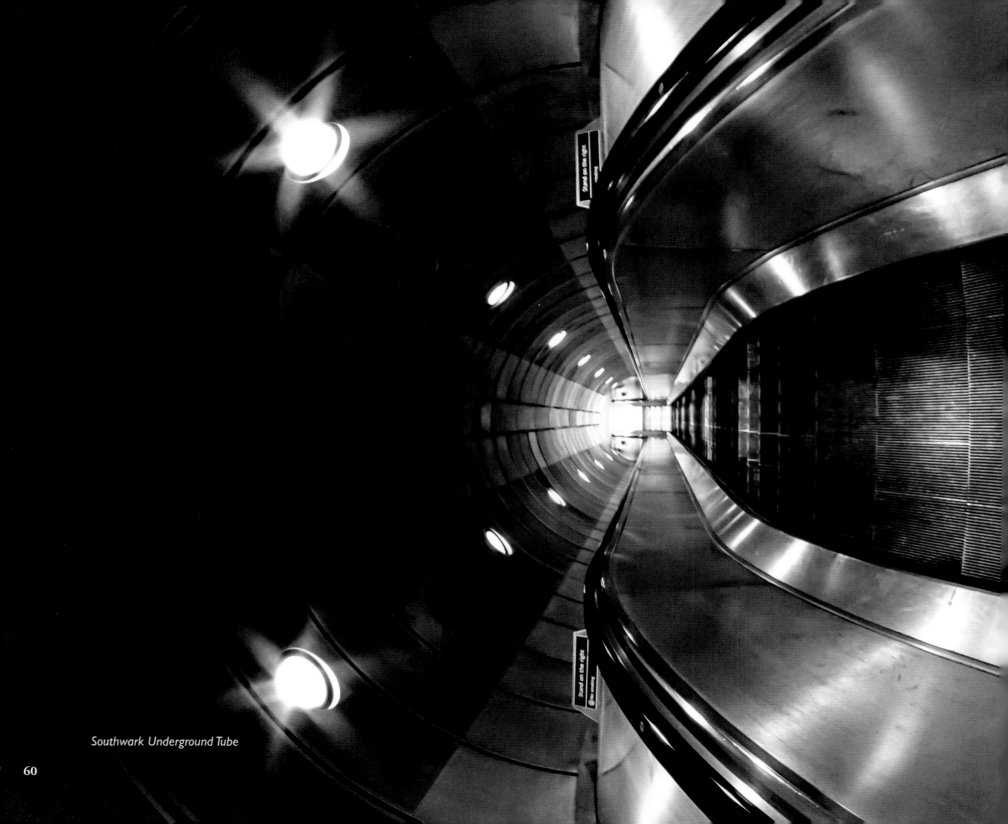

Southwark Underground Tube

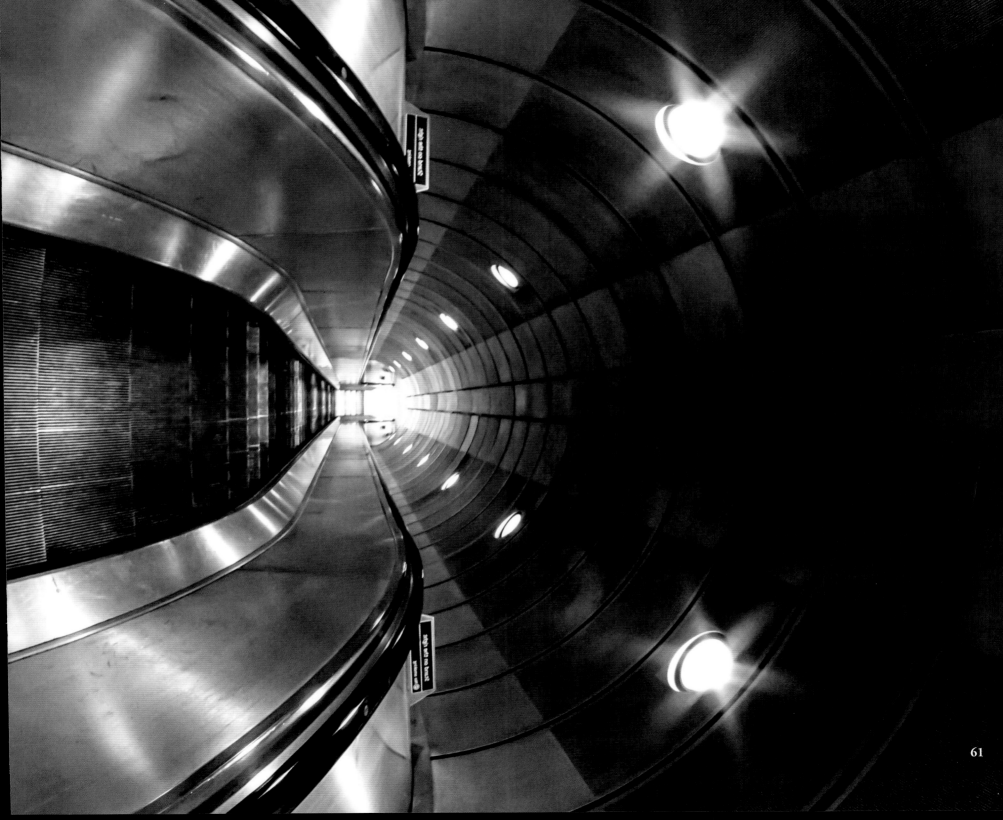

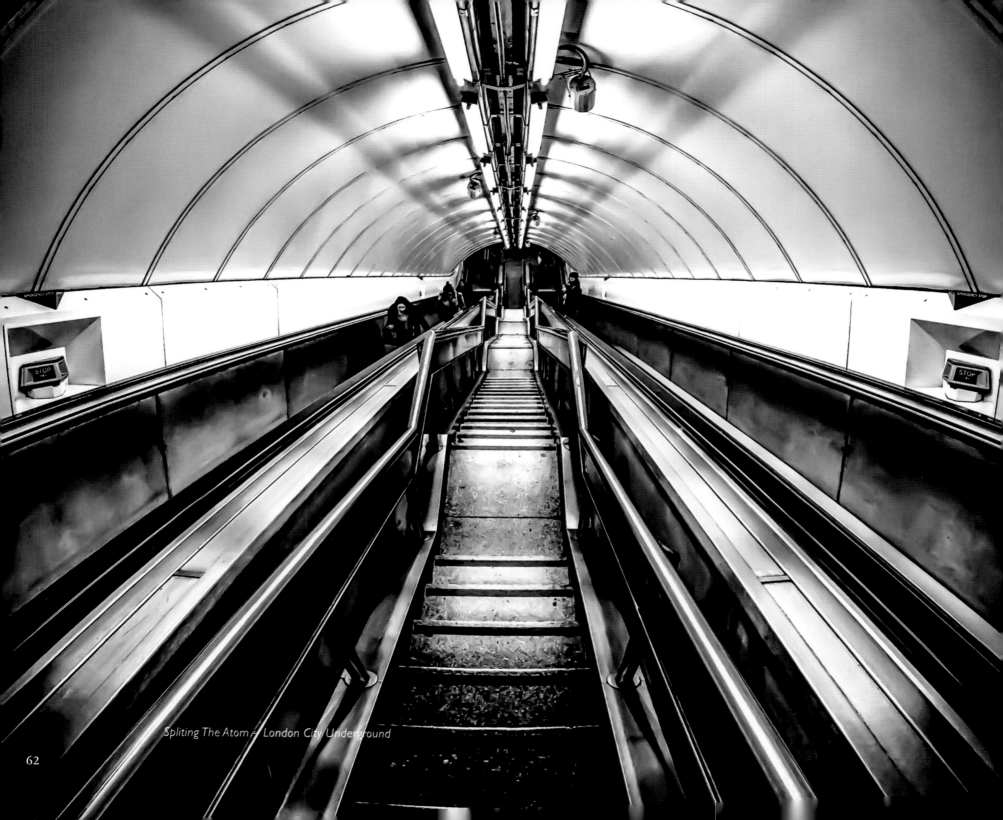

Spliting The Atom - London City Underground

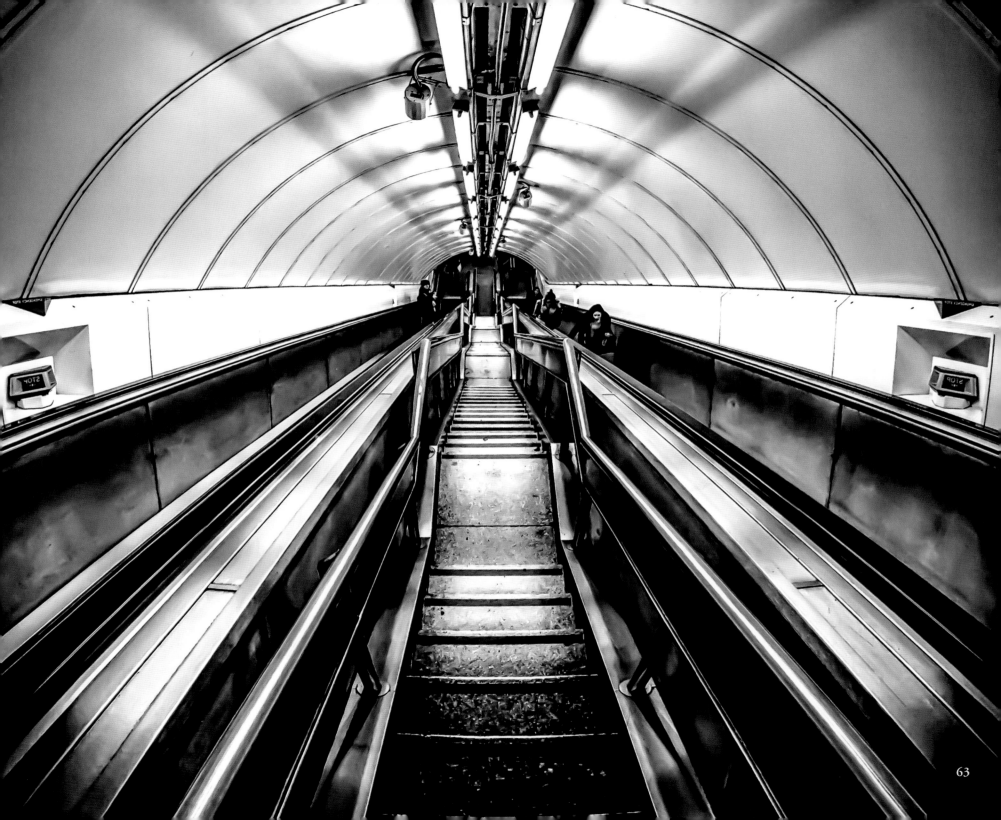

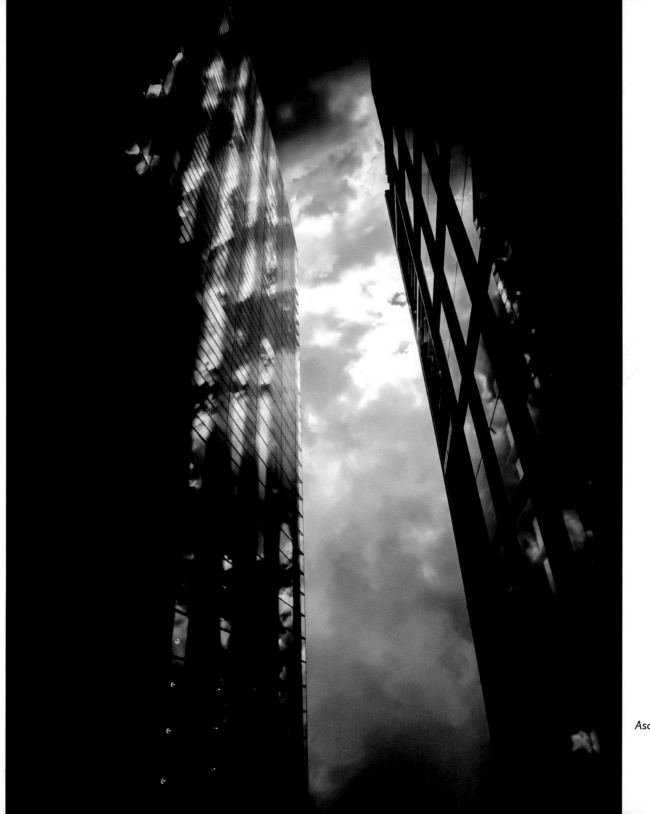

Ascent – Cheapside

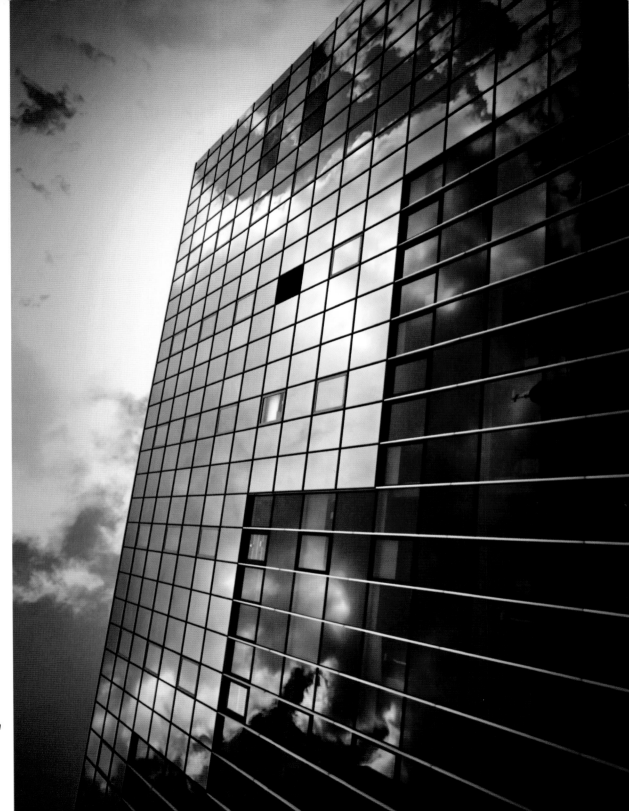

Black Hole – Shoreditch

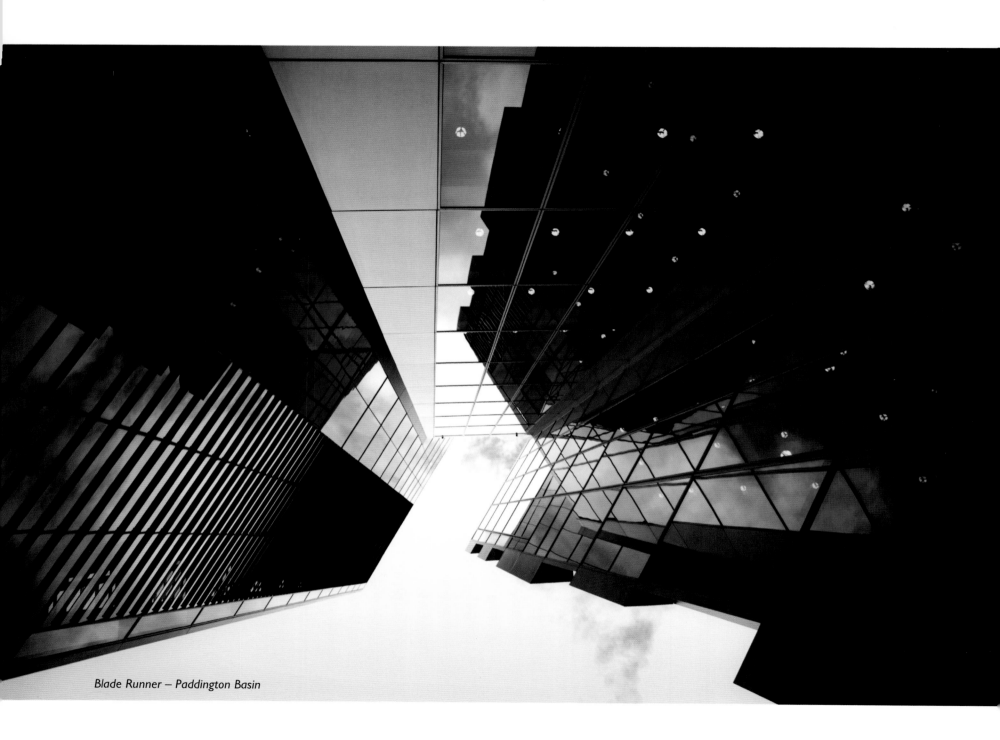

Blade Runner – Paddington Basin

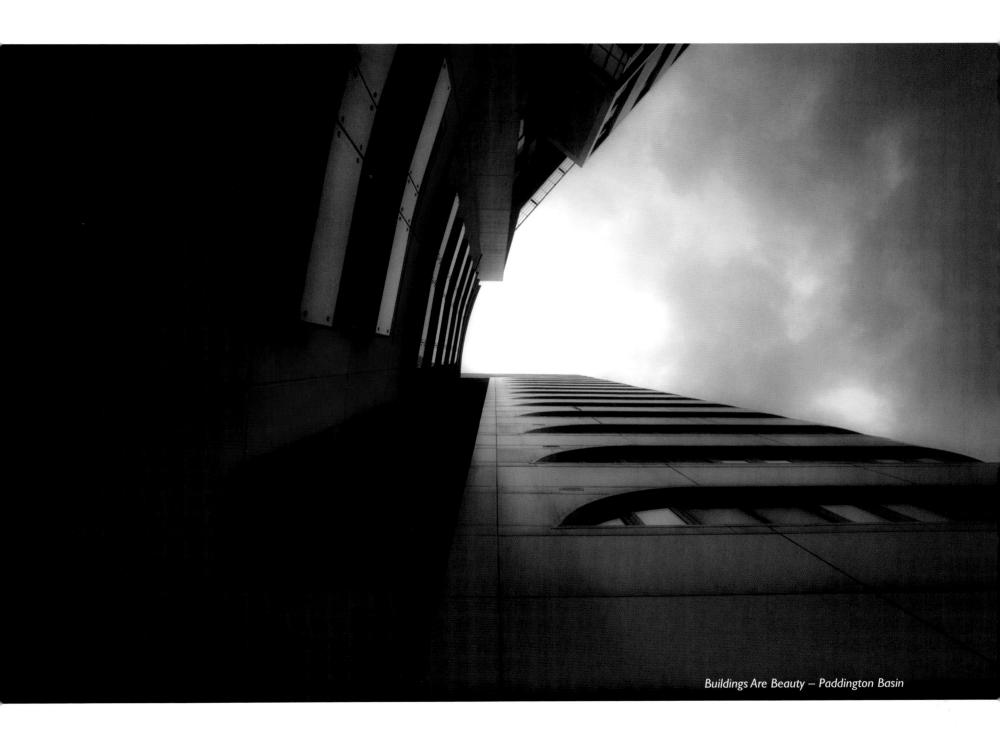

Buildings Are Beauty – Paddington Basin

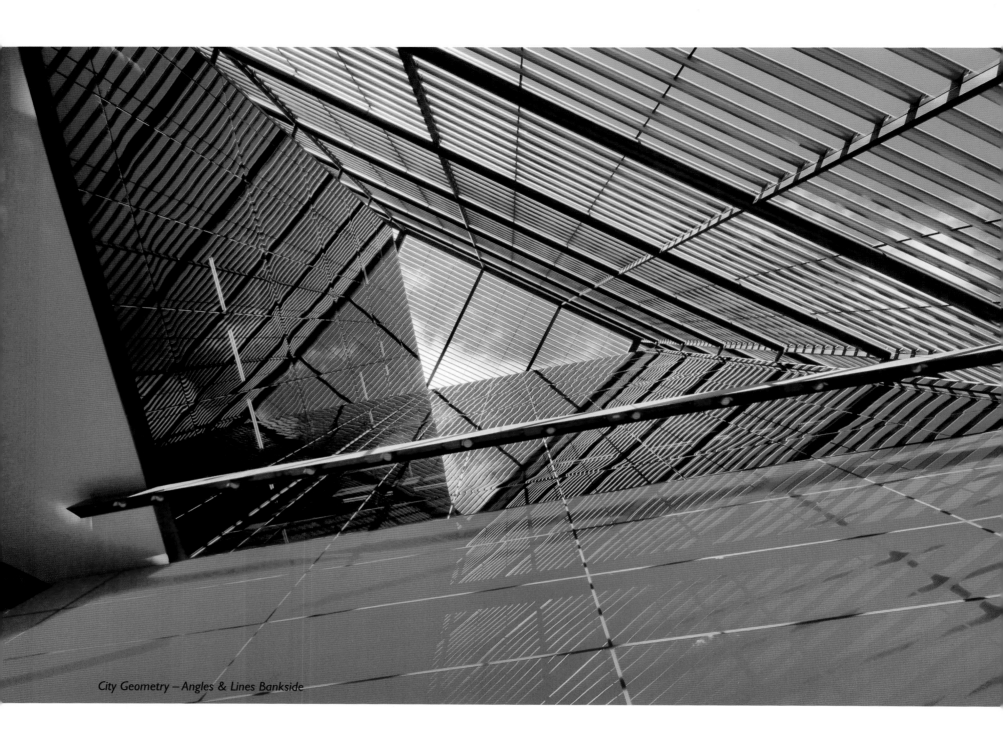

City Geometry – Angles & Lines Bankside

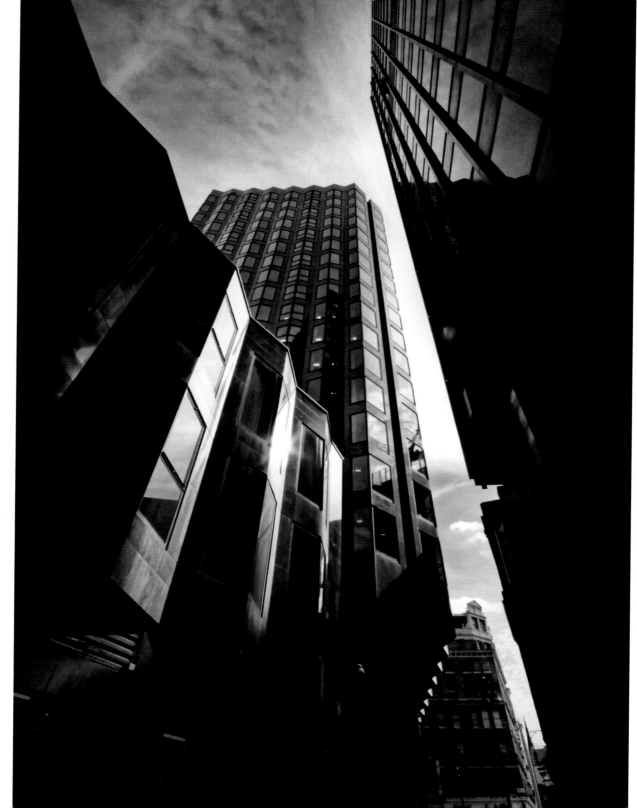

City Heat – Butler Place Westminster

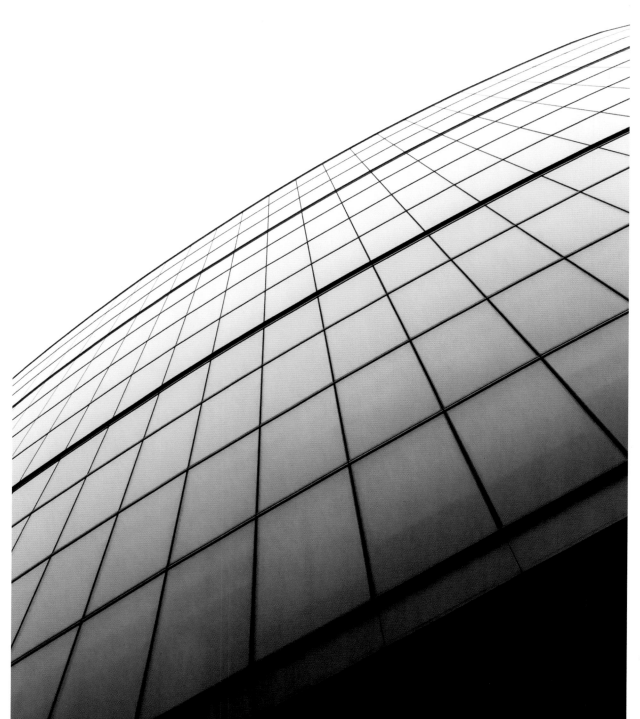

Dimensional – The Borough

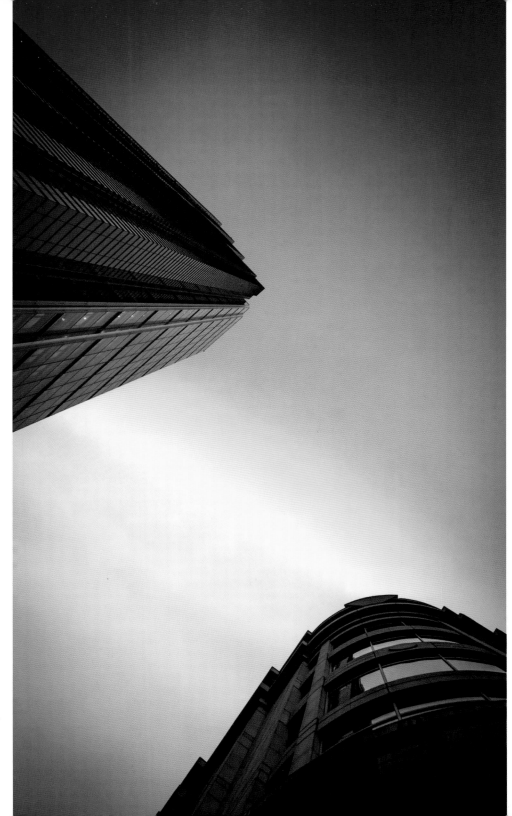

Do The Things You Want, Which You Only
Can Now — Sunset Rainbow — Bishopsgate

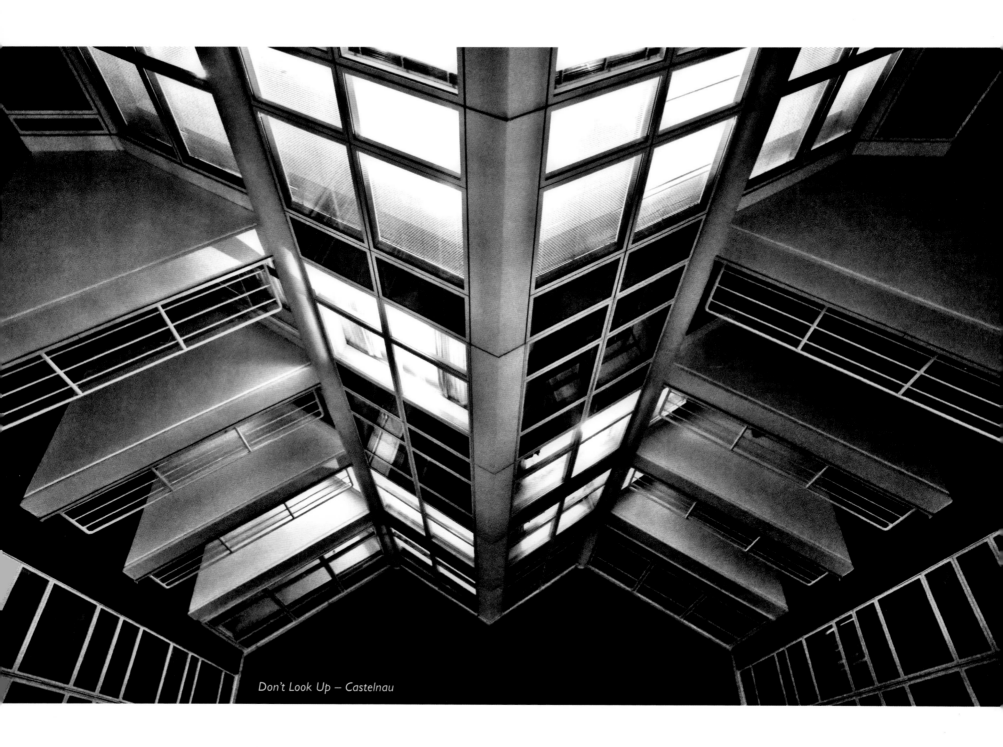

Don't Look Up – Castelnau

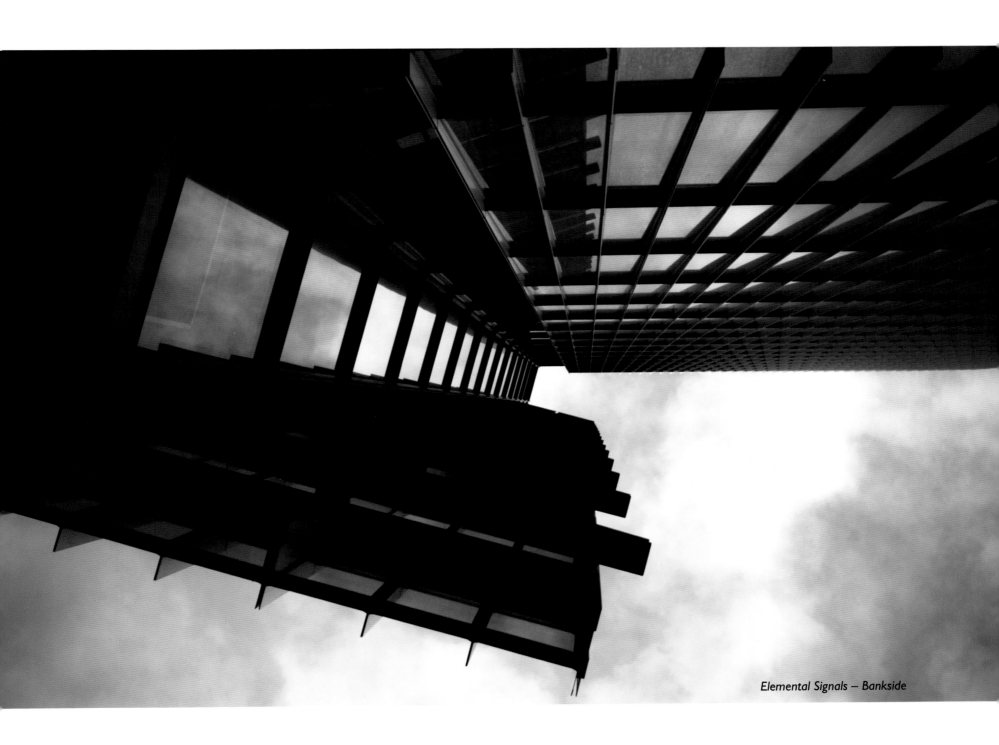

Elemental Signals – Bankside

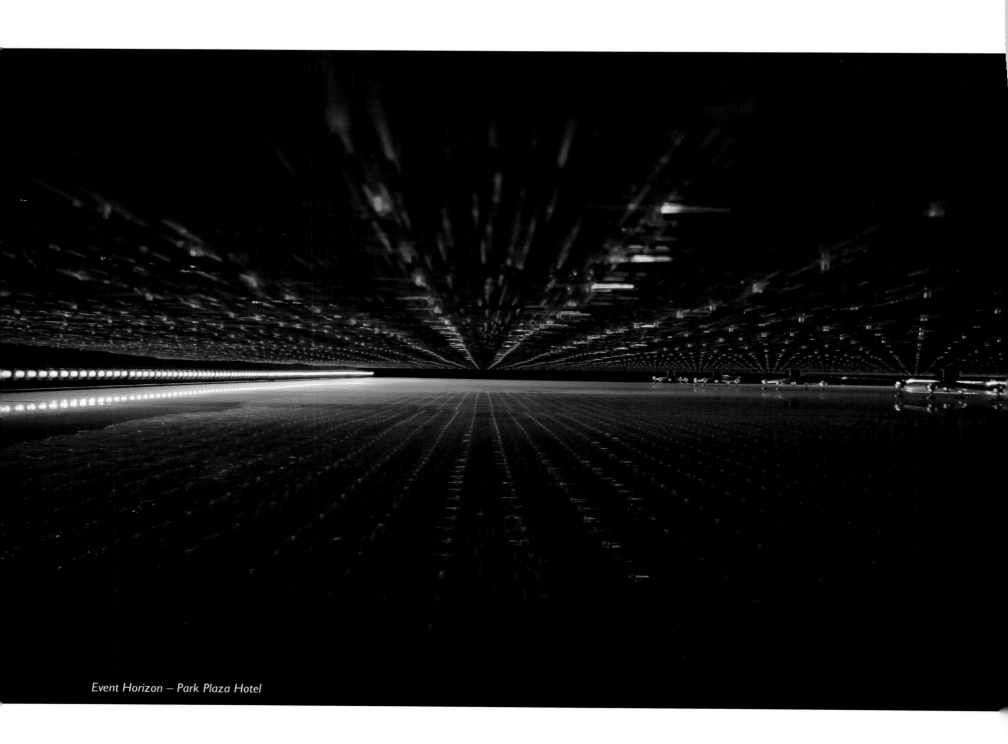

Event Horizon – Park Plaza Hotel

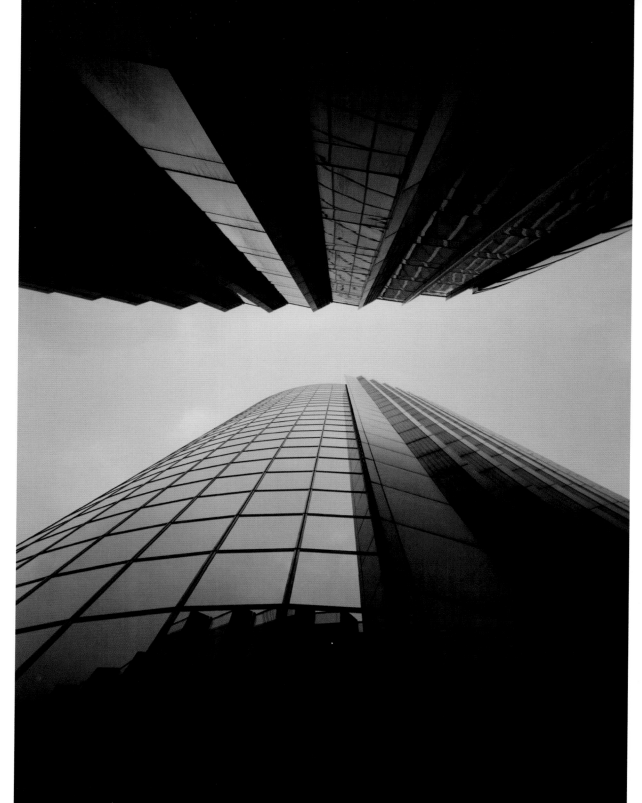

Face Off – Bishopsgate

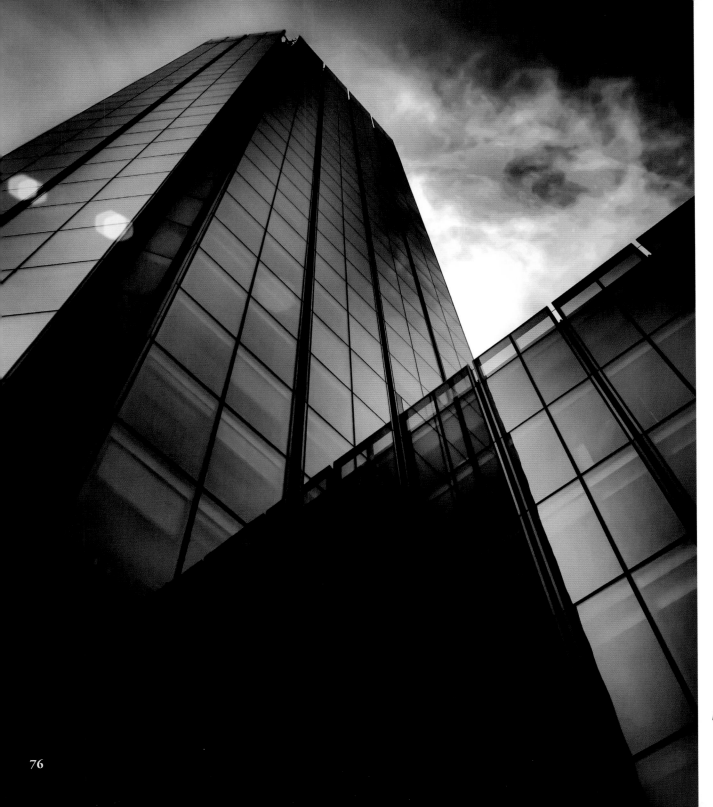

Face Your Demons – Southwark

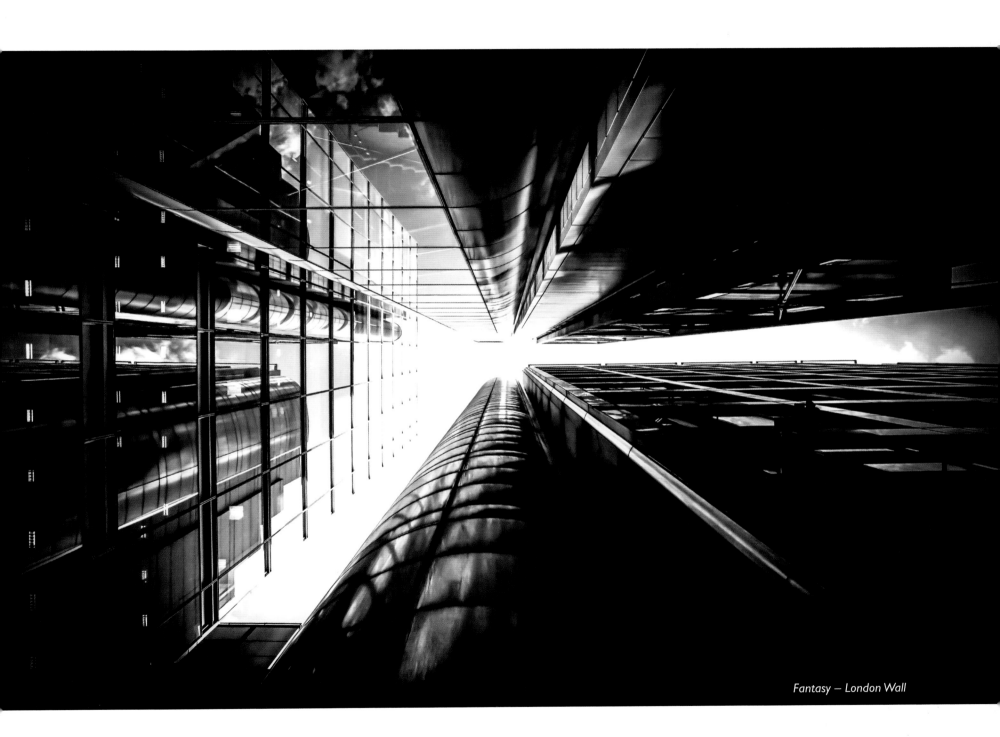

Fantasy — London Wall

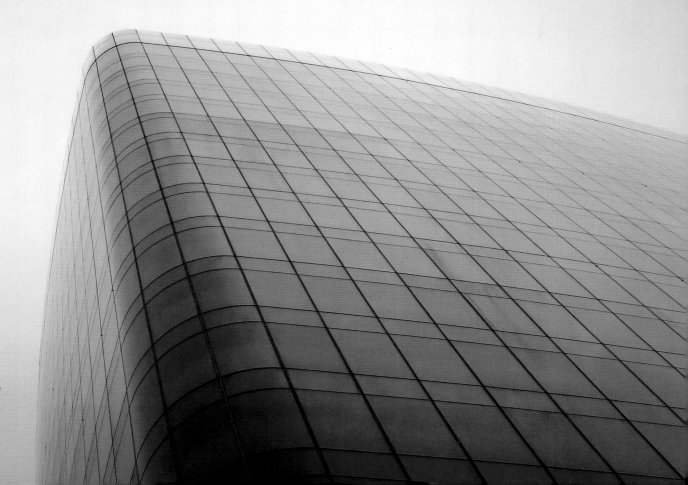

Freedom – London City Office Life – Aldgate

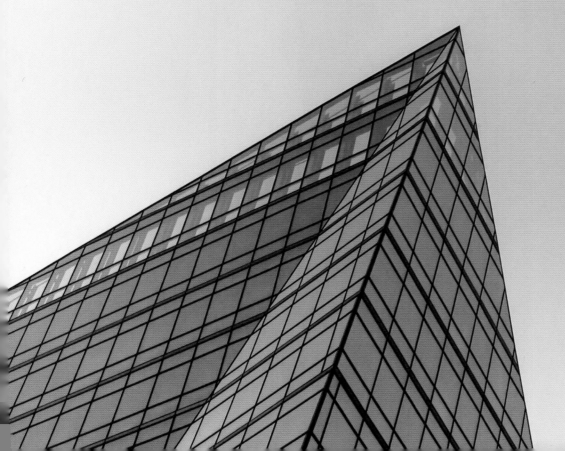

More Freedom – London City Office Life – Waterloo

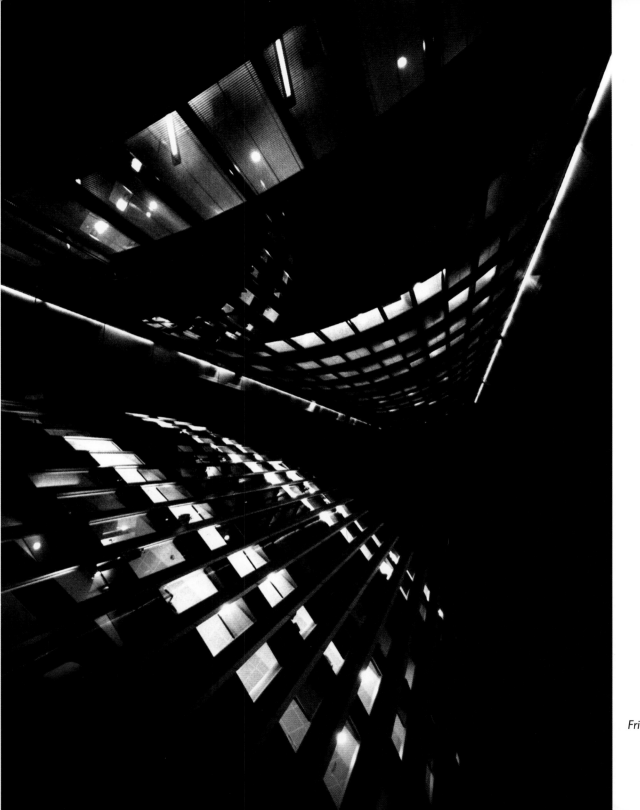

Friday's Child – Bishopsgate

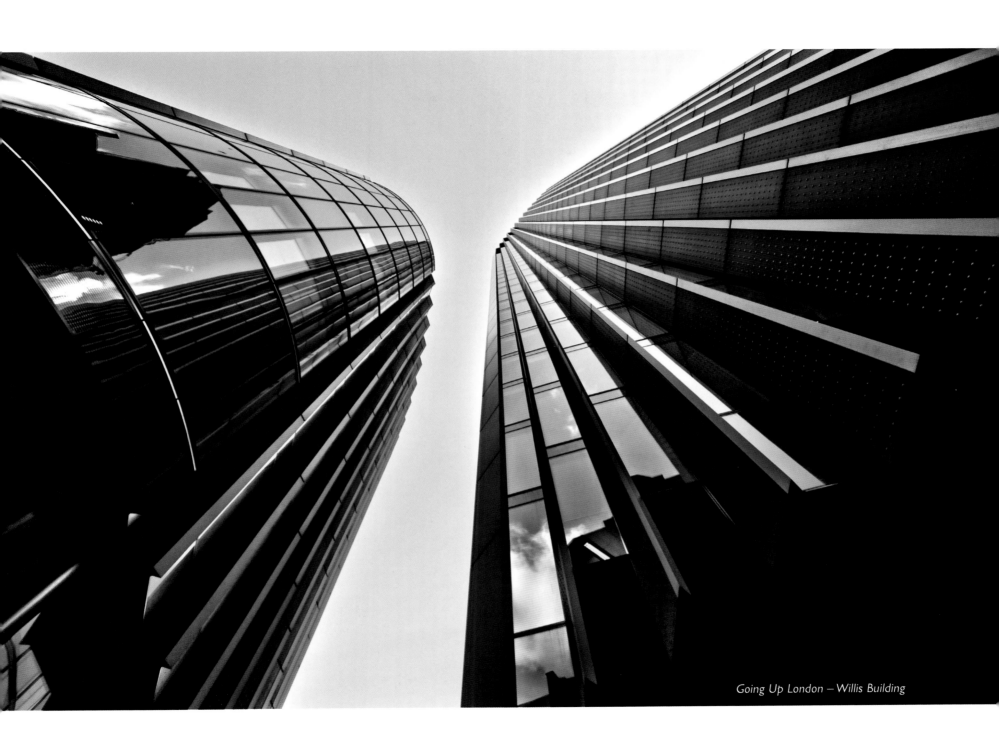

Going Up London – Willis Building

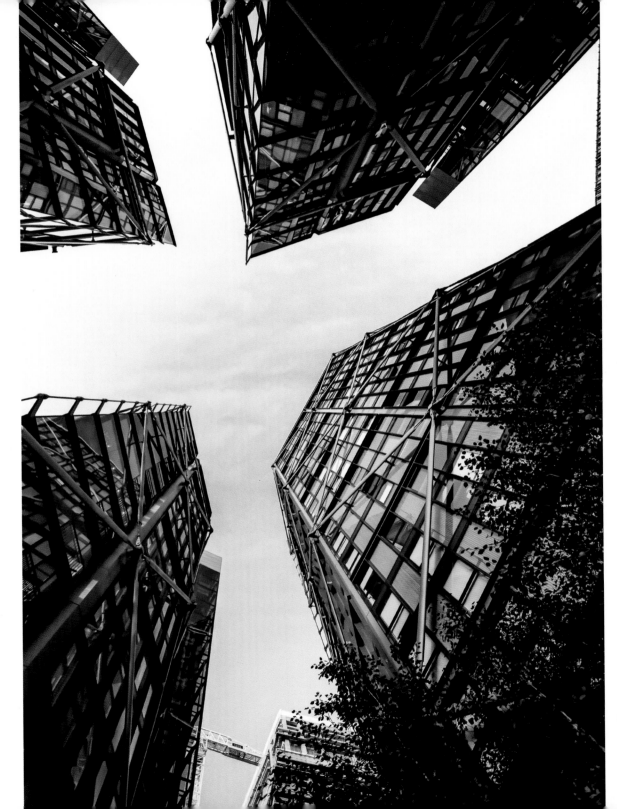

Golden Morning – Bankside

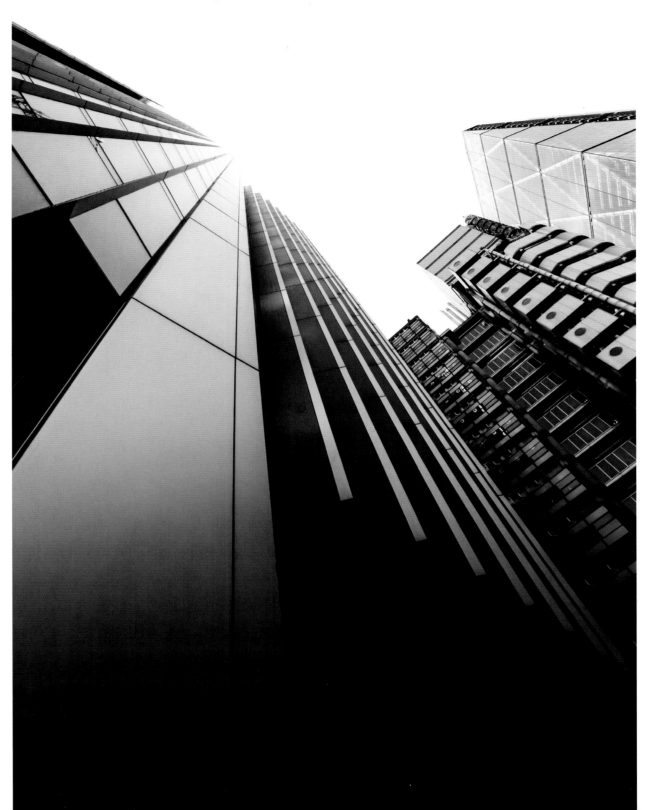

Good Morning London – Bishopsgate

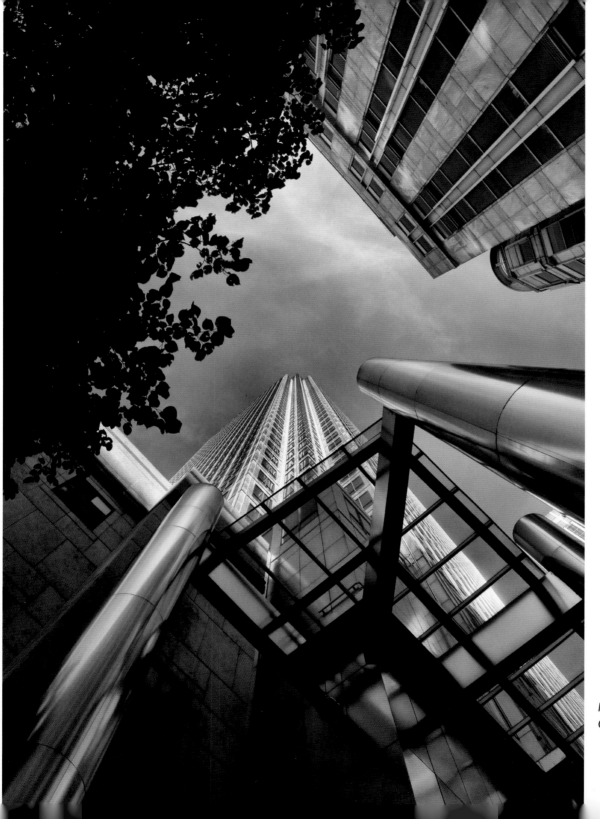

I Once Towered Over London Before The Shard —
One Canada Square Canary Wharf

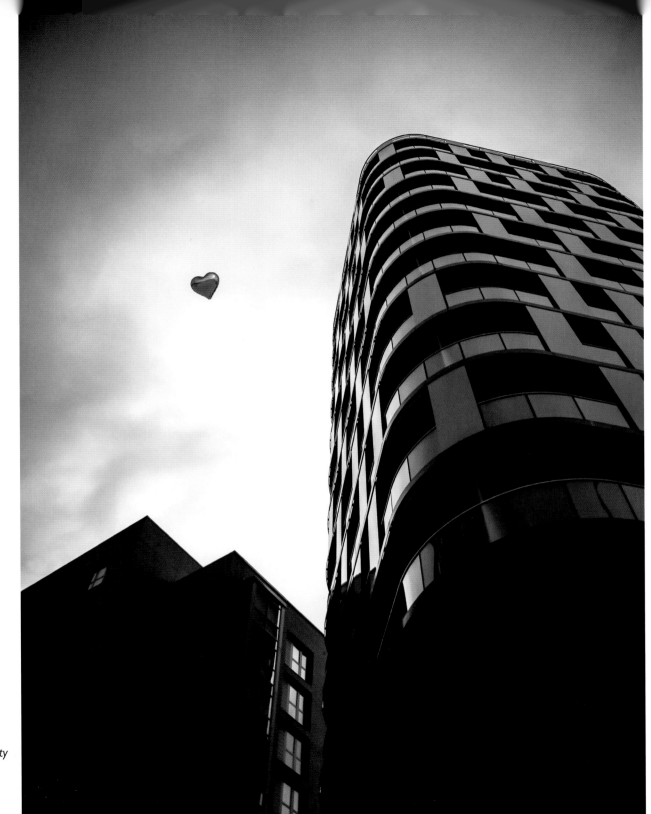

Is It Love or Obsession – London City

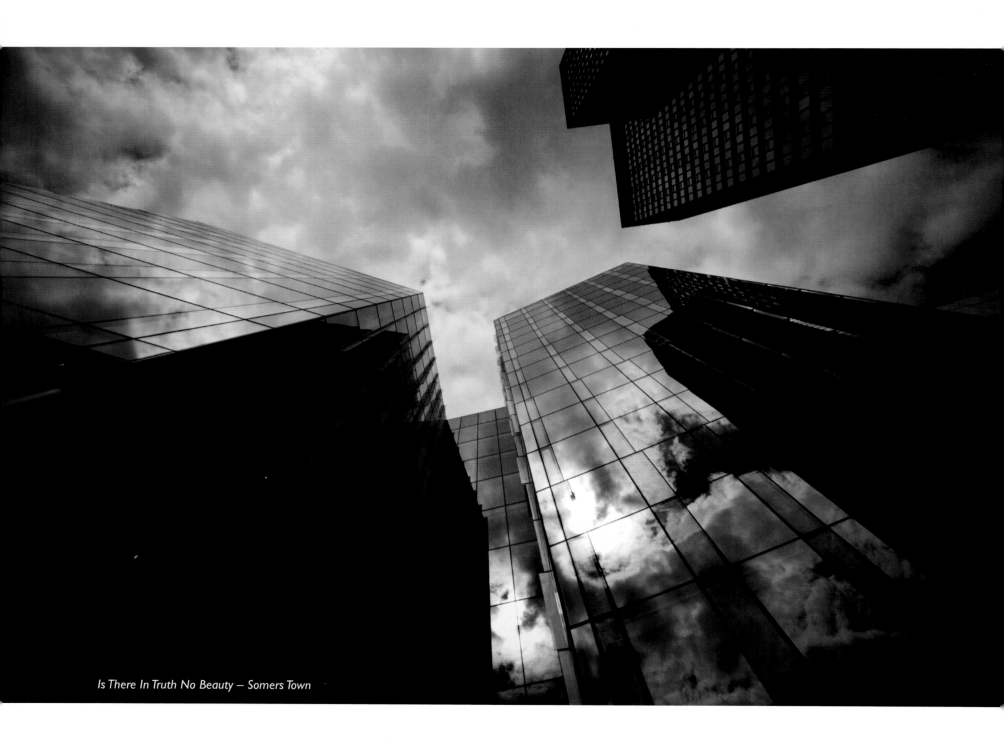

Is There In Truth No Beauty – Somers Town

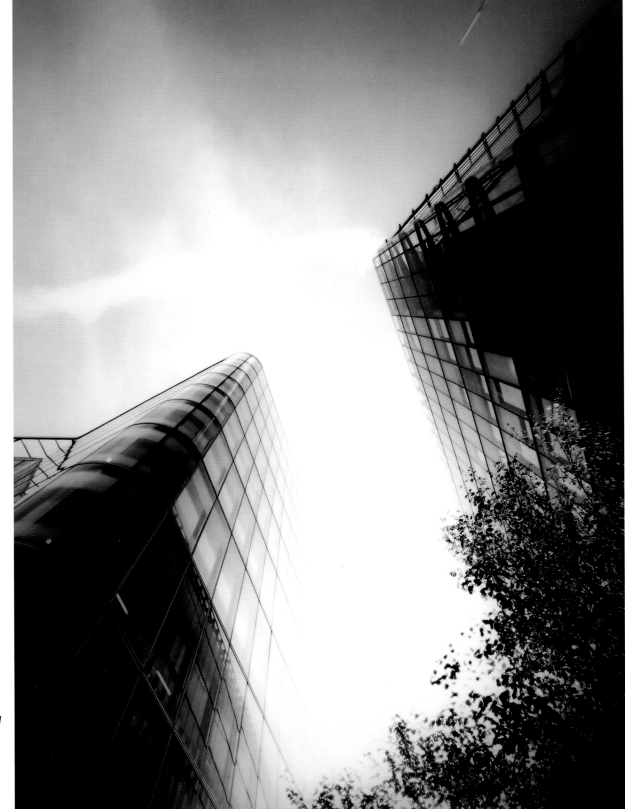

Left My Heart In London – Tower Hill

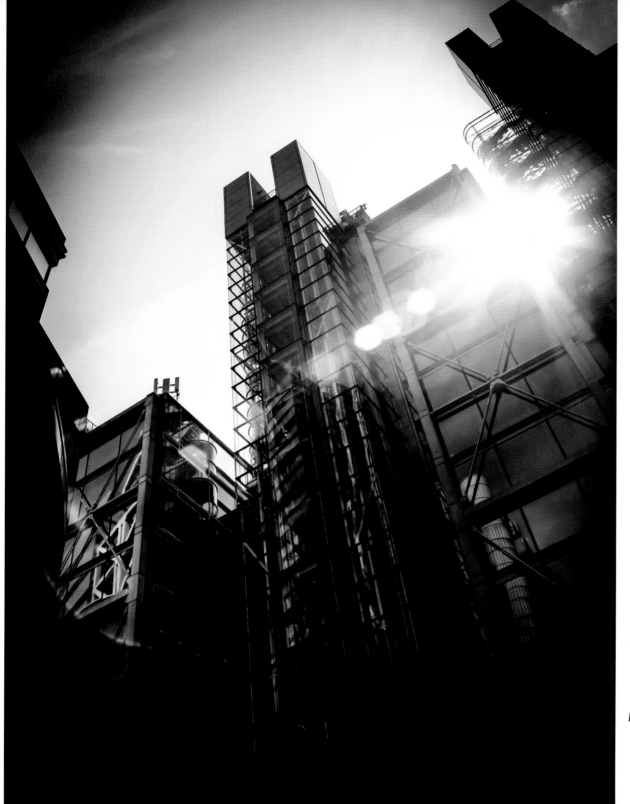

Breakthrough — London Wall

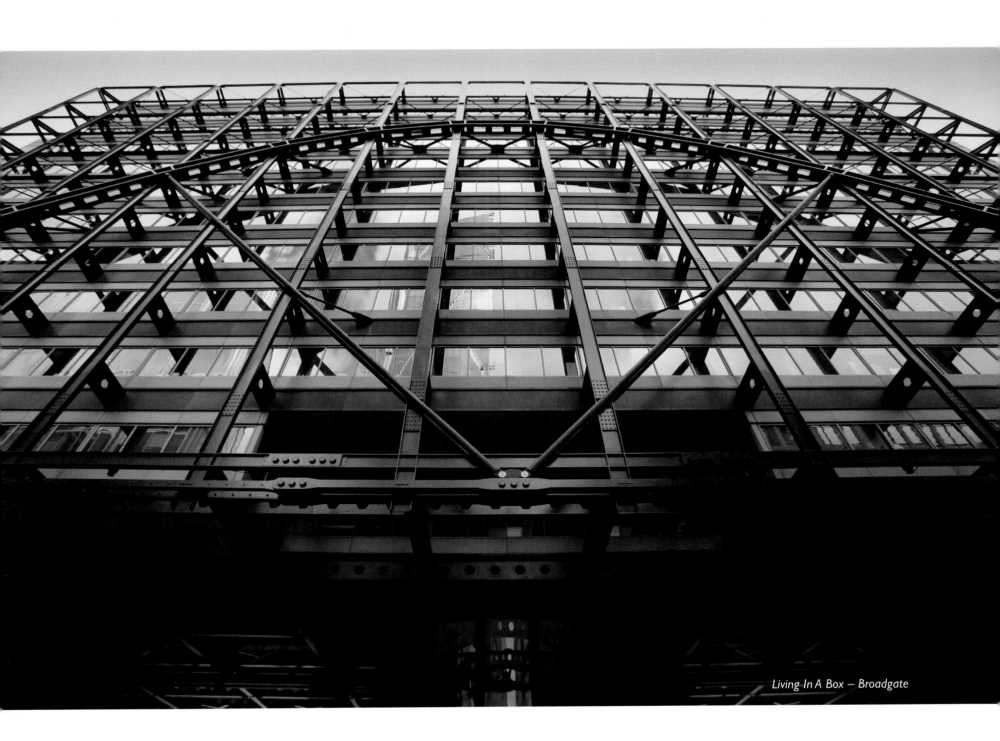

Living In A Box – Broadgate

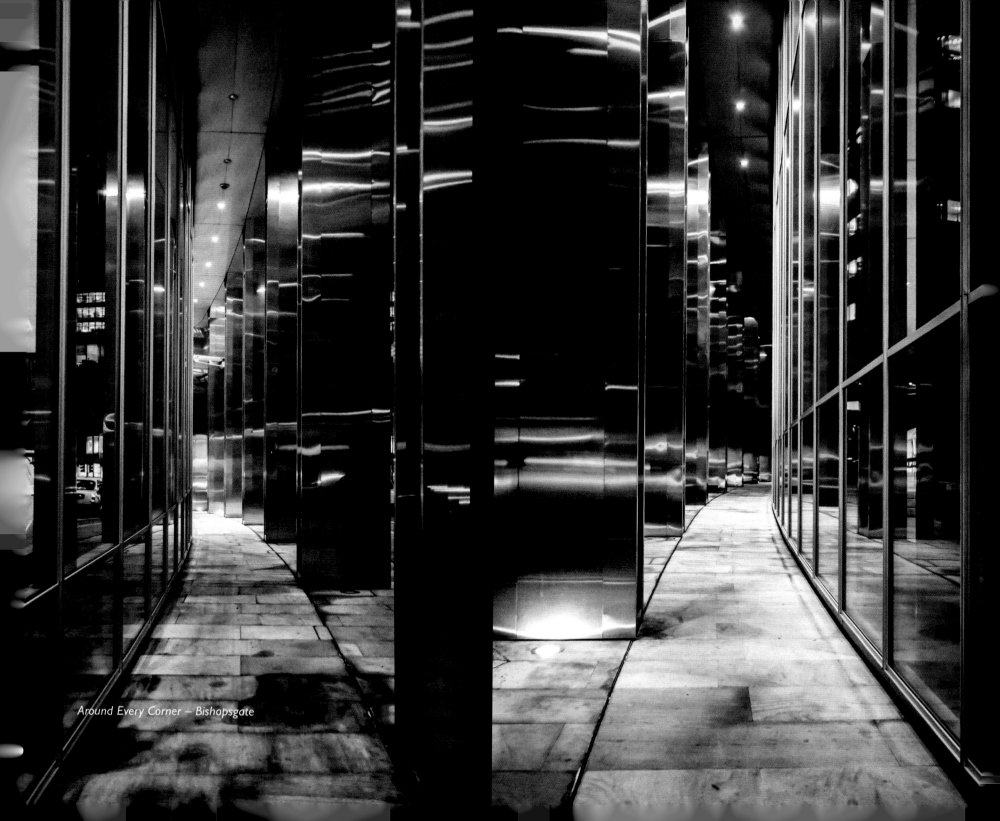

Around Every Corner – Bishopsgate

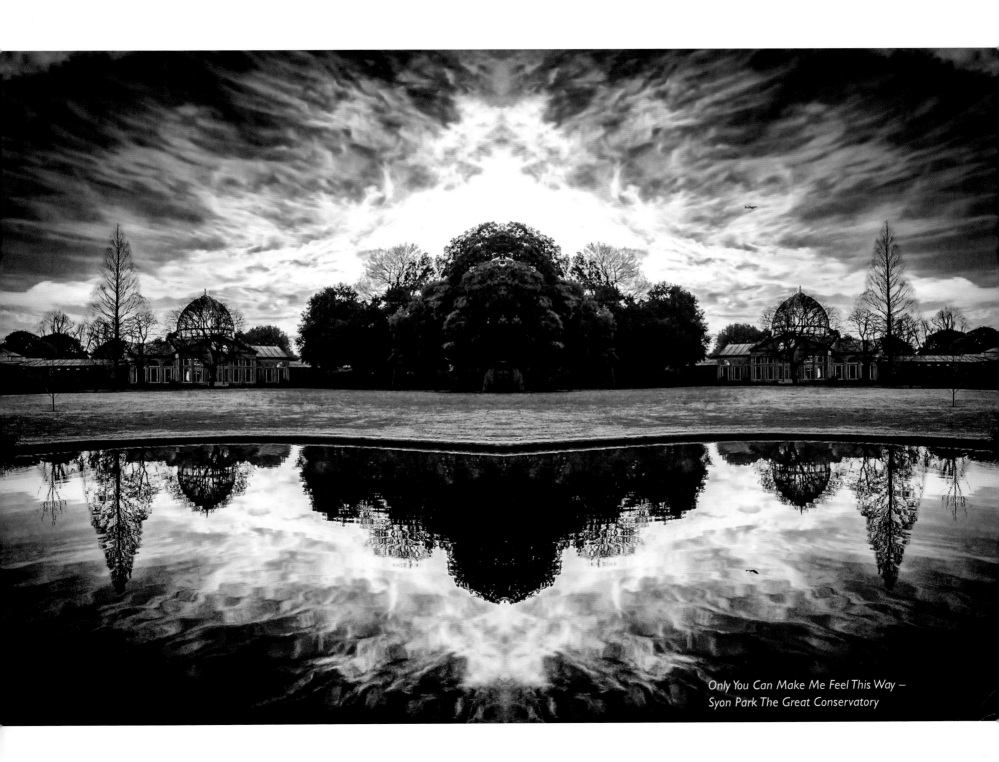

Only You Can Make Me Feel This Way –
Syon Park The Great Conservatory

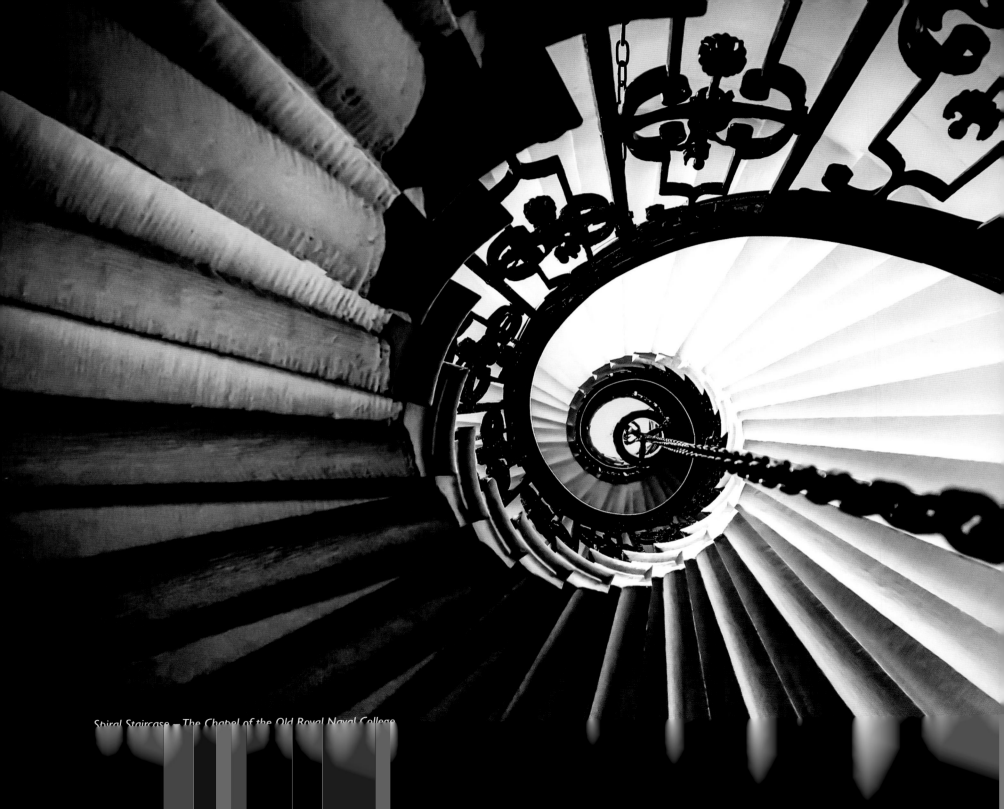

Spiral Staircase – The Chapel of the Old Royal Naval College

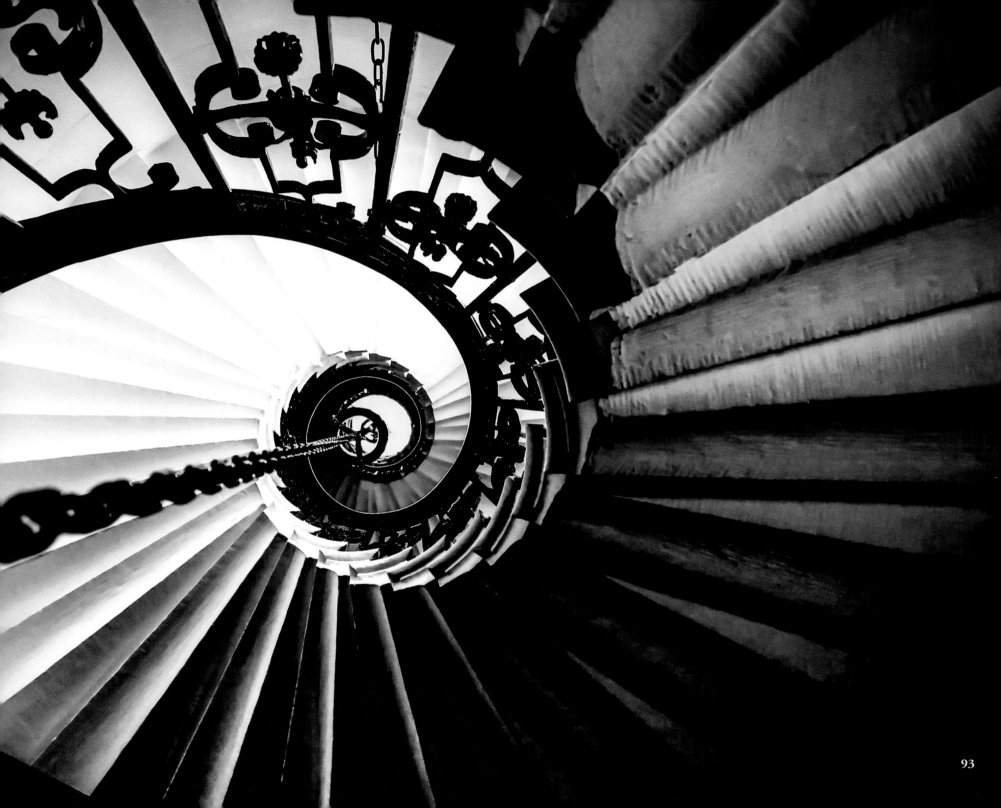

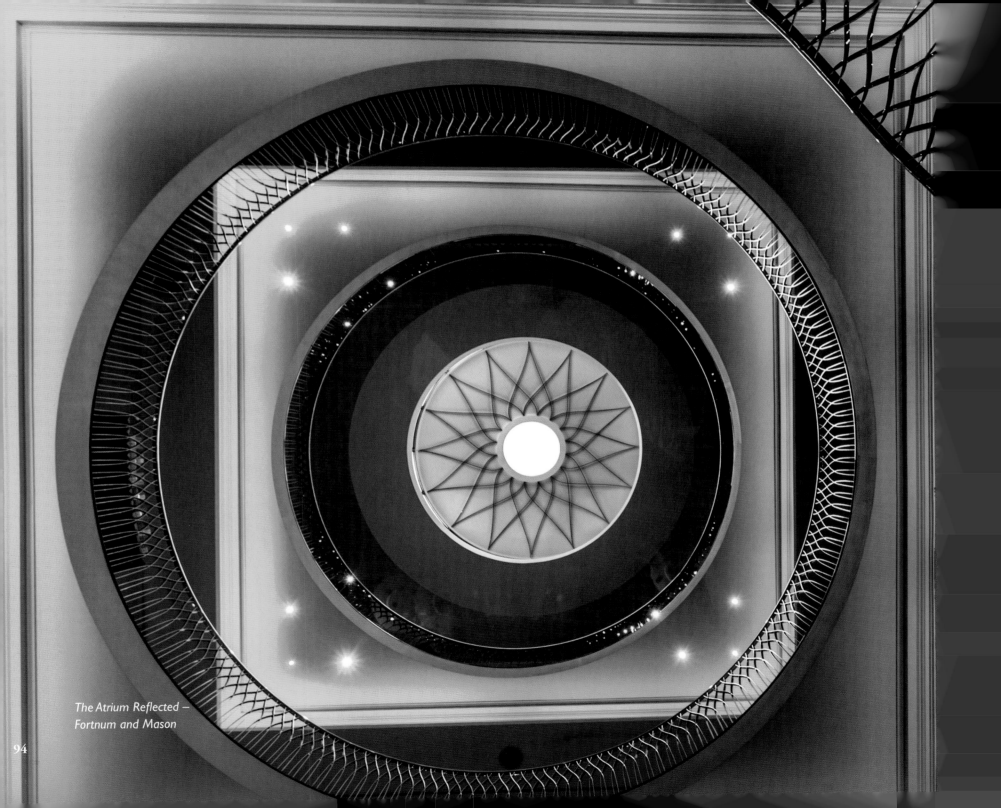

The Atrium Reflected –
Fortnum and Mason

94

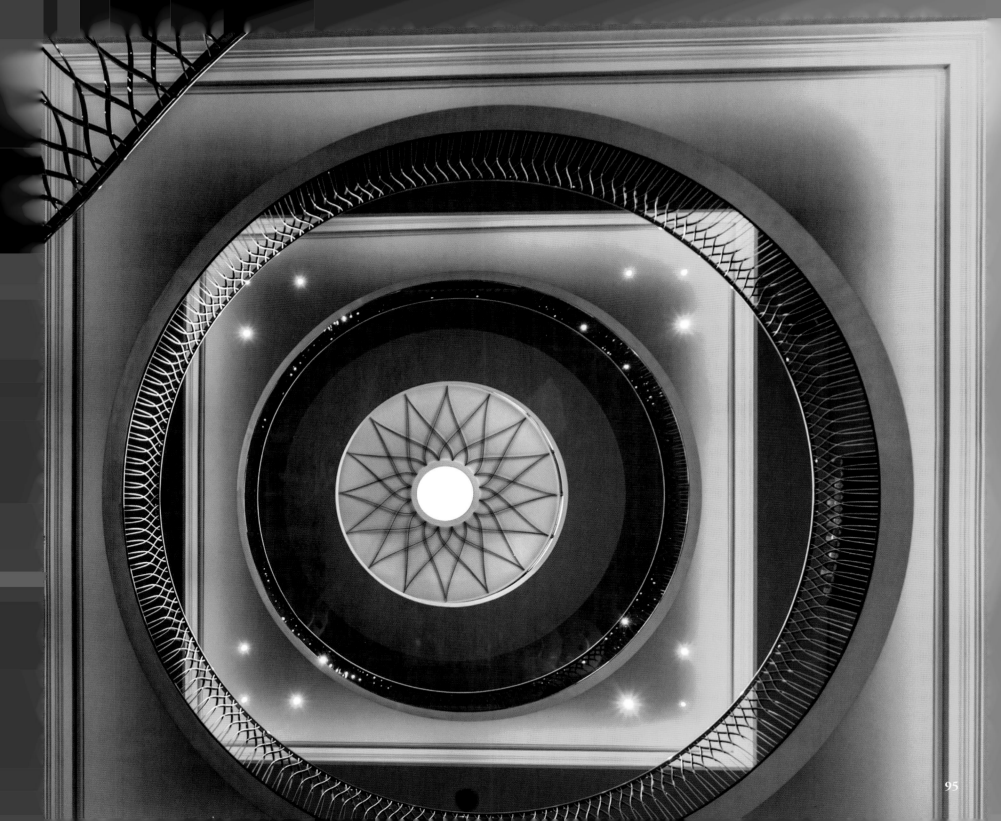

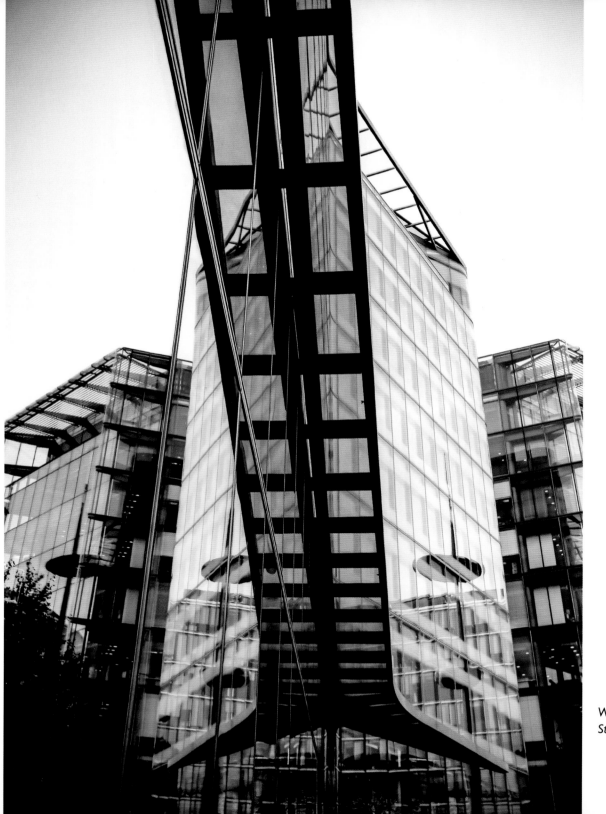

*Where Does The Real World
Start - More London*

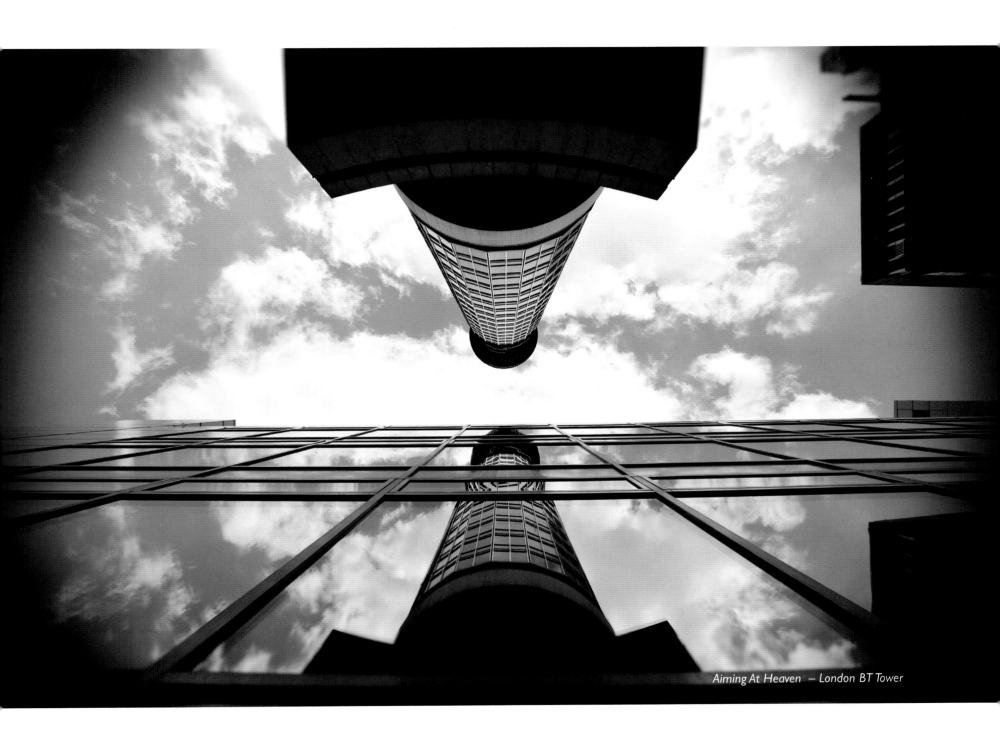

Aiming At Heaven — London BT Tower

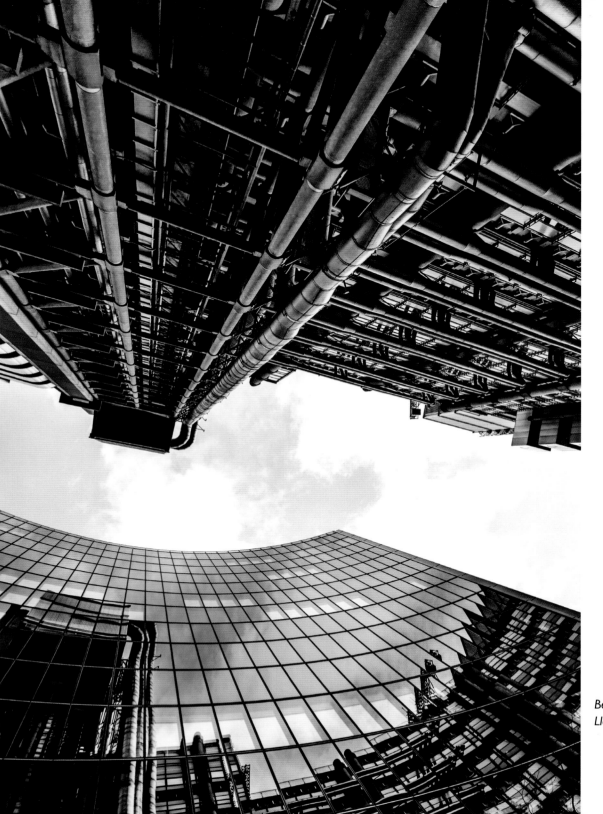

Between The Looking Glass –
Lloyds Building & Willis Building

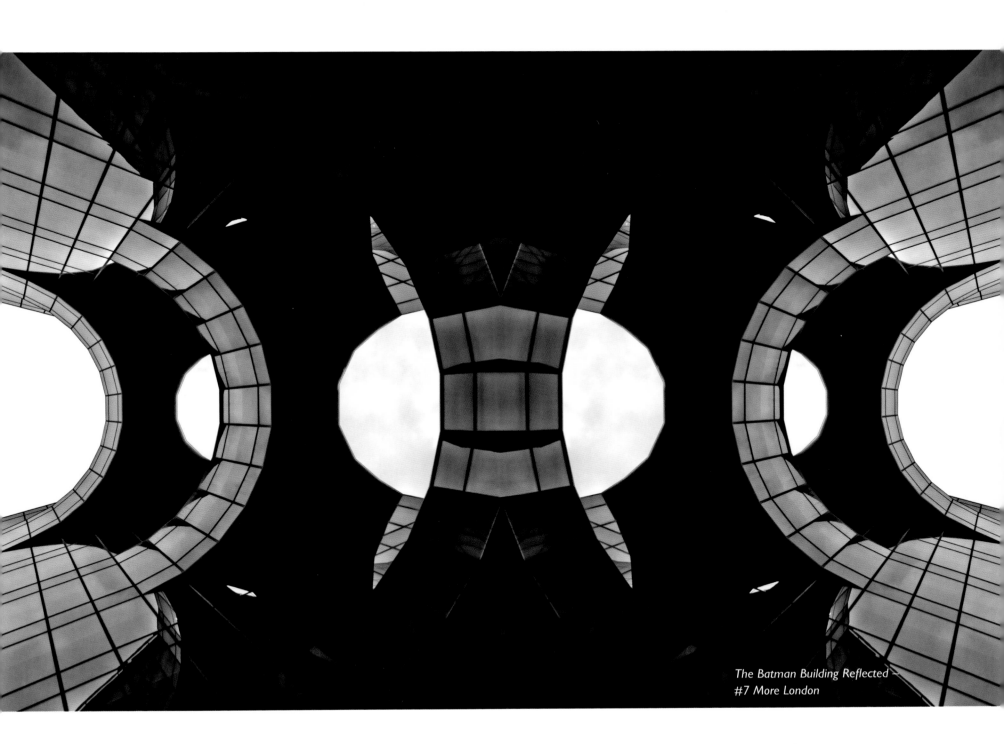

The Batman Building Reflected ~
#7 More London

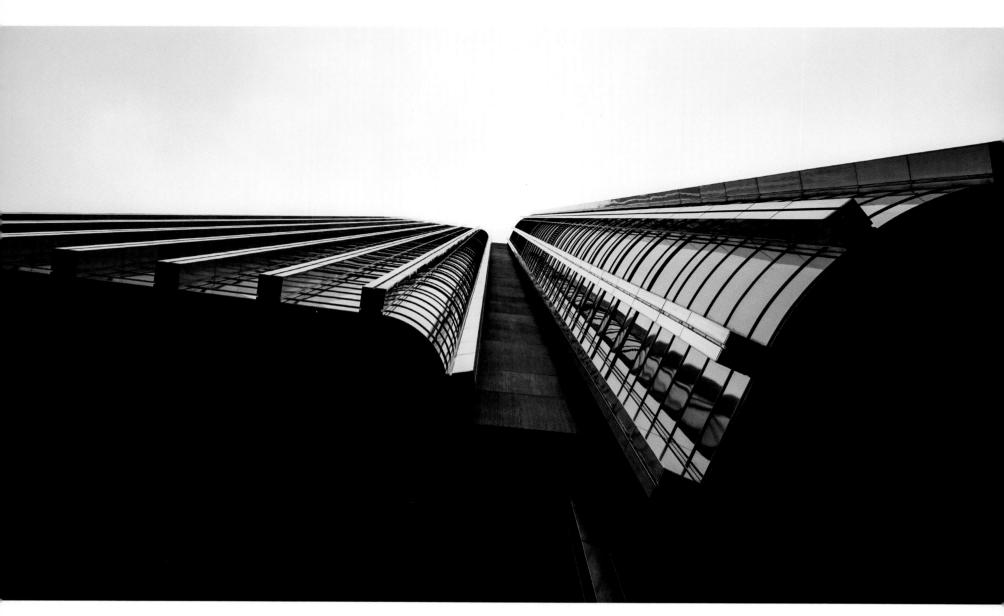

London City Modern Architecture — Willis Building

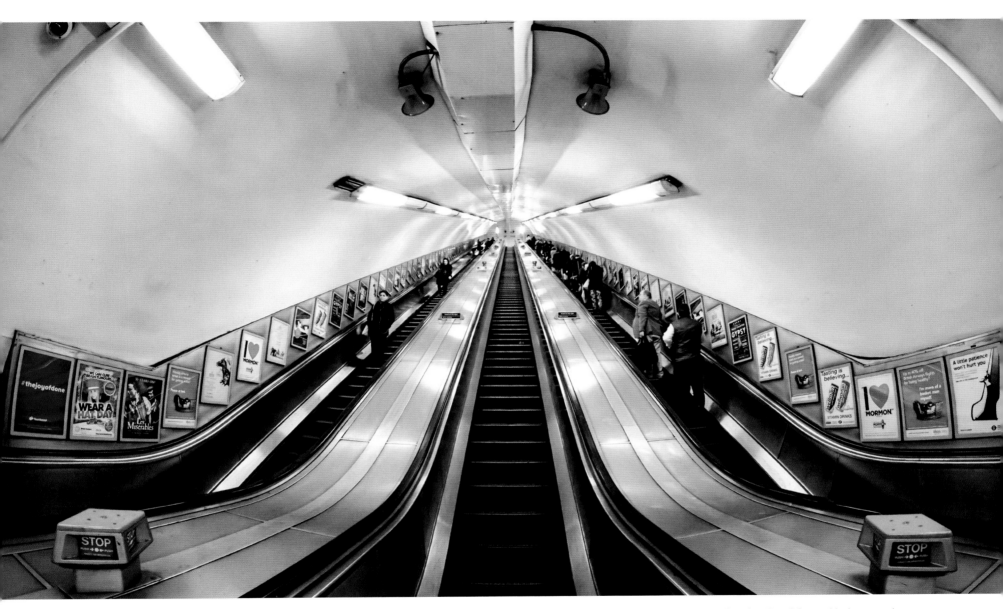

Another Bond Street Underground

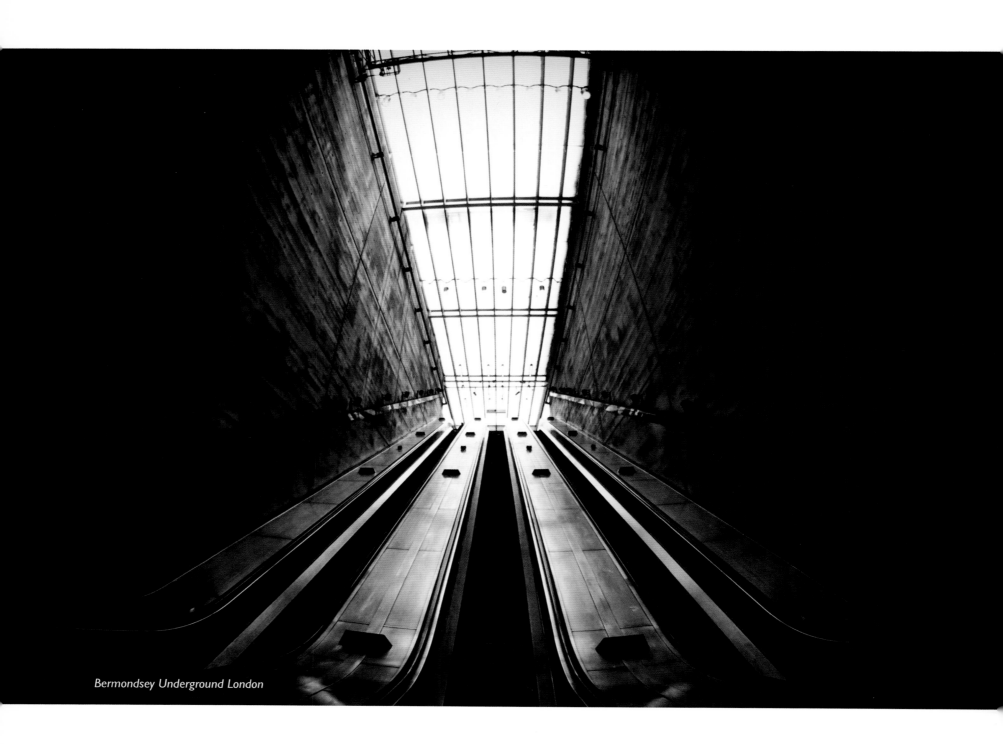

Bermondsey Underground London

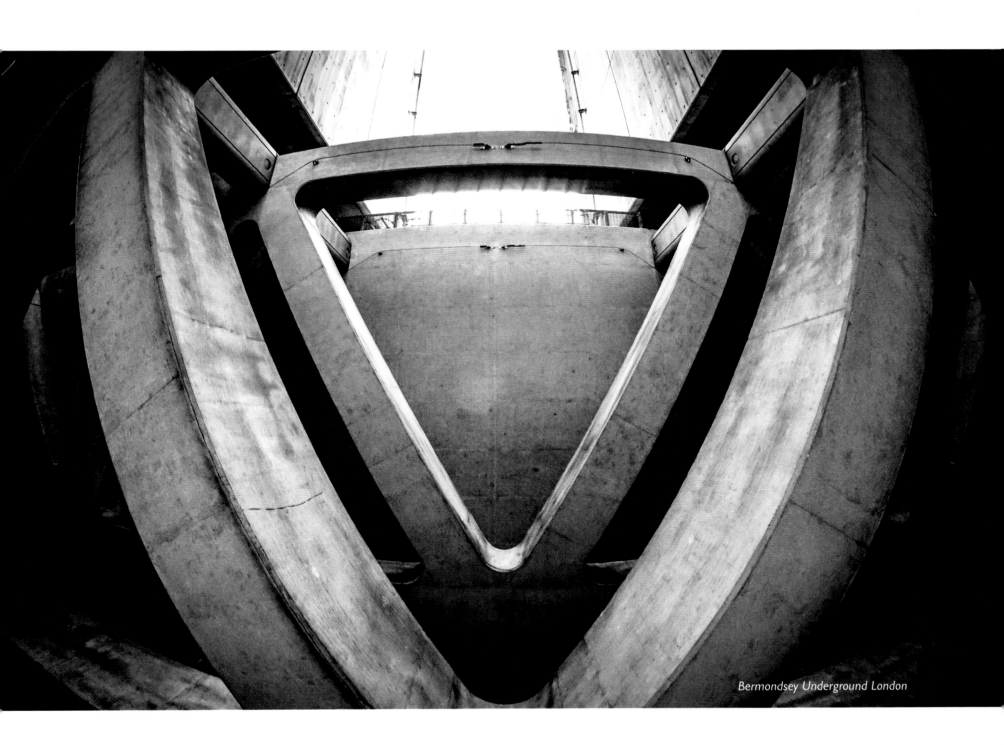

Bermondsey Underground London

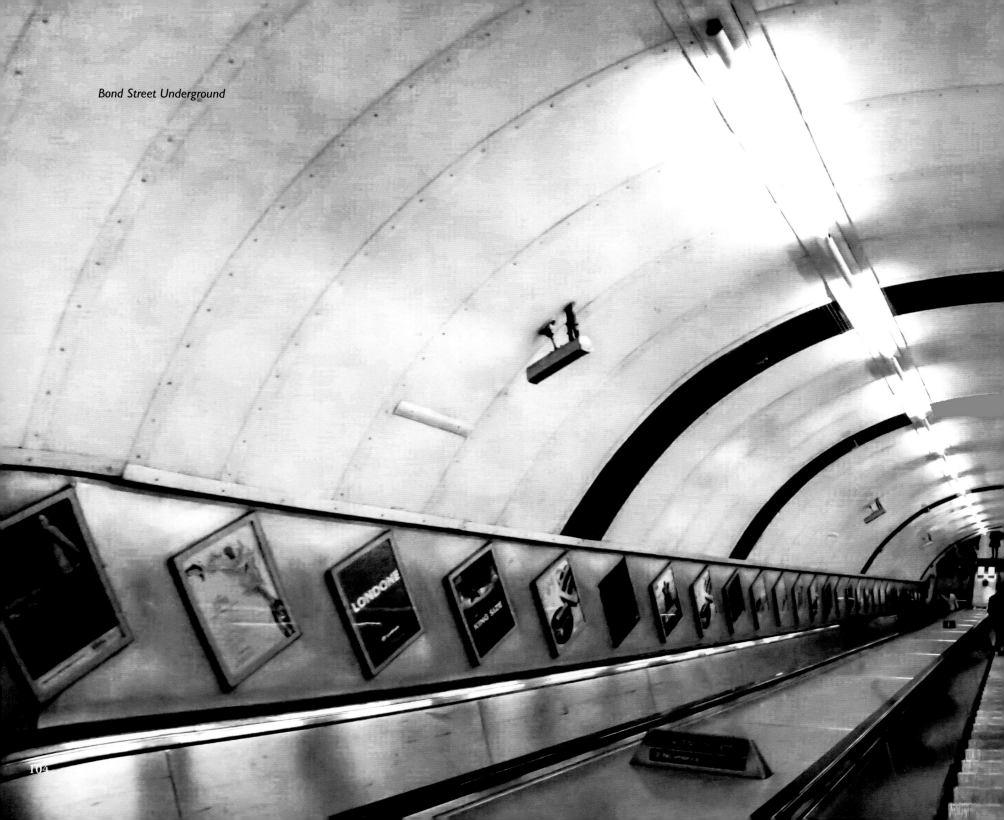

Bond Street Underground

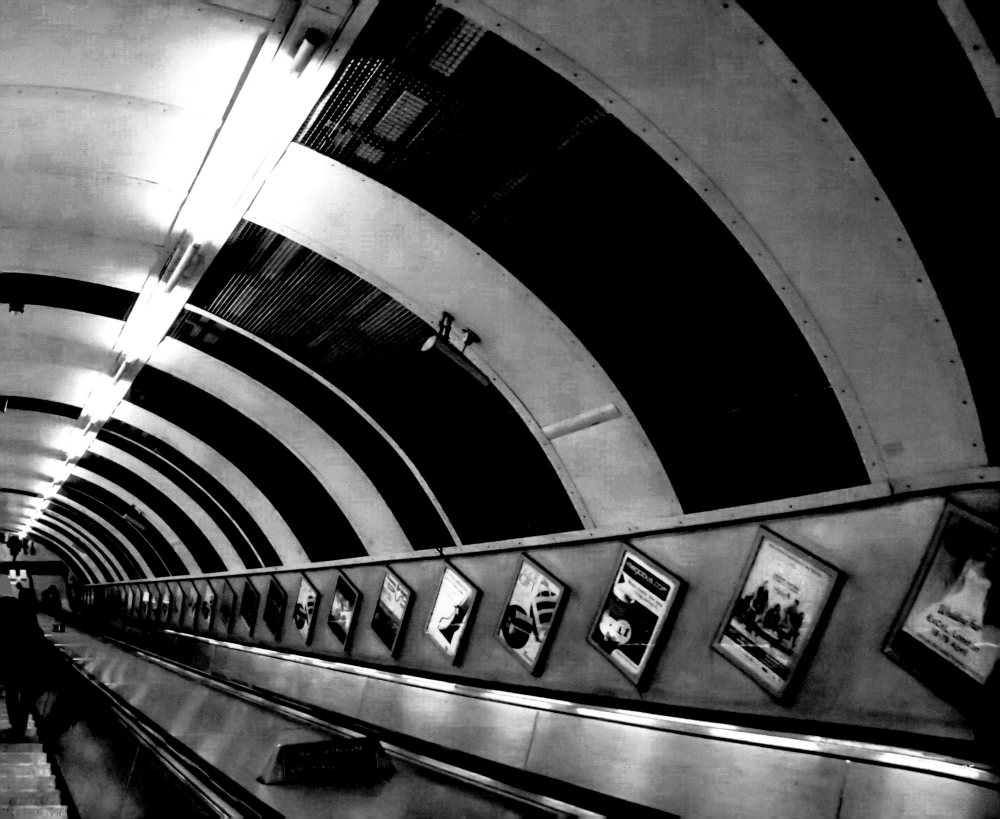

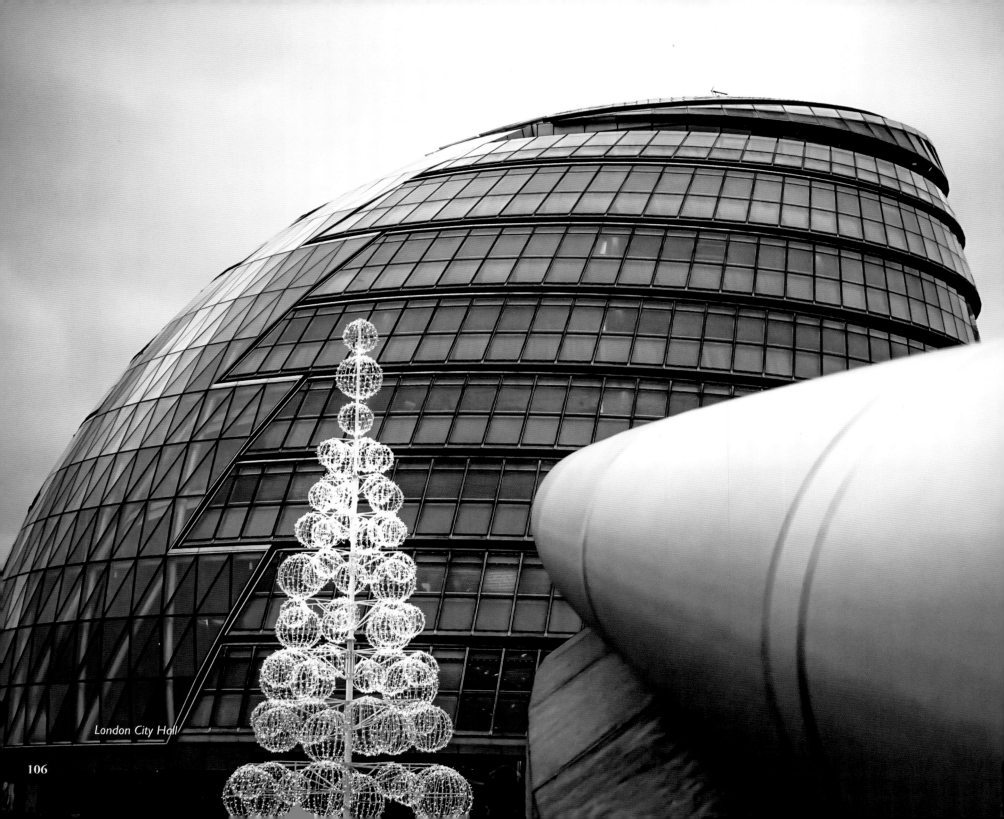

London City Hall

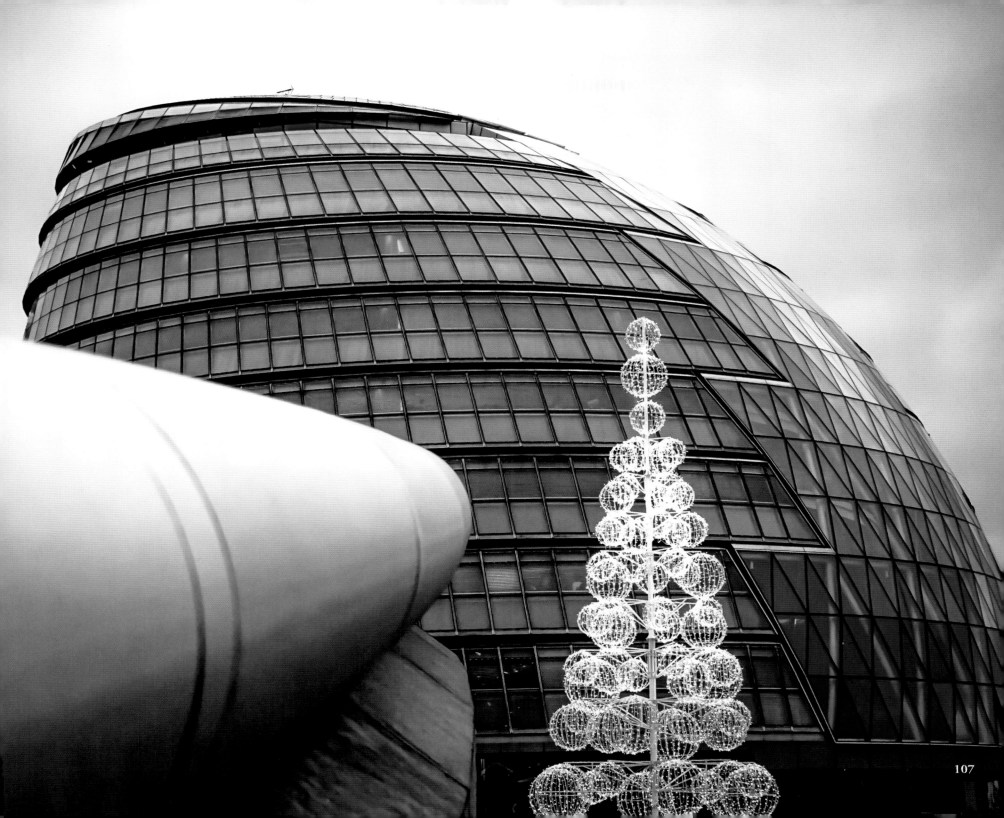

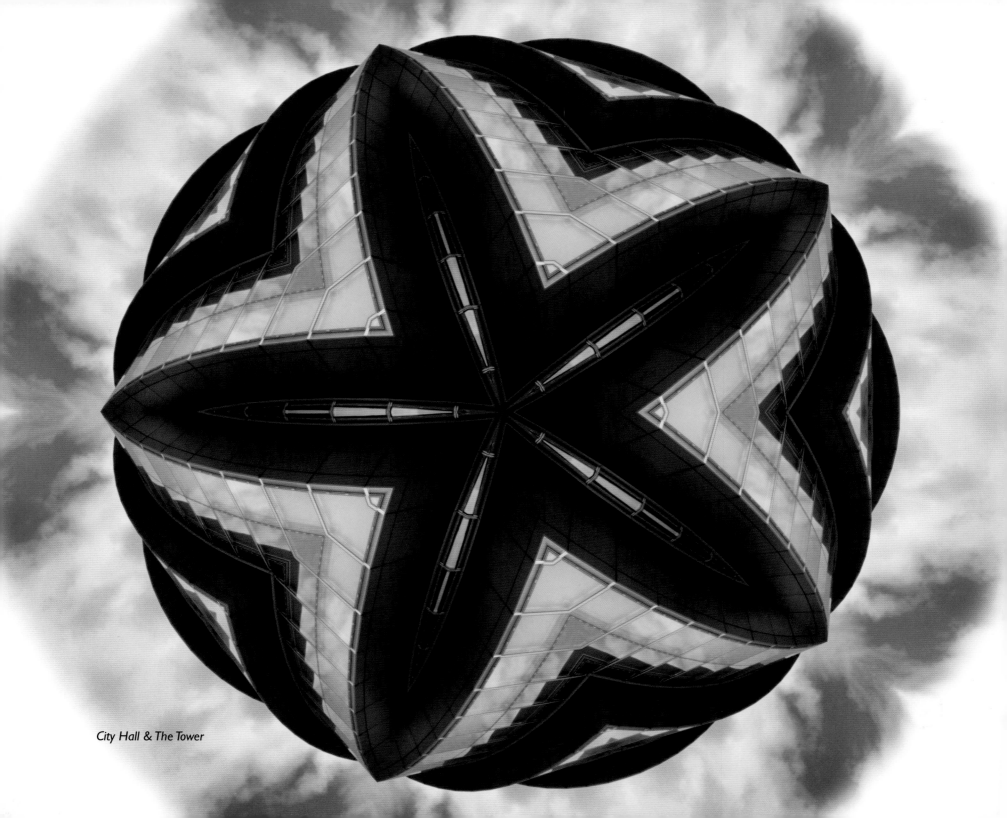

City Hall & The Tower

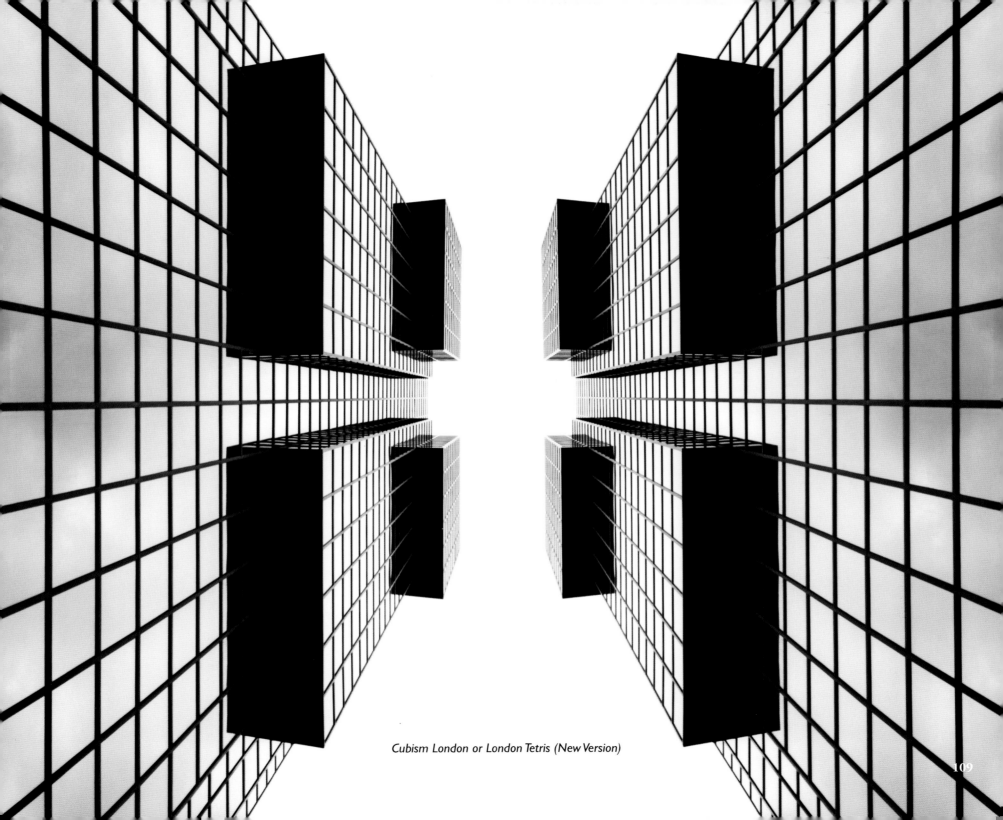

Cubism London or London Tetris (New Version)

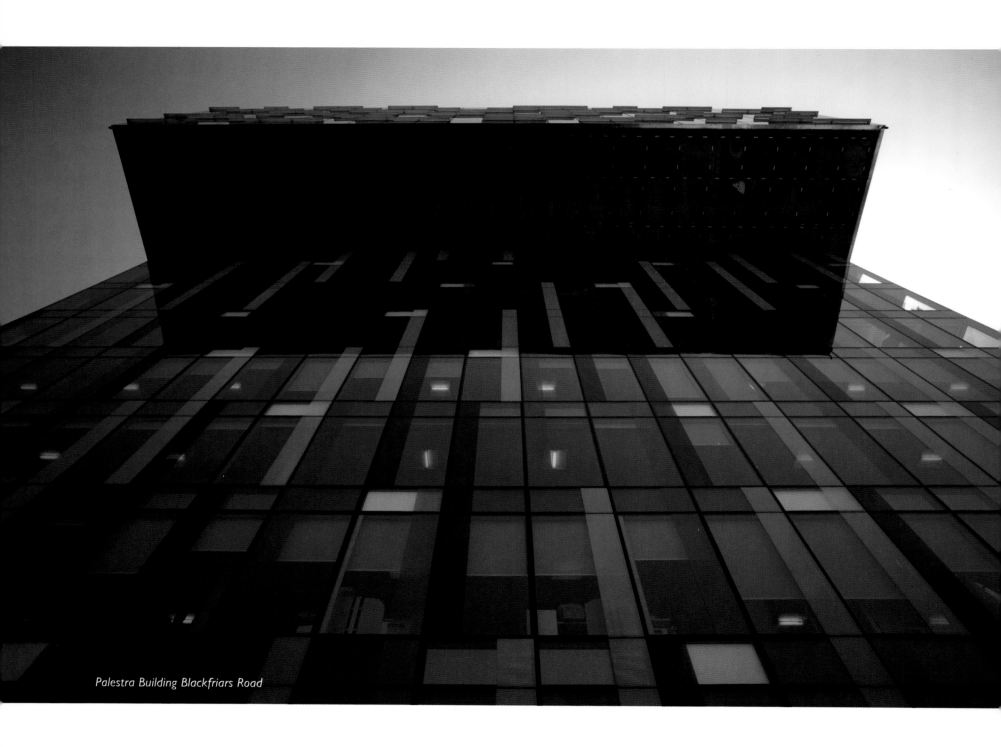

Palestra Building Blackfriars Road

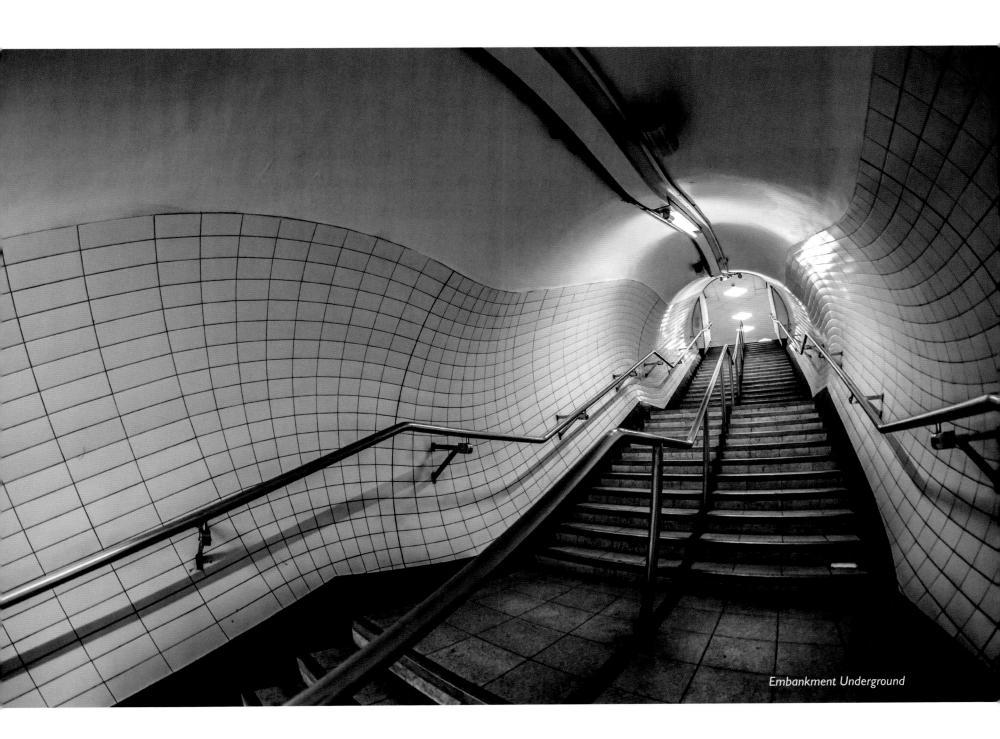

Embankment Underground

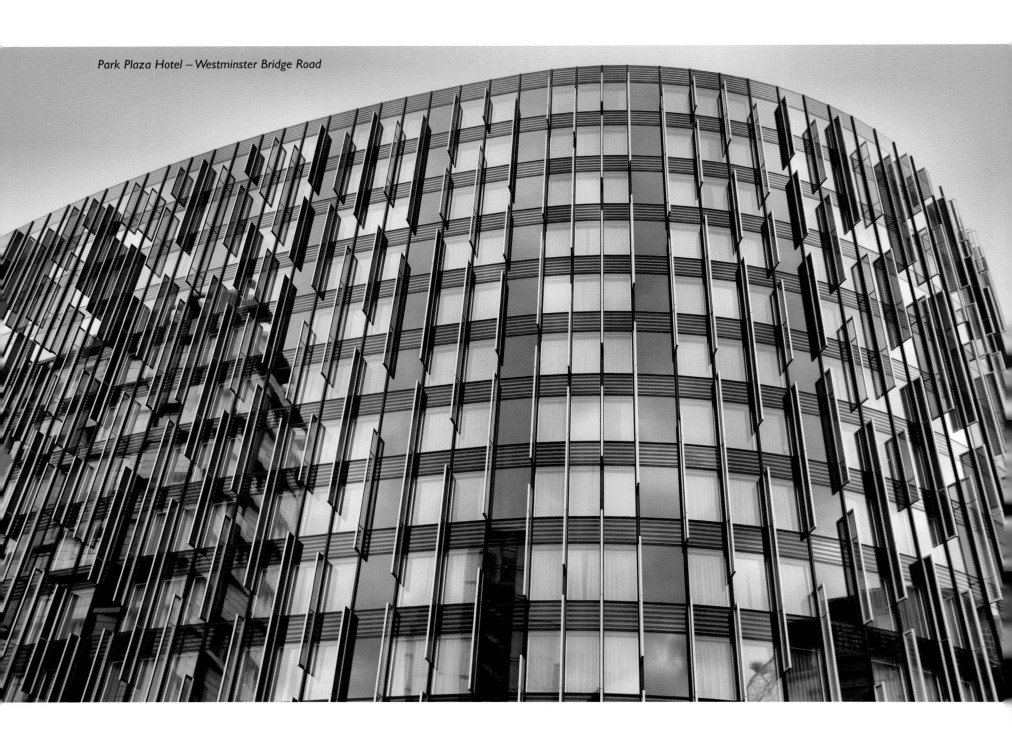

Park Plaza Hotel – Westminster Bridge Road

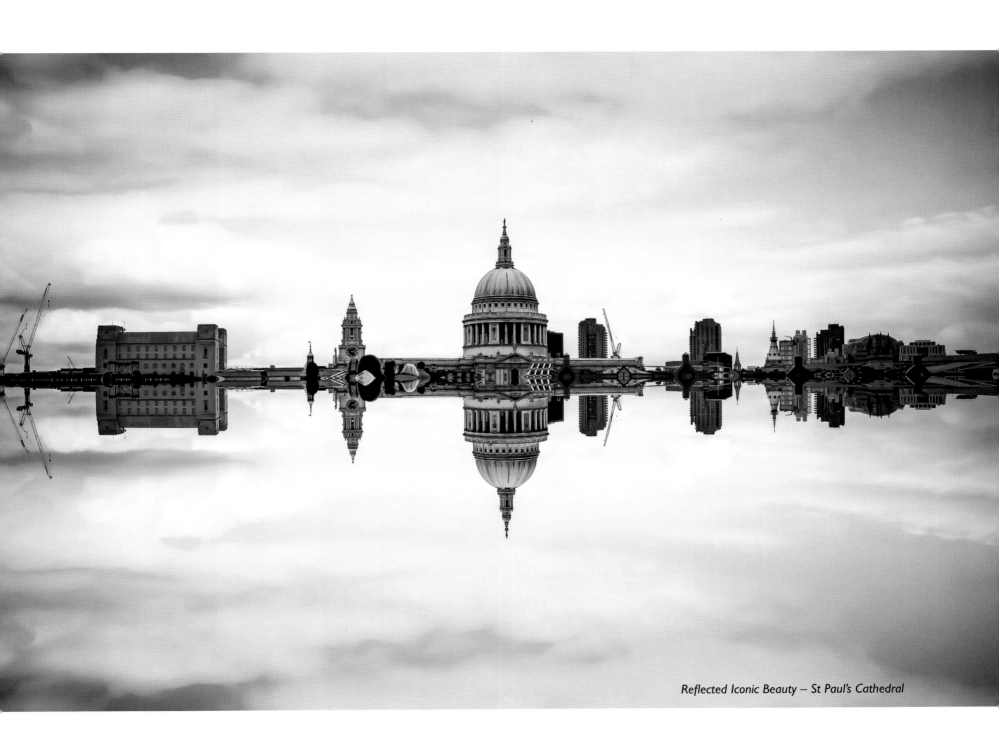

Reflected Iconic Beauty — St Paul's Cathedral

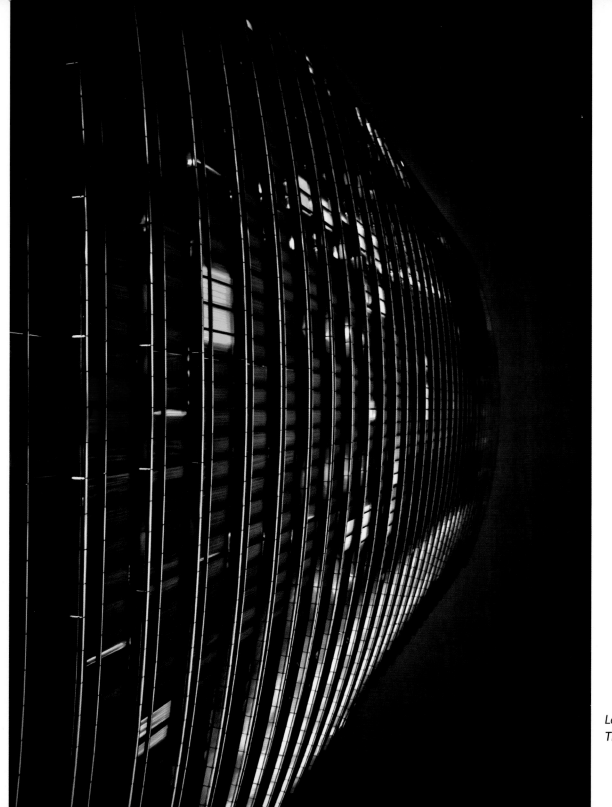

London City Rocks – Fretboard In The Sky – West India Quay

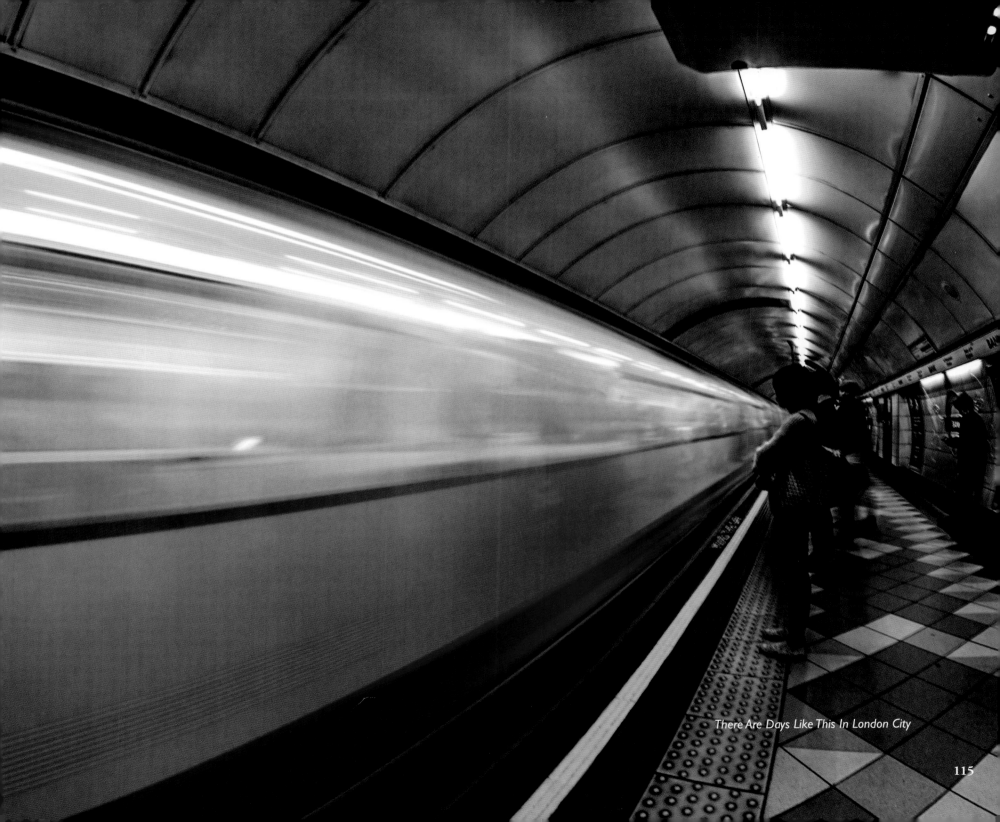

There Are Days Like This In London City

115

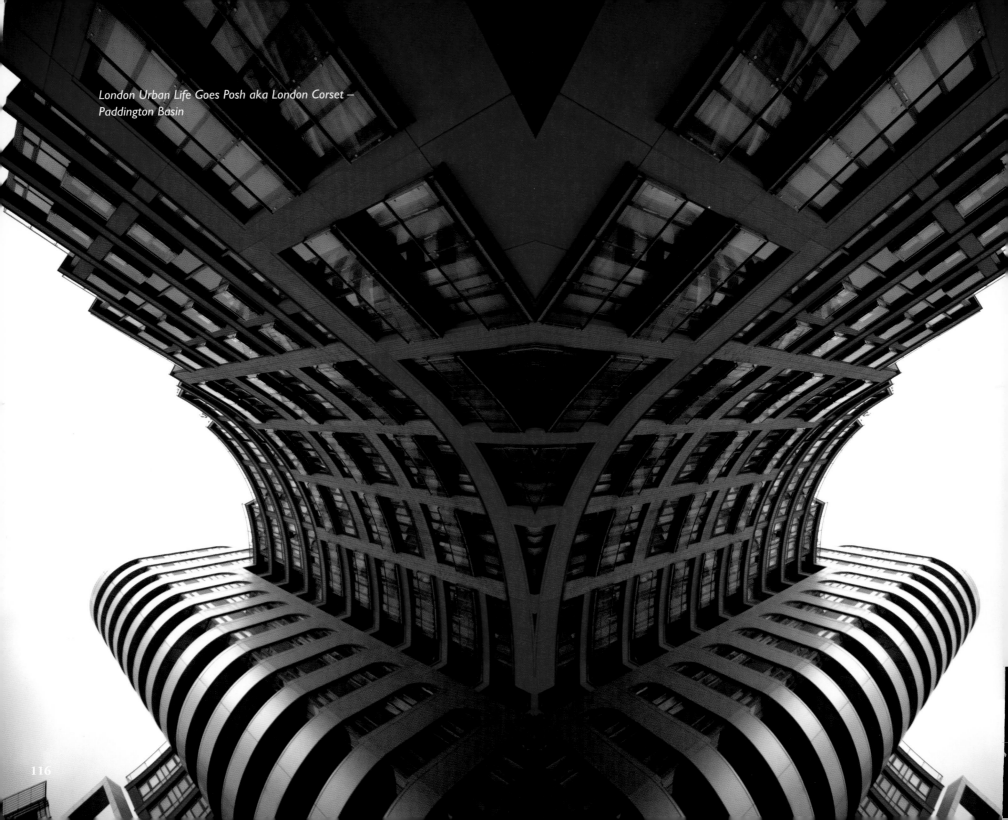

*London Urban Life Goes Posh aka London Corset –
Paddington Basin*

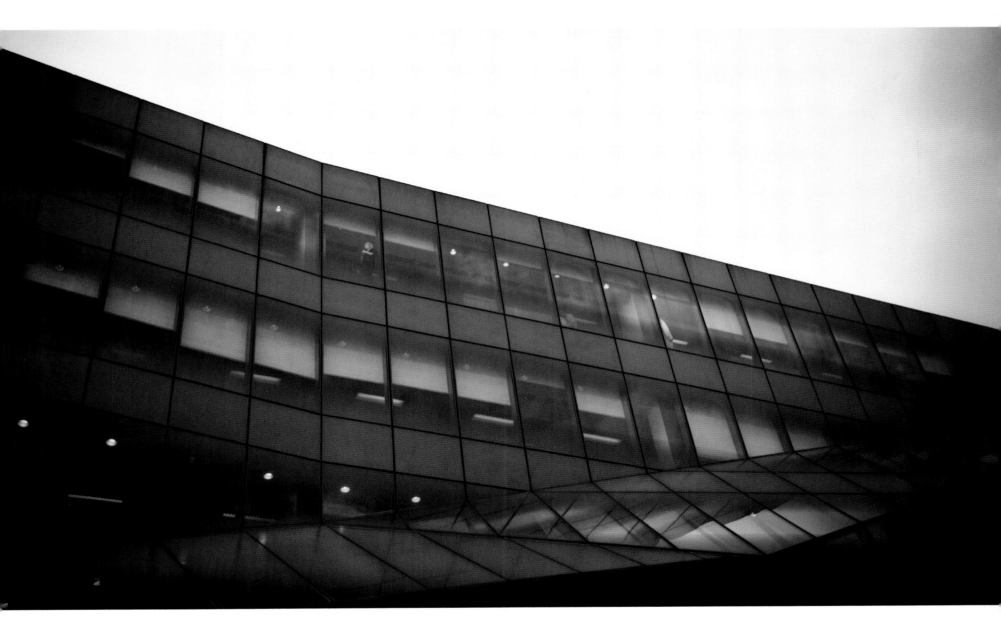

Lonely World – Cheapside

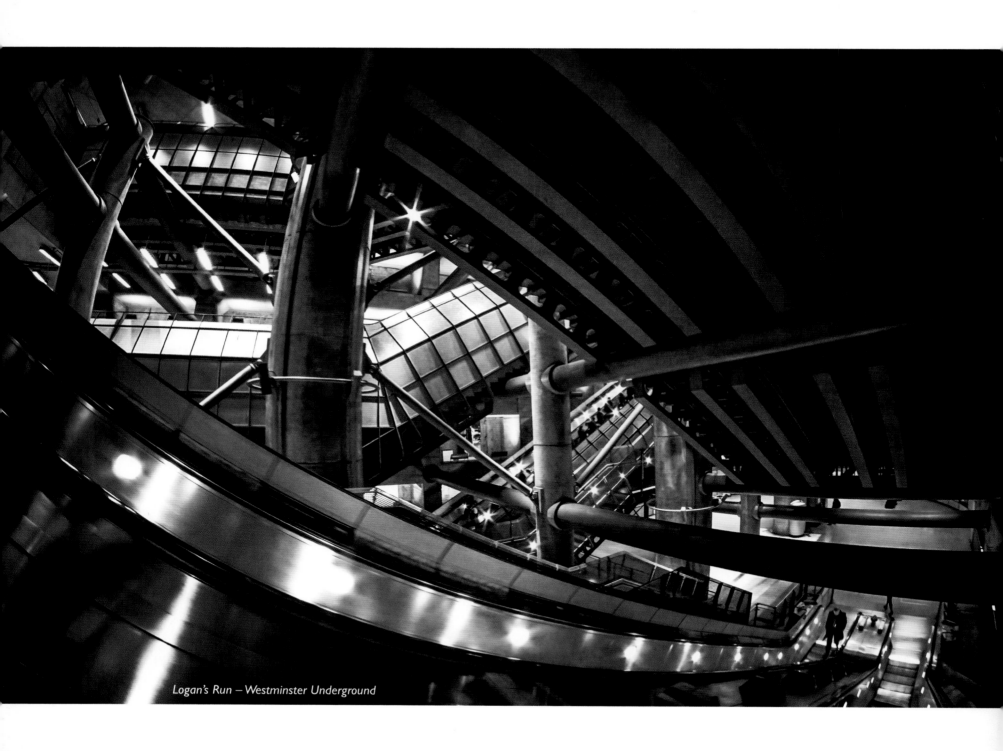

Logan's Run – Westminster Underground

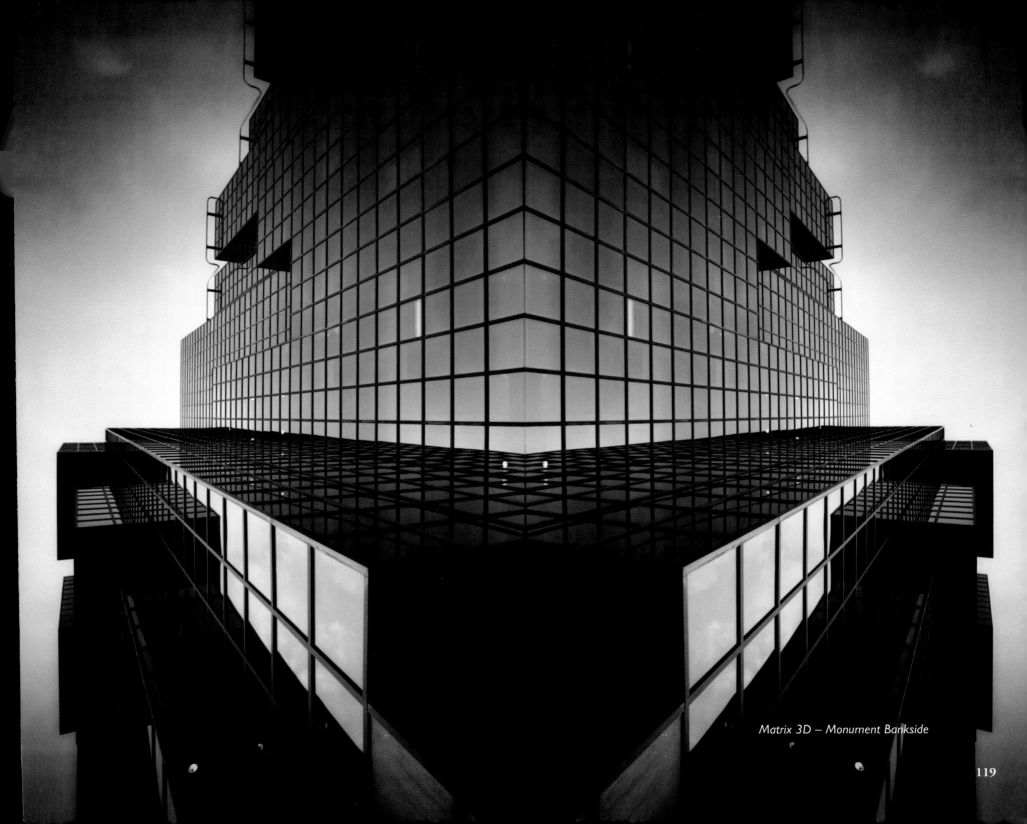

Matrix 3D – Monument Bankside

119

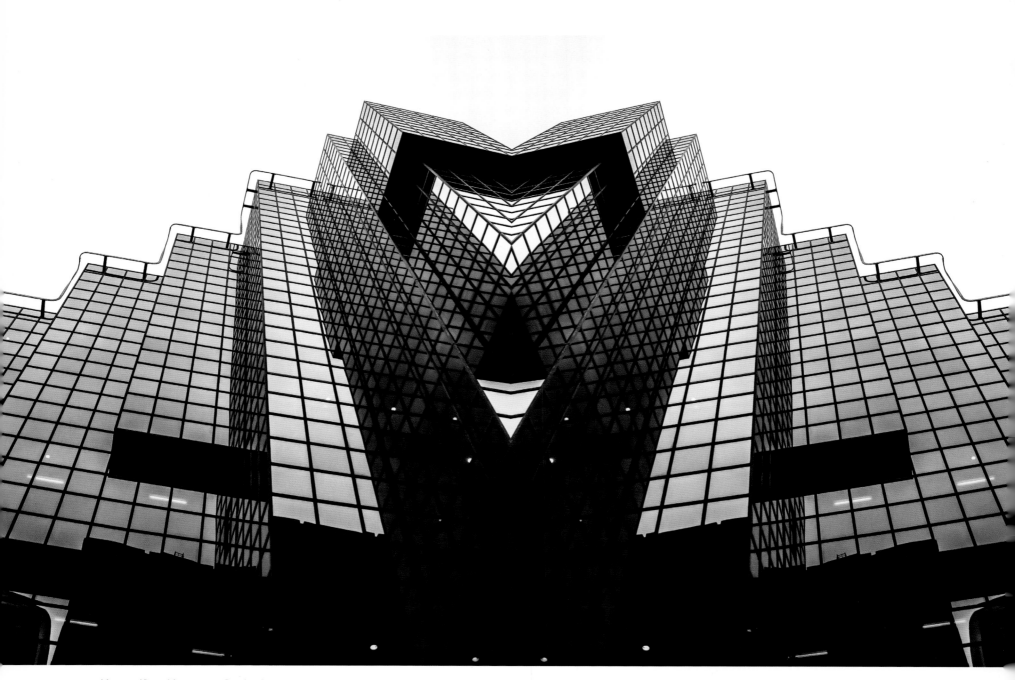

Matrix 4D – Monument Bankside

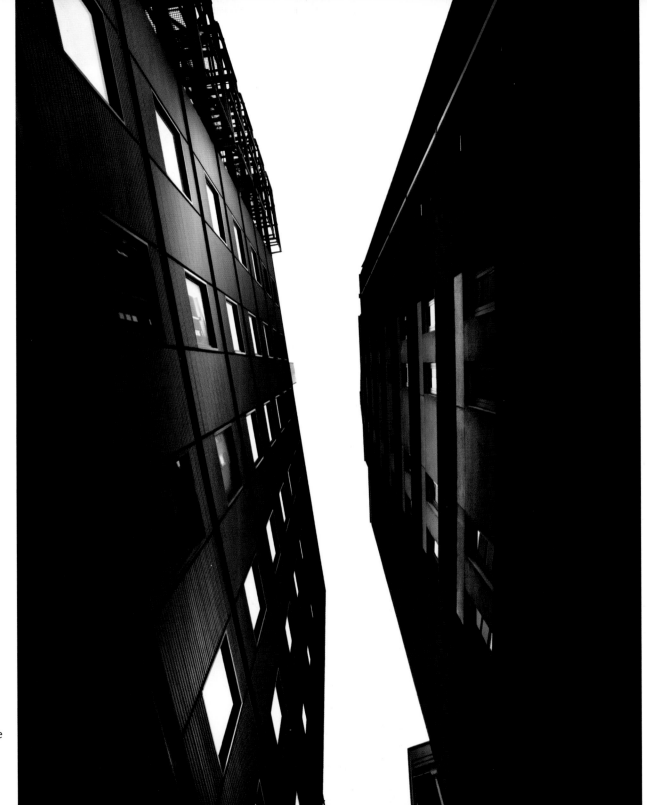

Metamorphosis – Bankside

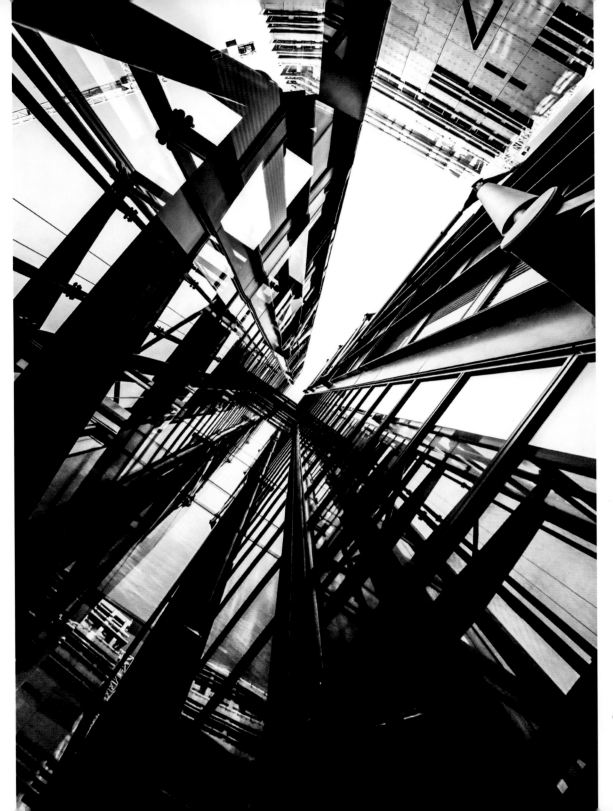

Odd Future – Blackfriars Road

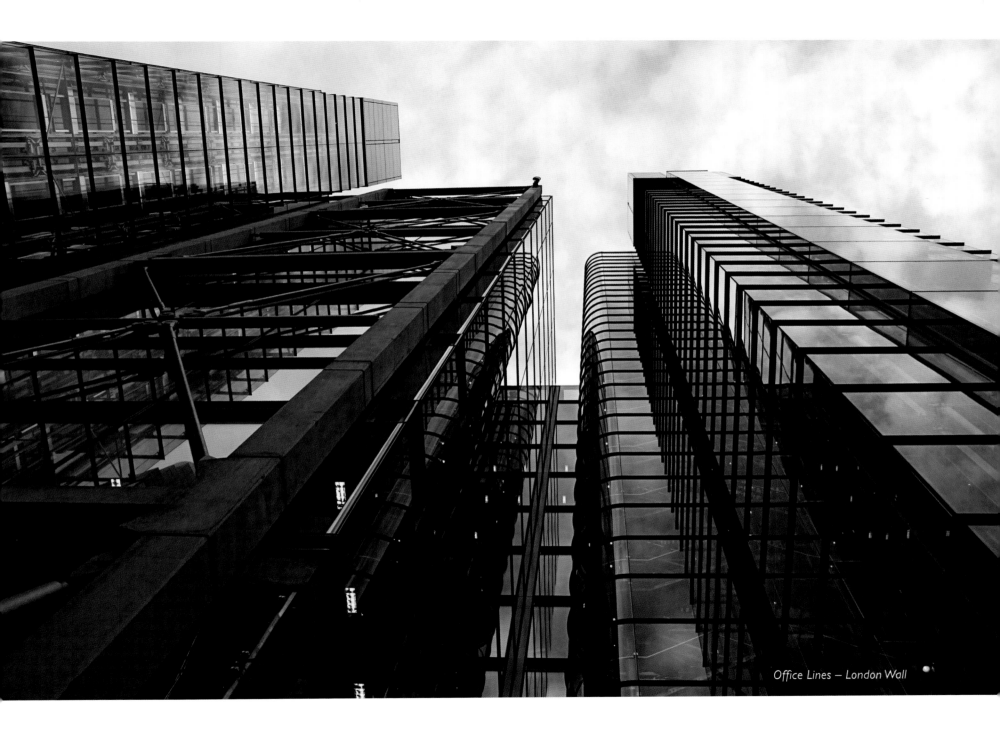

Office Lines – London Wall

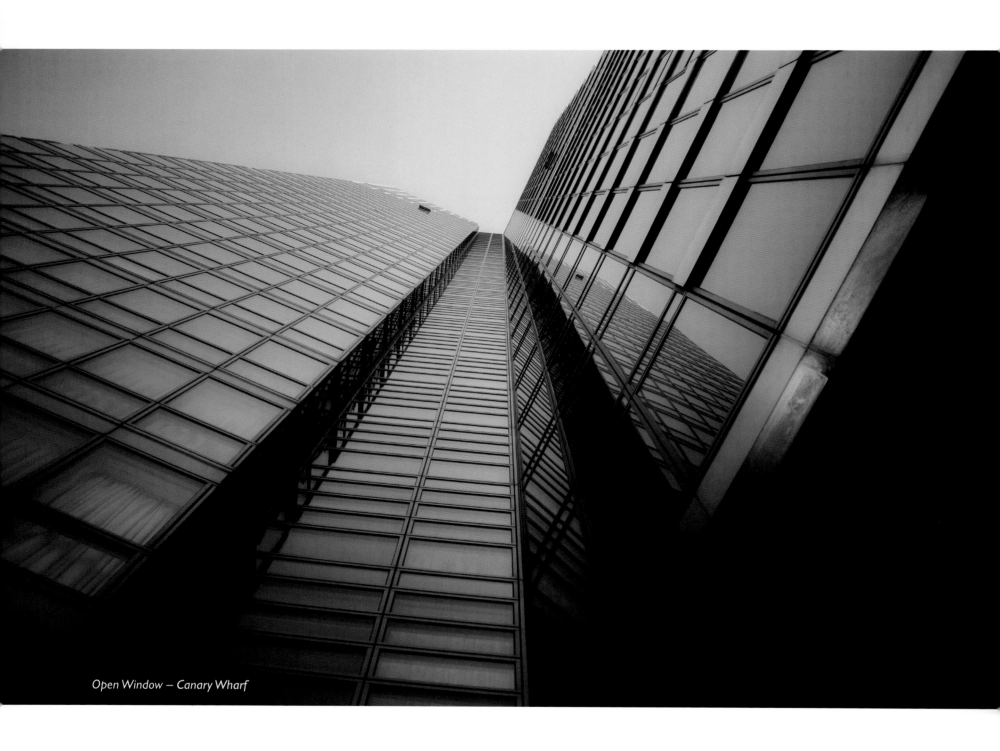

Open Window – Canary Wharf

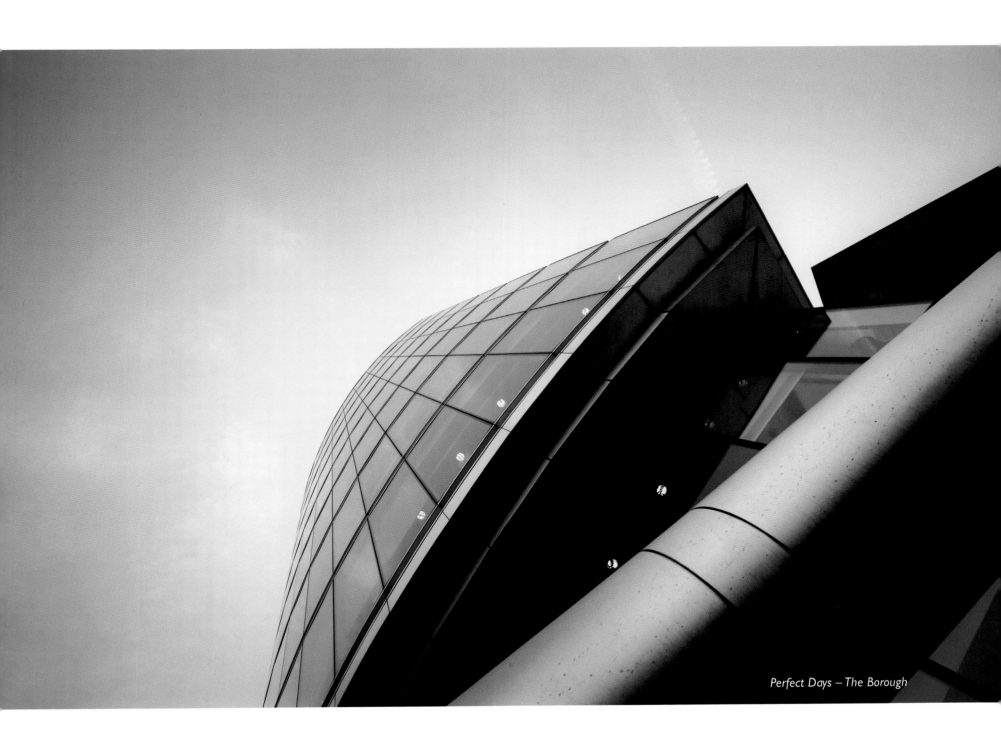

Perfect Days – The Borough

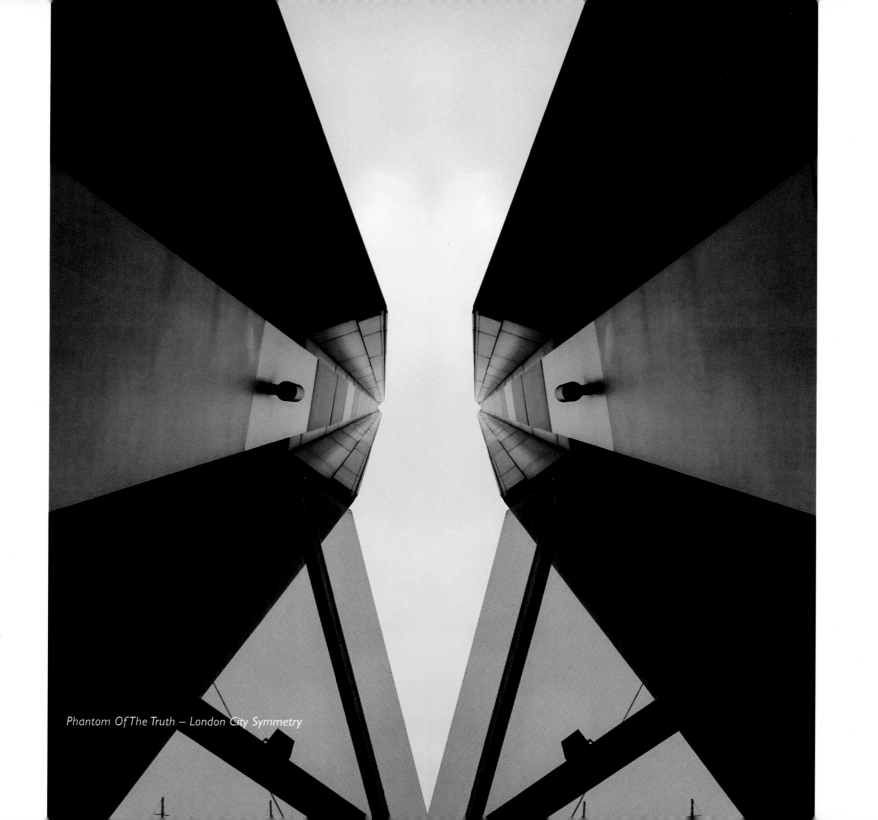

Phantom Of The Truth – London City Symmetry

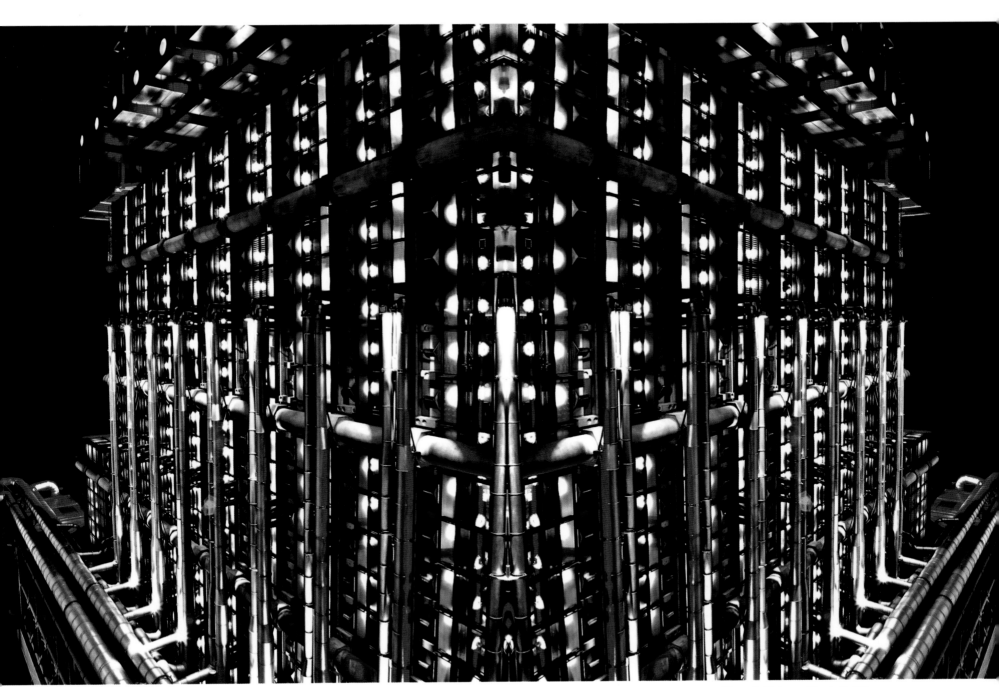

Pipes & Lights – Lloyds Building

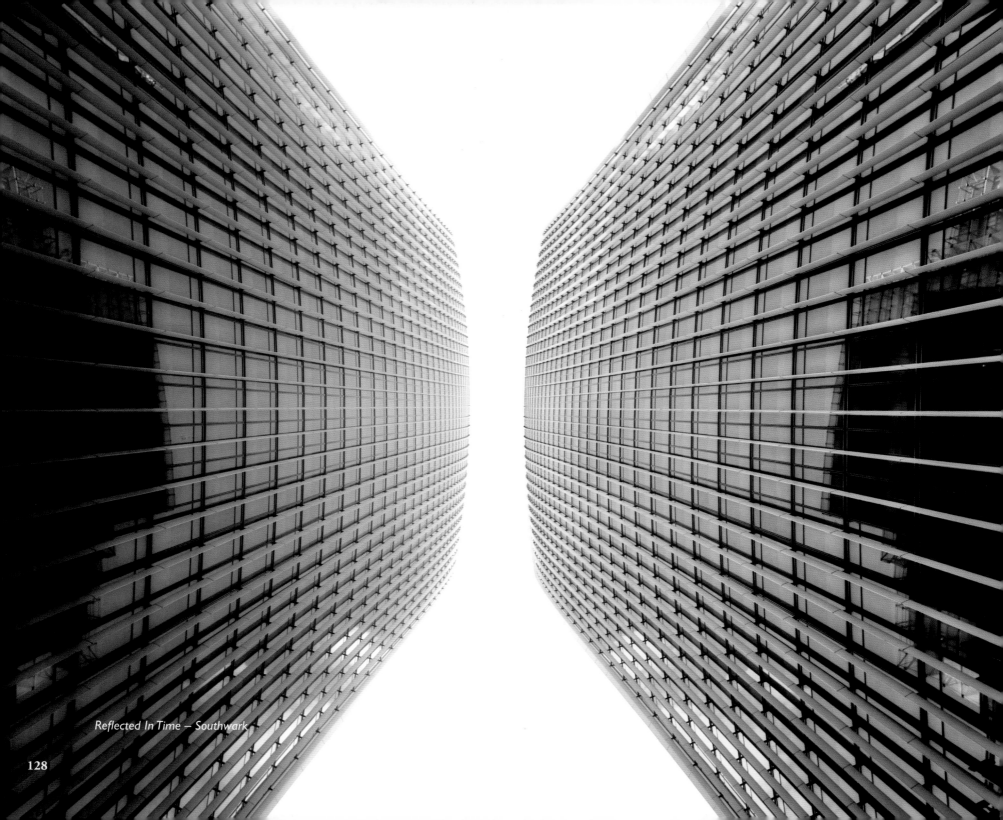

Reflected In Time — Southwark

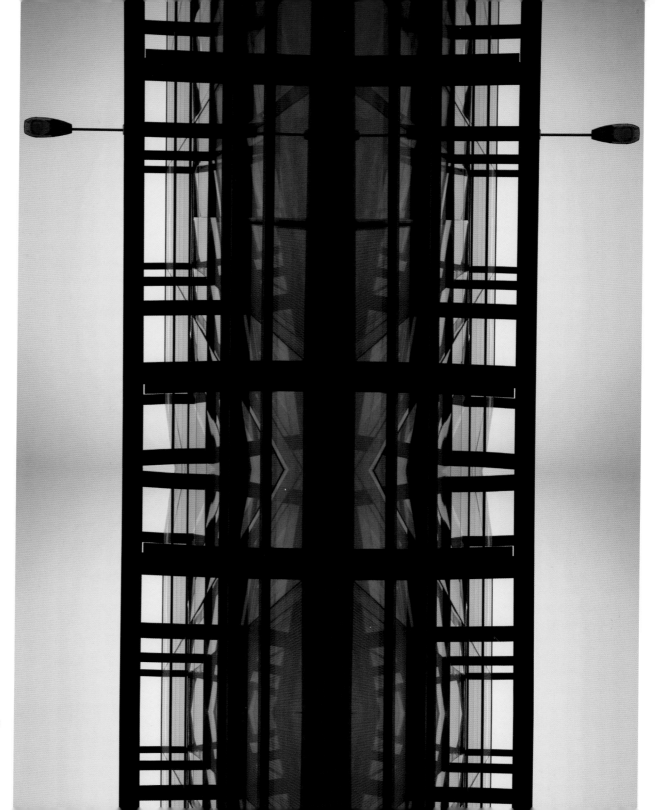

Reflected Symmetry Cheapside

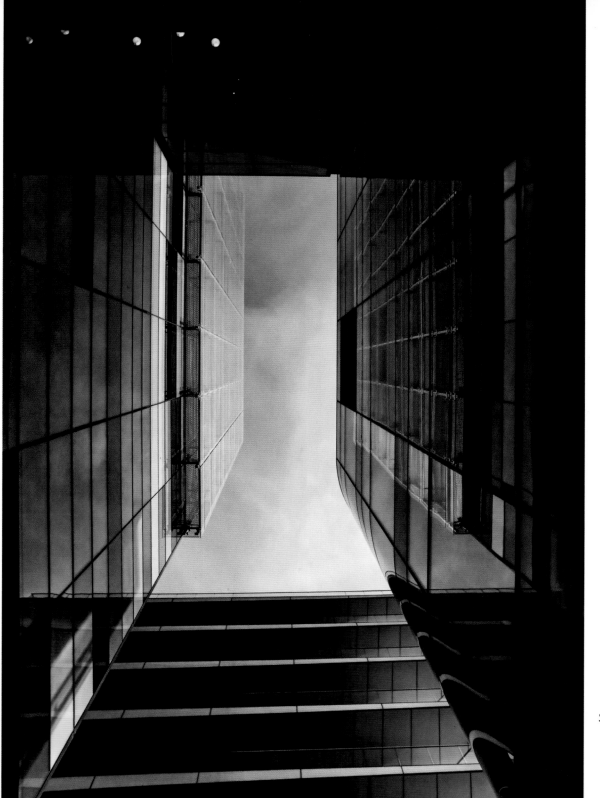

Shout To The Top – Bankside

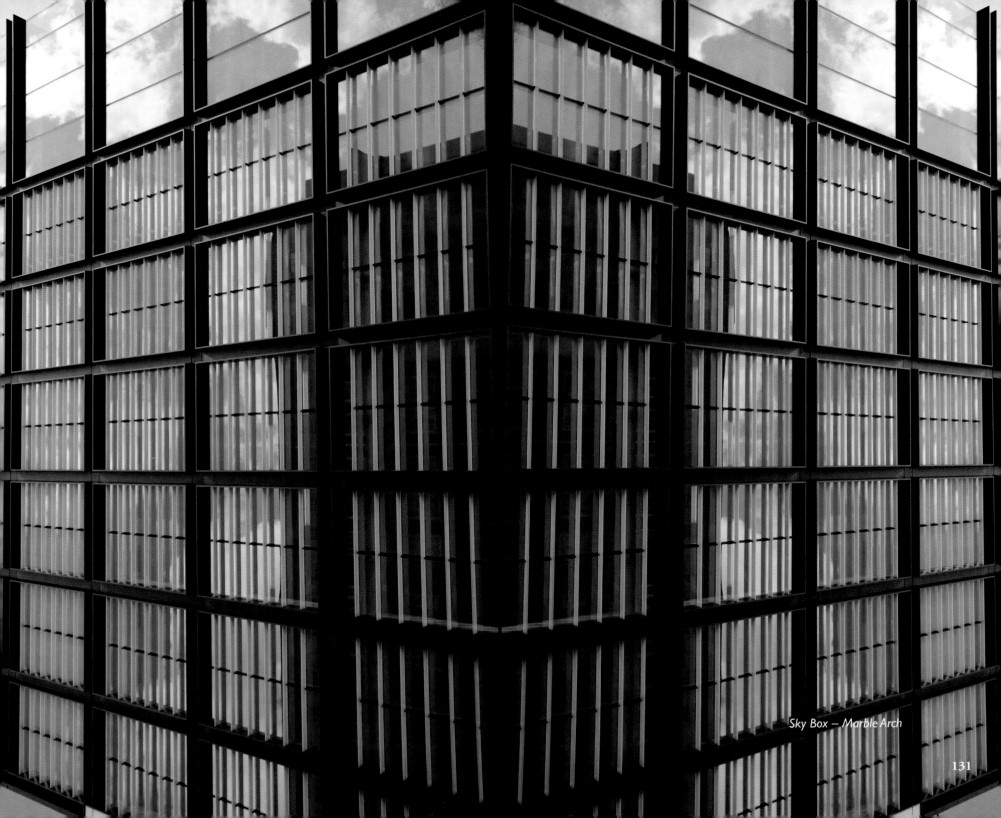

Sky Box – Marble Arch

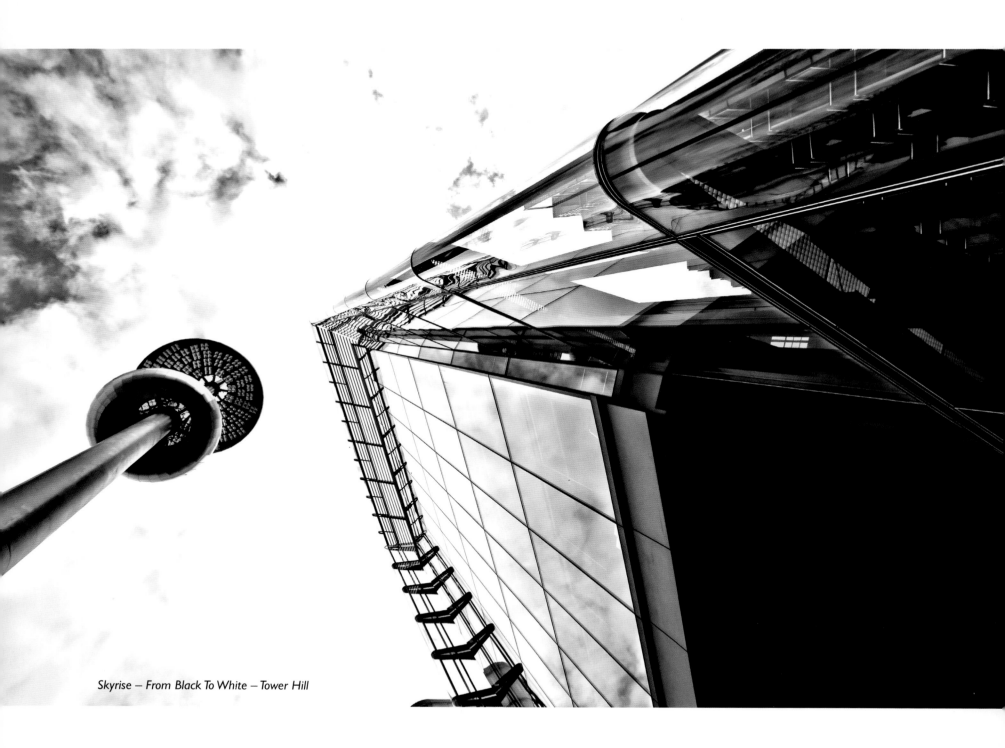

Skyrise – From Black To White – Tower Hill

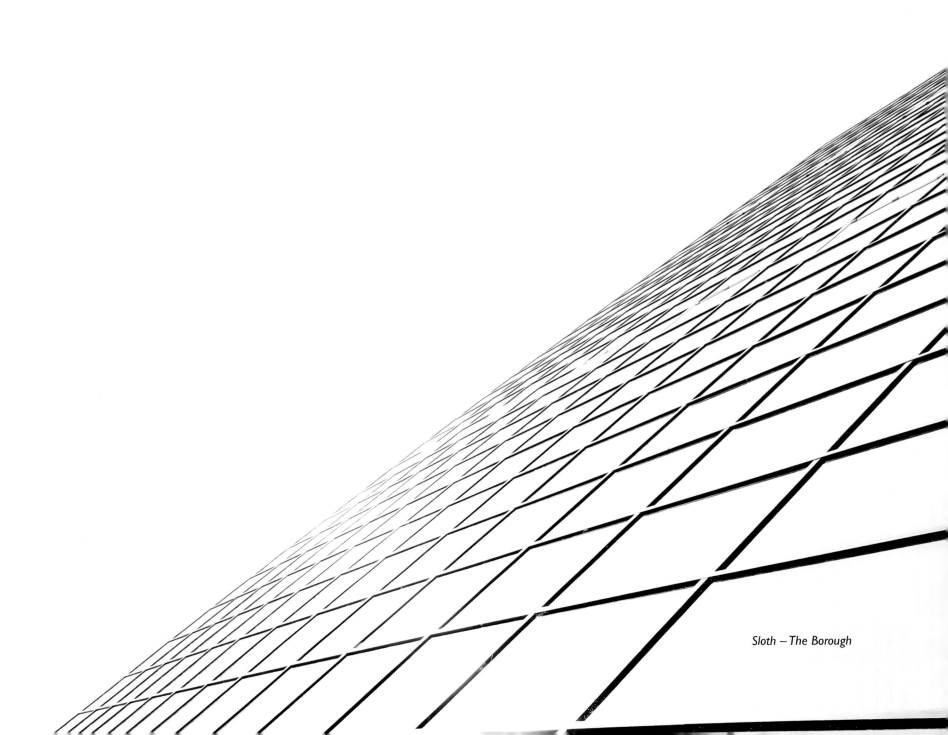

Sloth – The Borough

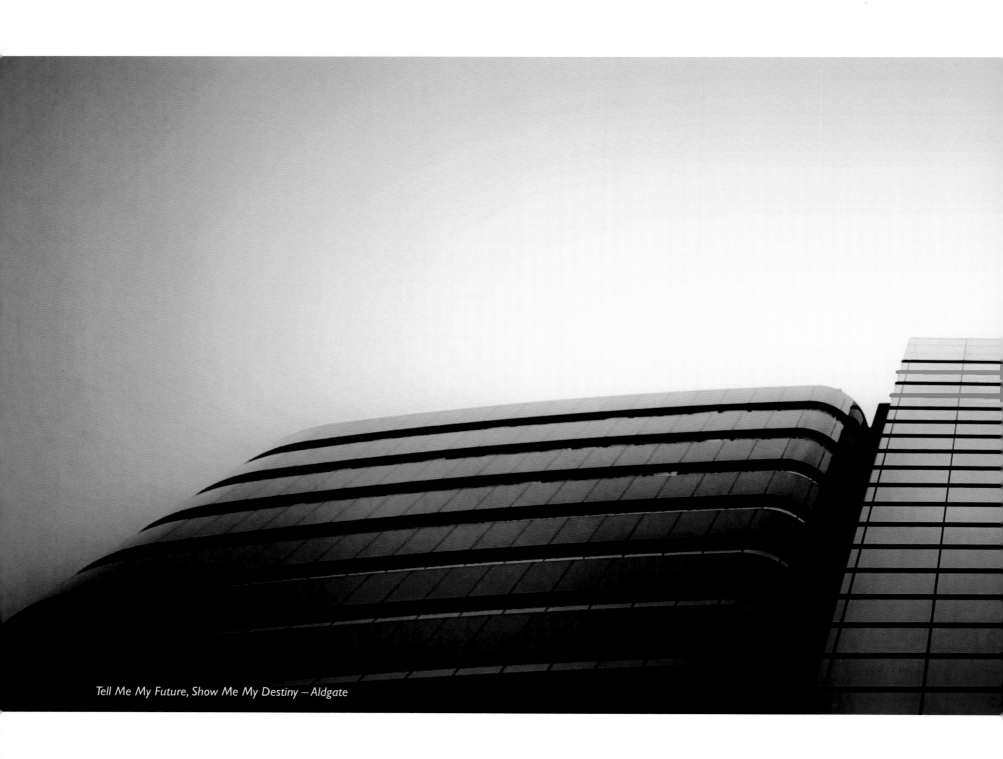

Tell Me My Future, Show Me My Destiny — Aldgate

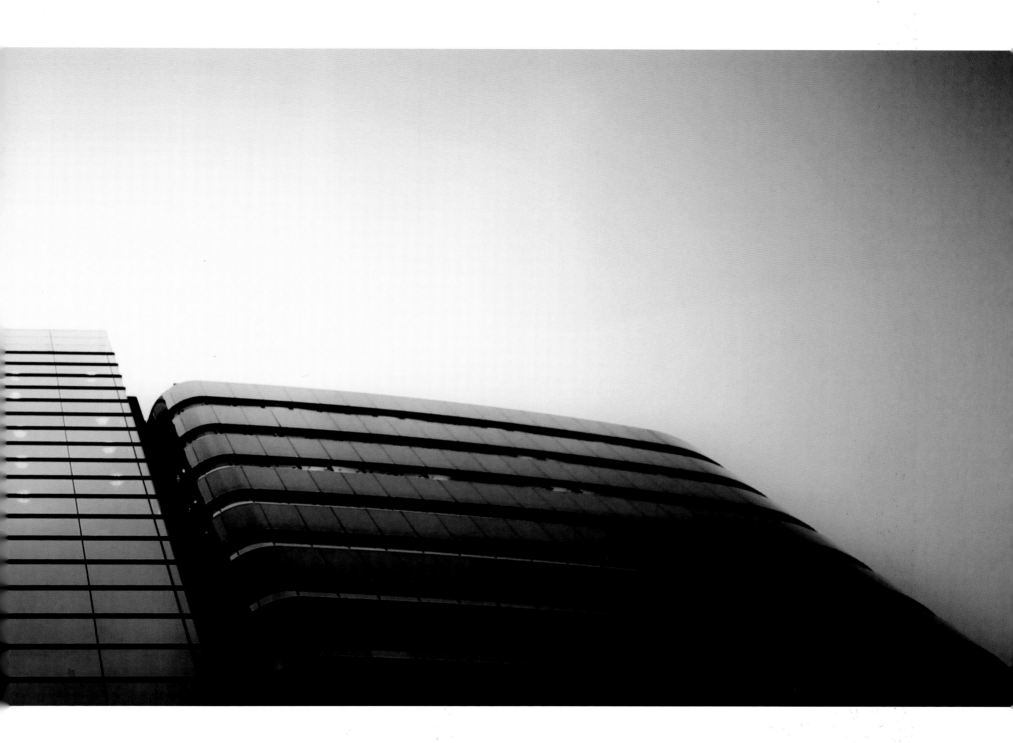

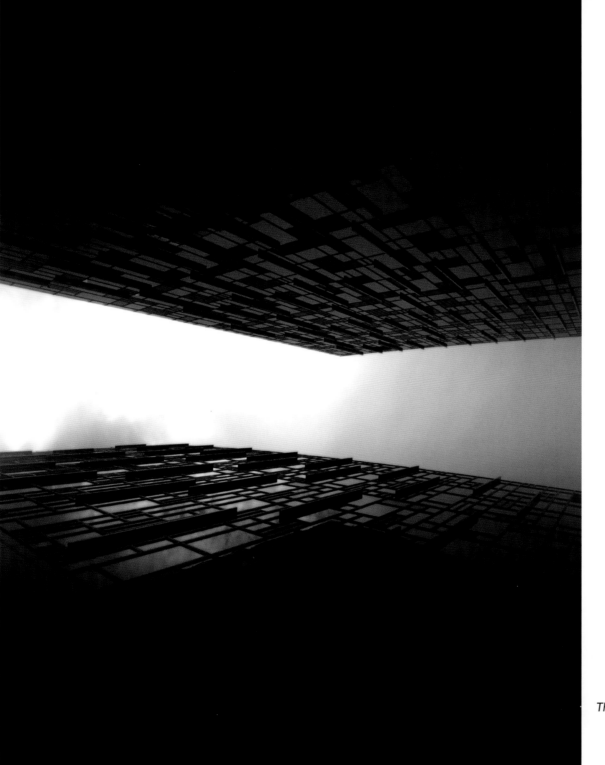

The Borg Cubes – O2 North Greenwich

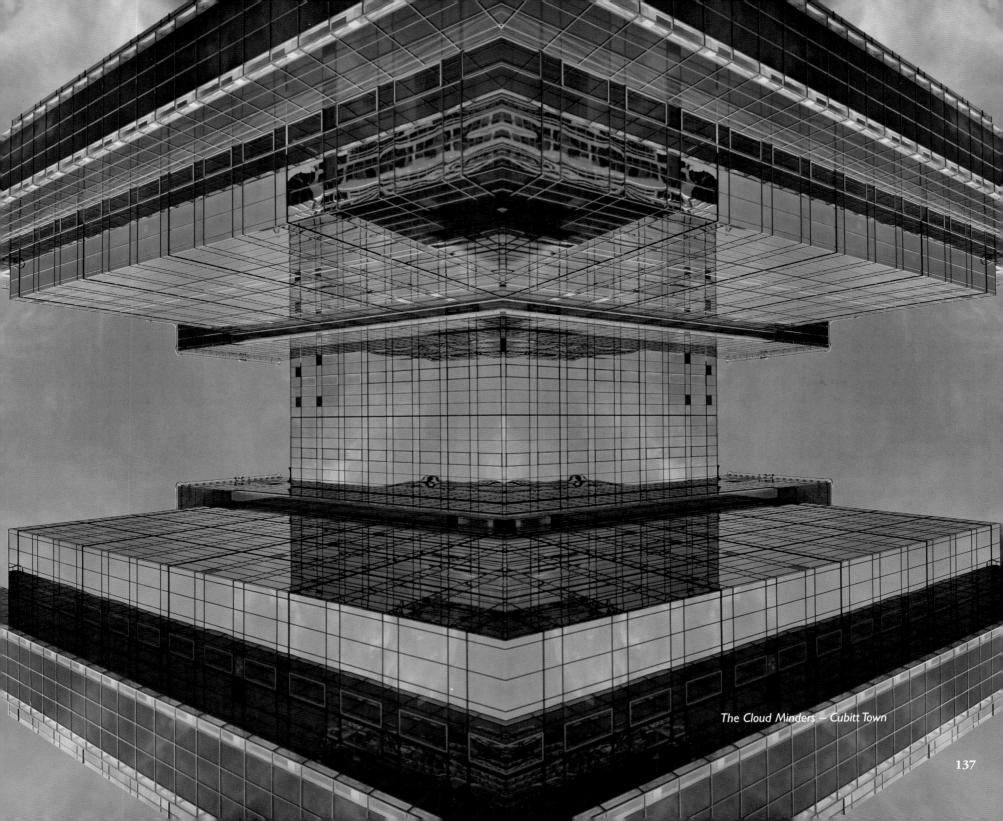

The Cloud Minders — Cubitt Town

137

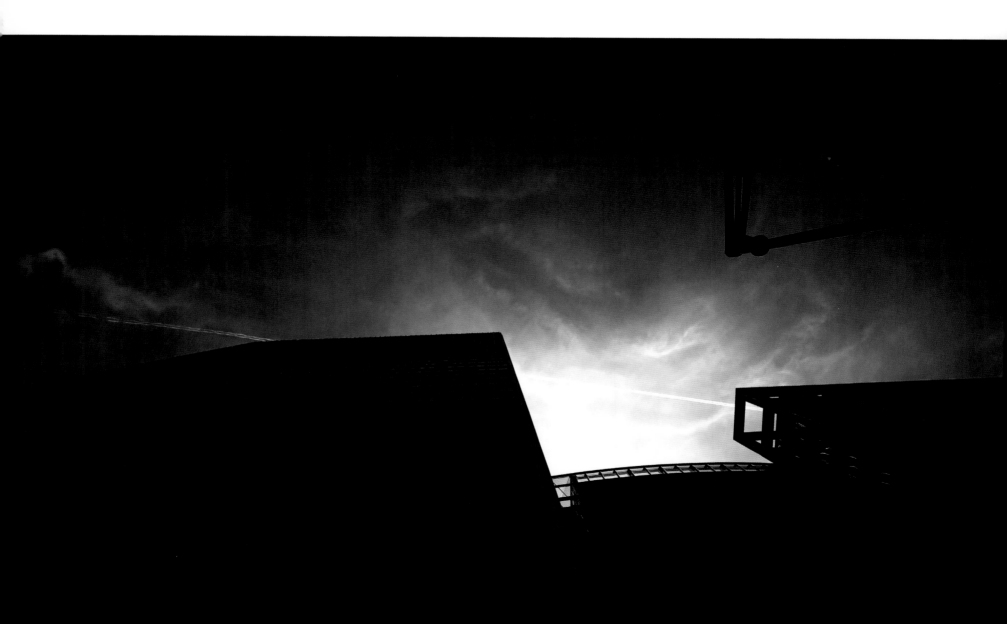

The Dawn Of Man – Canary Wharf

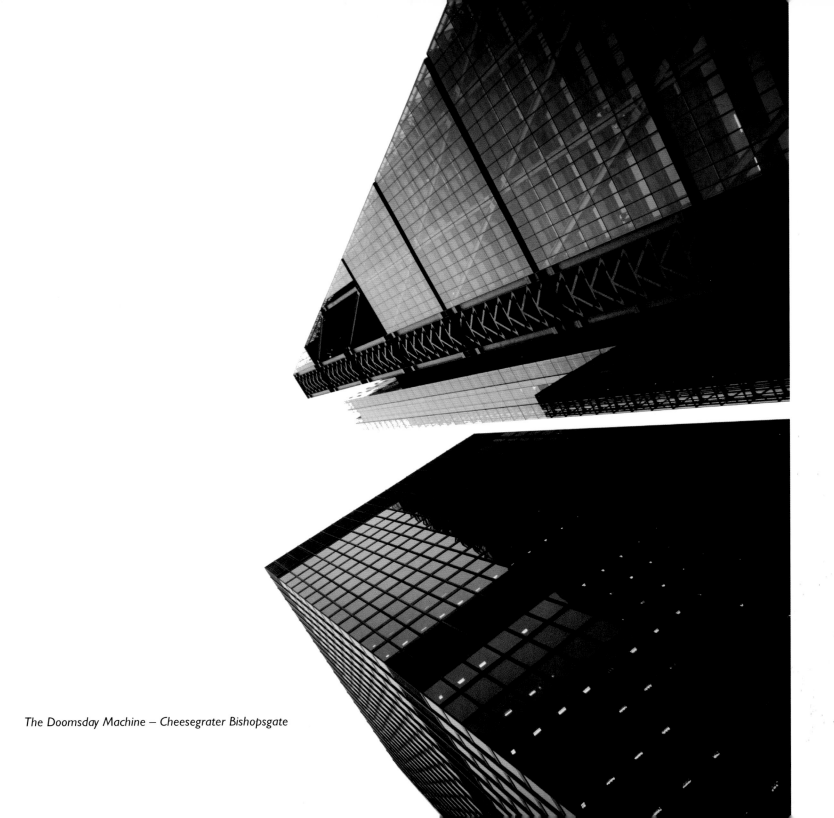

The Doomsday Machine – Cheesegrater Bishopsgate

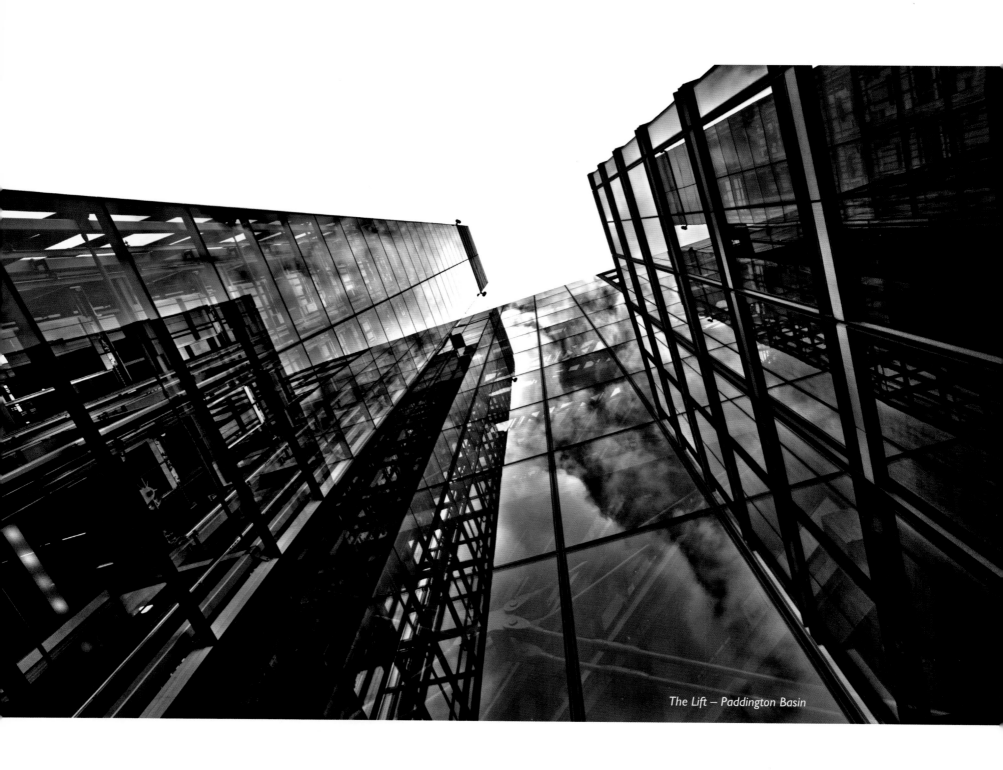

The Lift – Paddington Basin

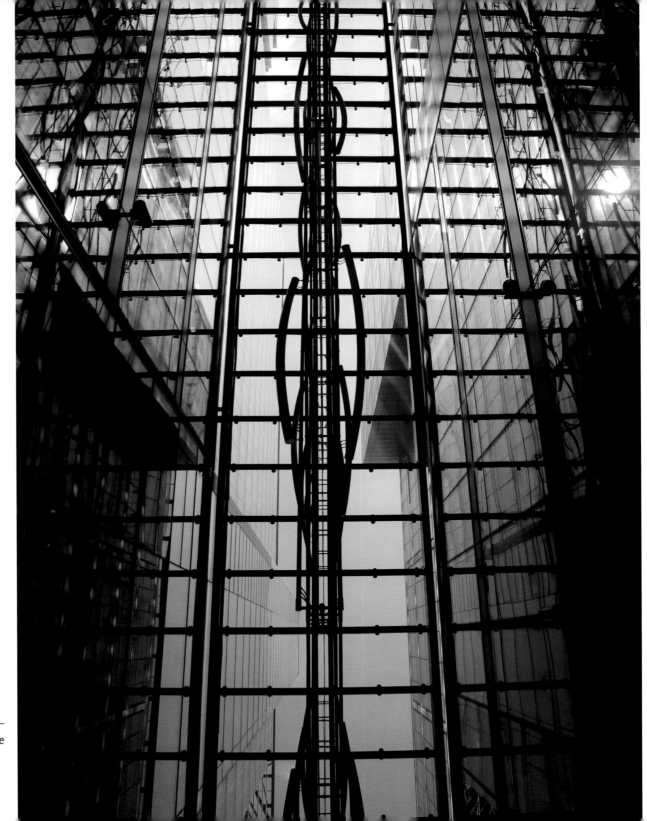

The Lines Are Drawn –
New Street Square

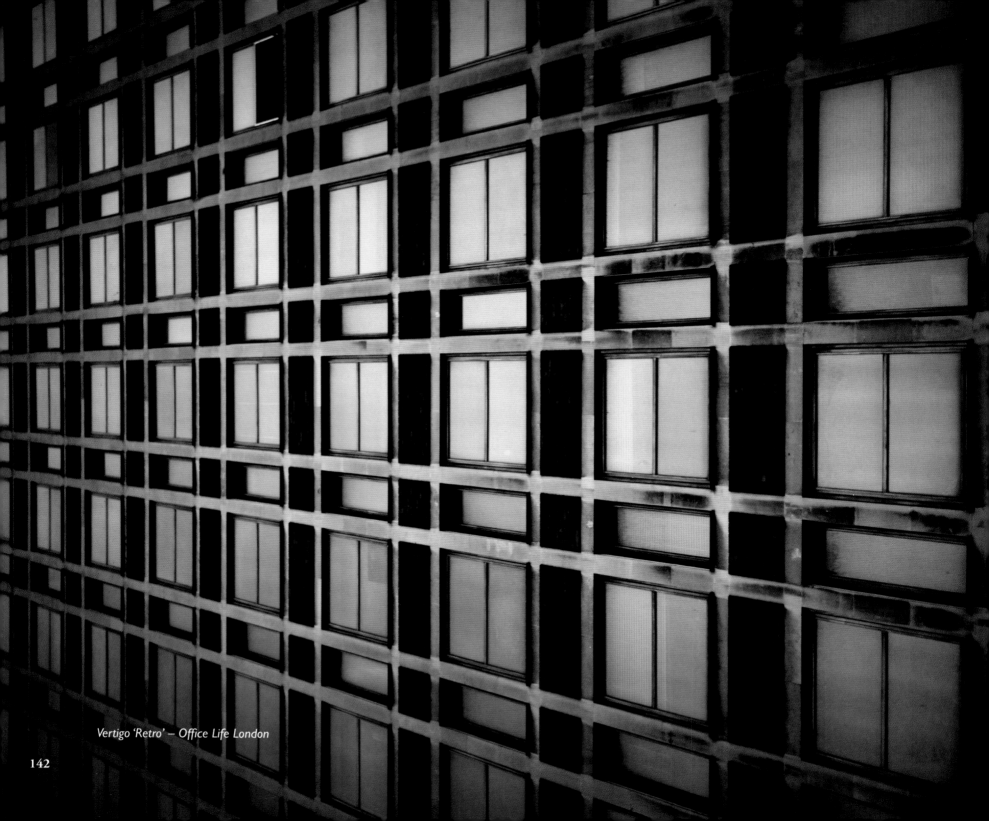

Vertigo 'Retro' – Office Life London

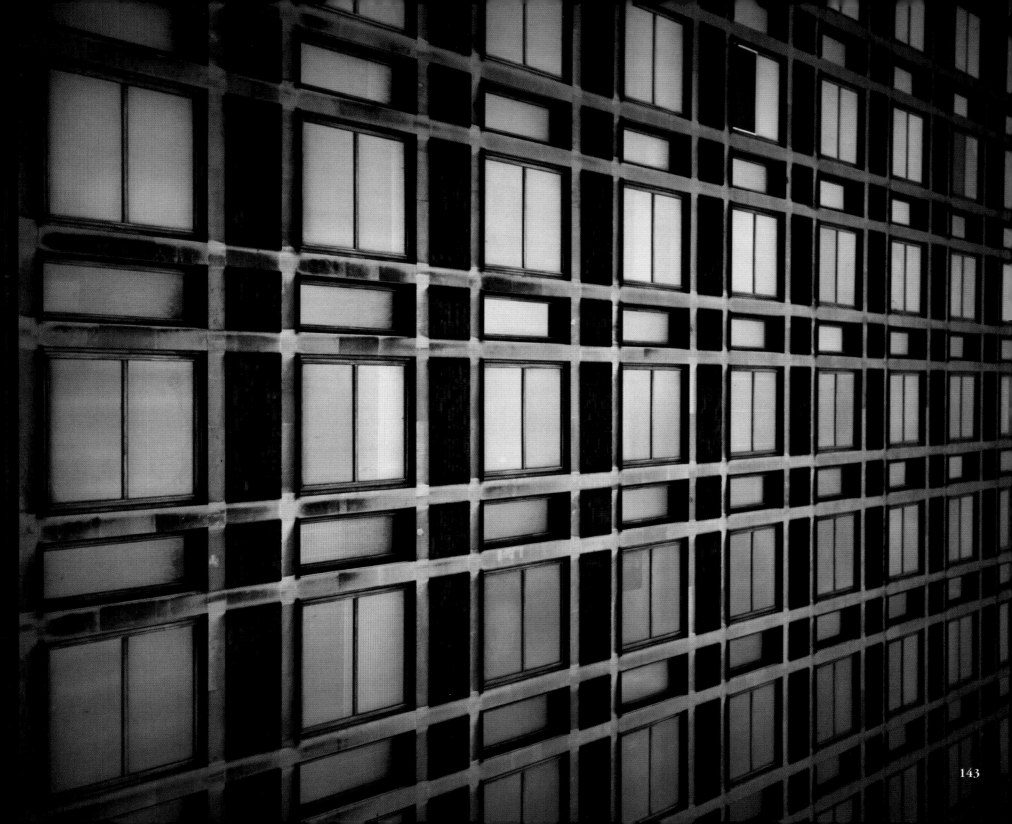

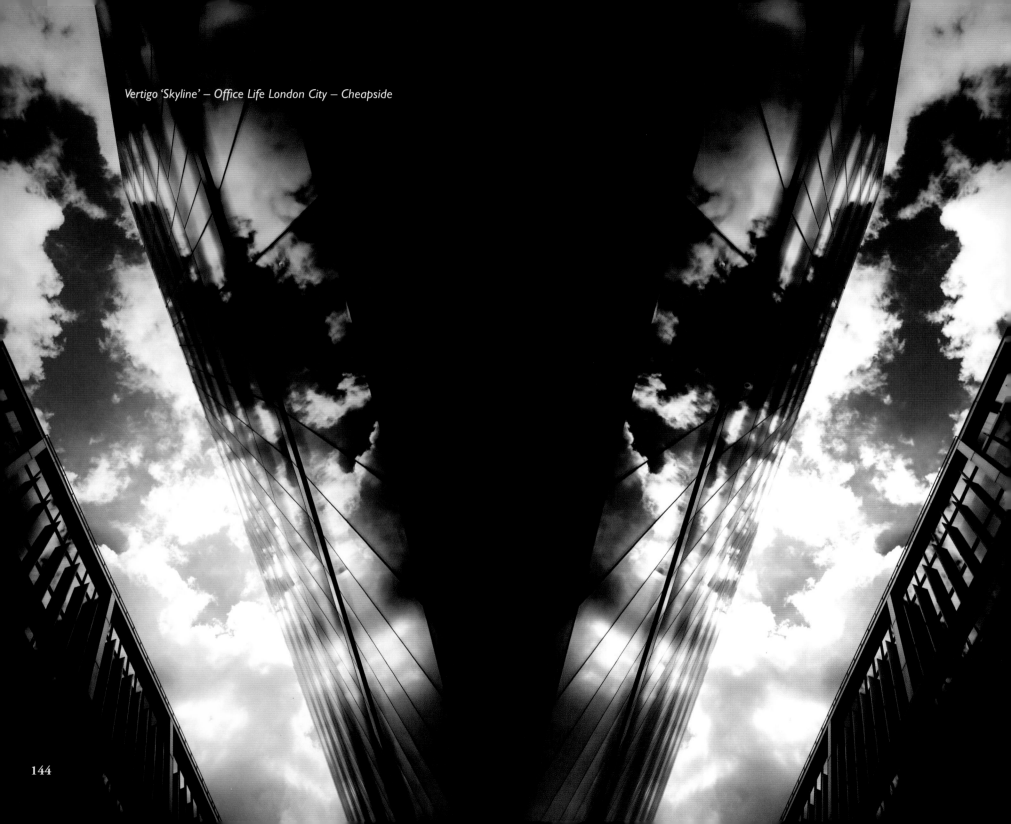

Vertigo 'Skyline' – Office Life London City – Cheapside

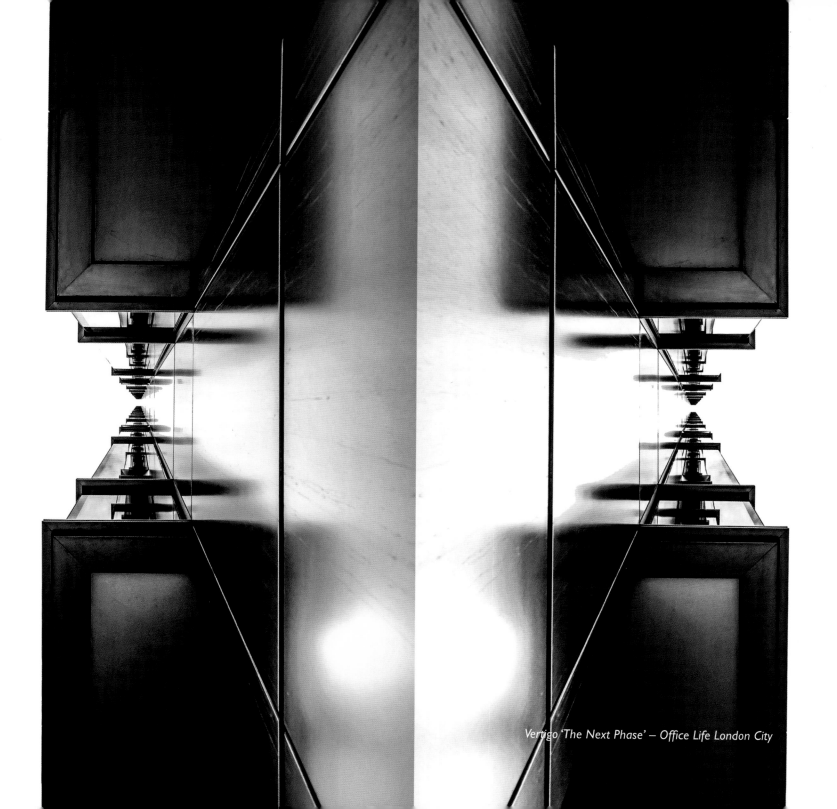

Vertigo 'The Next Phase' – Office Life London City

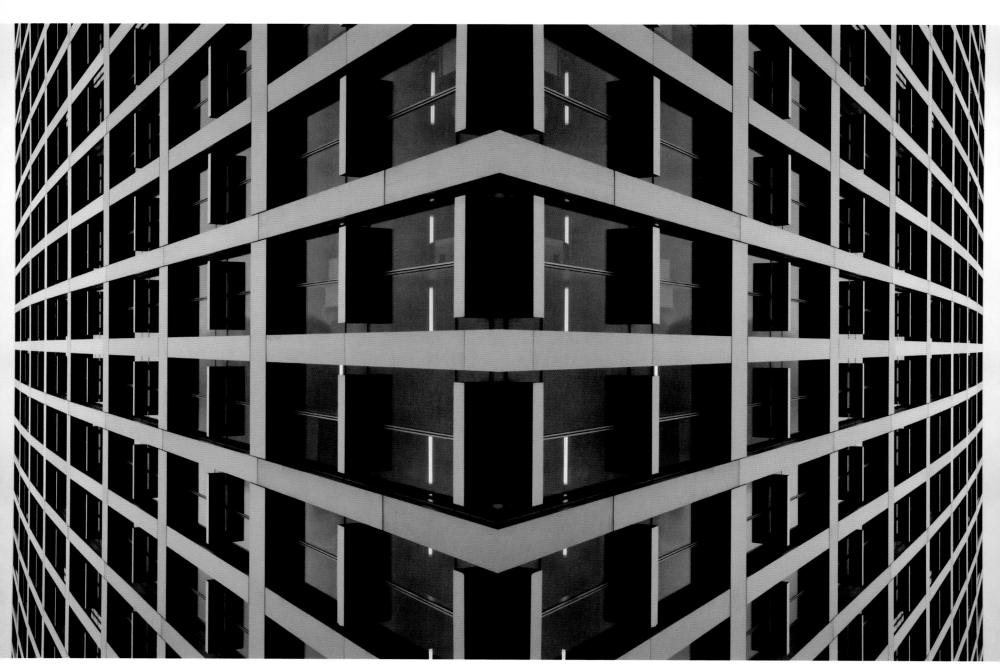

Vertigo 'Visage' — Office Life London City — London Wall

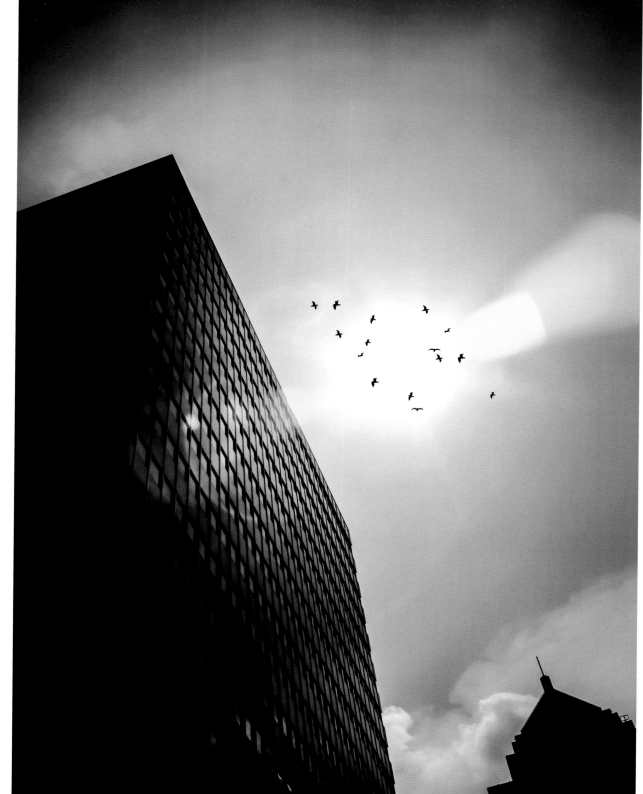

Vultures Circling – London City Life

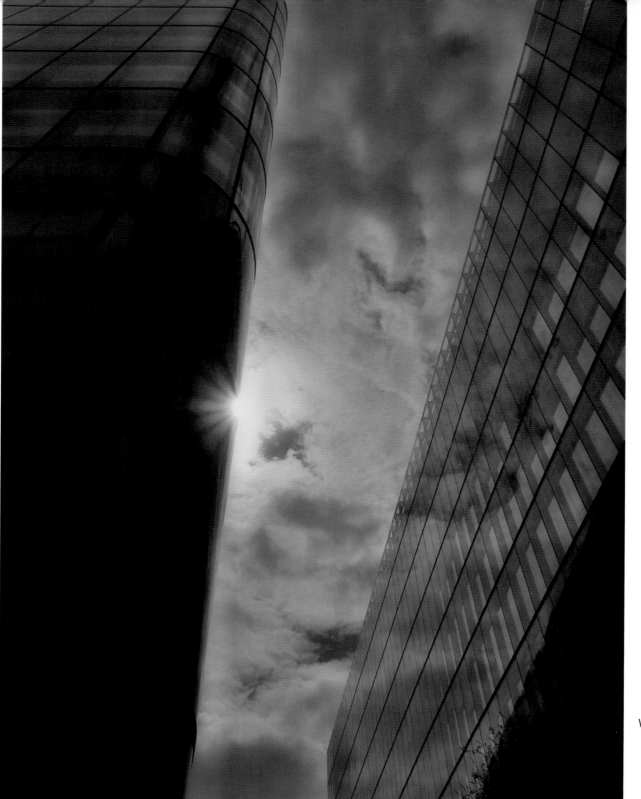

When Can I Leave – Tower Hill

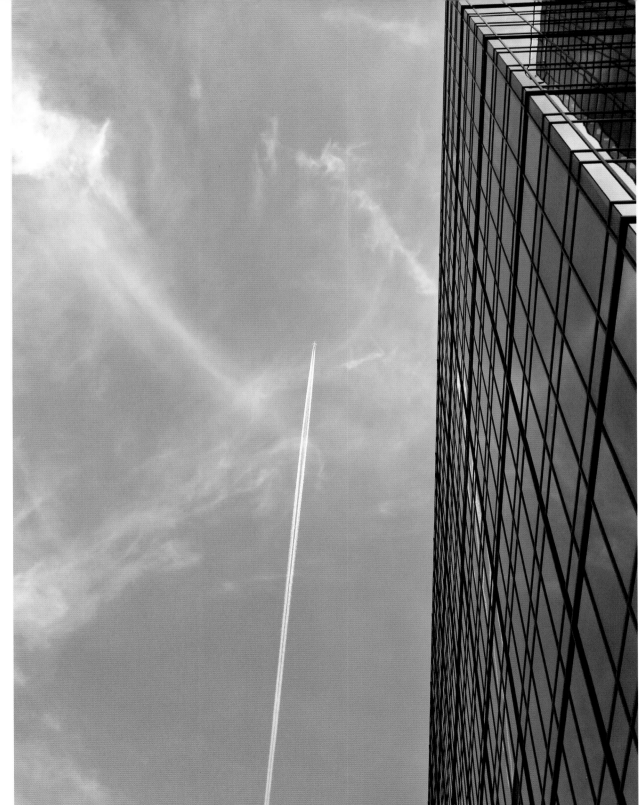

When Can I Go On Holiday
— Cubitt Town

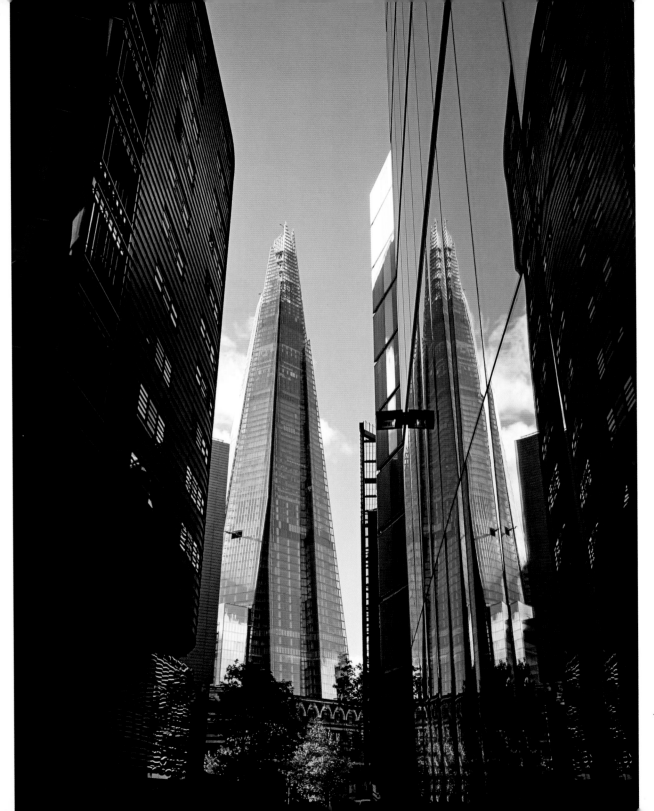

The Shard A City Reflects

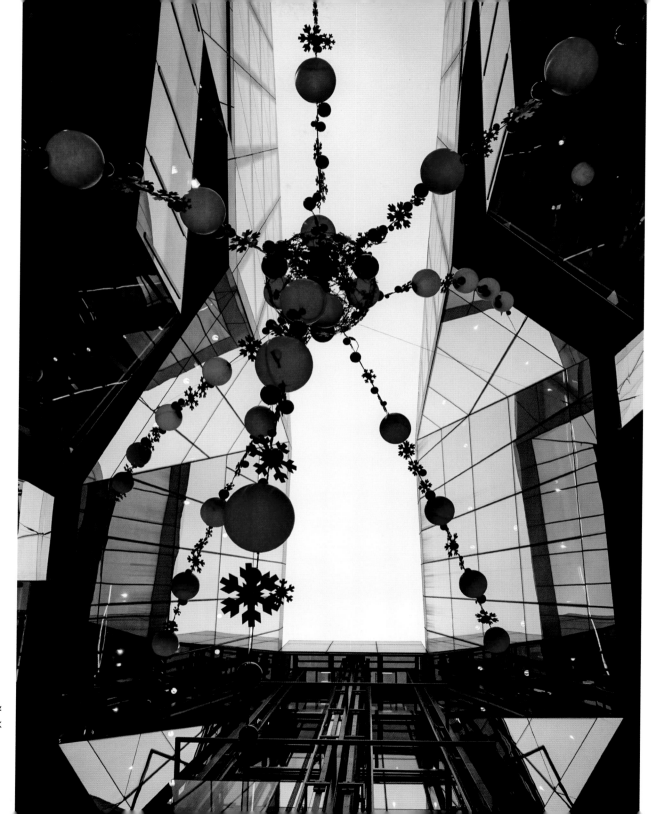

London – Architecture &
Christmas – Southwark

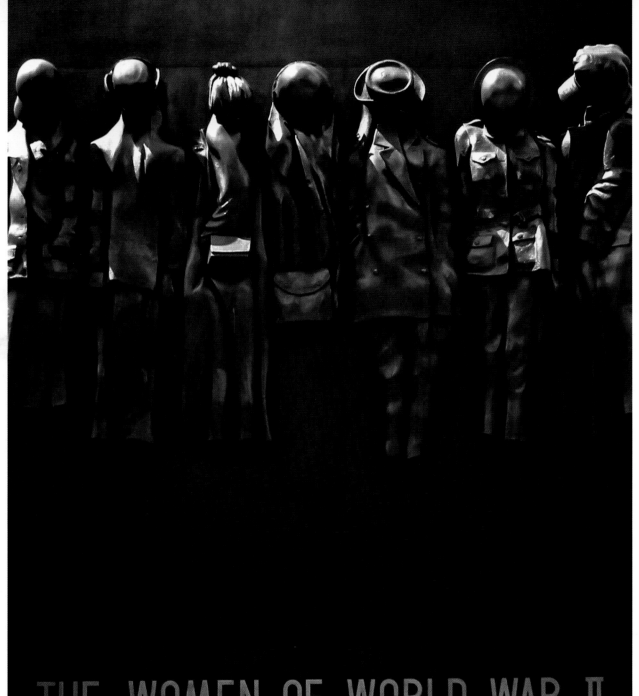

THE WOMEN OF WORLD WAR II

*The National Monument to the
Women of Worls War II*

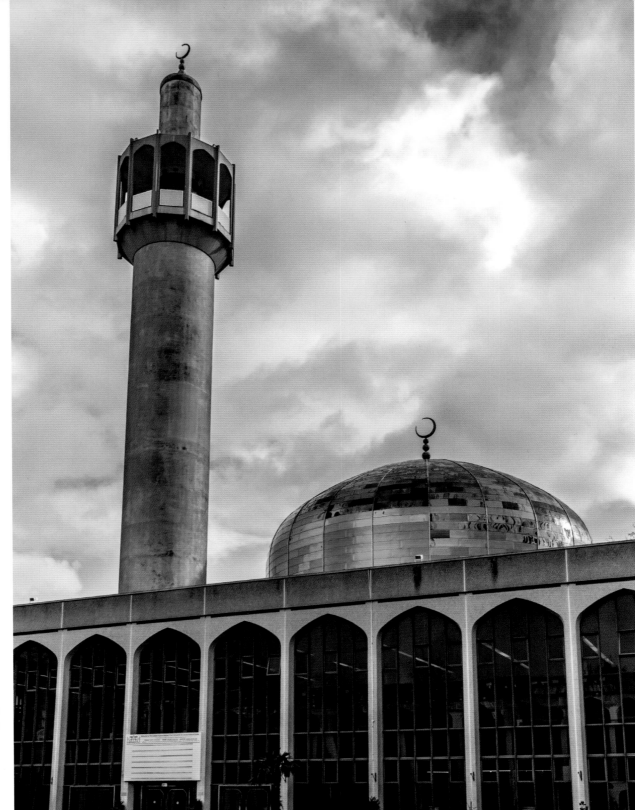

London Central Mosque aka
Regent's Park Mosque

Duck Heaven — Welcome To Chinatown Resturants

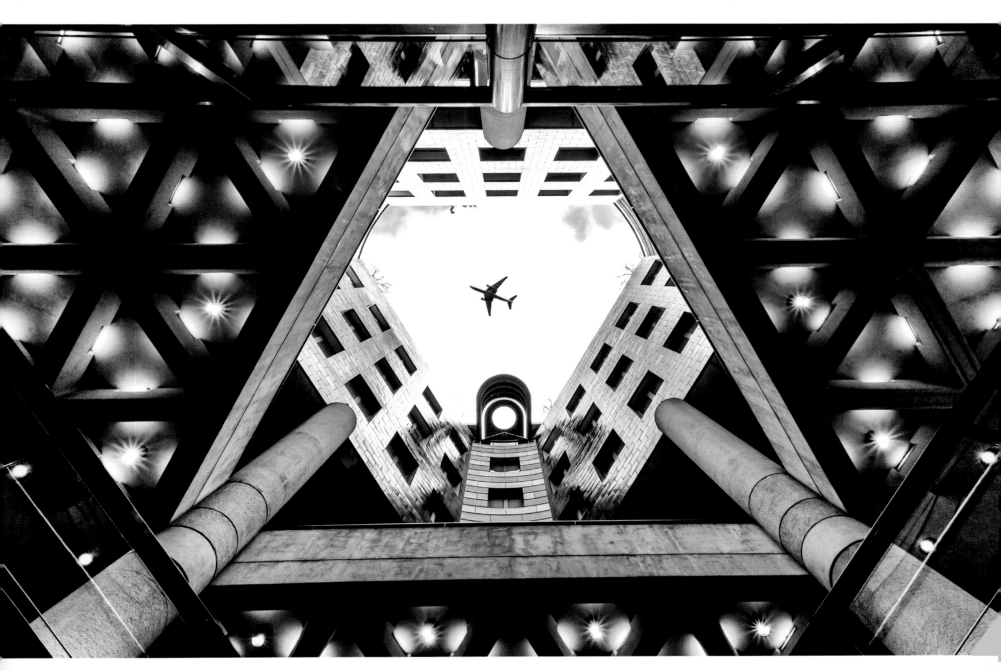

Miracles May Happen But Nothing Is Happening Yet –
London Urban City Life – No1 Poultry

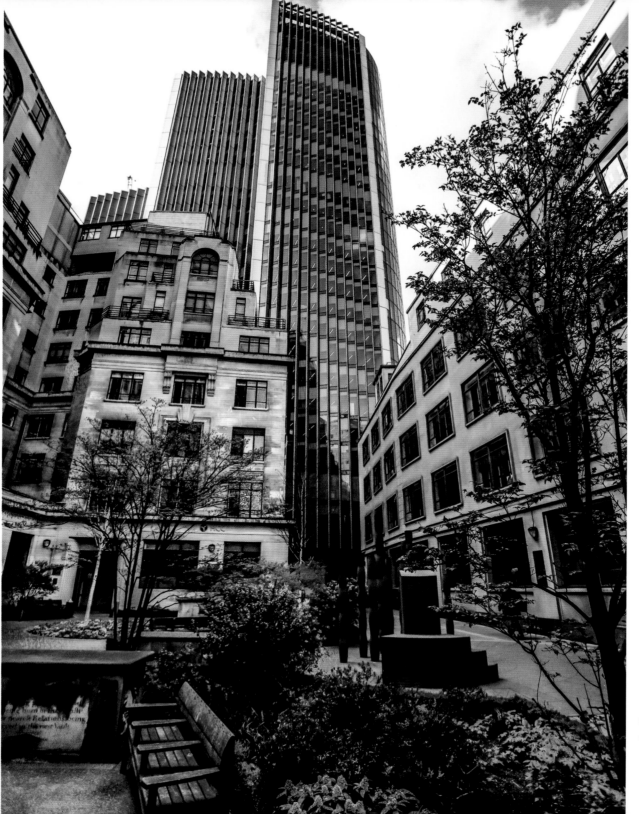

Greening The City – Fen Court
Garden & Willis Building

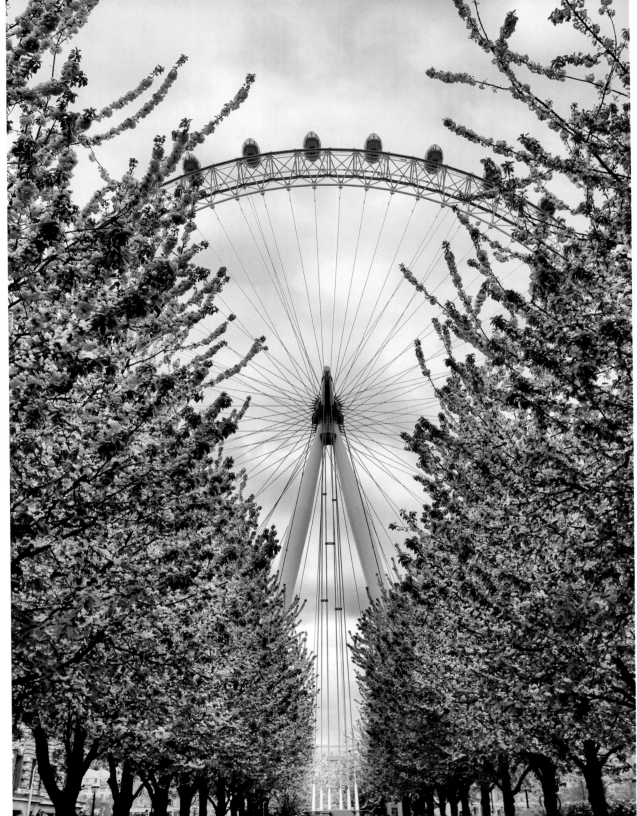

London Eye Blossom Spring

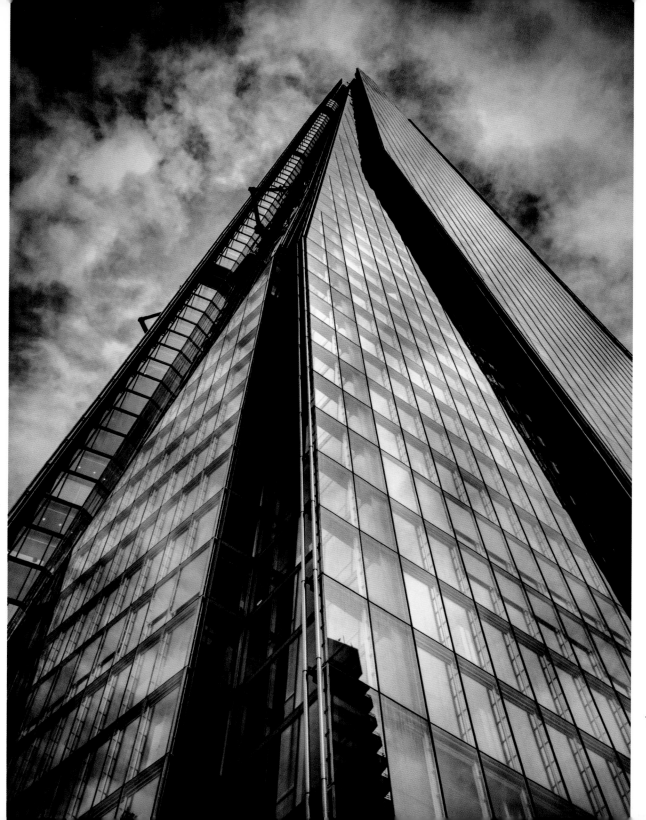

The Dark Crystal – The Shard

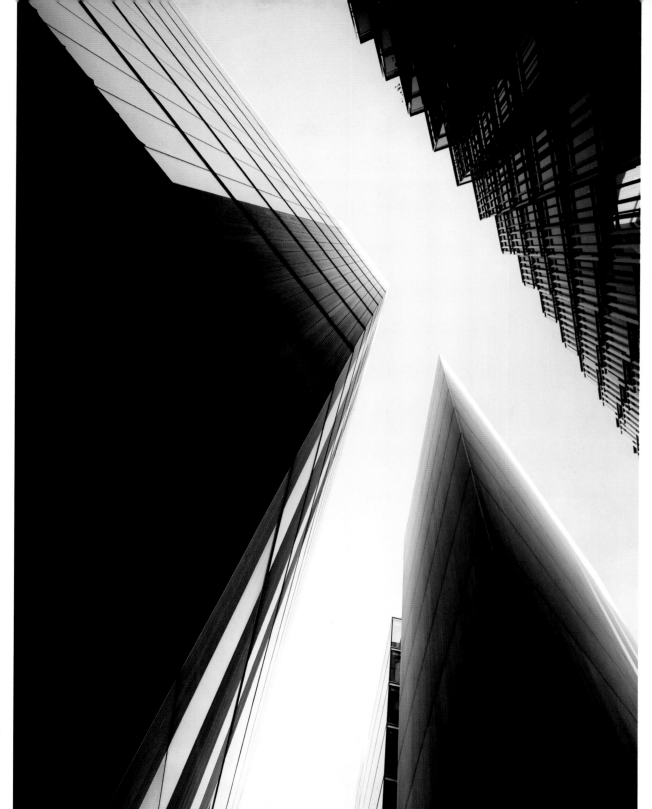

London City Life On
The Edge – The Sequel

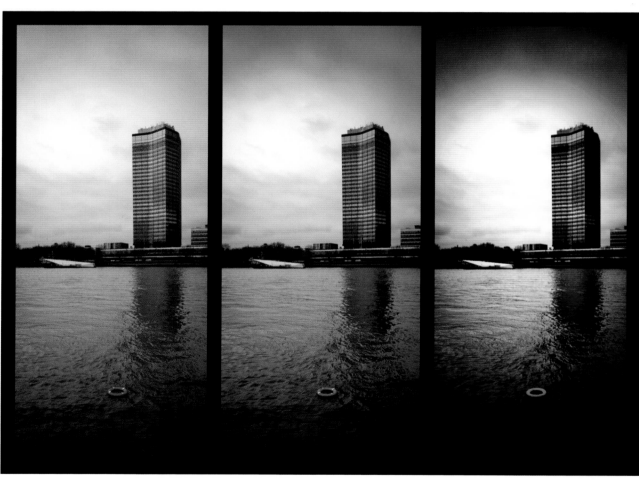

Millbank Tower Trilogy

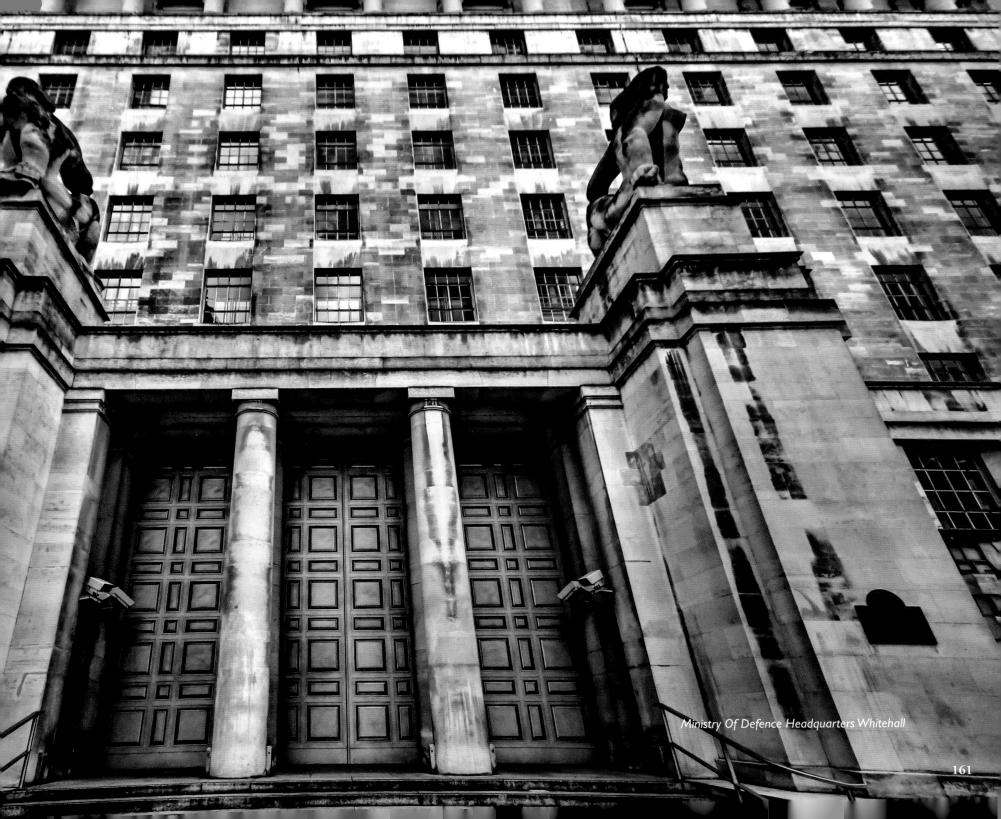

Ministry Of Defence Headquarters Whitehall

161

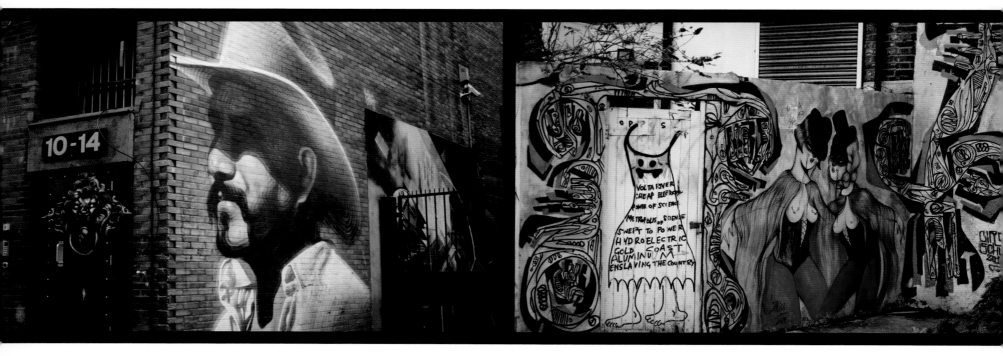

On The Wall – Shoreditch Street Art

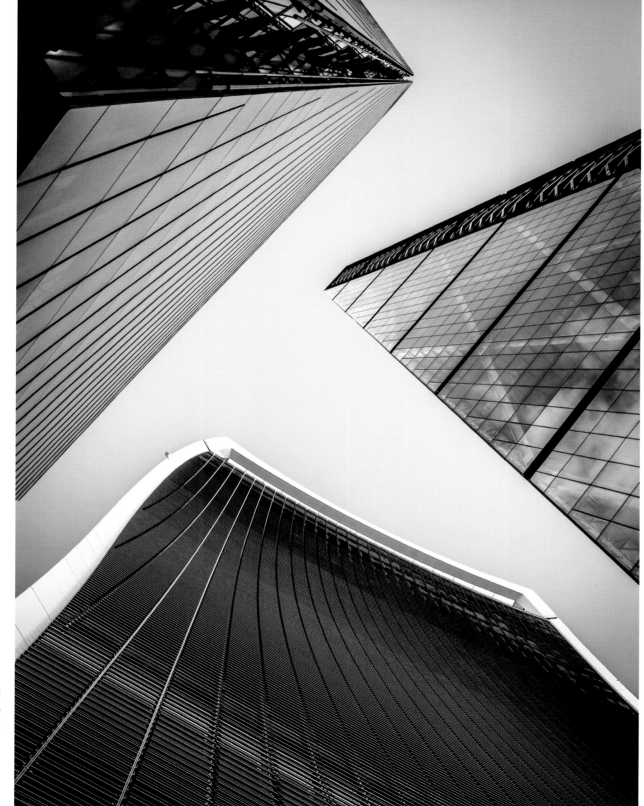

*Shape Of The Future – London
City Life (The Shard, The Walkie
Talkie & The Cheesegrater)*

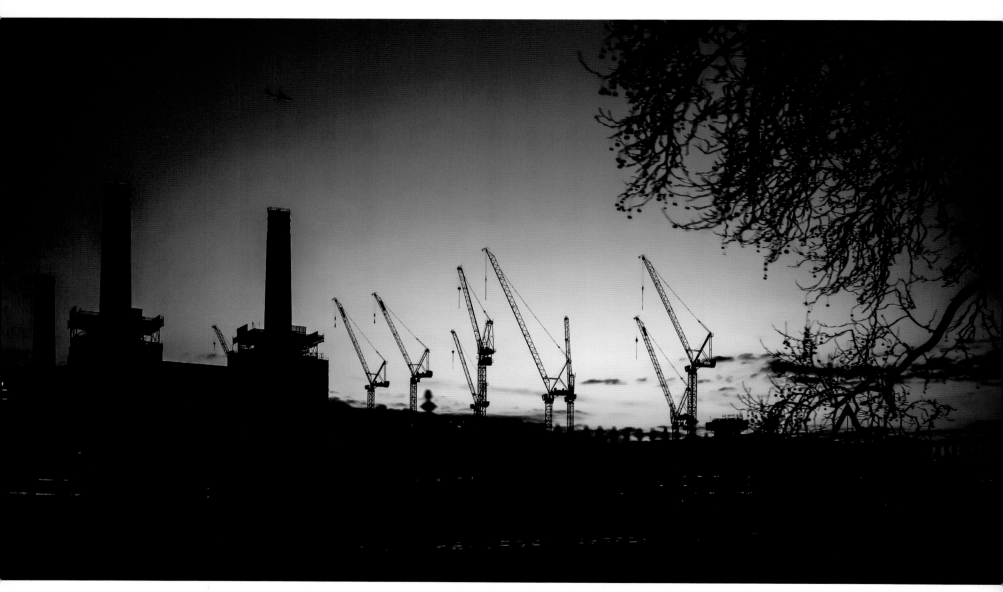

Sunset On Battersea Power Station —
Restoring A London Icon

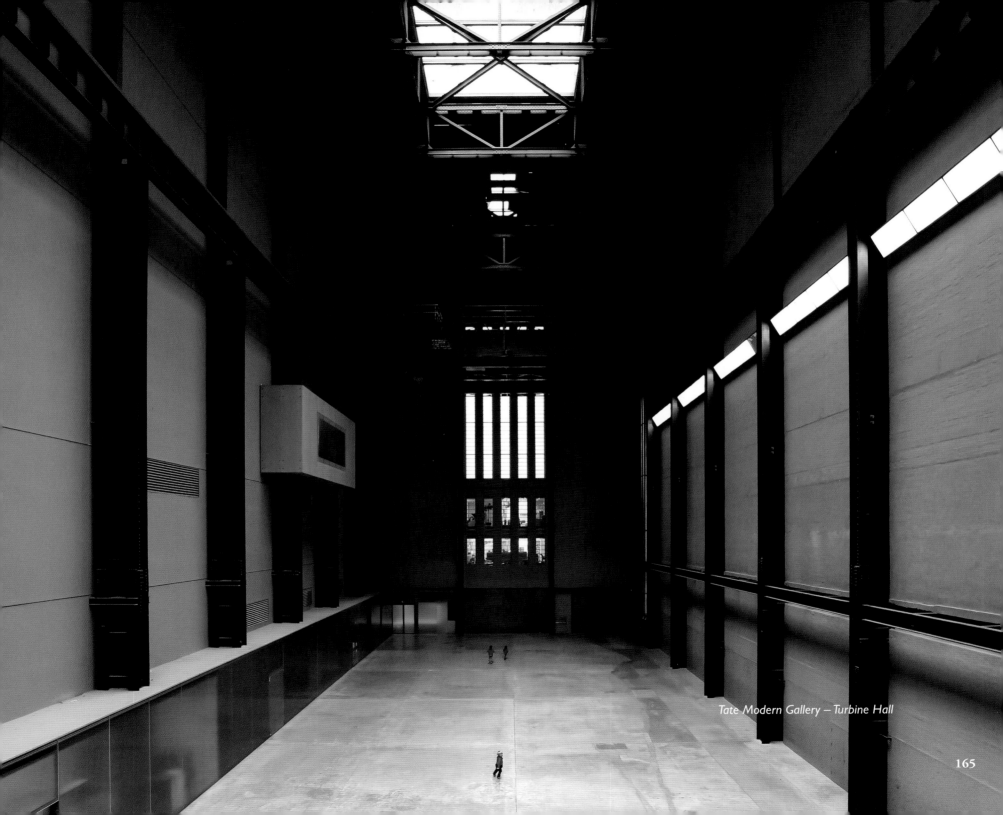

Tate Modern Gallery – Turbine Hall

165

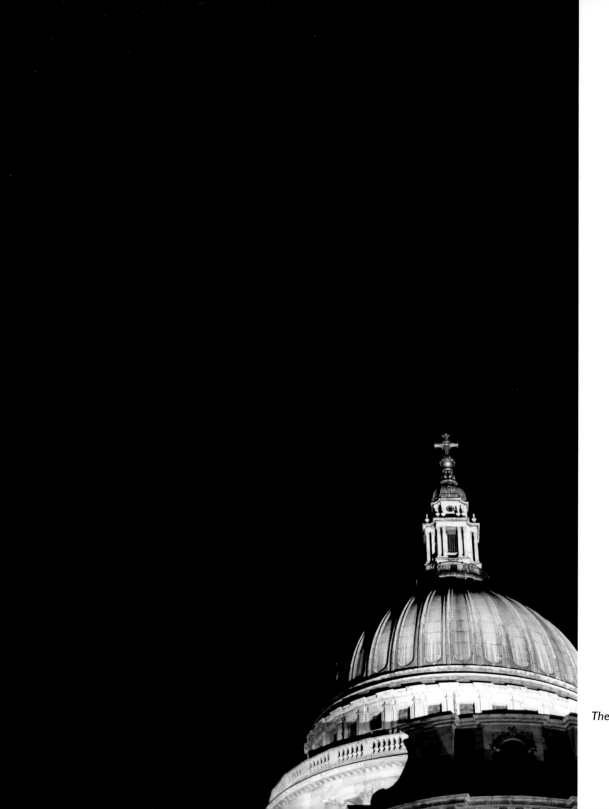

The Dome St Paul's Cathedral

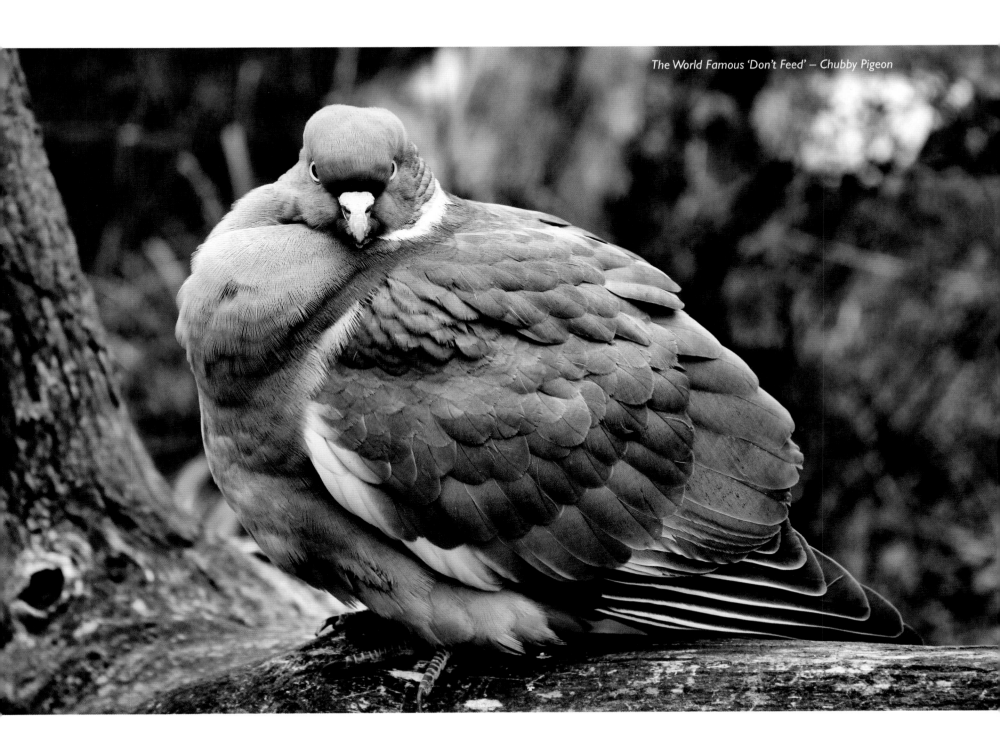

The World Famous 'Don't Feed' – Chubby Pigeon

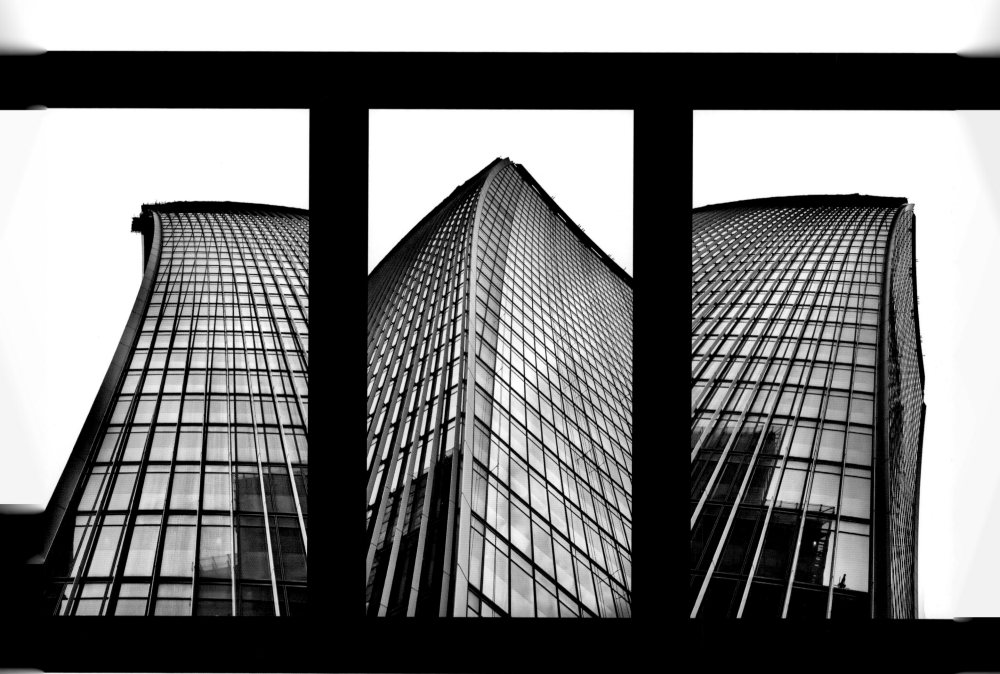

All Over Curves — Walkie Talkie

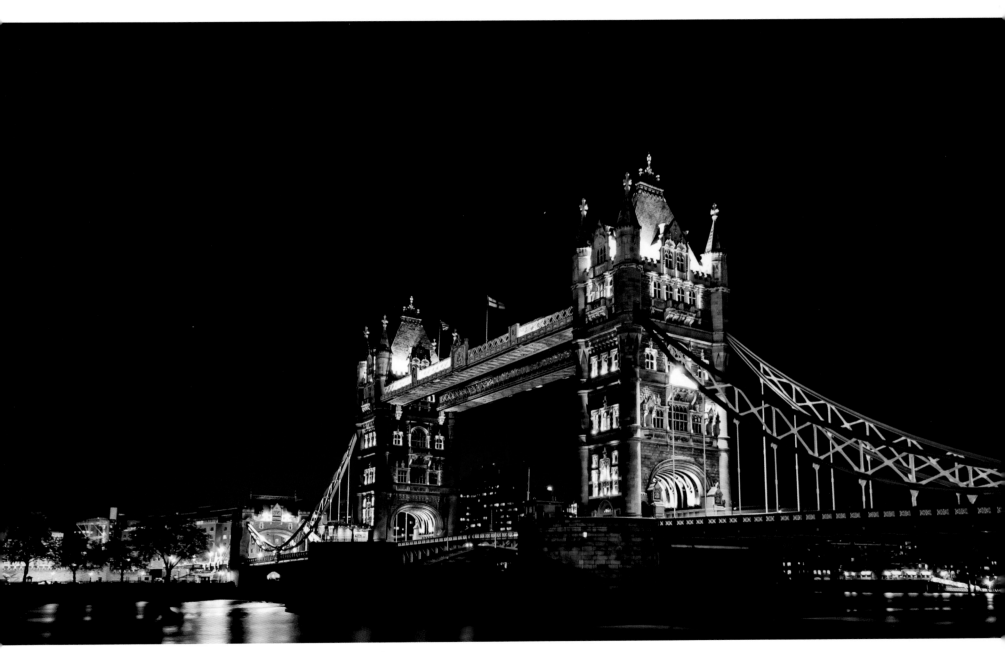

Tower Bridge Night Lights

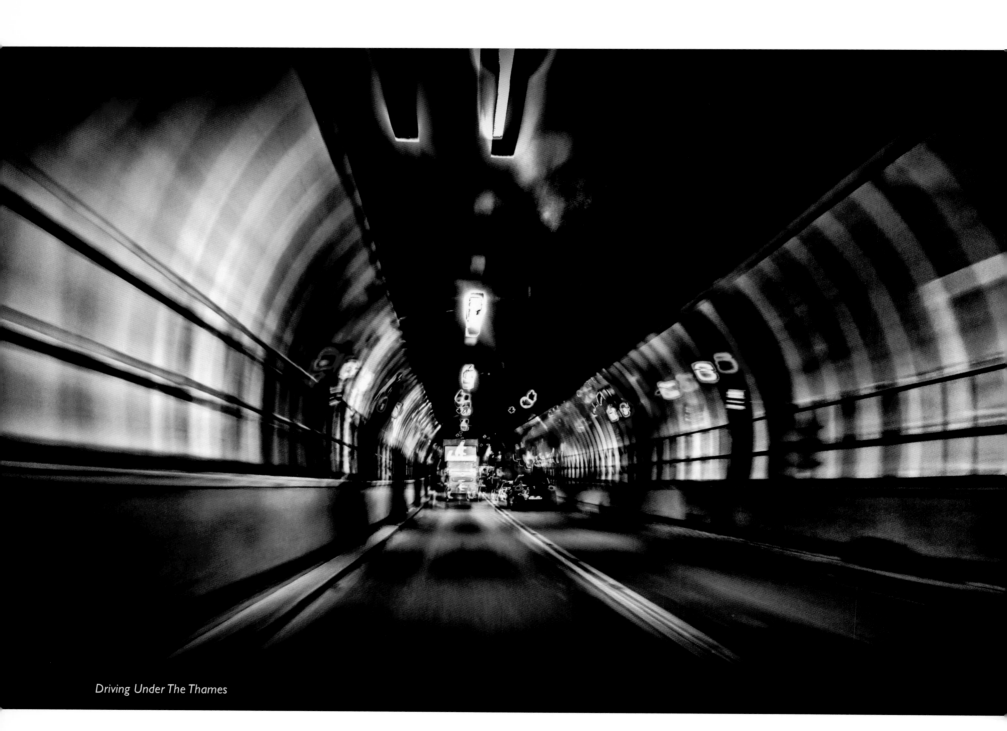

Driving Under The Thames

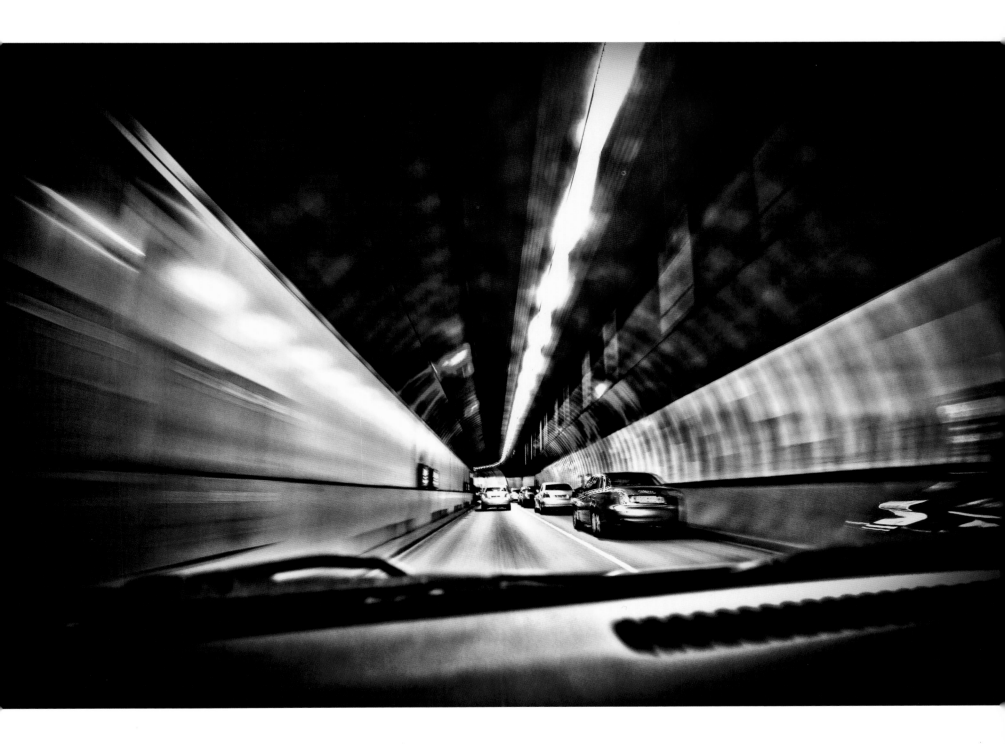

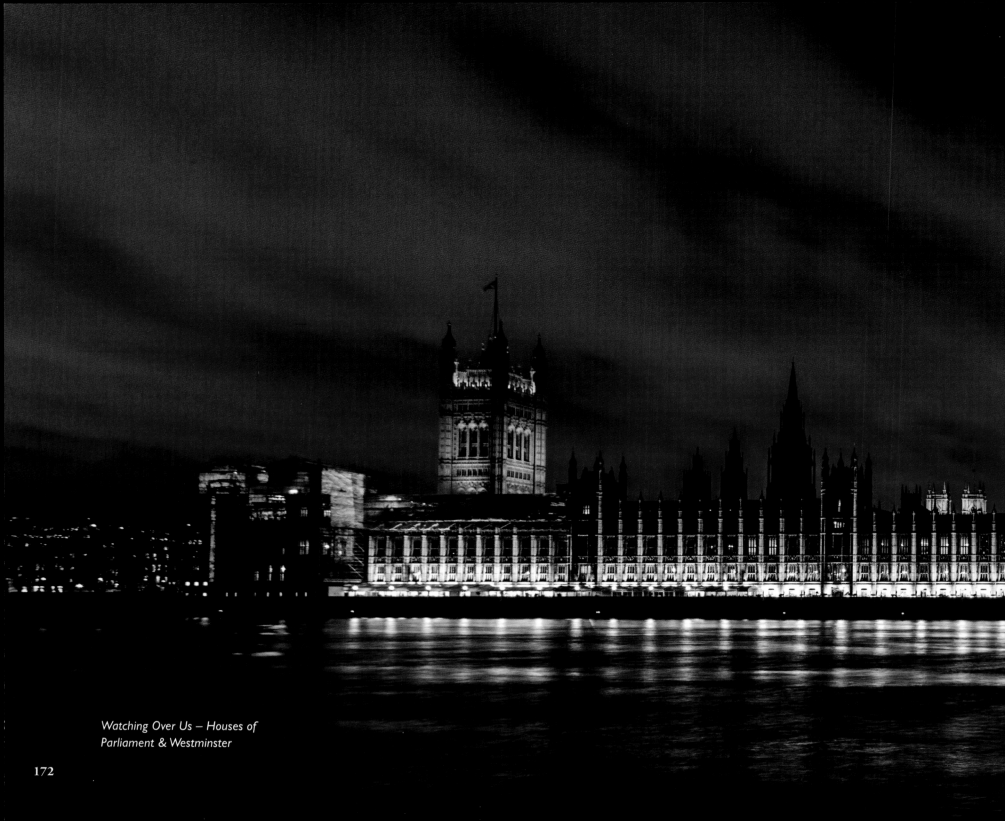

*Watching Over Us – Houses of
Parliament & Westminster*

172

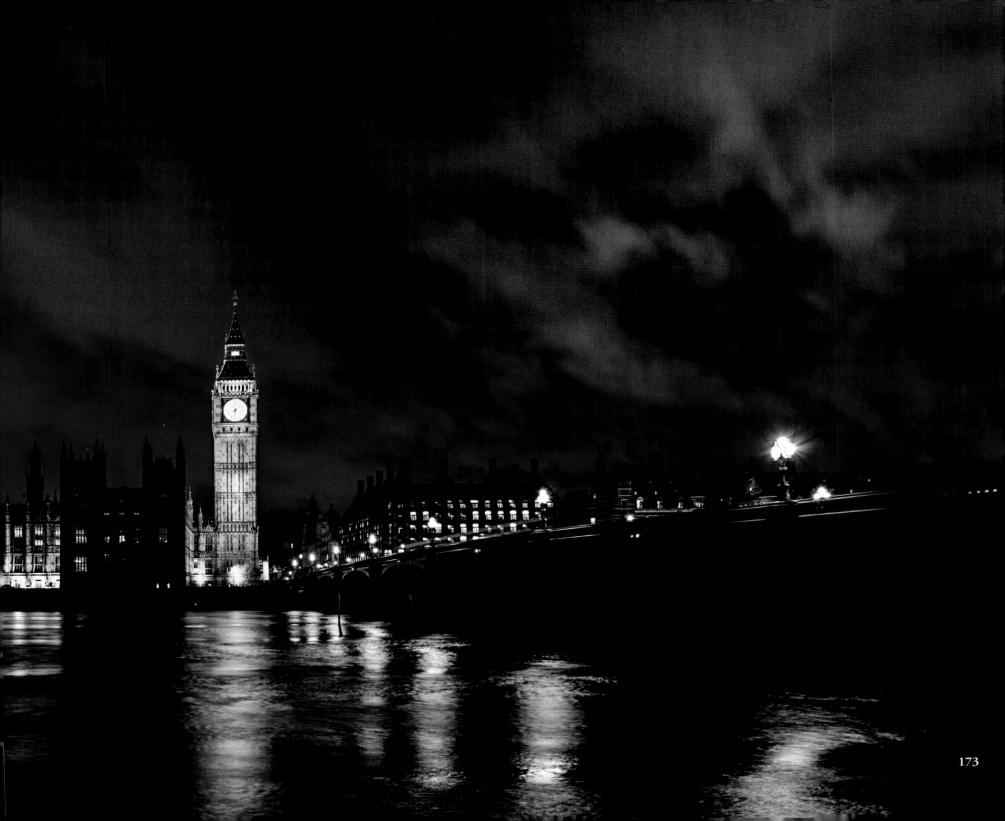

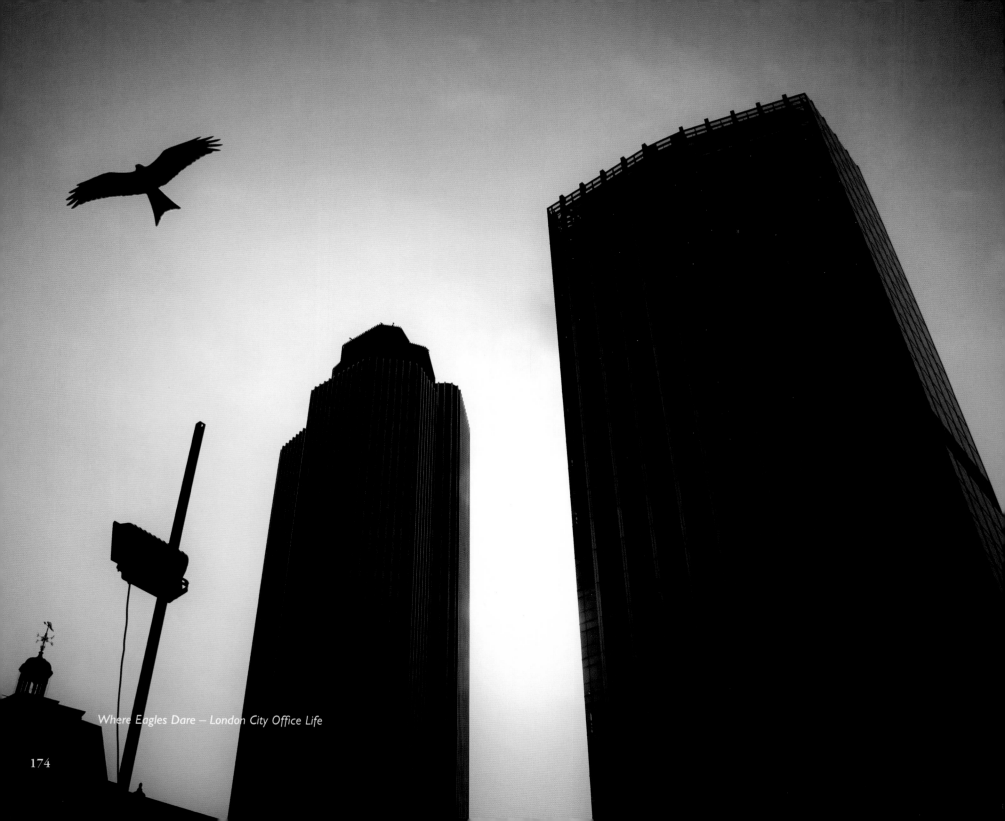

Where Eagles Dare – London City Office Life

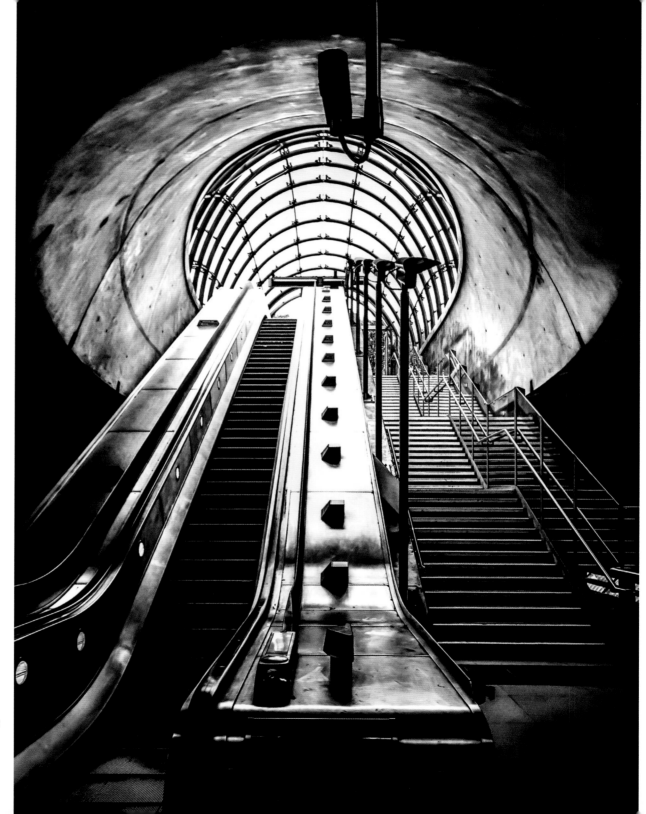

Another Canary Wharf Entrance

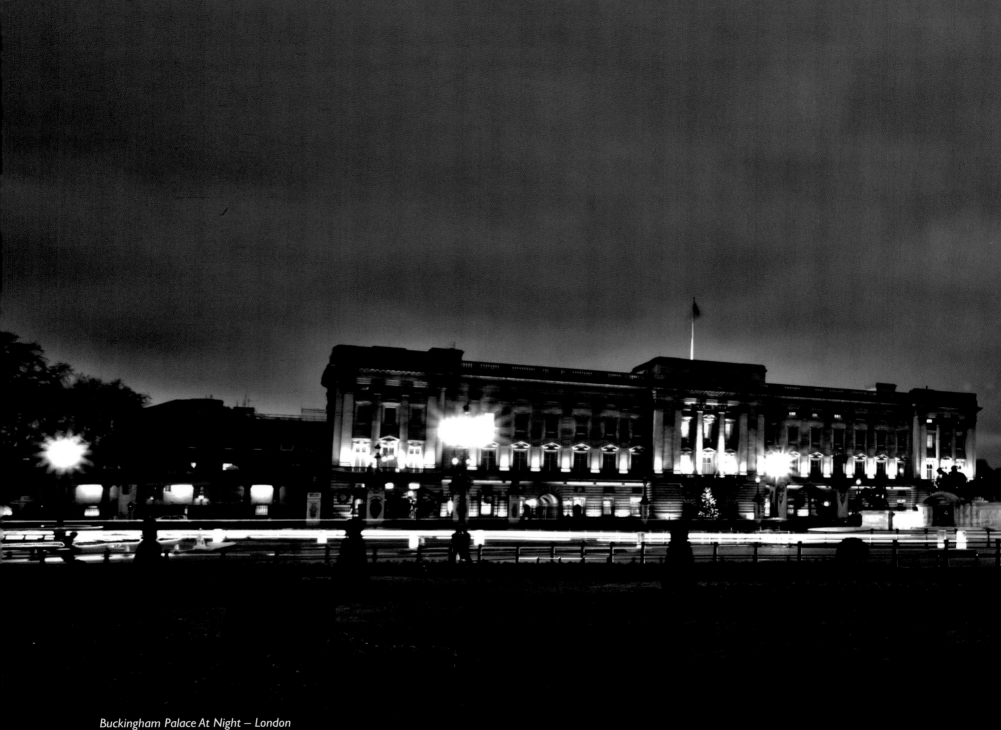

Buckingham Palace At Night – London

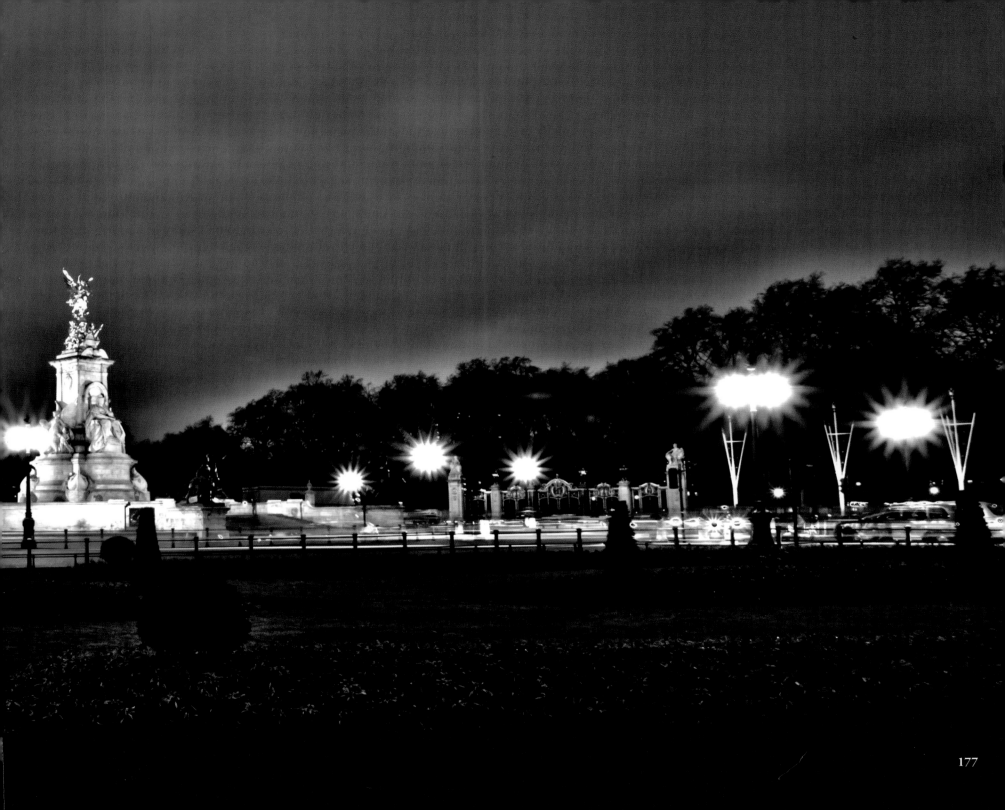

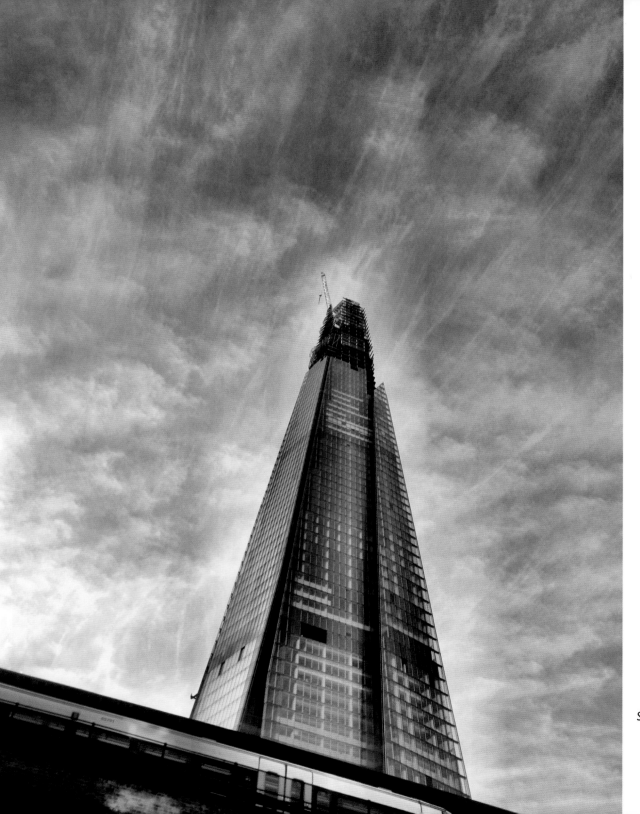

Shard Under Construction

The Congestion Charge

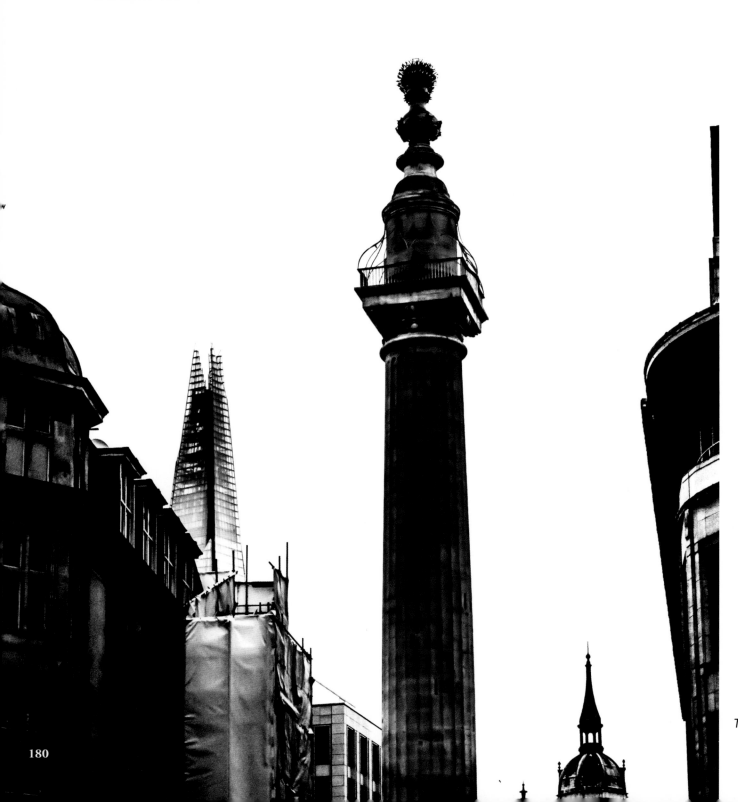

The Monument to the Great Fire

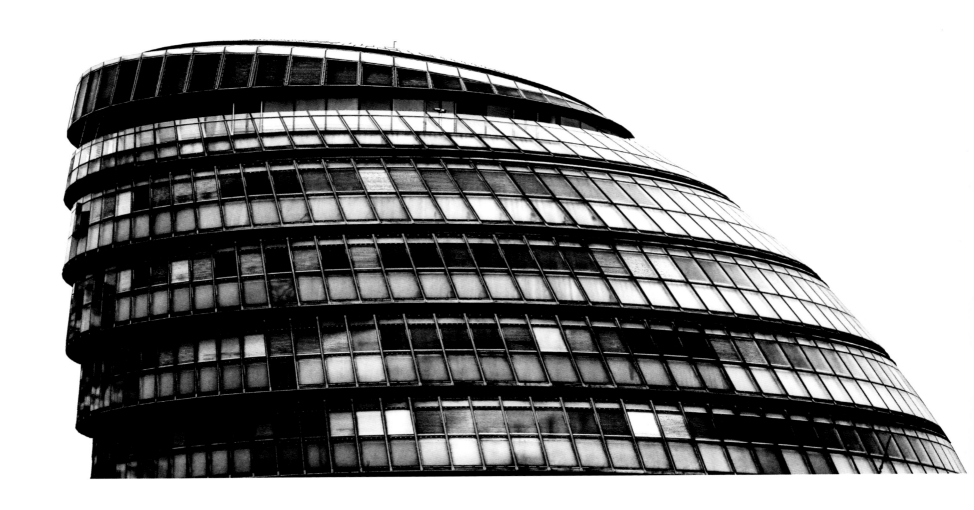

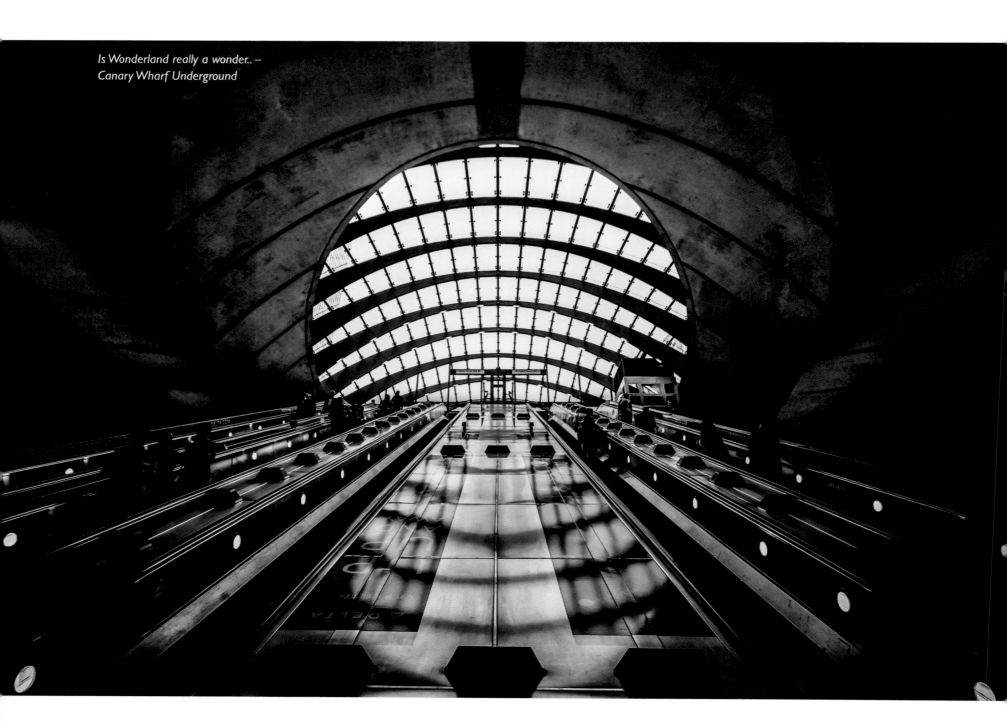

Is Wonderland really a wonder.. –
Canary Wharf Underground

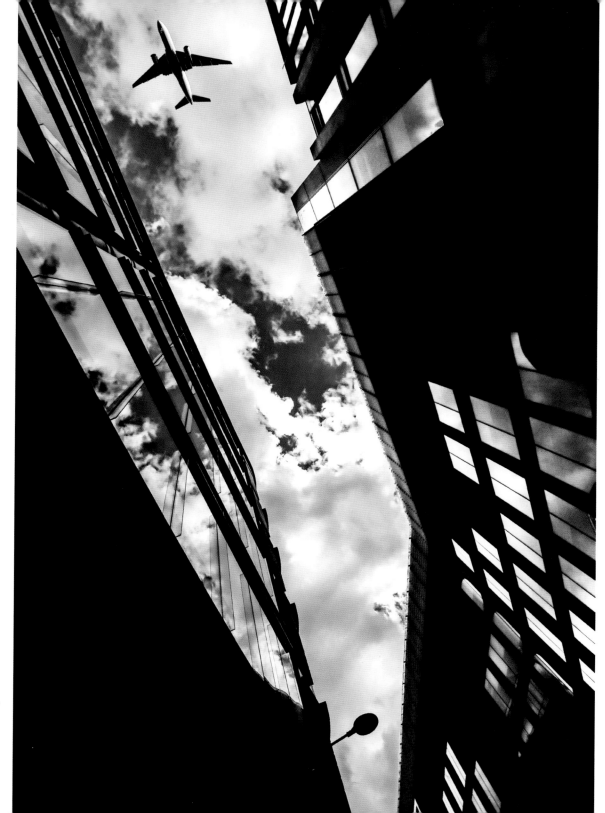

Secret Of My Success - Cheapside

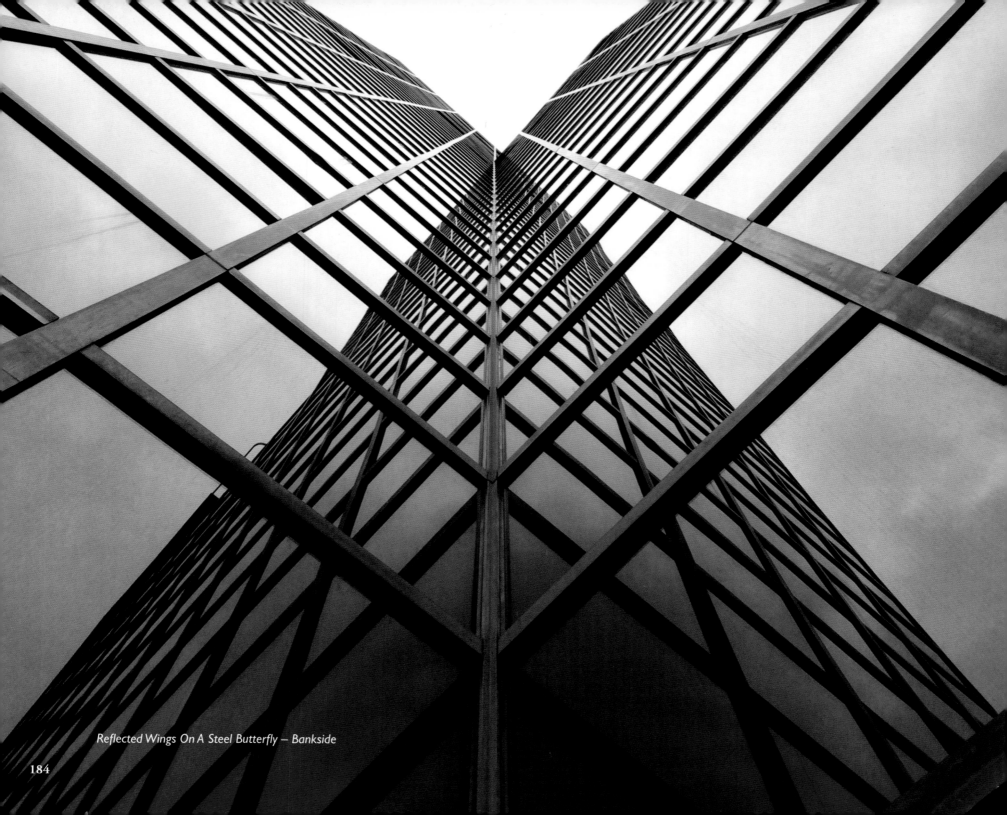

Reflected Wings On A Steel Butterfly — Bankside

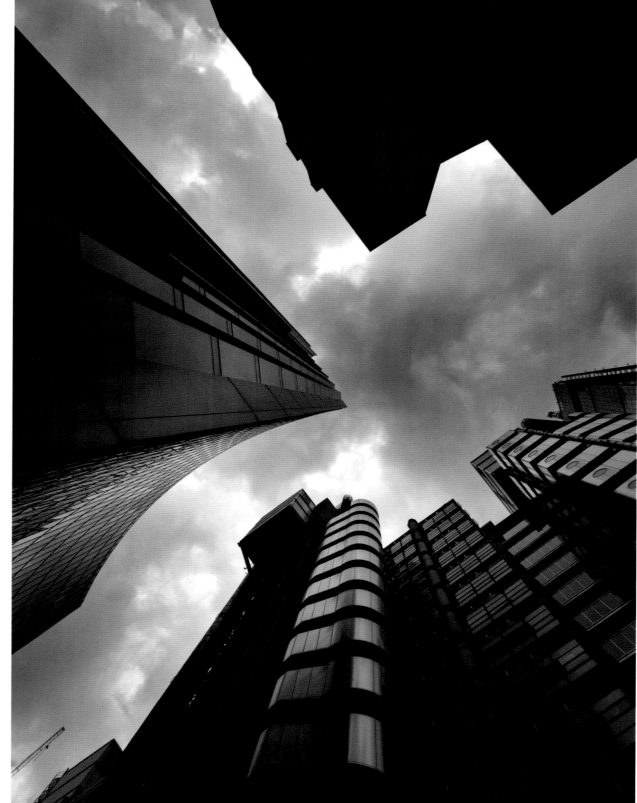

Patterns Of Force – Lloyds Building

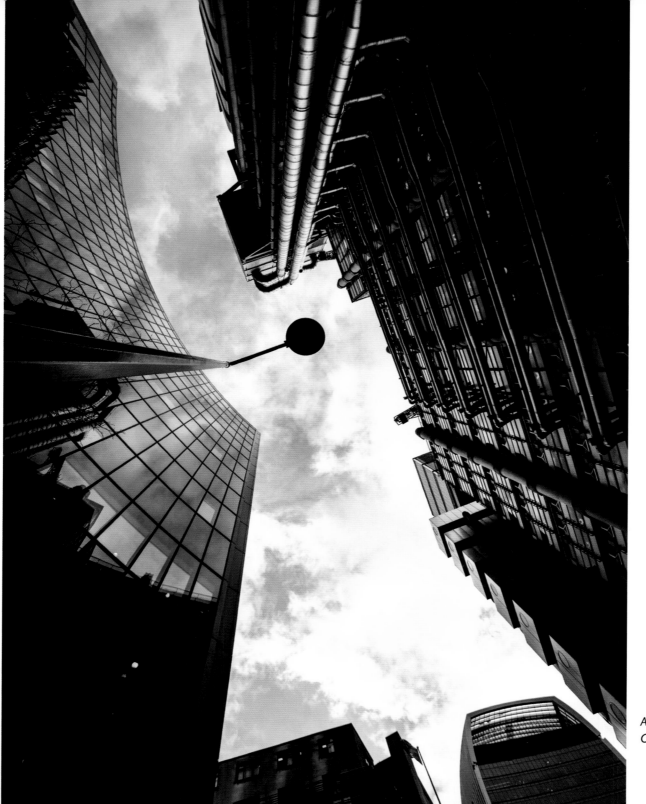

Another Good Morning London —
City Office Life

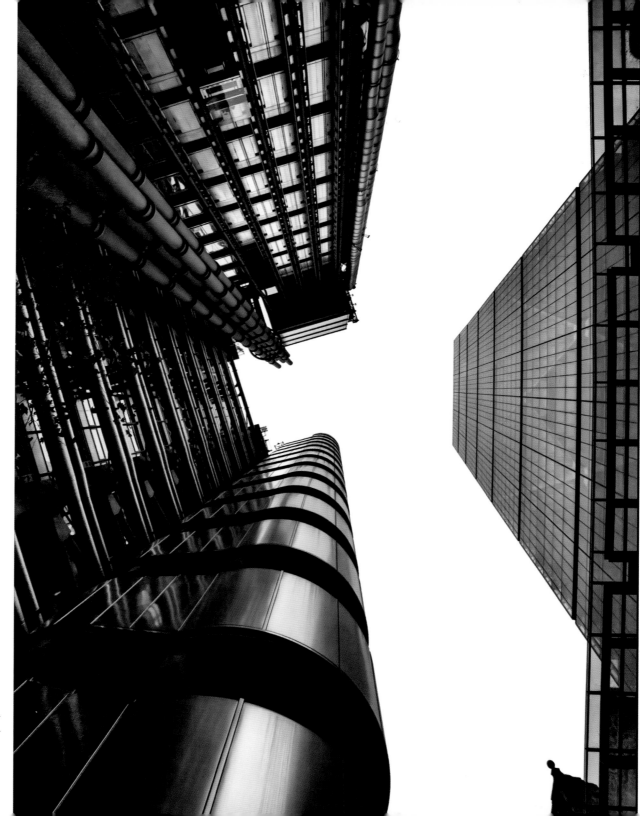

Balance Of Terror –
Lloyds & Cheesegrater

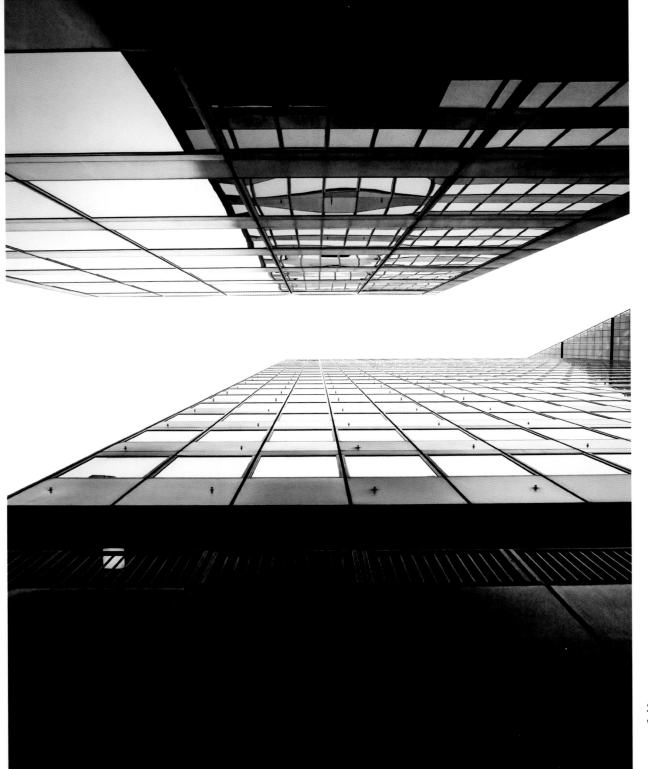

So Shines A Good Deed In A Weary World – St Helen's Building

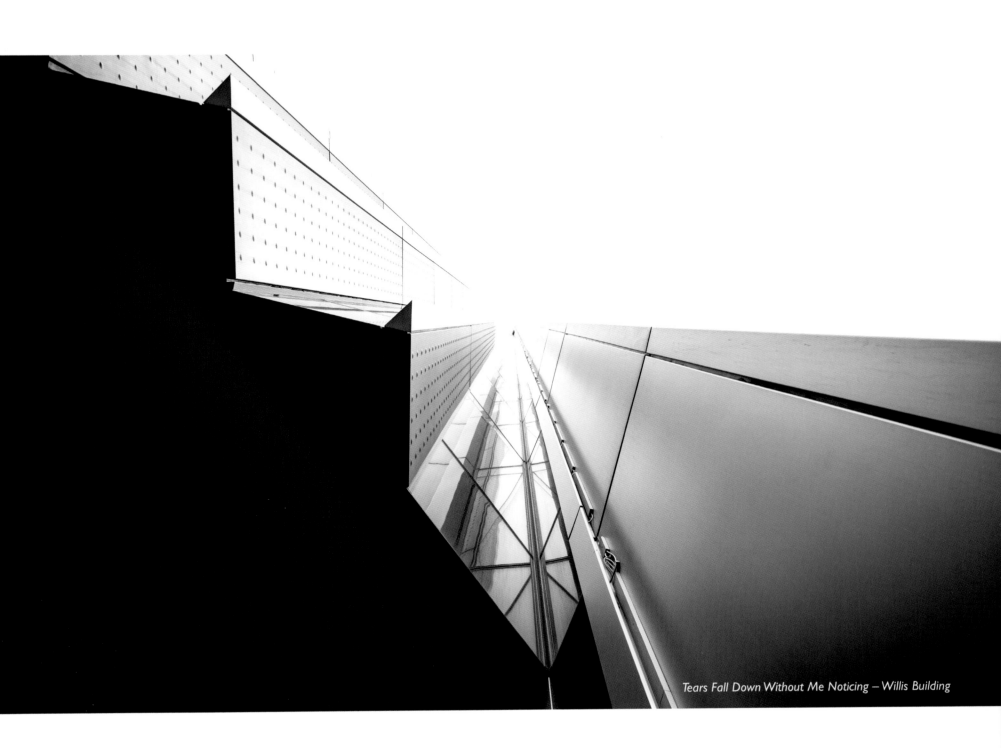

Tears Fall Down Without Me Noticing – Willis Building

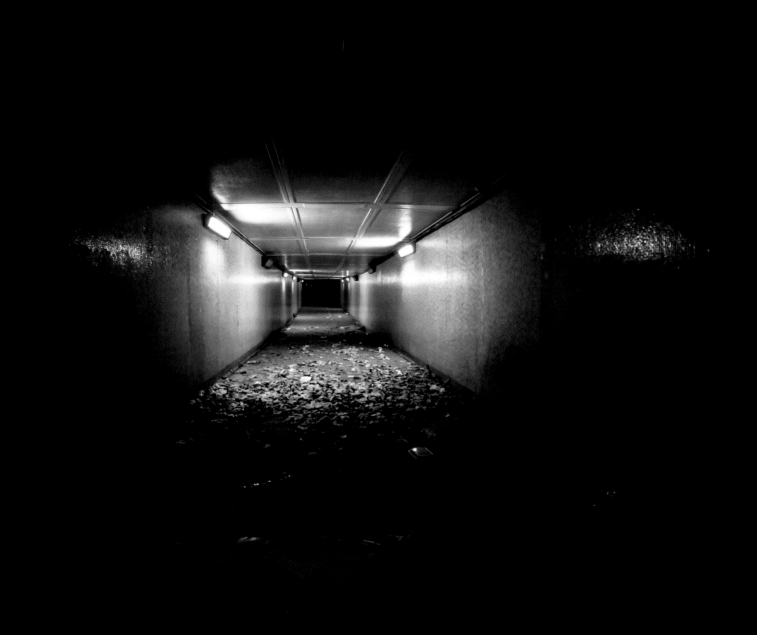

The Doctor Is Not In – Closed Off Underground

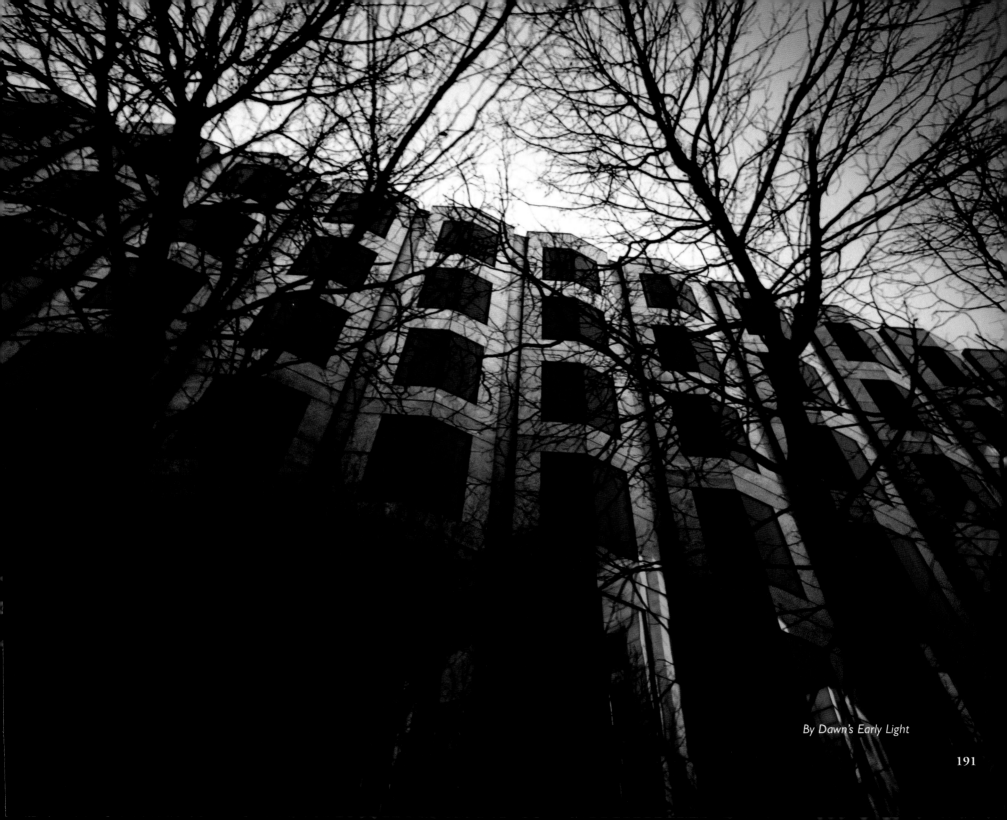

By Dawn's Early Light

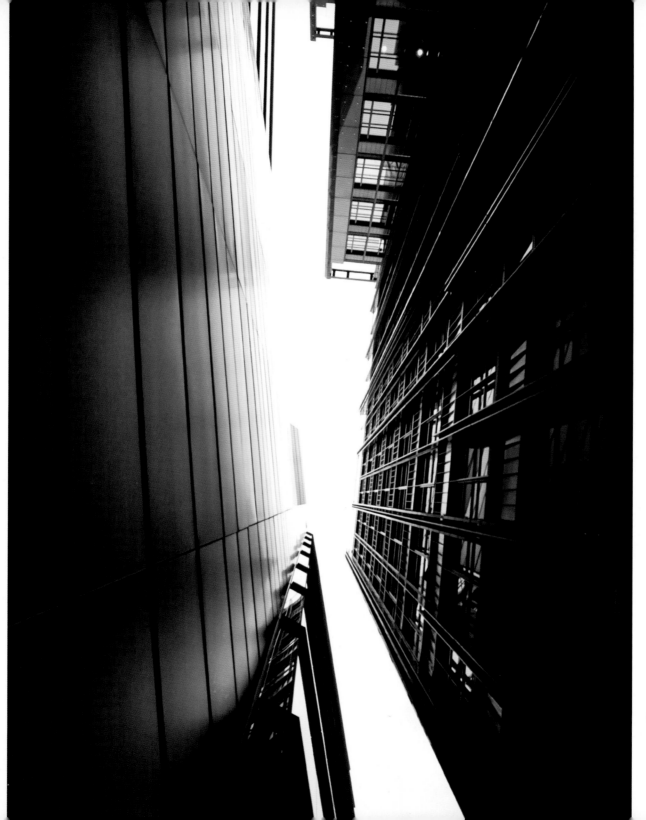

Certainty Is Fleeting

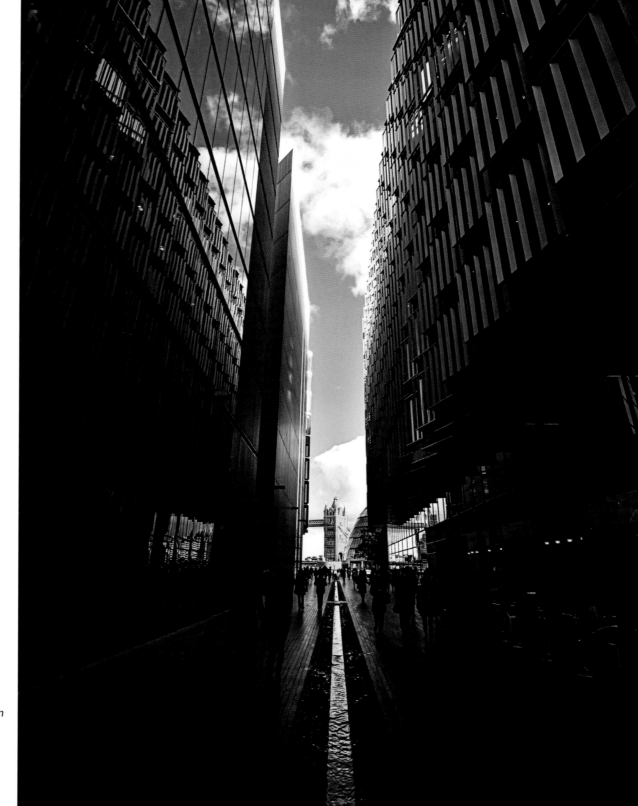

Towards The Tower — London

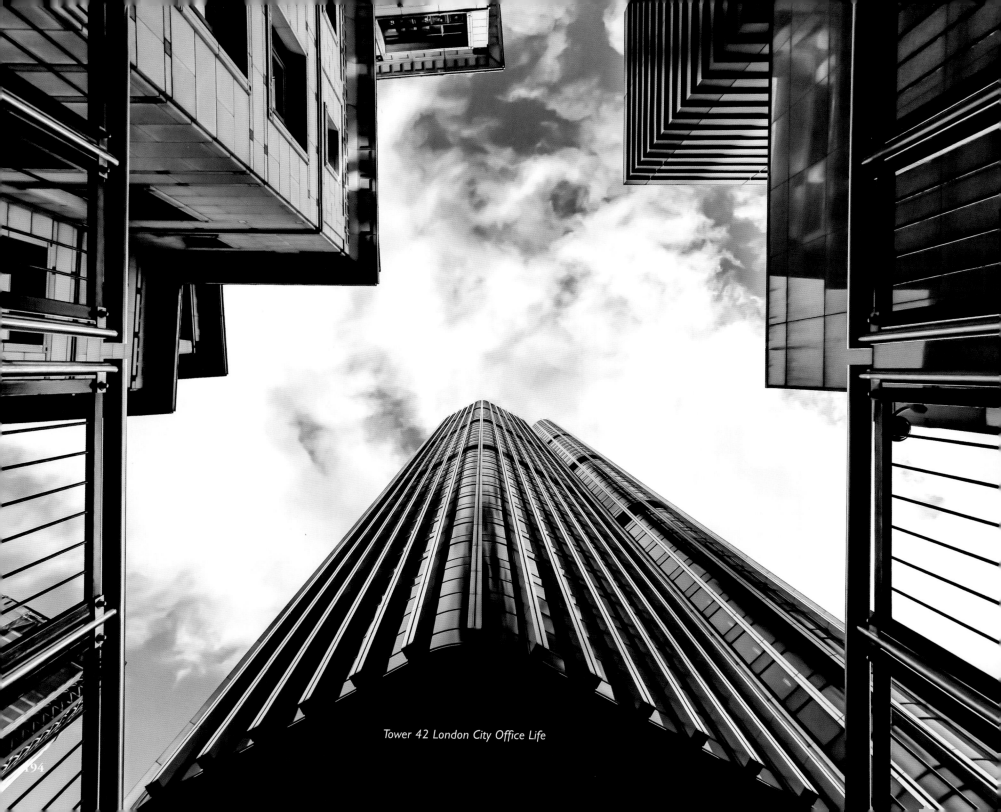

Tower 42 London City Office Life

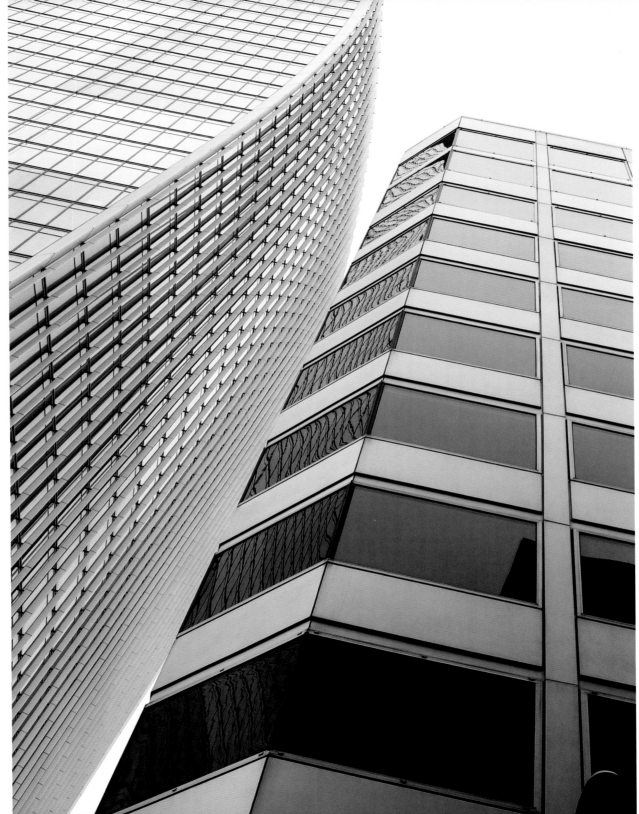

Running Out Of Room – Southwark

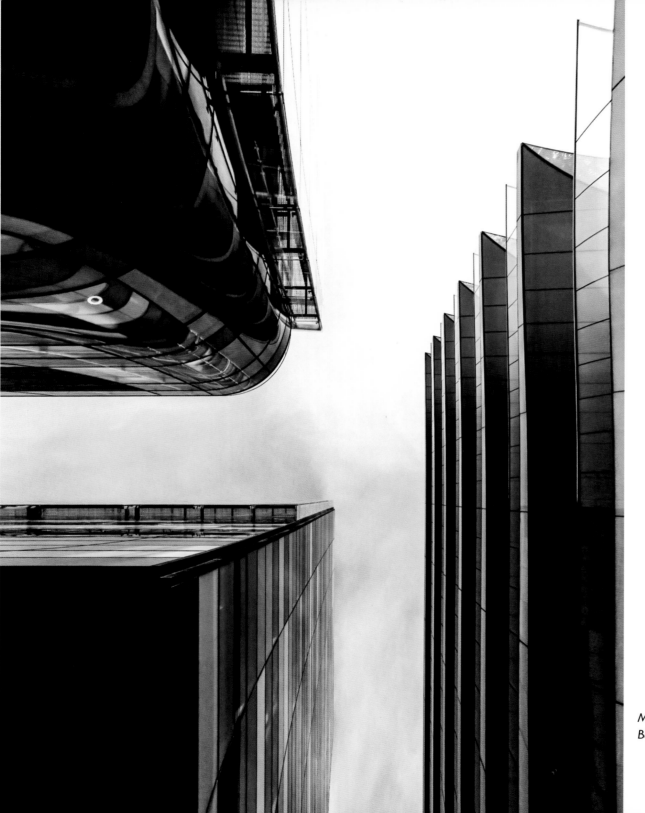

My Life My Way My Rules –
Bankside

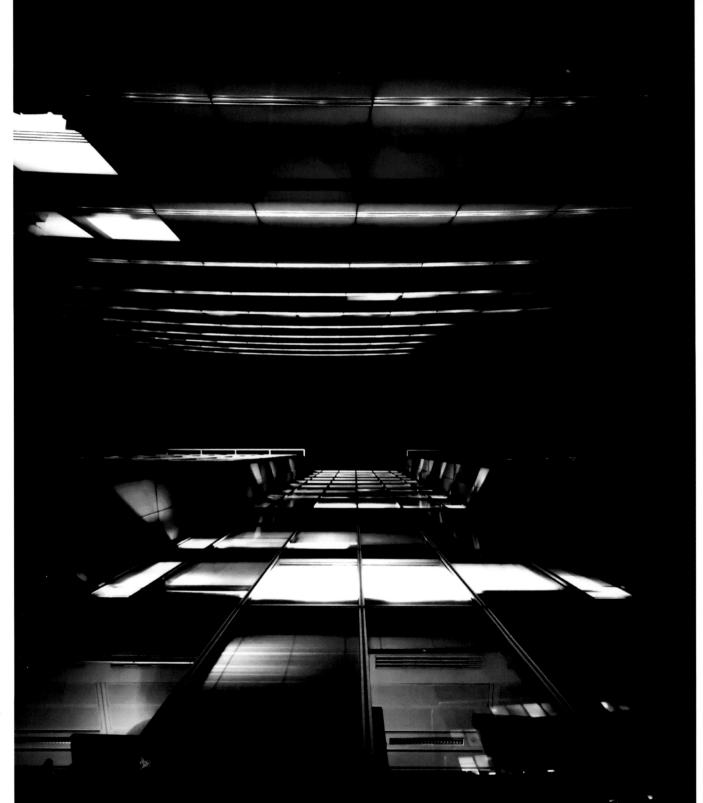

Night Face Off –
Bishopsgate

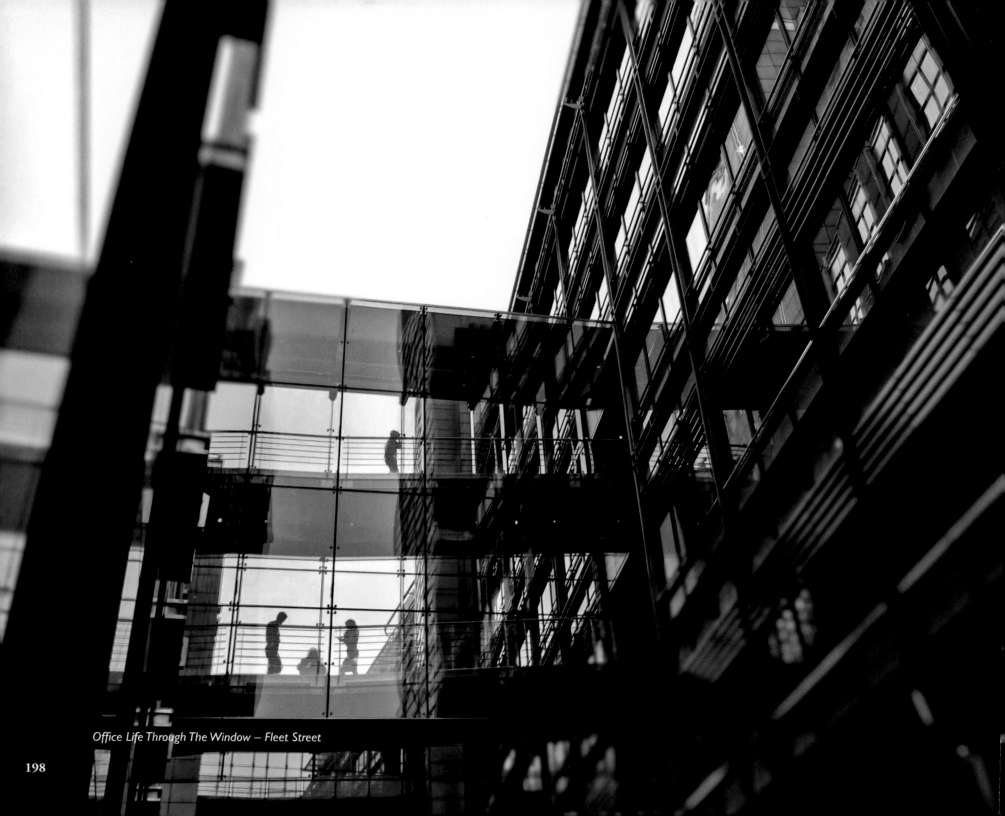

Office Life Through The Window – Fleet Street

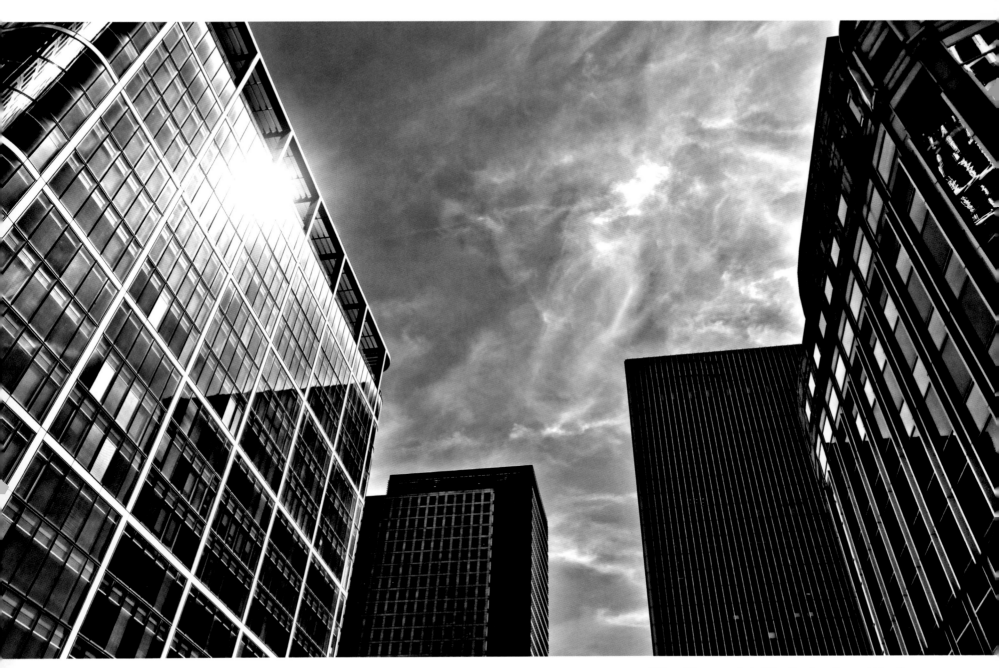

When Dinosaurs Ruled The Earth – Canary Wharf

Before Freedom — Aldgate

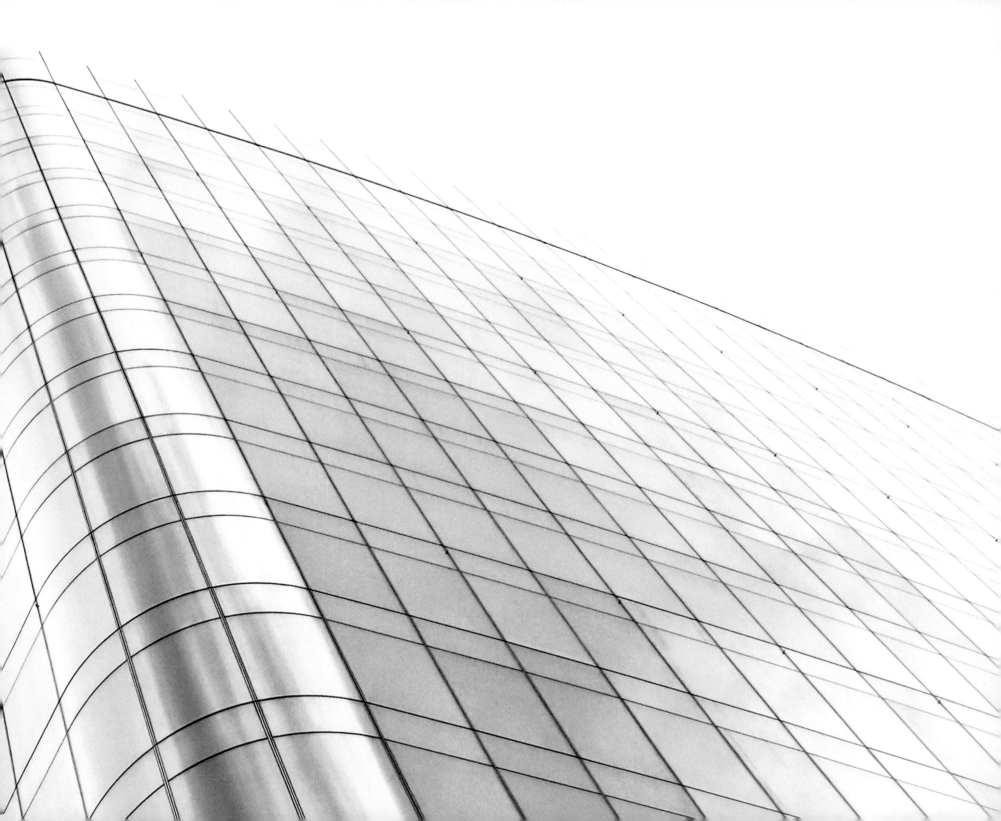

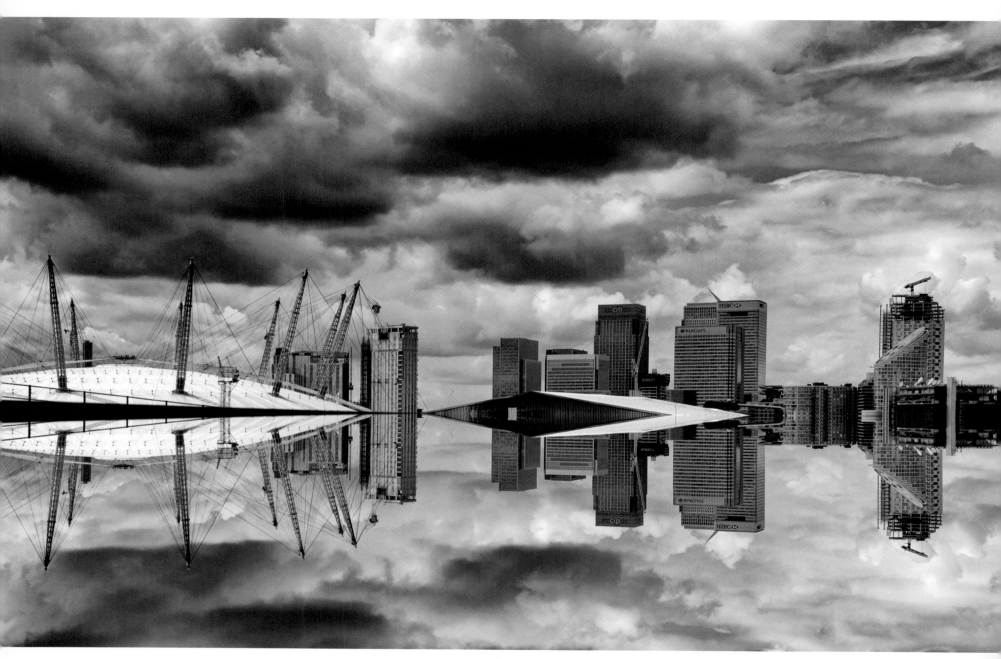

Canary Wharf & The Dome

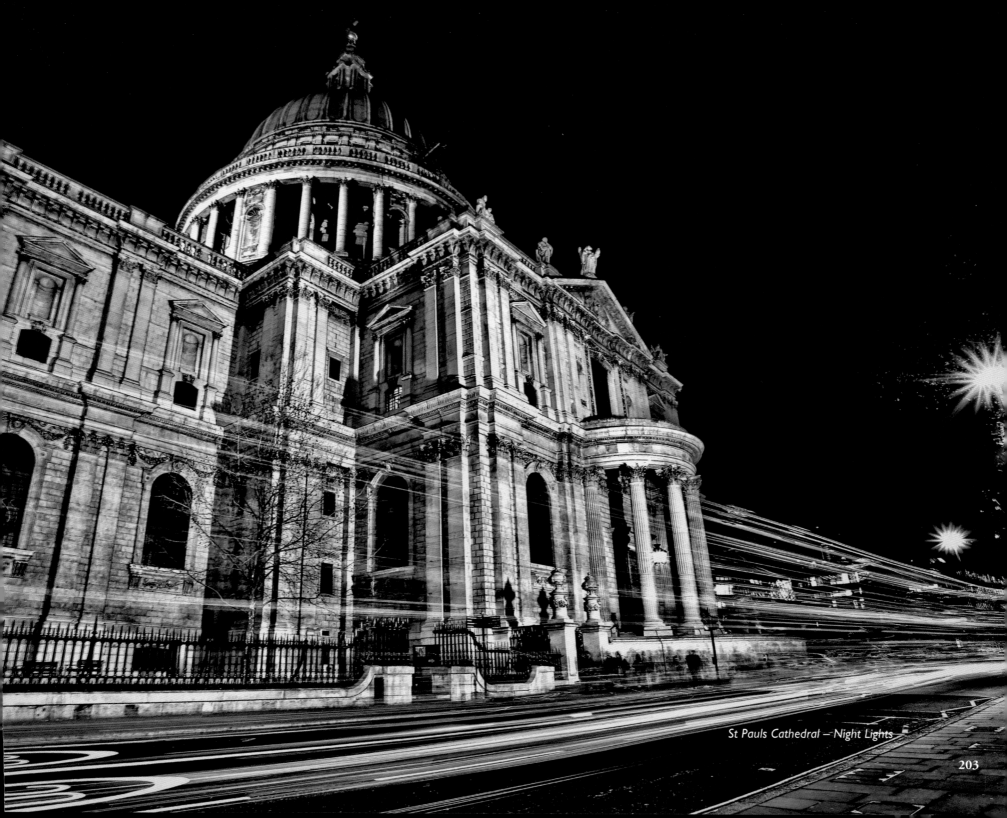

St Pauls Cathedral – Night Lights

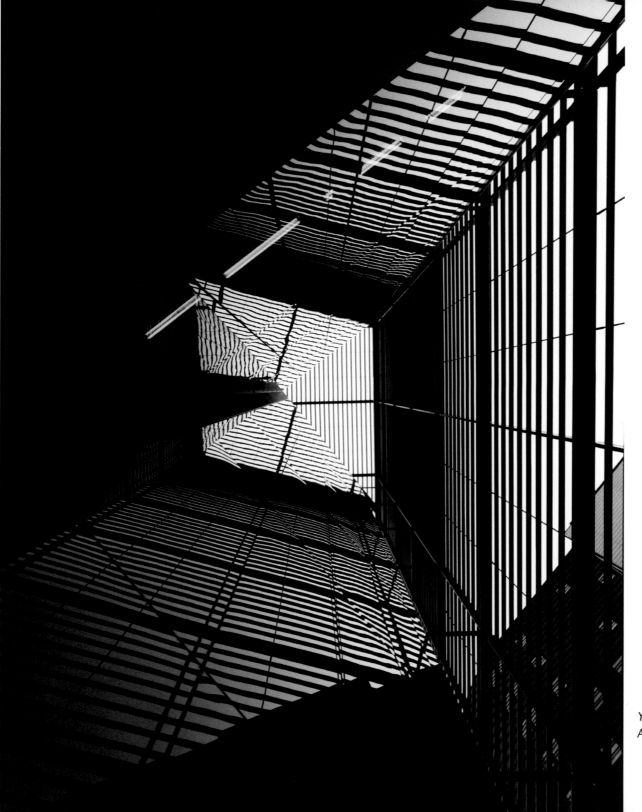

You Can't Do This If You Don't Have
A Dream (London Geometry) Bankside

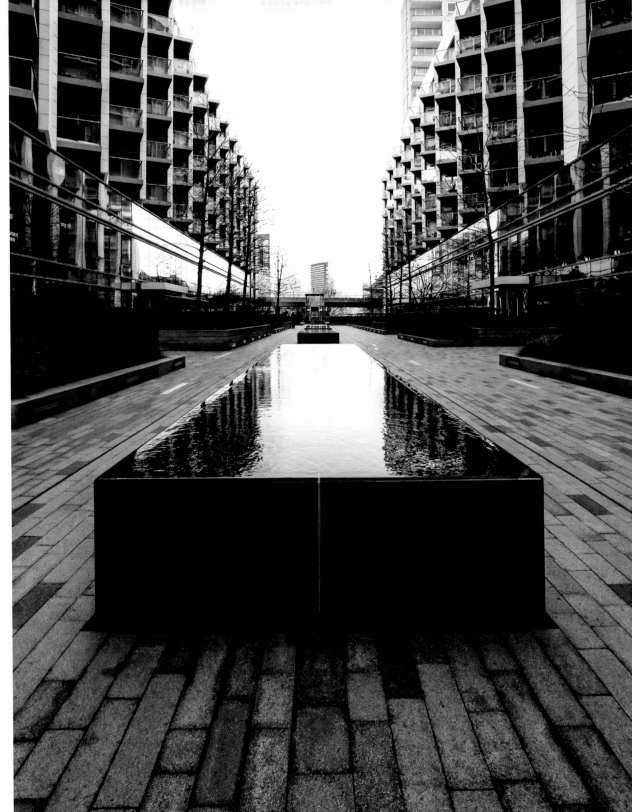

The Space Between – Millwall Dock

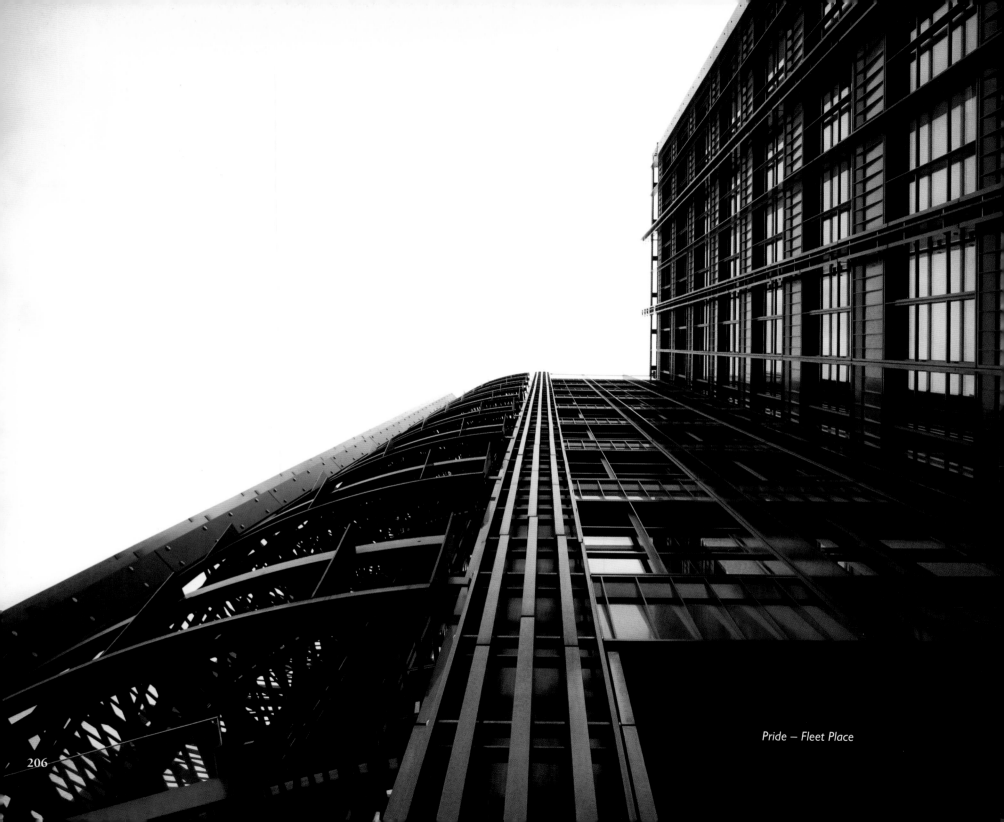

Pride – Fleet Place

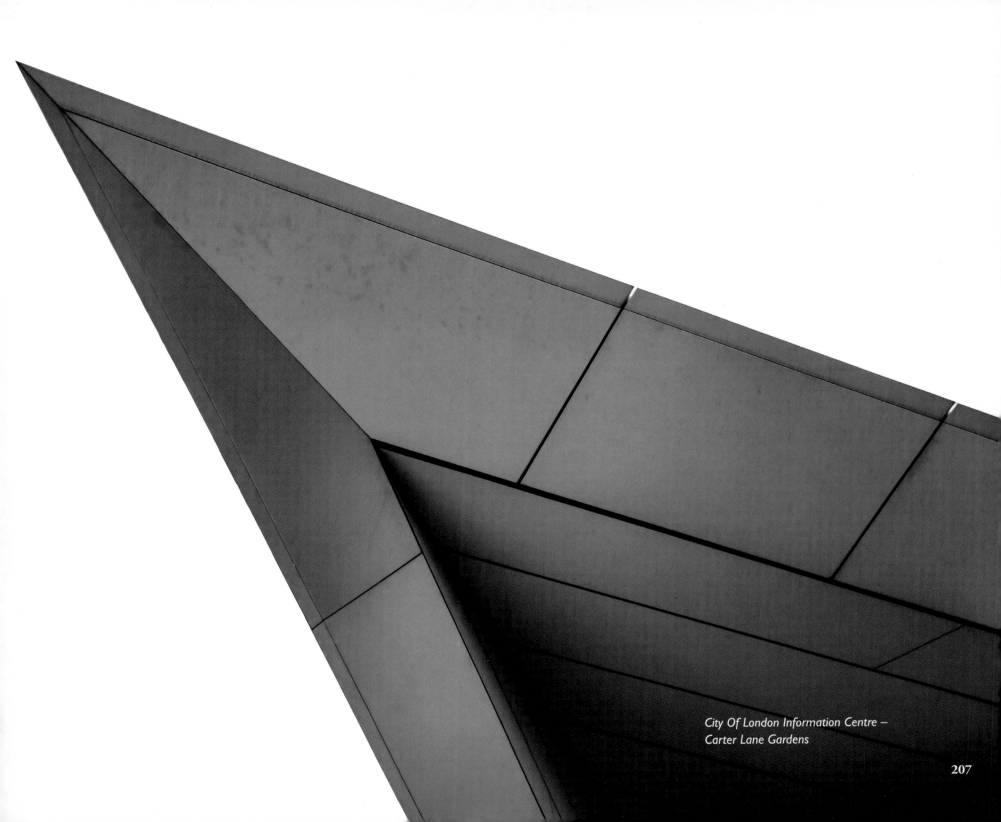

City Of London Information Centre –
Carter Lane Gardens

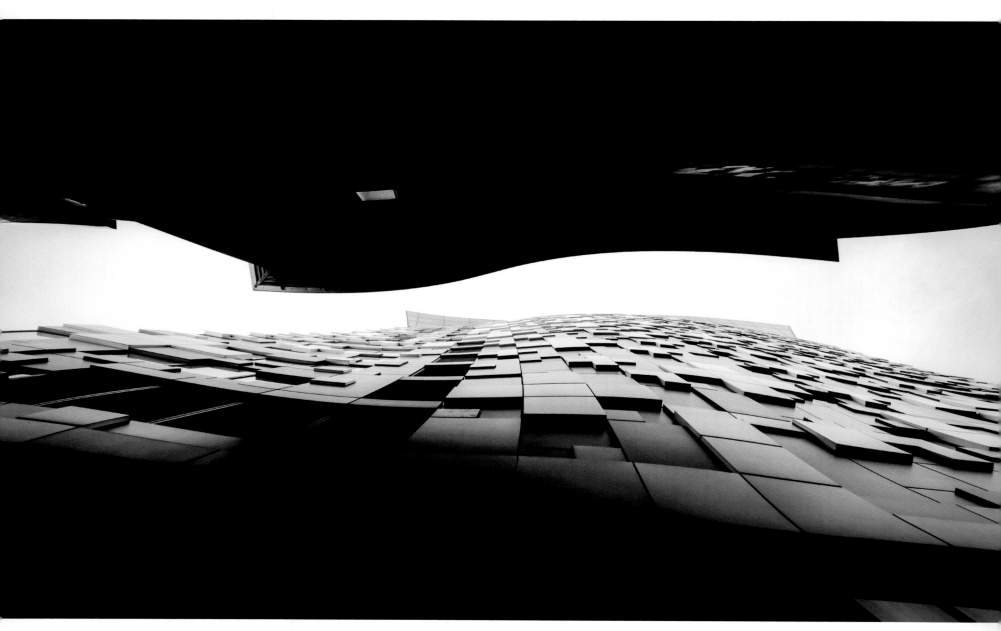

The Wind Blows Painting The Atmosphere

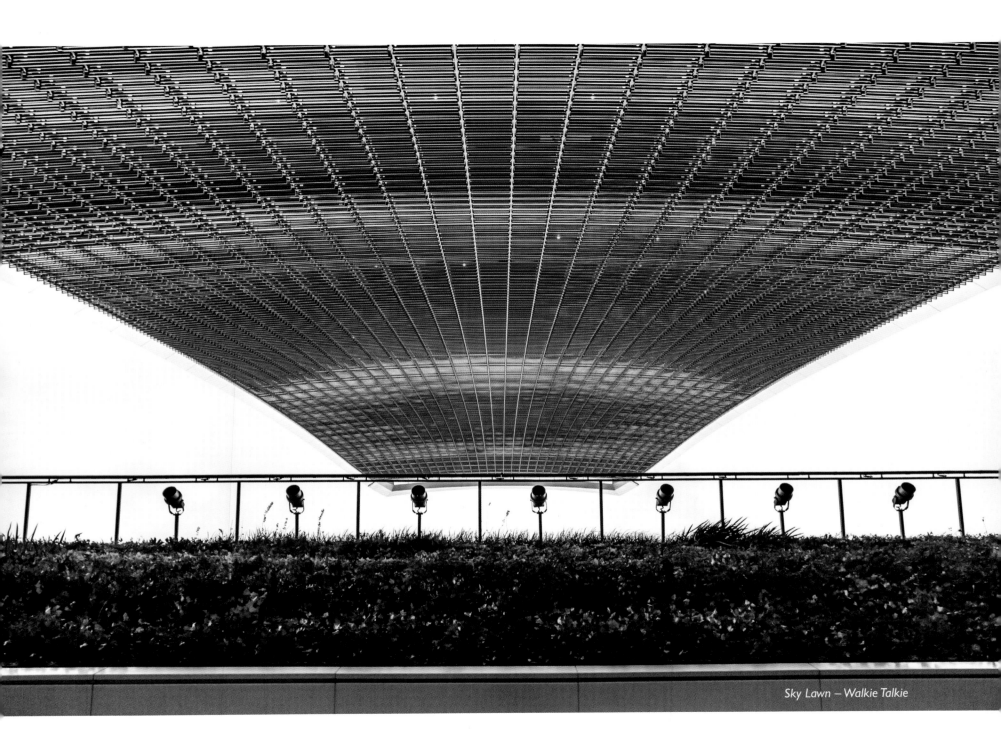

Sky Lawn – Walkie Talkie

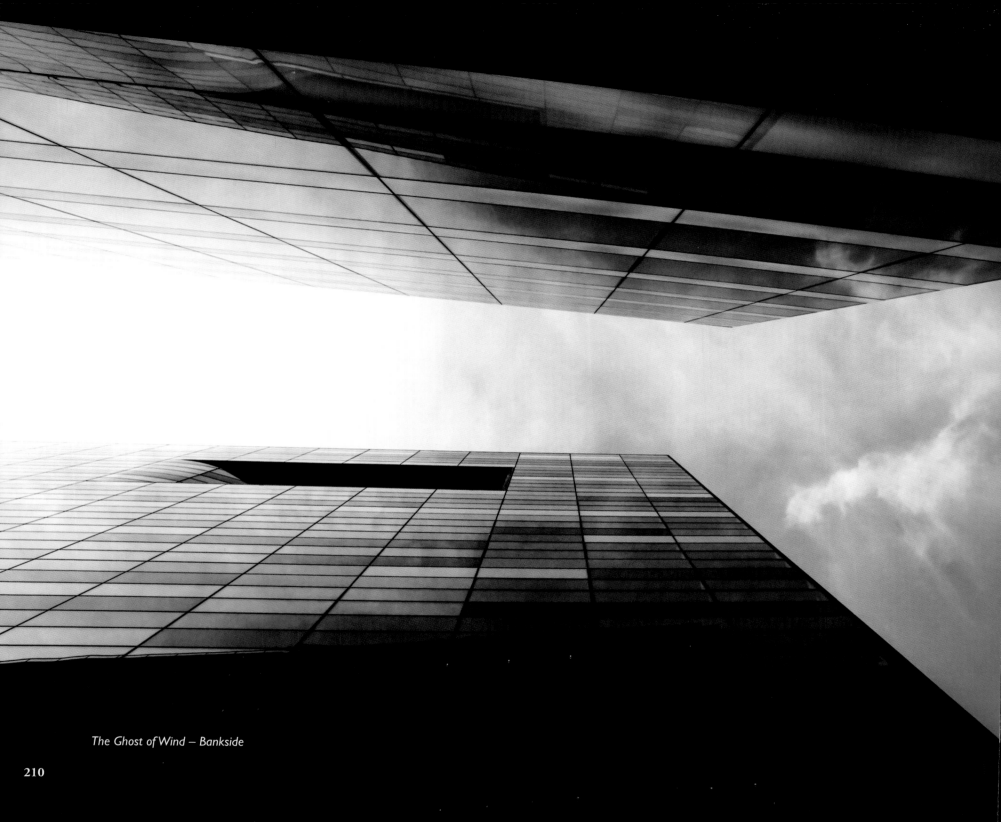

The Ghost of Wind — Bankside

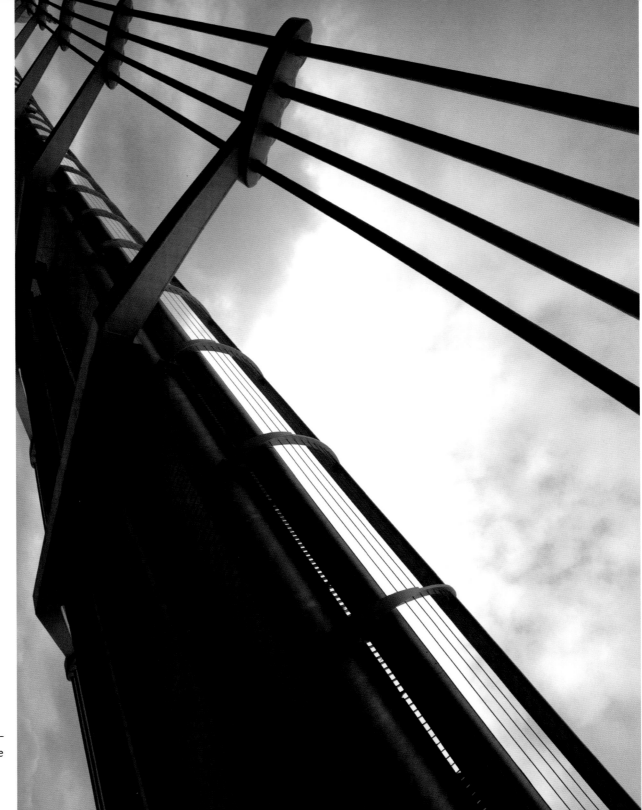

From Here To Eternity –
Millennium Bridge

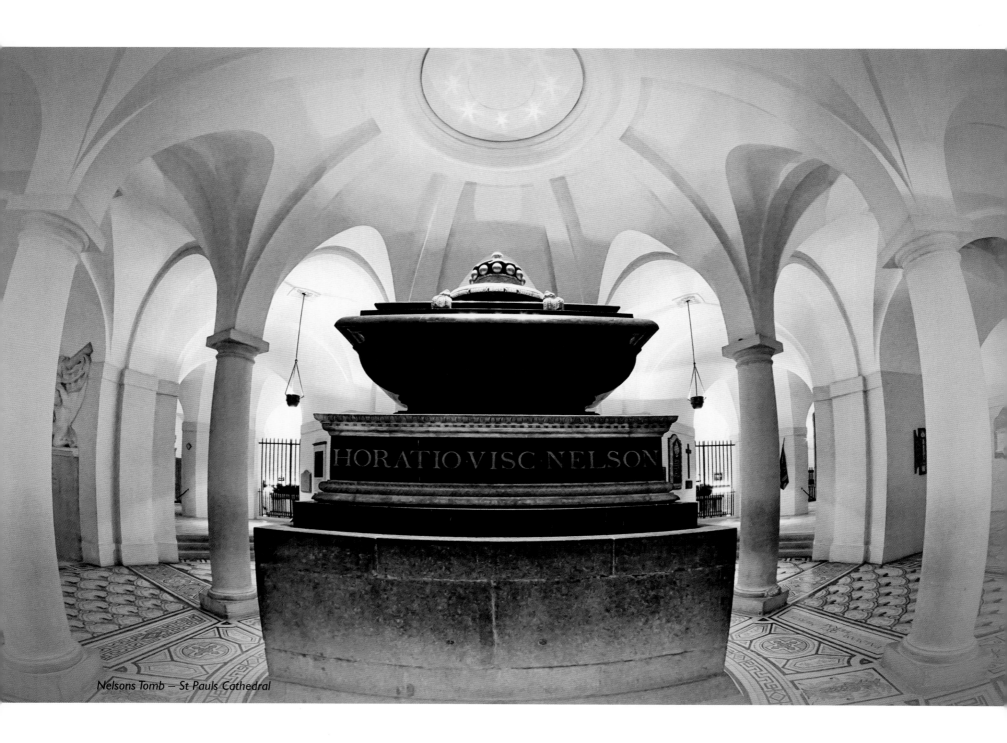

Nelsons Tomb – St Pauls Cathedral

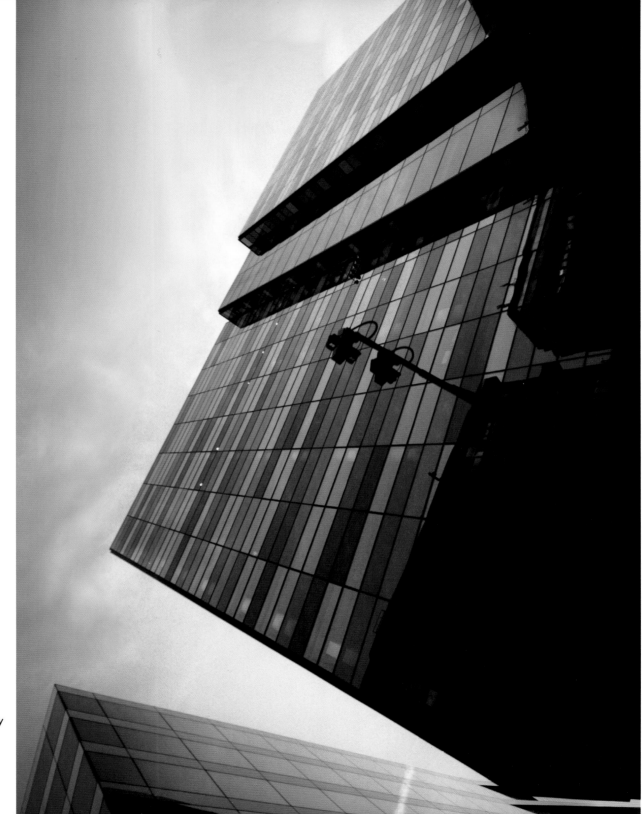

Age Of The Mayans – London City

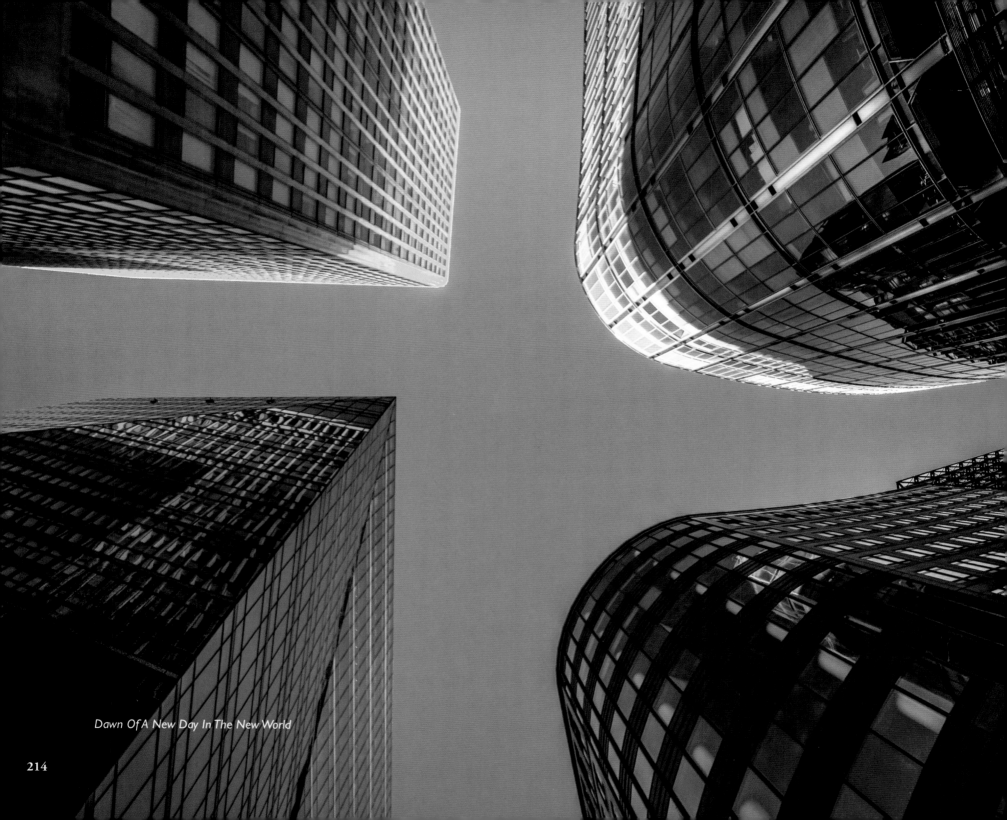

Dawn Of A New Day In The New World

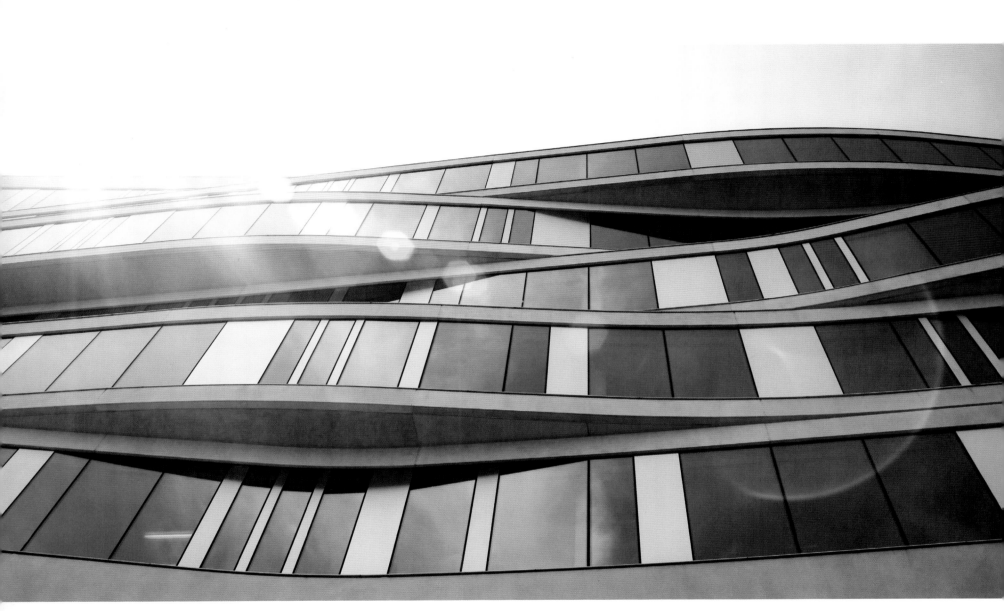

New Wave – London City Life

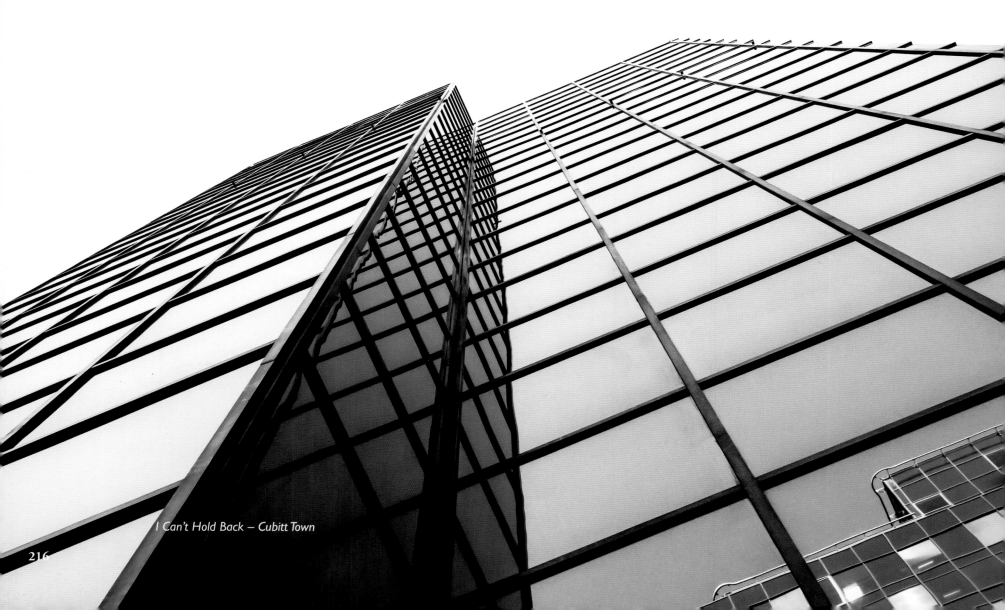

I Can't Hold Back — Cubitt Town

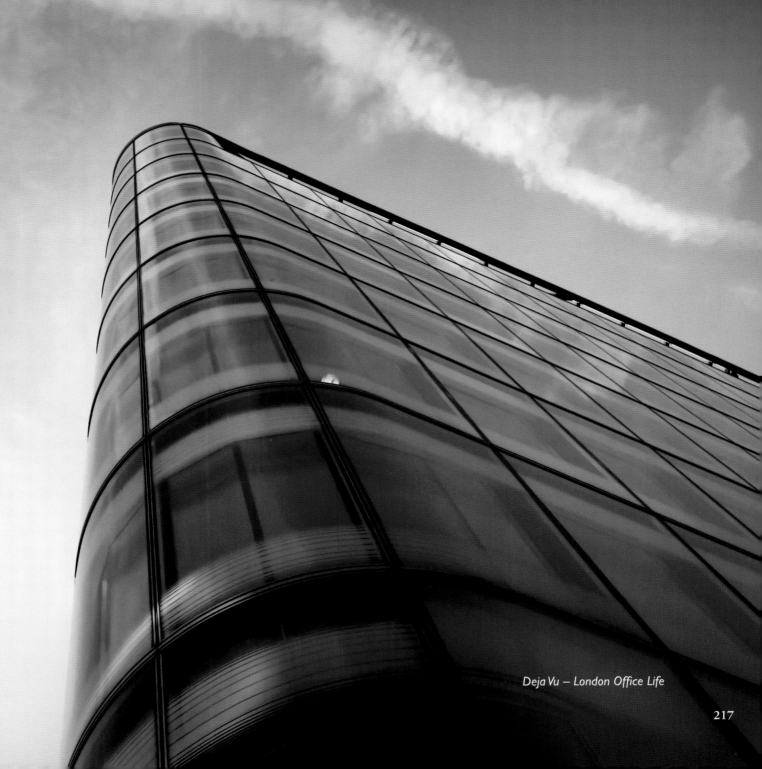

Deja Vu – London Office Life

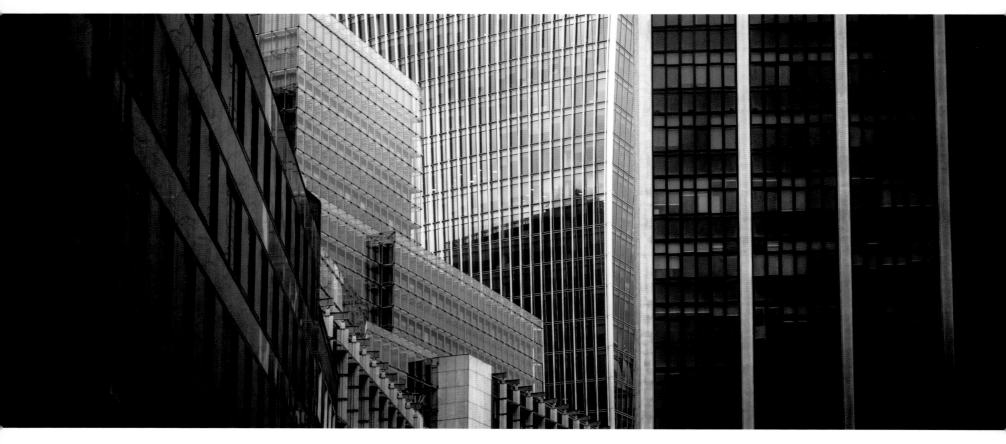

Live Life Like You Stole It – London City

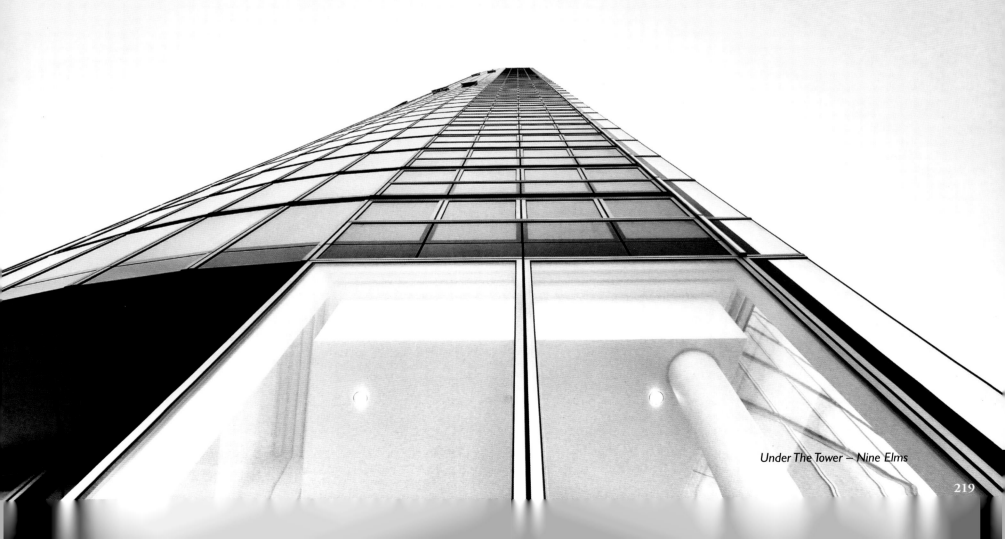

Under The Tower — Nine Elms

219

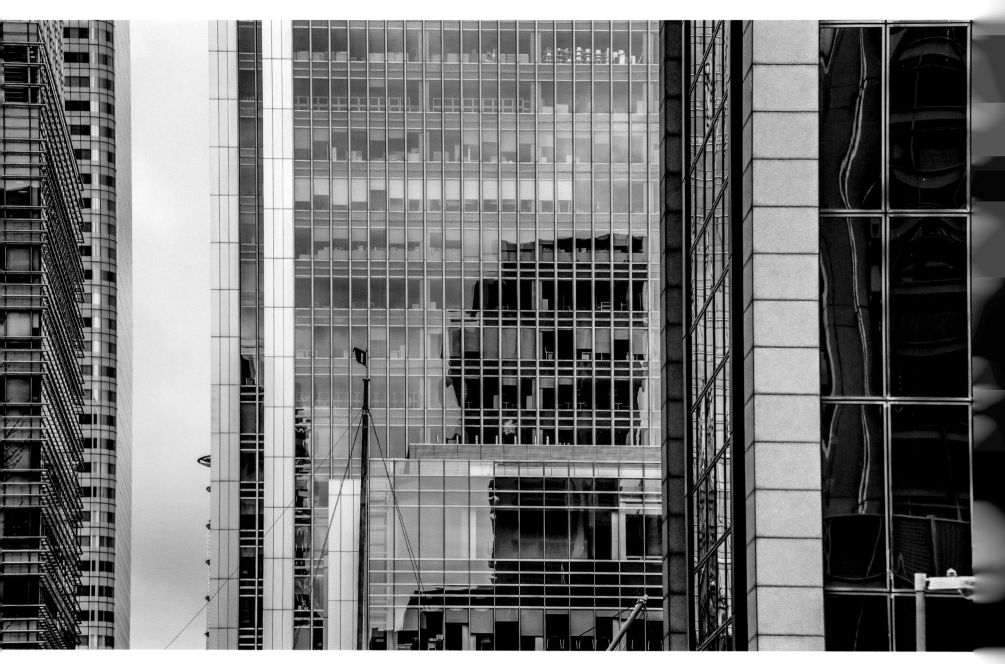

The wheel only worked for the man pushing it from behind – Canary Wharf

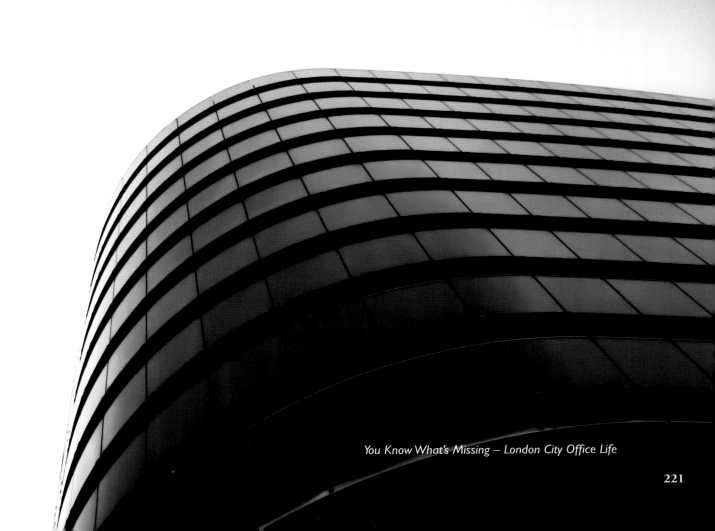

You Know What's Missing – London City Office Life

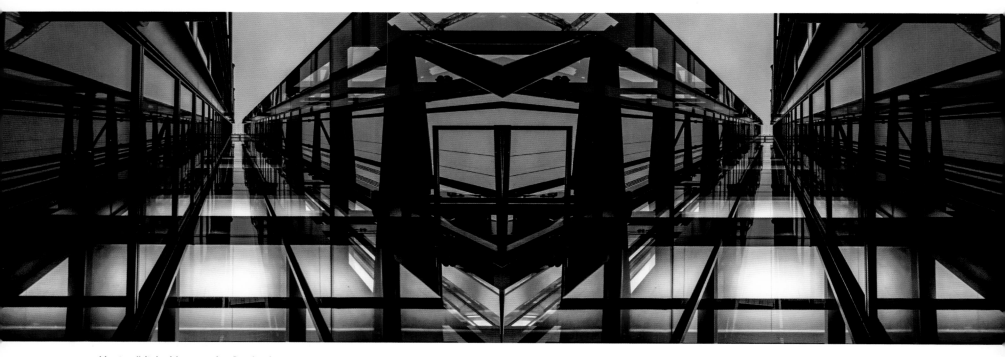

Vertigo 'Night Harmony' – Bankside

Unfathomable is the realm of impossibilities – London City Office Life

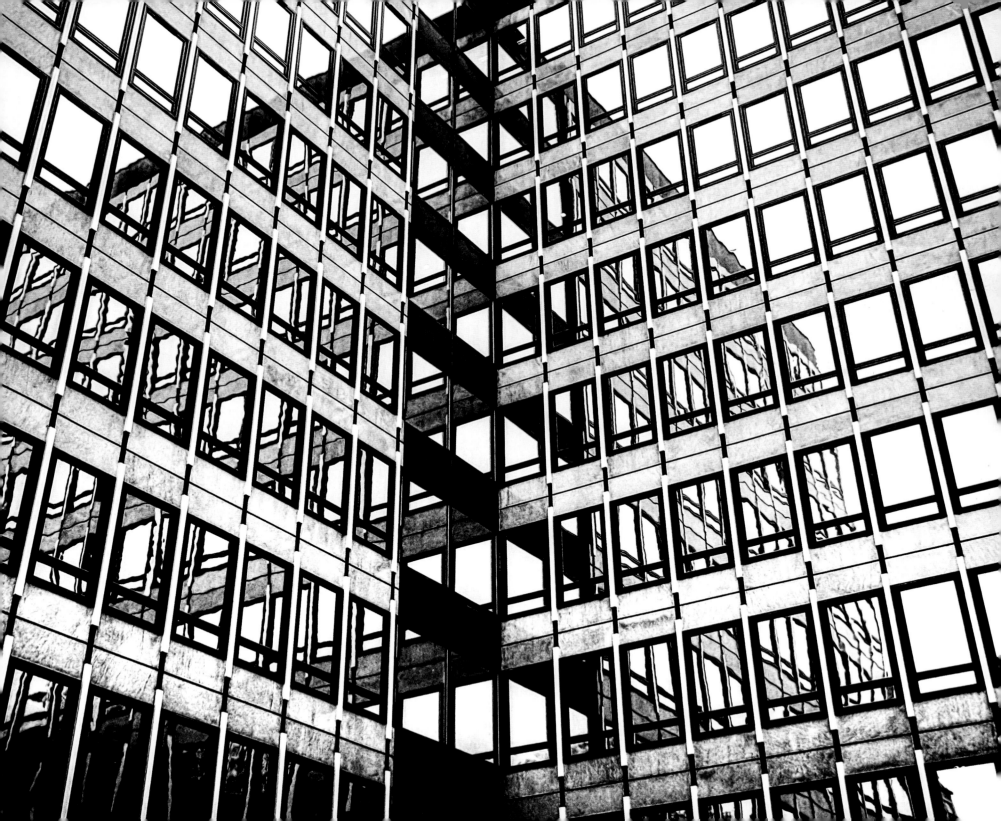

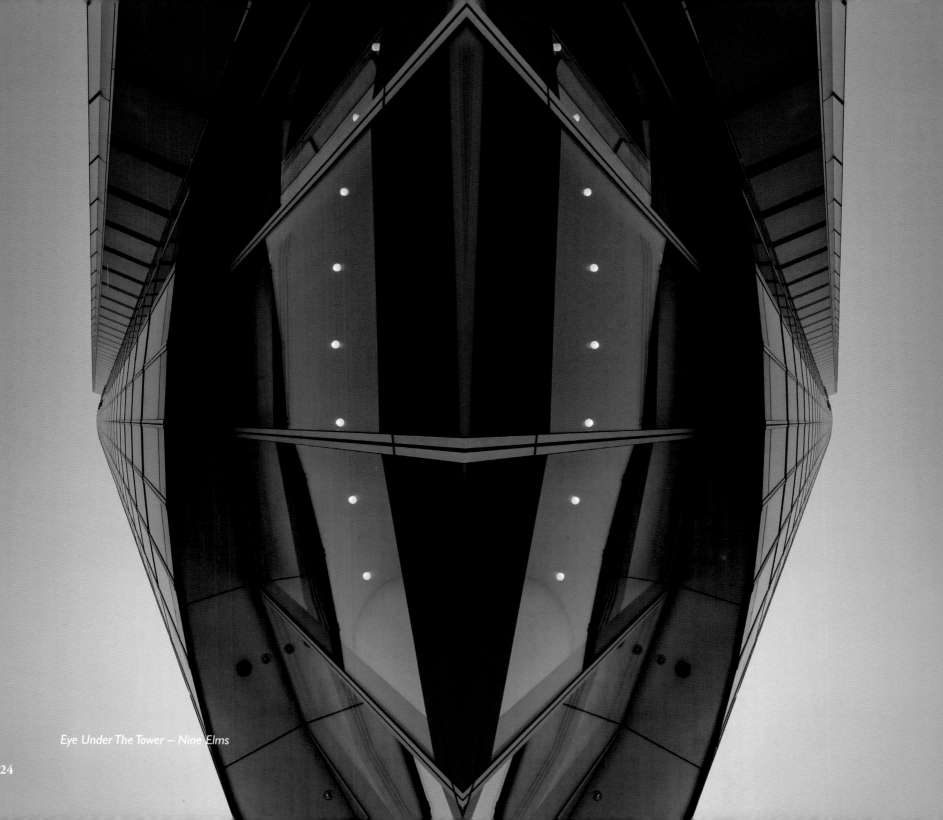

Eye Under The Tower – Nine Elms

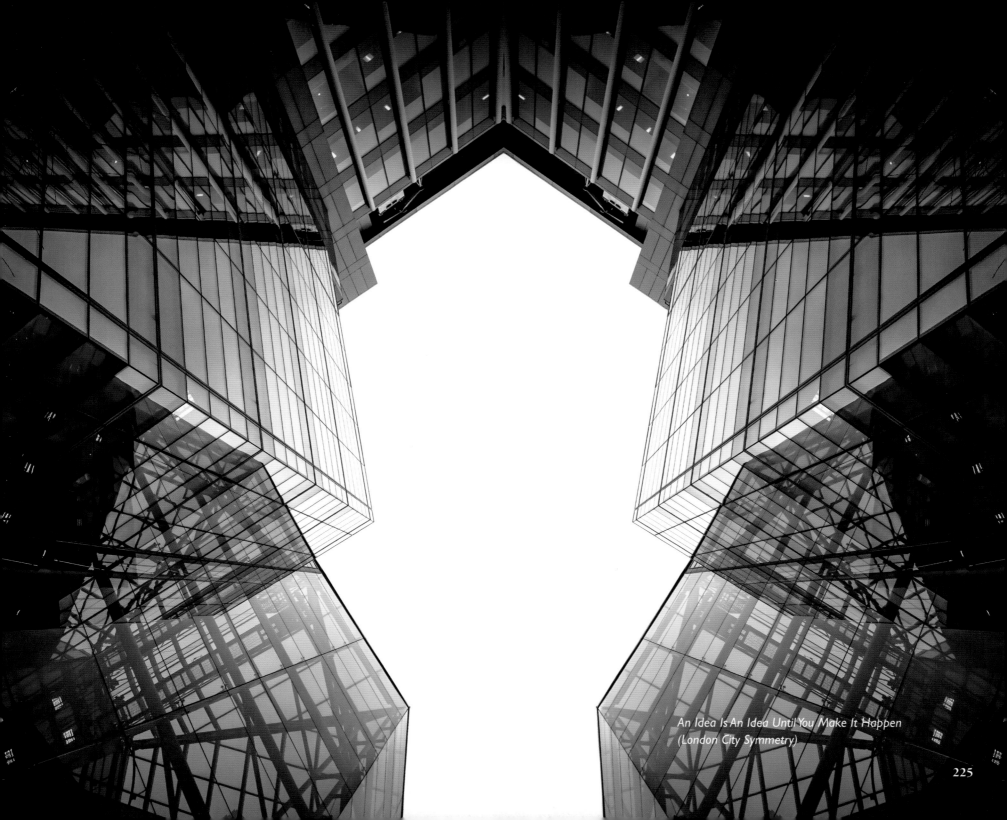

An Idea Is An Idea Until You Make It Happen
(London City Symmetry)

225

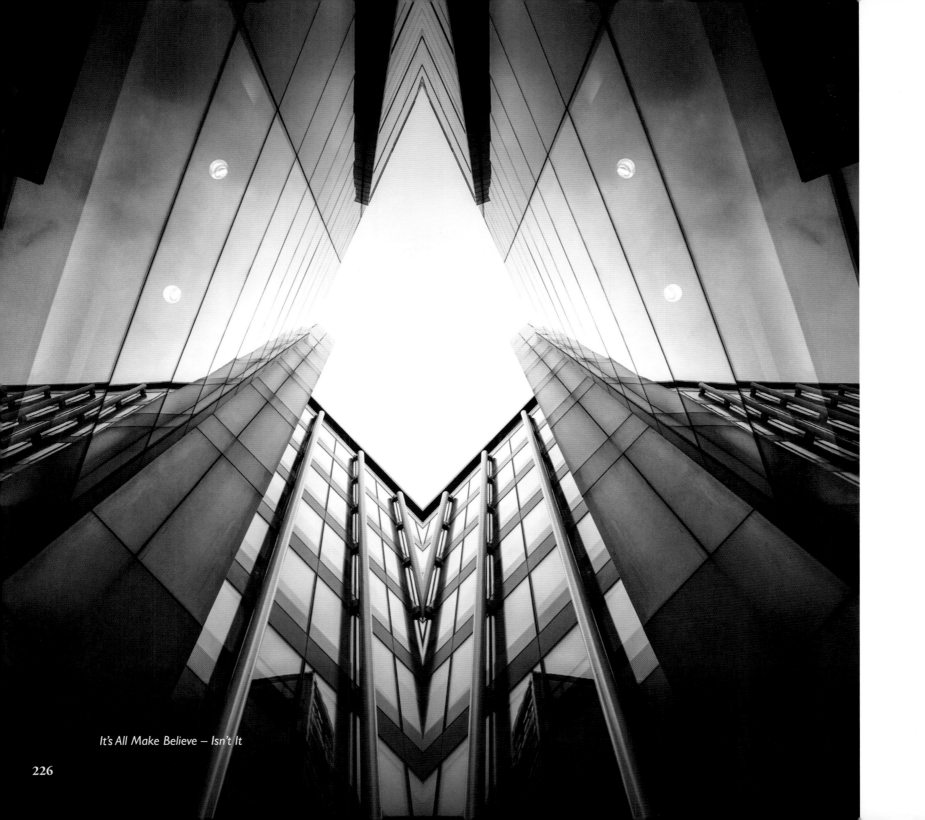

It's All Make Believe — Isn't It

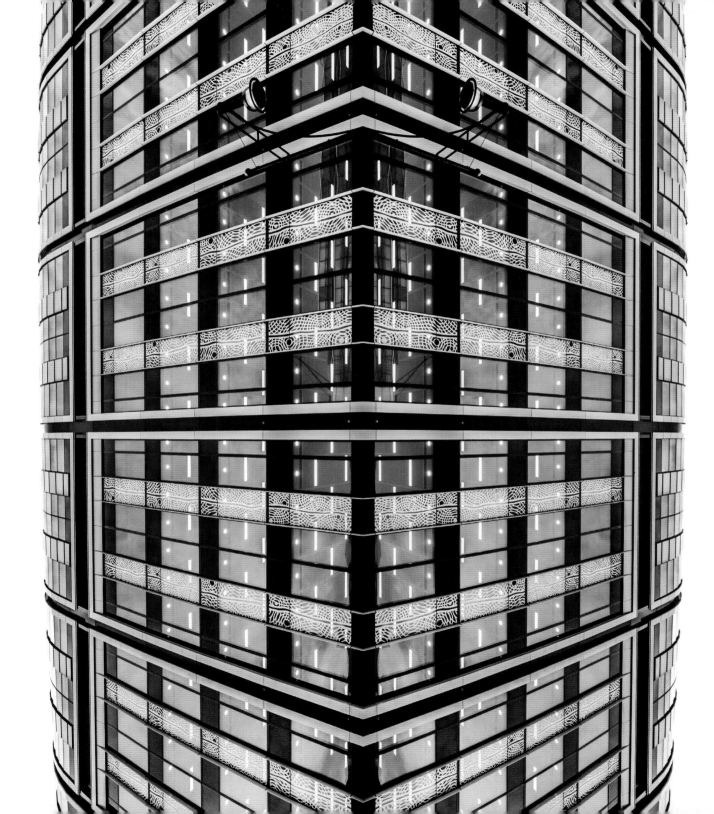

Vertigo 'Lace' – Park House
Oxfrod Street

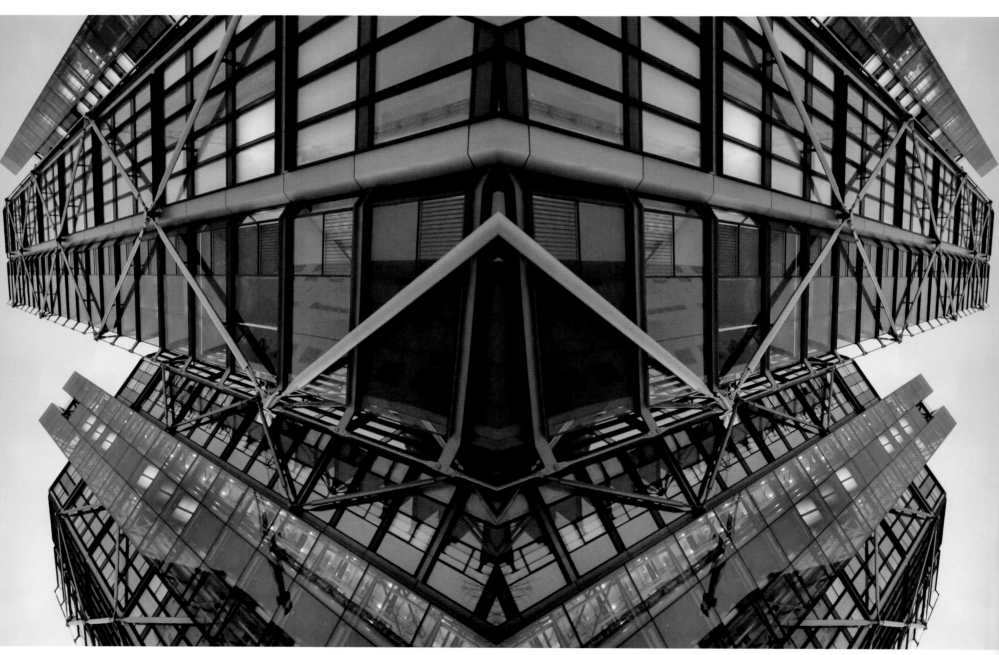

Face Of The City 'Origins' — London

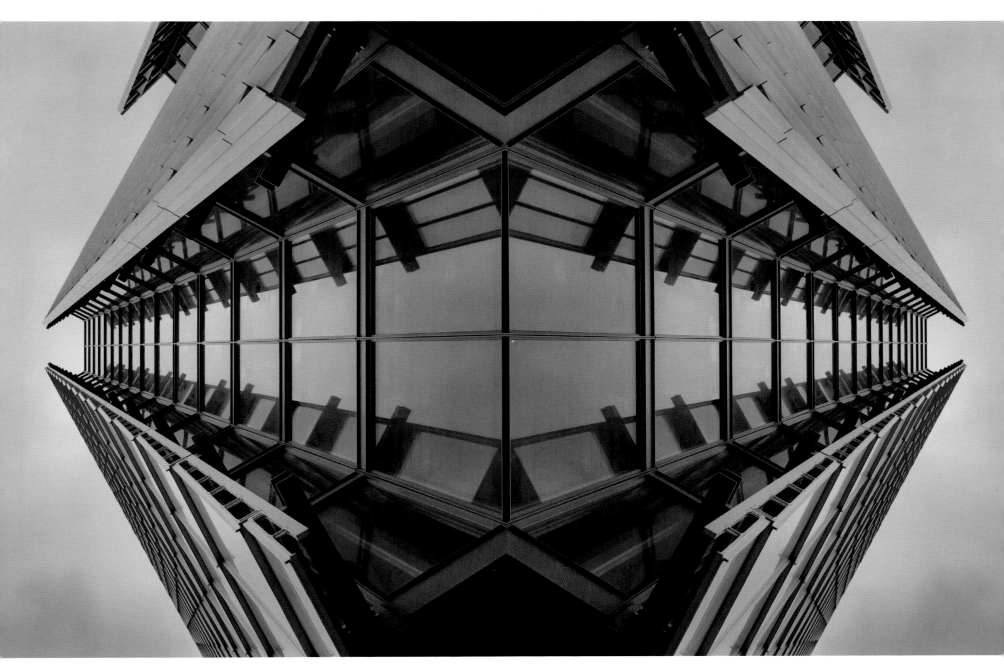

The Face Of The City 'Android' – London

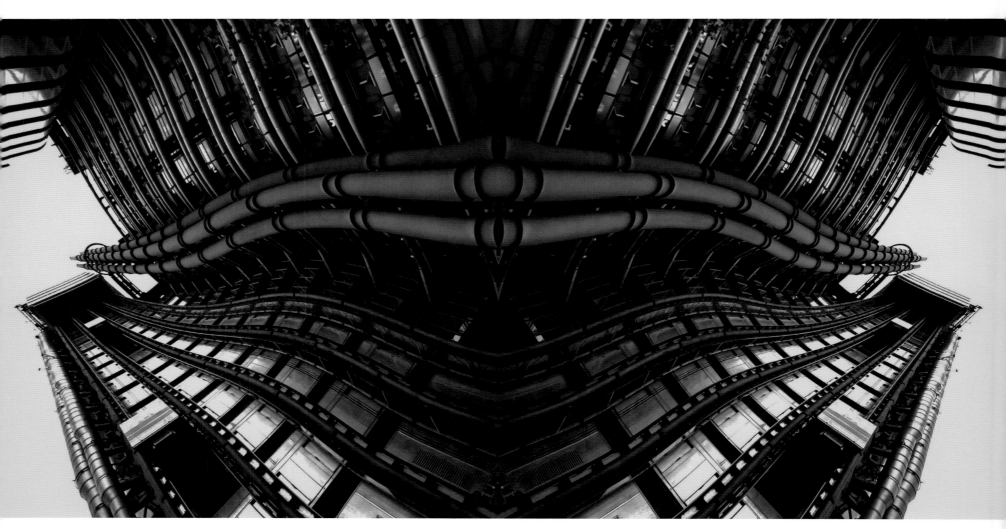

The Face Of The City 'Architect' – London

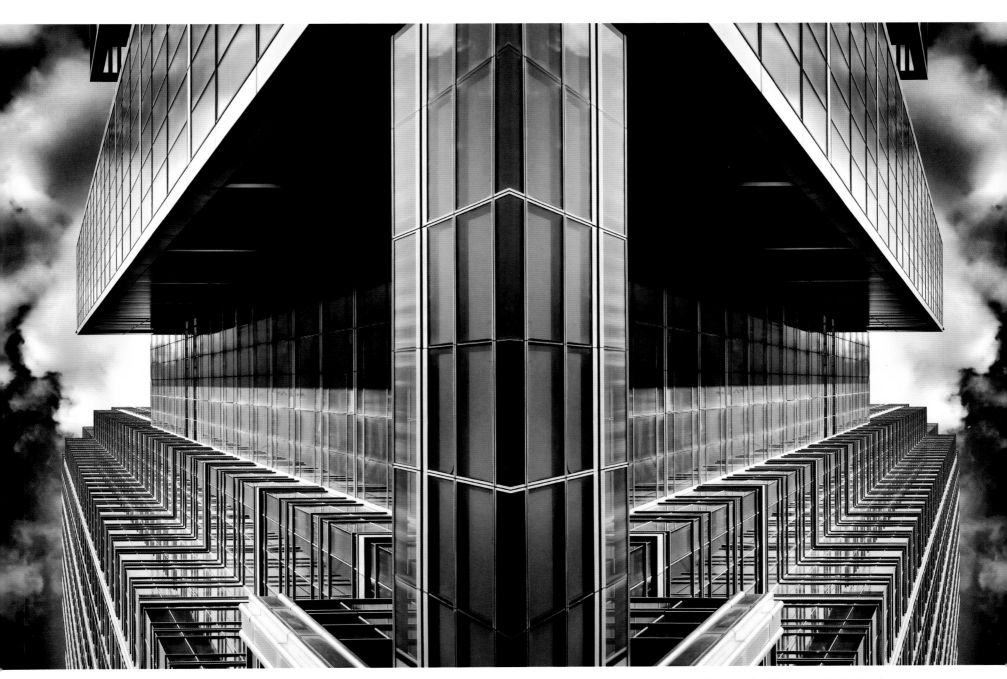

The Face Of The City 'Centurion' – London

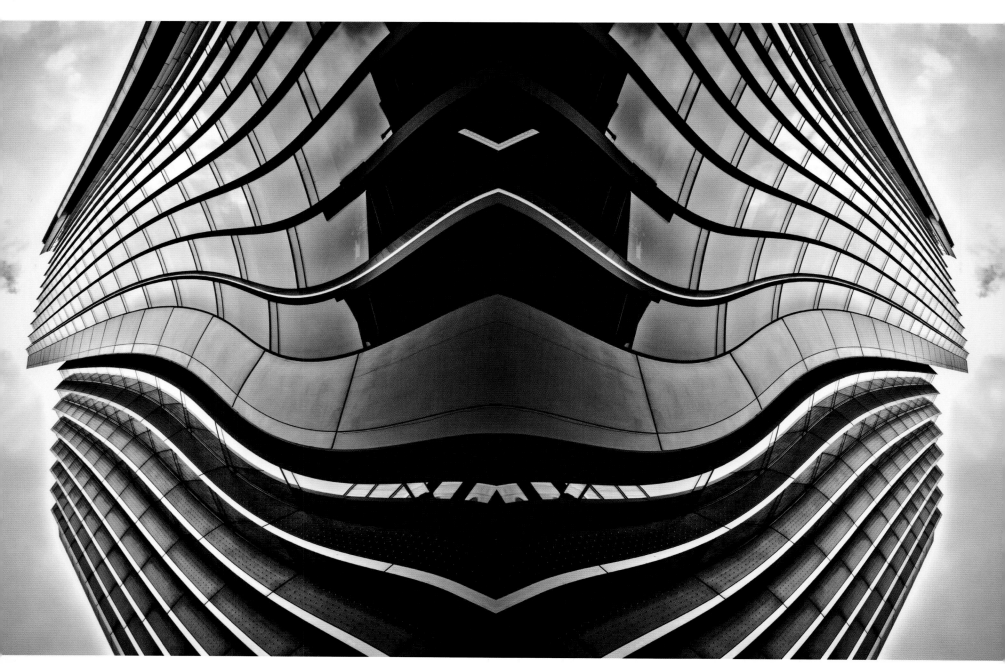

The Face Of The City 'MetalOrganic' – London

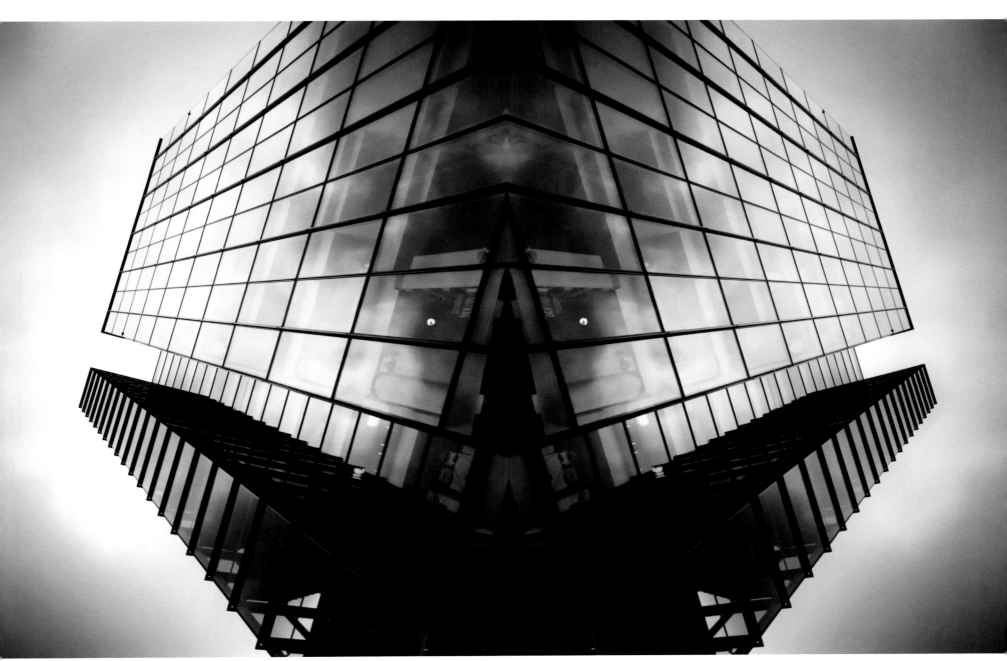

The Face Of The City 'Oculus' – London

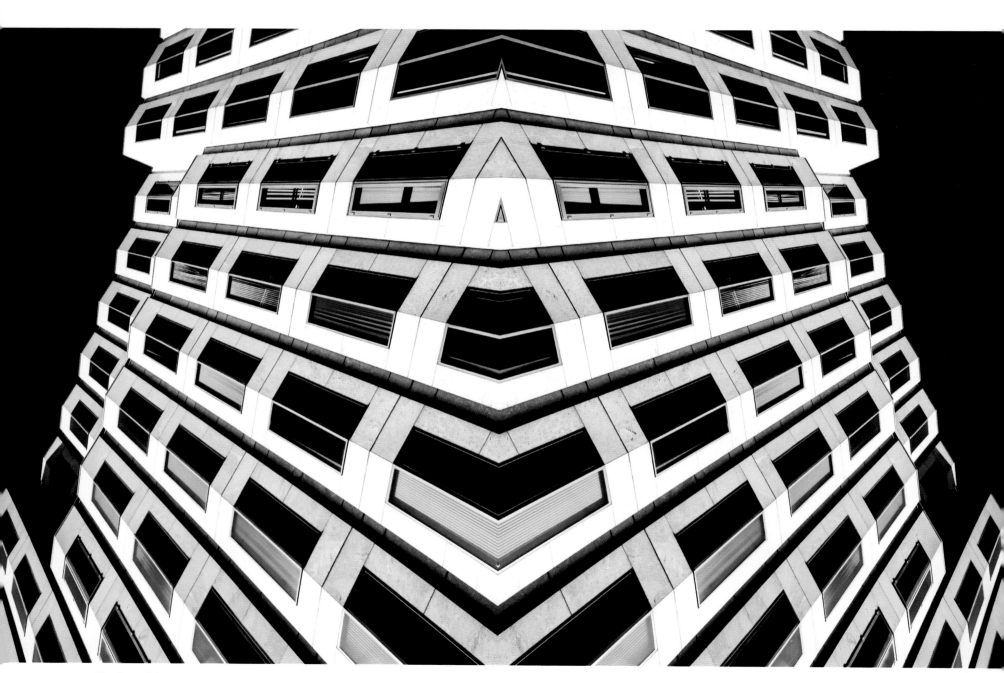

The Face Of The City 'Stormtrooper' – London

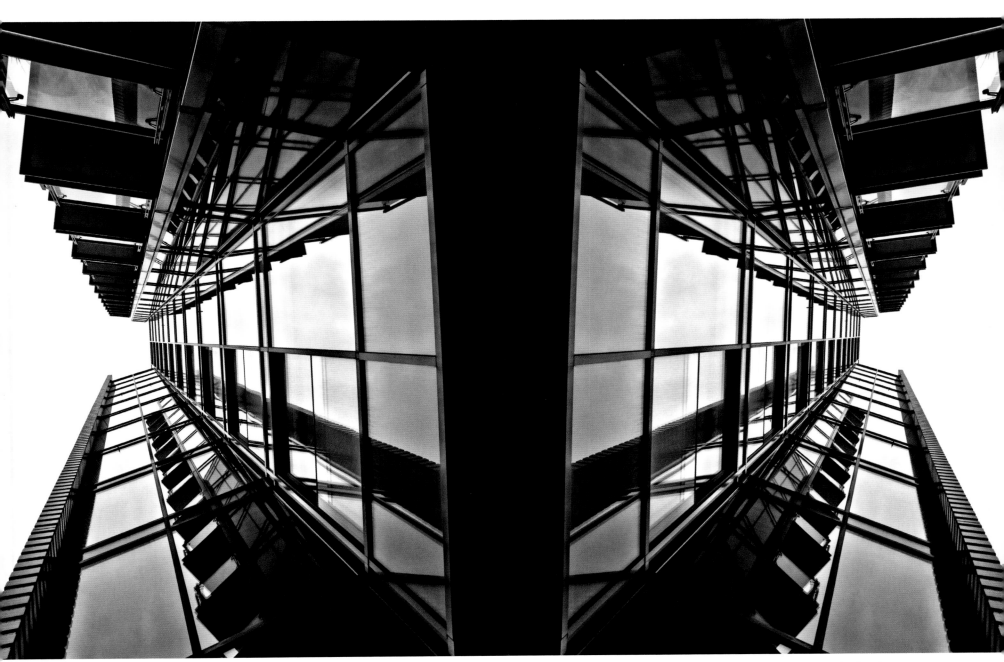

The Face Of The City 'Tint' — London

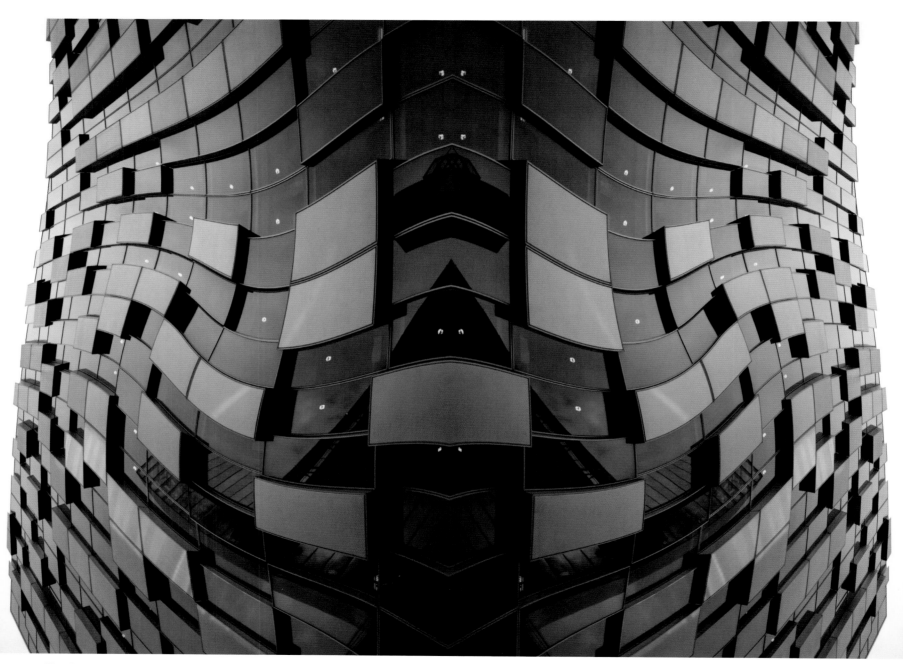

The Face Of The City 'Tron' aka 'Dead Space' – London

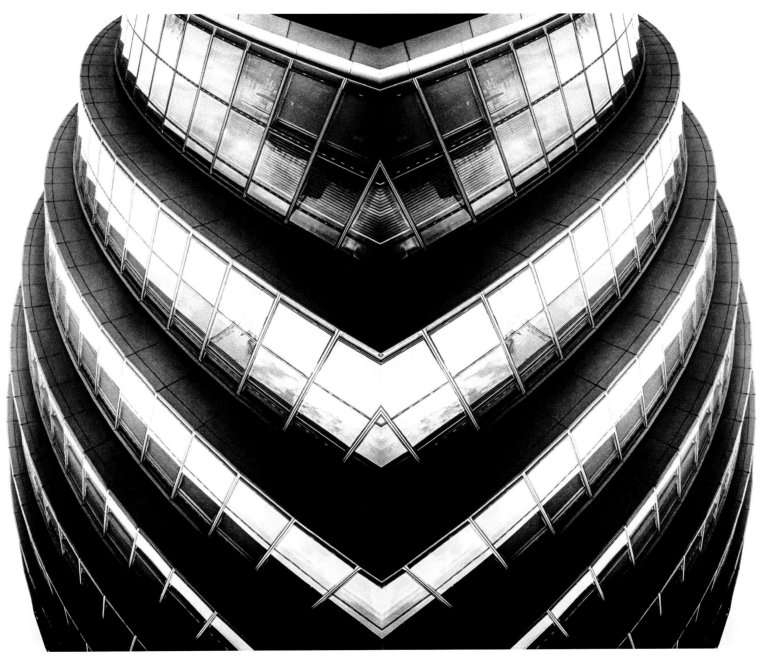

The Face Of The City 'Ultron' – London

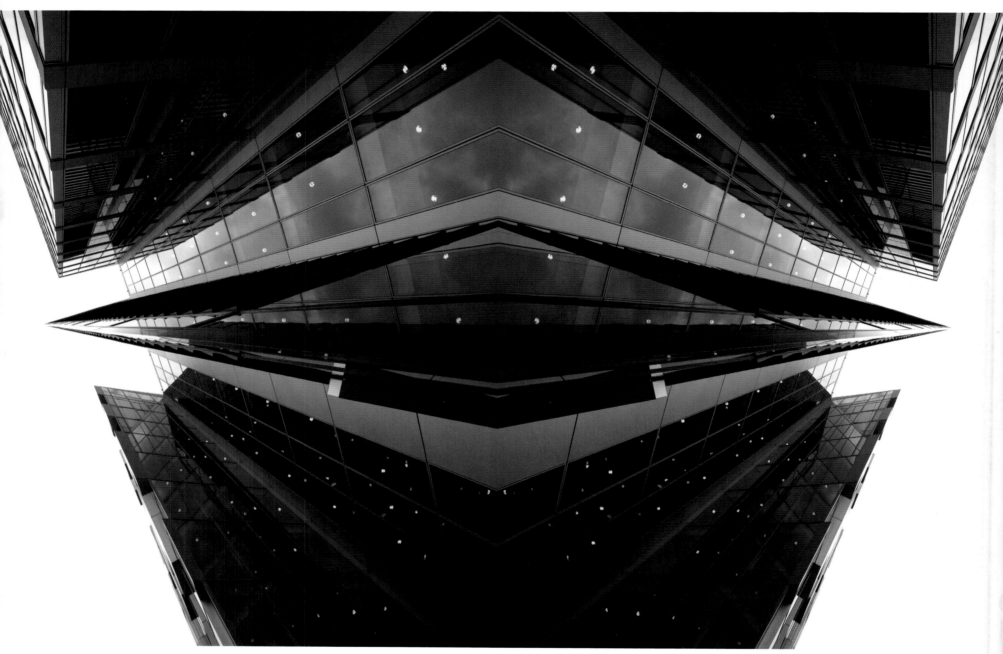

The Face Of The City 'Vector' – London

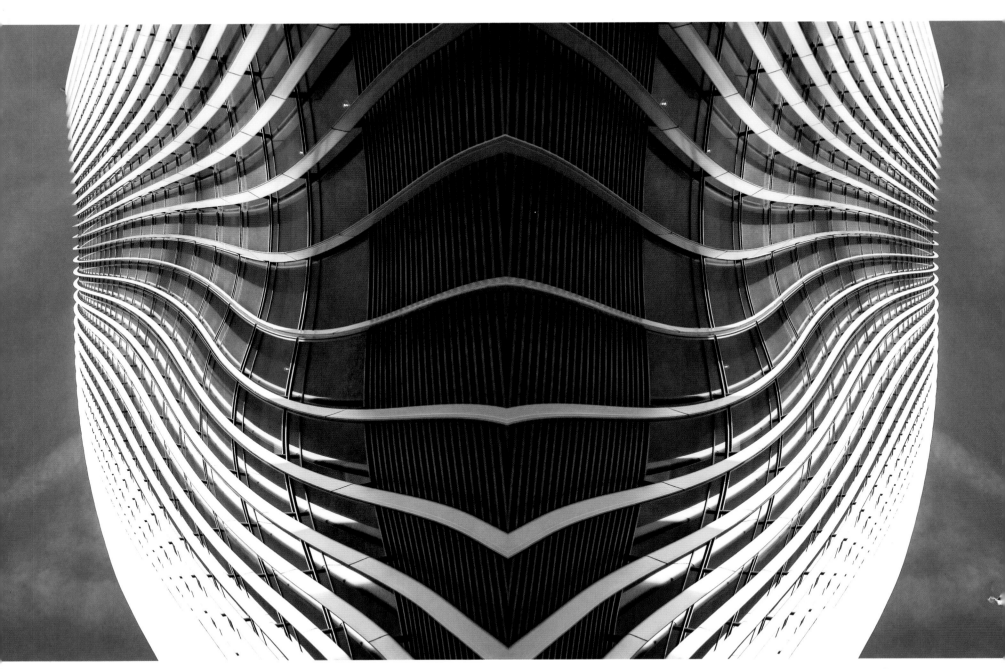

The Face Of The City 'Walkie Talkie' – London

First published in 2015 by New Holland Publishers Pty Ltd
London • Sydney • Auckland

The Chandlery Unit 009 50 Westminster Bridge Road London SE1 7QY United Kingdom
1/66 Gibbes Street Chatswood NSW 2067 Australia
5/39 Woodside Ave Northcote, Auckland 0627 New Zealand

www.newhollandpublishers.com

A record of this book is held at the British Library and the National Library of Australia.

ISBN 9781742578040

Managing Director: Fiona Schultz
Publisher: Alan Whiticker
Project Editor: Jessica McNamara
Designer: Peter Guo
Production Director: Olga Dementiev
Printer: Toppan Leefung Printing Limited

10 9 8 7 6 5 4 3 2 1

Keep up with New Holland Publishers on Facebook
www.facebook.com/NewHollandPublishers

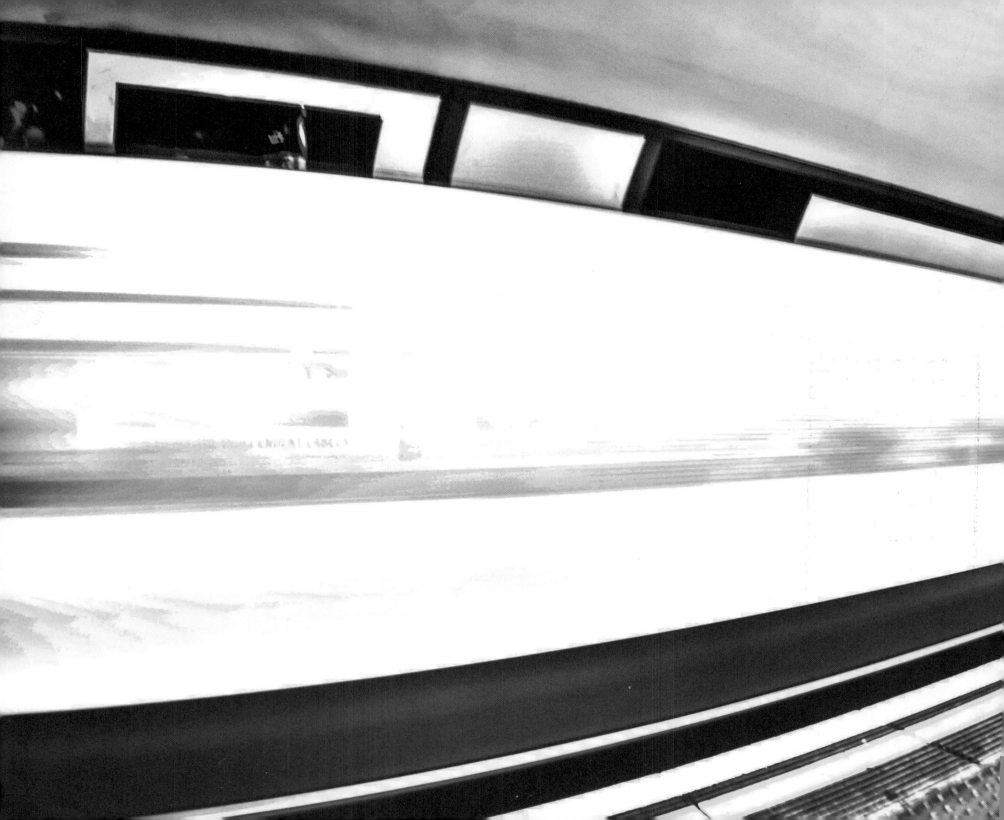